Digital SLR Video & Filmmaking

FOR

DUMMIES®

by John Carucci

WILEY

John Wiley & Sons, Inc.

Digital SLR Video & Filmmaking For Dummies®

Published by
John Wiley & Sons, Inc.
111 River Street
Hoboken, NJ 07030-5774
www.wiley.com

Copyright © 2013 by John Wiley & Sons, Inc., Hoboken, New Jersey

Published by John Wiley & Sons, Inc., Hoboken, New Jersey

Published simultaneously in Canada

For general information on our other products and services, please contact our Customer Care Department within the U.S. at 877-762-2974, outside the U.S. at 317-572-3993, or fax 317-572-4002.

For technical support, please visit www.wiley.com/techsupport.

Wiley publishes in a variety of print and electronic formats and by print-on-demand. Some material included with standard print versions of this book may not be included in e-books or in print-on-demand. If this book refers to media such as a CD or DVD that is not included in the version you purchased, you may download this material at http://booksupport.wiley.com. For more information about Wiley products, visit www.wiley.com.

Library of Congress Control Number: 2012956399

ISBN 978-1-118-36598-4 (pbk); ISBN 978-1-118-40176-7 (ebk); ISBN 978-1-118-40177-4 (ebk); ISBN 978-1-118-40178-1 (ebk)

Manufactured in the United States of America

10 9 8 7 6 5 4 3 2 1

WILEY

About the Author

John Carucci has written more than a hundred articles on photography, video, and technology. His work has appeared in many publications including *American Photo*, *Photo Insider*, and *Popular Photography*, where he served as a contributing editor.

Carucci works as an entertainment news producer for Associated Press Television, where he conducts studio interviews, covers field assignments (red carpet events, news events, interviews, and so on), writes scripts, and edits both television packages and online segments. He has covered numerous events in his role as producer, including the Toronto International Film Festival, the Super Bowl, and the Tony Awards. In addition to his television work, he also writes general news stories on the entertainment beat. Prior to that appointment, he was a photo editor covering sports, national, international, and features.

Carucci has worked behind the camera as a producer and director for numerous video projects and has directed several music videos.

Dedication

To the usual suspects: an actor, director, and a captain.

Author's Acknowledgments

It's hard to make a movie by yourself, and it's even harder to write a book by yourself. With that in mind, I have a lot of people to thank, both those directly related to the book and those, well, directly related to me.

Let's start with the folks at Wiley, starting with executive editor Steve Hayes for giving me the opportunity and having the patience to continually modify the plan to accommodate my busy schedule. Thanks to my editor, Linda Morris, for working with my ever-changing schedule that made the planet in *Star Trek II* after the Genesis project was tested on it seem stable.

Thanks to my agent, Carol Jelen, for finding this project and finding me. I appreciate all of your help.

My gratitude goes out to everyone that appeared, answered a question, and provided some assistance. And once again, thanks to Jillian, Anthony, and Alice for providing a base.

Publisher's Acknowledgments

We're proud of this book; please send us your comments at http://dummies.custhelp.com. For other comments, please contact our Customer Care Department within the U.S. at 877-762-2974, outside the U.S. at 317-572-3993, or fax 317-572-4002.

Some of the people who helped bring this book to market include the following:

Acquisitions and Editorial

Project Editor: Linda Morris

Executive Editor: Steve Hayes

Copy Editor: Linda Morris

Technical Editor: Mike Loomis

Editorial Manager: Jodi Jensen

Editorial Assistant: Anne Sullivan

Sr. Editorial Assistant: Cherie Case

Cover Photo: © Alexander Zhiltsov/iStockphoto

Cartoons: Rich Tennant (www.the5thwave.com)

Composition Services

Project Coordinator: Sheree Montgomery

Layout and Graphics: Jennifer Creasey, Joyce Haughey

Proofreaders: Lindsay Amones, Toni Settle

Indexer: Steve Rath

Publishing and Editorial for Technology Dummies

 Richard Swadley, Vice President and Executive Group Publisher

 Andy Cummings, Vice President and Publisher

 Mary Bednarek, Executive Acquisitions Director

 Mary C. Corder, Editorial Director

Publishing for Consumer Dummies

 Kathleen Nebenhaus, Vice President and Executive Publisher

Composition Services

 Debbie Stailey, Director of Composition Services

Contents at a Glance

Table of Contents

Introduction

*I*t's hard to imagine Alfred Hitchcock giving his cameraman instructions for shooting a scene with a DSLR. But then again, would anyone in 1982 believe video was viewable on anything other than 25" concave tube? Or that anything could ever compete with the quality of film?

But in 30 years, the world of cinema has changed, with many feature films shot digitally and sophisticated special effects features bundled into free programs for the masses.

But perhaps the most liberating technological advancement has to do with the ability for the consumer-level digital single-lens reflex camera to capture high-quality high-definition movies. That's a game-changer.

Ten years ago, if somebody said you could make movies with the same camera used for still photos, I would have questioned his sanity. If he went on to say the quality would look as good as a Mini-DV tape, I'd wonder if he inhaled some sort of toxic mold. But if he carried on about the camera's ability to capture movies in full-frame HD, words like "bonkers," "delusional," and "preposterous" would come to mind.

But I stand corrected.

Now you can capture movies in full frame HD with superior quality at an affordable price using the same DSLR used for your still photography, not just because of the low cost-to-quality ratio, but also for flexibility.

And that logic has spread to the professional arena with an increasing DSLR presence in broadcast news, movies, and even television shows.

Now that same power can be in your hands. The Canon Rebel Ti3 (and its ability to capture HD movies with whatever Canon lenses you choose for ultimate sharpness) starts at around $600. The video records on a media card and is easy to transfer to your computer. Using an inexpensive, nonlinear editing program like Adobe Premiere Elements 11, you can make a movie, and the only bounds placed on you lie in your own ability.

Not bad for a beginner, huh? But how good are DSLR movies?

Does good enough for the producers to shoot an episode of the television series "House" with the Canon 5D Mark II count? I would say so, and that you'd be hard pressed to tell the difference whether it was shot by movie camera or one originally designed for taking photographs. What makes this truly magical is that the DSLR is a camera you're most likely comfortable with using.

Although a DSLR camera does double duty, moviemaking versus still photography have two very different approaches.

Why? When you're taking a still image, you're responsible for a single frame. Although that's a tall order, as long as that frame is properly captured, all is well in the universe. If it's not, you keep going back to fix that one frame.

Movie capture moves at a different pace. For example, if you handhold a DSLR for movies like you would for still images, you may be disappointed with the results because the ergonomics simply do not allow it. It doesn't sit comfortably in your hand, so it's hard to hold and prone to shake. Instead, you can mount the camera on a tripod or some kind of rig to offset the balance.

And that's just one dilemma. Throughout the book, I point out these differences and give some sage advice, parsley and thyme optional.

Although this book focuses on DSLR moviemaking, it takes it from the perspective of a true moviemaking guide. So much of the information defies the type of camera that you use, especially when it comes to practical stuff like finding the right location, shot structure, and directing your actors.

In this book, I go through the basics and get a little crazy with effects. For postproduction, Adobe Premiere Elements lets you take your random clips and put them together into a cohesive movie. Why that program, you ask? Premiere is the little brother of the more pro-ready Adobe Premiere, and it offers a nice feature set and multi-platform support. I'm a Final Cut Pro guy, myself, but when I need to work with another program for some reason, I go back to the one I learned on, Premiere Elements.

Having danced between film, photography, and video my entire career hopefully makes me the right dummy to write this book. Moreover, by the end of the tour, er . . . book, feel free to give me a tip if you've learned something. Until then, I'll be providing the tips.

About This Book

I'm not a fan of overly procedural technical books, opting instead for the *get in* and *get out* style. *Digital SLR Video & Filmmaking For Dummies* helps make sense of DSLR moviemaking, but it goes further than being a jacked-up camera manual where information is camouflaged in a sea of words. I much prefer vital information up close and personal. Based on my experience as both a still photographer and television producer, I describe how to effectively use your DSLR to make movies.

I expect readers come to this book for quick information: cinematic tips, cool effects that impress your audience, advice on making an effective edit, and even some guidance through the presentation process.

With nothing more than a new camera and an overwhelming desire to master it, each of you comes from a different space in the community. Maybe some readers are still photographers looking to channel that energy into making movies. Others have familiarity with video production, but never thought of using a DSLR for it. This book will help you do both.

Foolish Assumptions

Send me your experienced photographers, established videographers, a student with a vision, or an amalgamation of the three, and I will write a part of this book just for you. I assume that you as a reader fall into one of the following categories.

Newbies

Don't tell me. Let me guess. You just got a new DSLR after learning you can make movies with it. The only problem is that none of the positive things you heard about it seems to work for you. Your movies are shaky. The audio is tinny, and there's a still frame representing what you thought was a performance.

If you didn't know before, you do now: DSLRs behave differently than camcorders, and they behave differently when used for movies than when they're used for still photography.

You want your movies to look stunning, and trust me, they will. Through an abundance of succinct information, aided by lists, illustrations, and tips — and did I mention a down-to-earth tone — you will get a grasp on DSLR operation. Everything from where to find the camera controls, how to capture a movie, and how to do non-linear editing await your understanding.

Students

If you're interested in making movies and not bound to a particular style or format, this book is for you. You can start from ground zero on the movie camera d'jour and cinematic technique. Before long, you'll be making movies proudly with your DSLR.

Photographers

Because you already know your way around a DSLR, this book helps convert your comfort level with the camera to eloquent moviemaking that shows effective, time-tested techniques. Cinematic tips enlighten you on the DSLR's powerful functions for moviemaking. I describe how to easily construct your movie, and then show it off as more than a moving still image.

Videographers

Videographers sit diametrical to the photographer, and while already familiar with shooting the moving image, the unusual ergonomics of the DSLR and the necessary accessories take some getting used to. Ripe with tips, this guide puts you in the easy chair, filling in the blanks with camera operation. In addition, special effects more suited to a DSLR are discussed in depth. While the software used for this book may differ from what you're used to working with, hopefully there will be a few nuggets that help translate to your favorite Apple program. (Wink, wink.)

Conventions Used in This Book

New terms are *italicized*. Website addresses appear in a special font. A series of menu commands that you should follow looks like this: File➪Save, meaning that you should click the File menu to select it, and then click Save from the submenu that appears. Sidebars present information that is interesting, but not absolutely essential.

How This Book Is Organized

Digital SLR Video & Filmmaking For Dummies is divided into five sections. Some may relish the part that pertains to the understanding the camera's video functions, whereas others will skip ahead to the filmmaking techniques or the postproduction section. Think of it as a smorgasbord of information.

Part I: Joining the DSLR Video Revolution

This section provides the reader with a swift overview of advancements in the HD moviemaking capability of digital single-lens reflex cameras. These range from consumer to professional models and include a base made up of a wide swath of users. In addition, you'll learn about the equipment needs for DSLR moviemaking, which differs somewhat from traditional television production.

Part II: Control the Camera, Control the Movie

Great moviemaking comes from understanding the fundamentals of videography and how they present themselves on a DSLR, sometimes with limitations. From proper exposure and accurate white balance to simple lighting techniques and pristine audio capture, you'll discover how to capture the best possible movies with your DSLR.

Part III: Fixing It in Post

After you understand the DSLR with all of its accessories and can use fundamental techniques for shooing your movie, it's time to put it all together. This section discusses setting up your computer and how to use the software. Using Adobe Premiere Elements, you'll become familiar with setup, basic editing technique, and adding effects. The section concludes with ideas for showcasing your movie.

Part IV: Becoming a Filmmaker

This part covers the business of filmmaking. It briefly describes the functions of writing, directing, shooting, and acting in a movie.

Part V: The Part of Tens

The *For Dummies* version of a Top Ten list provides insight into some common moviemaking techniques, that start with, uh, moviemaking. I offer my top ten tips for creating a music video, covering a wedding, and even making a documentary.

Icons Used in This Book

What's a *For Dummies* book without icons pointing you in the direction of really great information that's sure to help you along your way? In this section, I briefly describe each icon used in this book.

This icon marks a generally interesting and useful fact — something you may want to remember for later use.

This icon points out helpful suggestions and useful nuggets of information.

When you see this icon, you know that there's techie stuff nearby. If you're not feeling very techie, feel free to skip it.

The Warning icon highlights lurking danger. With this icon, I'm telling you to pay attention and proceed with caution.

Where to Go from Here

Democracy rules with this book, and although everyone from beginner to expert can get something from its hallowed pages, not everybody needs to read cover to cover unless you really want to make my day.

Certain readers may find some of the book too remedial, whereas others may deem some topics too advanced. You know who you are, so feel free to flip, skim, and even jump past anything that doesn't pertain to your interests on any given day. There's always tomorrow for you to come back to it.

Psst. I've got a couple of tips to help you.

Despite your familiarity with either DSLR or moviemaking, you will still want to look at the Tip and Remember icons. If you're looking for quick information, look at the lists, both bulleted and numbered. There's no shortage of them.

If you already know the basics of how to use a DSLR, don't bother with Chapter 1 — just skip ahead to Chapter 2.

If you already own a DSLR, you probably won't want to read about other DSLR models, unless of course you're not happy with your own camera, in which case head to Chapter 3.

If you're a seasoned video camera operator, skip the chapters that explain video equipment like dollies, audio gear, and editing software.

If you're a complete beginner, start at Chapter 1. If you're an experienced still photographer looking to use your DSLR for filmmaking, start at Chapter 5. Maybe you're comfortable with camera work, but want to brush up on Adobe Premiere Elements. In that case, Chapter 12 can be a good place to start.

Occasionally, our technology books have updates. If this book does have technical updates, they will be posted at www.dummies.com/go/dslr videofilmmakingfdupdates.

Part I

Joining the DSLR Video Revolution

The 5th Wave By Rich Tennant

THE NEW HOLLYWOOD

CUT! PASTE!

*T*he DSLR captures stunning still photographs and equally impressive movies. But unlike taking a photograph, shooting movies requires a little more finesse.

Part I provides you with a quick overview of the DSLR and everything that attaches to it. And then there's the stuff that supports moviemaking, like sound gear and stuff to keep the camera steady.

If you're up to it, the journey begins now . . .

Going from Still to Video in a Single Camera

*O*nce upon a time, still cameras and video camcorders lived separate lives and told different tales. But then out of the shadows emerged the DSLR, and before long, it changed the game by capturing movies and still photography with the same camera.

Prior to that, the 35mm single-lens reflex, or SLR, was the primary tool used to create masterful photography. Professional photographers populated the pages of magazines and newspapers, whereas amateurs documented the family vacation and captured embarrassing pictures of Junior. For personal use, the same 8mm movie camera used to silently document childhoods of a bygone era was the choice of budding filmmakers. That was succeeded by amateur video equipment, which captured sound and visuals with enough detail to preserve memories but not enough quality to do much else.

By today's standards, the image quality was not much better than that of iPhone video quality, so you could forget about doing anything professionally unless you mortgaged your house to buy state-of-the-art equipment. Ironically, the same equipment that had a few more zeroes in the price tag back then is inferior to what you can buy at your favorite electronics store for a fraction of the cost.

The revolution sparked by the DSLR is hardly new. Dual-use cameras have been around for years, with older DV camcorders offering still photo capability and digital point-and-shoot cameras having a simplistic movie mode. But that doesn't mean it was a good thing. Taking a still image with a video camera is like walking down the up escalator. Yeah, you'll get to where you need to be, but it's cumbersome, inefficient, and there's no good reason to do it that way. When you consider the relatively poor image quality and lack of photography-based controls of these early dual-use cameras, you'll see why they were the most unnecessary feature since tonsils and an appendix.

The idea of a still camera being able to capture video seems odd, yet the DSLR is an effective moviemaking tool. In this chapter, I take a look at why movie capability works so well with a DSLR.

Making Movies with Your DSLR

Adding video capability to a camera designed primarily for capturing high-resolution still photography seems like a no-brainer. A high-res still camera already offers the ability to capture a high-quality image thanks to excellent optics and its ability to perform well under low-light conditions. So capturing images in succession, albeit very fast succession, was not an impossible dream. And now that it's here, the HD-capable DSLR sets you on the path to professional quality with an initial investment of a camera body starting as low as $500. With the addition of a few accessories, you can start making movies right away.

Here are a few advantages to using a DSLR over a camcorder:

- **Larger sensor:** A camcorder uses a very small sensor — often as small as 1/8" — whereas a DSLR has a much bigger one. How much bigger? Some match the size of a full 35mm frame, meaning that they are 24×36mm, or about 1 inch×1.4 inches. By comparison, a 35mm motion picture frame measures 18×24mm, as seen in Figure 1-1. While the full-frame sensor is reserved for the more expensive DSLR models, even the entry-level cameras use a sensor larger than a camcorder's. For example, the Canon Rebel T4i uses an APS-C sensor (22×15mm) that captures more information than a prosumer model costing ten times more. Of course, higher cost doesn't always translate to being better.

- **Better low-light capability:** The larger CMOS (complementary metal-oxide-semiconductor) sensor found on a DSLR performs significantly better than the CCD (charged-coupled device) sensor used on many camcorders. This translates to more detail, especially in the shadow and highlight areas, as seen in Figure 1-2.

- **Superior optical choices:** The interchangeable lens system used for still photography provides the freedom to use the right lens for the scene as opposed to being stuck with the one that came with the camera.

Figure 1-1: A comparison of full frame, APS-C, and 35mm film frame sizes.

Figure 1-2: This twilight scene shows the detail you get with a bigger sensor.

But it's also important to remember camcorders have some strong features not found on a DSLR. For one, they cover a wide focal range and have power zoom. But these conveniences don't necessarily lead to better image quality even with sharp optics. Then there's the cost factor, which can be considered lop-sided at best. Purchasing a camcorder, at least one worthy of producing broadcast quality video, is far more expensive, with the entry level at the $2,000 range. From there, prices climb high like a hike up Pikes Peak.

Unfortunately, there are also some drawbacks to using a DSLR instead of a camcorder. They include

 ✓ **A DSLR is not very ergonomic.** Unless you can grow a third hand, you'll have to consider using a tripod or another form of stabilization. Otherwise, it's hard to deal with all of the accessories for audio, lighting, and monitoring. Many serious users use a tripod or mount their cameras on a handheld rig unit. See Chapter 2 for more information.

 ✓ **DSLR and camcorders aren't that similar.** It's as easy to misuse a DSLR as a still camera. The camera's original intent was for still photography, so it follows that time-honored design, replete with a different control set than a camcorder. It's also held differently than a camcorder. Being

cognizant of these differences leads to improved operation and ultimately a better movie, but sometimes that's easier said than done.

⌐ **DSLR has a cumbersome control set.** The controls are confusing for photographers and baffling to videographers at first because the controls are still more common to still photography than moviemaking.

Understanding the SLR part

Bursting onto the scene in late 1940s, the single-lens reflex camera gained widespread popularity over the next five decades. It was the choice of pros and serious amateurs for shooting 35mm film. In the 1990s, it morphed into the DSLR, using a digital media card instead of a roll of film. Over the last couple decades, the DSLR has improved with each generation until it has overtaken the conventional film camera. Although the DSLR differs from its film-bearing predecessor, it also shares many similarities.

Not sure about that? Break it down. The *single-lens* part of the name refers to the fact the camera uses one lens. The *reflex* part of the name pertains to the mirror and prism that let you look into the camera's viewfinder and through its lens for accurate framing of the scene. You know, sort of a what-you-see-is-what-you-get sort of thing.

The SLR captured a still image on film, and that film came in dozens of types, each with very specific qualities. Color balance, saturation, and grain structure varied with each, so selecting the proper emulsion was like picking the right wine.

Figuring out the digital part

Kodak ushered in the DSLR era in 1991 with the commercially available DCS-100, which was basically a Nikon F3 body with a 1.3-megapixel camera that cost as much as Nissan Maxima. Even more shocking is that the camera produced an image with less data than the average cellphone captures today.

Regardless of the quality factor, Kodak started a revolution by replacing the film with a sensor and saving each shot to a PC Card memory card. (It was essentially a portable hard drive with moving parts.) The quality was acceptable, especially when you consider that the image didn't require processing, at least in the chemical sense. And of course, those sharp optics compensated for the limitations of the small file size. More than 20 years later, the DSLR does more than take superior images; it also adds the ability to capture high-definition movies.

Although they use a CMOS sensor that captures varying amounts of data, HD movie cameras are bound to 1920×1080 pixels, so the actual amount of pixels captured doesn't have as much significance as it does with still photography. The physical size of the sensor determines how much sensor landscape it

occupies. These range from the equivalent of the full-frame 35mm to the smaller-sized APS-C or the even smaller Micro 4/3. These sensor sizes share similarities with film format sizes (35mm, 6×6cm, 4×5, and so on) and the amount of information they capture.

Interestingly enough, that Canon Rebel T3i you just paid $600 for has a bigger sensor than the Sony PMW-EX1R HD prosumer camcorder costing many times more. I'm not saying that the DSLR is better; it's not, out of the box. But with the right accessories, it can equal, and at times, exceed, the quality of its more expensive counterpart.

Buying a suit is a fair analogy for purchasing a DSLR. Regardless of how good it looks to start with, you need some accessories to finish it: a belt, shirt, and a tie (unless you're going through some mid-life crisis rock-star thing). Sound familiar? The DSLR has a lot of horsepower under the hood, but it needs some assistance to bring it to its potential. In the next few sections, I talk about accessorizing your DSLR.

Changing a lens

Selecting the perfect lens for each situation — as opposed to using the one that came with the camcorder — is a luxury of using a DSLR. Covering a football game? Slap on a telephoto and bring the action closer. Or get a little freaky with an ultra widengle, as seen in Figure 1-3, and get an up-close and personal perspective. Whatever the situation, you can use the right lens as long as you have it in your bag making the DSLR perfect for moviemaking.

One caveat is that it's sometimes hard to calculate focal length, depending on the size of the sensor. If you're using a higher-end DSLR that offers a full-frame 35mm, it has a wider field of view than when you're using a model with the smaller APS-C frame size. More on that in Chapter 2.

Figure 1-3: For this shot, I used an ultra wide-angle lens placed close to the subject.

Defining DSLR Users

How do you define yourself as a DSLR user? Well, what did you do before using it to make movies? Given the democratic freedom of the format — as both a still photography and HD video camera — it's possible to cover a wide range of user types. But, if you want to use your DSLR to take pictures and make movies, you're in unique company:

- **Neophyte user:** This is your first DSLR, and you bought it to take still photographs and perhaps dabble in making movies. The only thing stopping you is that you're not quite sure how to do it. Well, you've come to the right place because this book sets you on the right path. The foundation of DSLR moviemaking begins with a clearly defined breakdown of camera controls, fundamental description of moviemaking technique, and a crash course on non-liner editing using Adobe Premiere Elements.

- **Home video enthusiast:** Could it be that you identify more with Ken Burns than Steven Spielberg? If so, the DSLR is for you when it comes to capturing those golden moments. Whether you started out with a Super 8 movie camera, worked the room with a VHS-C camcorder, or dabbled in DV moviemaking documenting the world (even if that meant on your own street), there's good news. The DSLR will open new doors for you and let you take still photos too.

- **Economy-minded pro:** Professional video camera operators have a strong understanding of the moviemaking process, so adapting to a DSLR is not much of a stretch. You understand basic camera operation no matter where the controls are located, and know the DSLR can provide above-average performance with its modular approach to building the best setup.

- **Experienced still photographer:** You've mastered the DSLR for still photography, but one day, you realize you'd like to herald its moviemaking capability. You know how to operate the camera, but you need to understand cinematic technique. Awaiting your Midas touch, many topics in this book help bring your penchant for capturing amazing images come to life.

Deciding Whether to Get a DSLR

Regardless of whether you're contemplating the caloric intake of the chocolate pudding diet, questioning your commitment to macrobiotic vegetarianism, or longing for the extreme rush of bungee jumping off a high bridge, you have to consider the pros and cons. Guess what? The DSLR is no different — though it's less filling, tastier, and safer than those choices, respectively speaking.

That doesn't mean you won't notice the difference when making movies. Because the DSLR was originally designed for still photography, the movie mode is a bit unrefined, at least in comparison to a dedicated video camera. In the next sections, I look at the pros and cons of DSLR.

Understanding why DSLRs are not quite the same as a video camera

Both mittens and gloves keep your hands warm, yet each provides a noticeable difference when it comes to dexterity. Don't know what I mean? Try to pick a coin from your pocket or make the "OK" sign while wearing mittens. It's just not going to happen. The same is true for holding a DSLR. Compared to holding a dedicated camcorder, holding a DSLR feels like picking up stuff with mittens.

By and large, clutching a video camcorder feels more comfortable. Just slide your hand through its strap and your thumb naturally sits on the button. Viewing the scene is ergonomic thanks to a flip-out screen, and the controls are easily accessible.

Conversely, the DSLR is like the "mittens" of movie cameras. The leverage of holding it in your hand is hardly ergonomic. Neither is the Record button, which differs on each camera. It's on the back of many cameras, as opposed to the shutter button, which is on top. That's just weird.

Movie controls are nested in the menu, much like a camcorder. The difference is that on a camcorder, the functions pertain solely to video capture. Because the DSLR menu system focuses more on the still photography, not many functions are relevant to moviemaking.

To simplify the process and reduce the margin for error, consider adjusting the menu settings before going out to shoot. Then when you need to grab your camera and go, you won't shoot an entire scene only to find out it's green or shot in standard definition or slightly blurred thanks to low shutter speed.

But it's not that simple because each camera differs with where its functions are located. For example, the controls on a Canon Rebel T3i differ from the Nikon D3200, yet the basic idea of making necessary adjustments remains the same.

These settings make good sense for staying ready:

- ✔ **Capture in HD:** Be sure to set at 1920×1080. And if the camera allows, set on the proper frame rate. If you plan to edit at 29.97 frames per second, for example, be sure to set it.

- ✔ **Use manual settings:** When exposure is set to Manual, you can tweak in Live View to your exact needs.

✔ **Make sure sound recording is on:** Many first timers have done their best D. W. Griffith impersonation, unintentionally, of course. (Griffith directed the first feature-length feature, *Birth of a Nation,* a silent film.)

✔ **Set White Balance to Automatic:** Do this only as a safety precaution — sometimes you need to shoot quickly. Nothing is worse than shooting an outdoor scene with the white balance set to Tungsten and making everything blue, as seen in Figure 1-4. Don't be blue! Just cover yourself on Automatic until you can take a manual reading of the scene.

Figure 1-4: This can happen if you don't adjust for the scene.

The DSLR clearly requires some finesse, but when everything is properly set, it can reap some amazing results that include

✔ **Beautiful image quality:** With a sensor many times bigger than ones found in a dedicated prosumer camcorder — and combined with sharp optics — you'll capture the best possible image, as seen in Figure 1-5.

✔ **Lens versatility:** Whether you go with the funky fisheye to creatively frame the subject or decide on a long telephoto lens to bring the action closer, suddenly, the idea of giving up the power zoom ubiquitous on camcorders is not that big of a deal. Besides, as you gain experience, you'll discover that zooming is a moviemaking no-no, anyway, so no harm, no foul.

✔ **Impressive depth of field control:** Still camera lenses offer a clear advantage over the level of focus in the scene. You can render tack-sharp elements in the scene using a wide depth of field. Conversely, you can also create a narrow area of focus for an effect often seen in feature films.

✔ **Increased functionality:** Using a wide range of accessories, you can transform the DSLR into a more functional moviemaking tool. Remote triggering devices, rack systems, wireless transmitters, viewfinder adapters, and numerous other toys help carry out your moviemaking dreams.

✔ **Remarkable low-light capture:** One advantage of the bigger sensor size is that it significantly reduces the noise usually associated with low-light capture. In addition, fast lenses (f1.8 or faster) allow you render more detail in the image than the average camcorder. Then there's ISO capability that allows you to control the sensitivity of the sensor. As the sensitivity goes higher to handle low-light situations, visual noise increases. But with each generation of the DSLR, that challenge seems to lessen, letting you capture under low light with reasonably good image quality.

Using a DSLR to shoot your movie has a huge upside. Just remember that it's built to shoot photos first, and video capture is merely an option. Some aspects of DSLR moviemaking are rough around the edges, like these:

✔ **Focus issue:** One rough area of DSLR filmmaking comes with dealing with focus. It's not as friendly as a camcorder. For one, it's hard to get precise focus while using the camera's live LCD screen. It's not like a camcorder lens that allows you to zoom all the way in to focus, so that when you pull out, the focus is exact. Quite the contrary: Camera lenses provide little leeway due to the relatively short ratio between focal length. It gets worse when you're using a fixed focal length or a camera with a short zoom. And then there's autofocus, which has its own shortcomings.

✔ **Lack of sufficient controls:** DSLR cameras can capture high-quality movies, but because the camera's first function is to take still images, it has fewer controls for moviemaking. Many DSLR models offer little control over exposure while shooting.

✔ **Limited recording time:** Some cameras limit capture to 12 minutes at a time in the full HD mode. This limit shouldn't present a problem because you would rarely need to have such a long continuous take. Unless, of course, you're shooting something like kids at a school recital or play. In that situation, you'll need to stop and start at appropriate points of the show.

✔ **Not ergonomic:** Because it's designed for shooting stills, the DSLR is not as comfortable to hold for making movies. The lightness of the body and the weight of the lens tend to make you shaky when you hold it by hand.

✔ **Not kind to audio:** Although DSLR offers spectacular image quality, the same cannot be said for audio capture. But what can you expect when the built-in microphone that was originally put there for voice notes for still photos becomes the primary means of capturing sound? One look at the pinhole design should tell you all you need to know. Combine that

with a lack of control over audio levels and XLR cable connectivity and it becomes abundantly clear that the audio will not be stellar. On a bright note, the camera does offer a mini-plug for adding an external microphone as well as a line mixer with XLR inputs.

- ✔ **Rolling shutter:** Although it sounds like a retractable accessory for your bedroom window, *rolling shutter* is actually a common imaging defect that occurs when the camera moves too fast. Pan too quickly and you'll see its effect. And what's that? Portions of wobbled, skewed, or partially exposed elements in the frame.

- ✔ **Single sensor:** This is not really a con as much as a tradeoff. The bigger sensor is clearly superior under low-light conditions. Although color rendition is good, it's not as good as that of dedicated camcorders with three CCD capture.

- ✔ **Temperamental to temperature:** DSLR cameras are notorious for overheating and can stop recording without warning.

Figure 1-5: The attributes of a still photo camera can result in impressive movies.

Continuous takes

Most areas of filmmaking opt for a modular approach to assembling the film as a montage of scenes. But that didn't stop Alfred Hitchcock from experimenting in his 1948 thriller, *Rope.* He shot continuous takes using the full ten minutes each film reel captured, continuously panning from actor to actor. The film was then assembled as a series of long takes using a variety of tricks.

Seeing how DSLR is familiar to still photographers

DSLR moviemaking touches a cross-section of users, yet none more than still photographers. Still, sometimes it creates a bit of a paradox for this crowd. Part of mastering DSLR moviemaking depends on understanding the camera, whereas the other half is forgetting what you already know about it. Before you look at me funny, it's because you need to look at a DSRL as something other than a still camera. Switching to the movie mode unlocks a magic door, and you'll see and hear things that you've never heard before. Take that as a sign for things to come.

Thinking in Movie Terms

We're not in Kansas, anymore, Dorothy. You must abandon using the DSLR as you would for still photography. Instead, you must embrace more cinematic fundamentals. Shooting to edit, breaking up shots, differing angles, and considering sound are the new rules of the game.

Returning to my analogy for buying a men's suit off the rack, your DSLR straight out of the box can shoot a movie as well as a suit fits you off the rack. Yeah, it works, or fits, depending on the camera or suit. But with a little help, it gets better. The next step is making sure you have the right equipment.

The following accessories are a good place to start:

- ✔ **Have a wide range of lenses:** A basic arsenal includes a wide angle, telephoto, and zoom lenses. Good glass is a plus; having an ultra wide and fast lens (with a low aperture setting) is also beneficial.

- ✔ **Something to keep it steady:** Because you can't hold the camera with the same ease as a dedicated camcorder, you'll at least need help from a sturdy tripod. If you foresee a lot of handheld shots, consider getting a rack system. See Chapter 3 for more information.

- ✔ **Enough audio accessories:** Thanks to that microdot of a microphone, you'll only get sound resplendent of a bad home movie. Improve those odds with an optional external microphone that mounts to the top of the camera. Most likely, you're not going to get multichannel recording with it. So, if you're really serious about audio, you can use an adapter for XLR cables. Need even more control? Get an optional sound recorder that can capture audio separately and match it later with software.

Putting It All Together

More often than not, being a successful filmmaker depends on wearing many hats. Some are clearly more prominent, but the role of quality-control expert is often overlooked. Verifying correct white balance, proper exposure, sharp focus, and a variety of framing choices assures that each shot helps build the movie block by block.

How you fill the frame communicates your intentions. How much area the subject occupies, or which direction it moves through it, or at what camera angle the scene is shot helps tell your story. But camera placement only takes you so far. That's because if you don't take special care with lighting, none of that other stuff matters, as seen in Figure 1-6. Distinguish when you need to take advantage of natural light and when to bring your own. After that, the opportunities are boundless. Throw in some time-lapse sequences. Maybe green screen keeps the party going by making things more visually interesting.

Figure 1-6: A well-lit and composed scene.

Realizing that half the movie is shooting it

The movie process begins with a spark, an idea. That idea is then cultivated into a screenplay. Scenes are eventually shot and reshot, and sometimes shot again. And none of that footage matters if it's not put together properly. The editing process makes or breaks your movie by controlling the pace and showing the audience what's important. Montage editing, as it's sometimes called, is the grammar for the visual language of filmmakers. Figure 1-7 shows a succession of shots that can lead to a successful edit.

Figure 1-7: By showing alternating frame size and perspective, you can lead the viewer in or out of the scene.

Making your movie sing in post-production

The moderately priced Adobe Premiere Elements has enough power to carry out your earnest intentions, and it's super easy to learn. Best of all, advanced effects are just a step away. Premiere Elements offers the perfect blend of function and price. After getting acquainted with its advanced features and cross-platform versatility, you'll be making your first movie before you know it, and then another and another after that.

Figuring out what to do with your movie

After you've planned, shot, and edited your movie, it now awaits the next step. But what exactly is that? The answer, grasshopper, lies in your ambition. There are no limits regarding what you do with it. Send it to a short film competition if it's a short film. Enter a contest, hold a private screening, or become a YouTube sensation, as seen in Figure 1-8. Does that sound good for your future? It should: The sky is the limit. Or maybe I should say that the world is the limit, as in the World Wide Web.

Figure 1-8: For your chance to become a YouTube sensation, you have to start by uploading your movie to the popular video-sharing site.

2

Exploring DSLR Video Capabilities

*N*ow that the light bulb above your head has gone off and enlightened you to the world of DSLR moviemaking, it's time to choose a model that works for you, or to learn more about the one you're already using if it suffices when it comes to making your masterpiece.

Although they look similar, not all DSLRs are created equal. Some are designed for consumers; others are made for professionals. The price disparity between the ceiling and floor is high, but that's not to say that an inexpensive model won't accomplish what you need, or the most expensive camera body is a shoo-in for making great movies. The camera is merely a tool that acts as an extension of your own ability, knowledge, and creativity.

The right camera for your needs usually ends up being the one that offers the functions you need at the price you can afford.

Selecting the Right Camera

Models like the Canon Rebel T4i sit on the lowest rung of the price ladder, but don't let its $700 price tag fool you. Its high-definition video capability at a wide range of resolutions and frame rates offers a lot of camera for the money. It can easily produce a broadcast-quality movie.

More serious users, however, may opt for the movie-friendly Canon 5d Mark III with its solid design, full-frame sensor, and dedicated functionality for DSLR moviemaking. The Mark III costs nearly six times that of a Rebel, however, so make sure your needs warrant the extra cost.

Which camera you use is dictated more by your needs than an overwhelming difference in image quality. Nonetheless, the process of selecting the right camera can make you feel like Goldilocks trying to find the right bed or picking the perfect lunch.

Working on a budget

In porridge-speak, lower-end cameras are the cold stuff. More practically, however, they're for the budget-conscious. Not everyone gets to sleep in Papa Bear's bed, or buy a 5d Mark III for that matter, especially if photography is not your profession. As long as you're capturing in full HD and using quality optics, it's perfectly acceptable to use an affordable DSLR and expect to see optimal results.

Features, durability, and sensor size play big parts in camera pricing.

Just like film formats came in different sizes, so do camera sensors. And depending on the actual size, the sensor determines how much the image is magnified on it. Using the same 50 mm focal length on cameras with different sensors will give different results, with the larger sensors including more of the scene.

The APS-C sensor is smaller than a full-frame, so it renders focal length on the long side. Compared to a full-frame sensor, it makes the image larger on the sensor. That means that your 50 mm lens turns into an 80 mm lens when using the APS-C sensor because it adds a crop rate of 1.6X. That means the subject will be 1.6 times larger on the sensor. Nikon uses a 1.5X. A 4/3 and Micro 4/3 uses a 2X factor.

On the positive side, cameras with an APS-C sensor make your 200 mm lens more like a 320 mm lens, bringing the subject far closer. On the downside, that 20 mm lens on the wide side now behaves more like a slightly wide 35 mm focal length. Other than that, all that matters is that the camera captures in high definition.

Durability is another issue. The more expensive models are made of titanium. That means models at the bottom of the class are not as solidly designed and often not as ergonomic. These include the Canon T3i, the Nikon D3100, and Sony SLT-A35.

As for feature variations, more expensive models include sophisticated audio control and better Live View functionality (more on that throughout

the book). Still, many of the main differences between DSLR price points have more to do with still photography functions than movies. Features like greater capture size, metering options, and viewfinder integrity are a few functions found on better models.

Blowing the budget

Papa likes his porridge hot, and his cameras too. That's a full frame DSLR with reinforced body, more nested controls, and a viewfinder that provides 100-percent coverage. This class of camera offers a sensor that covers as much ground as a 35 mm frame to produce the most quality in your image. On the telephoto side, the magnification comes at face value, so you won't get any closer than you would when using a 35 mm camera, but that's a problem most of us can live with.

Also in the mix (no pun intended), are more sophisticated audio controls, improved sensor technology with lower noise and increased image quality, and a more solid feel. Popular models in this elite group include the Nikon D4 and Canon 5D Mark III, as shown in Figure 2-1.

Figure 2-1: The movie-friendly Canon 5D Mark III camera body.

Using something just right

Need more than what the basic models offer, and don't want to spend more money than necessary? Most of the cameras in this group offer controls and features found on more expensive models. They still use the smaller APS-C

sensor size but are more ruggedly designed than those found in the entry level and a bit more ergonomic. Some models in this class include the Canon 7D, Nikon D7000, Panasonic Lumix GH2, and Sony A77.

Understanding Camera Controls

Although each model differs slightly, most cameras have a similar feature set, give or take a few functions. On most DSLR cameras, the shutter button is on the top right of the camera, where there's usually a dial for adjusting shutter speed and aperture functions. Some models use a rear dial for changing aperture.

DSLR moviemaking has a few of its own controls, but it mostly depends on the same functions that you would use for still photography. The most notable difference is the shutter button, which on most models is not located in the ergonomic position on the front right side of the camera; instead, it's positioned on the back near the Live View monitor.

A camera's sensor records the image, but unlike with still photography, there's no distinction over megapixels because HD capture remains consistent at 1920×1080 pixels. DSLR cameras use a CMOS (complementary metal-oxide-semiconductor) sensor, and it differs slightly form the CCD (charged coupled device) commonly used on video camcorders.

For DSLR movies, a variety of sensor sizes exist, as seen in Table 2-1, starting with full-frame, which covers approximately the same space as 35 mm frame. Nikon calls it the *FX format* and includes it on its D4 and D800 models. Canon cameras using the full-frame sensor consist of the EOS-1D X and 5D Mark III.

Next on the sensor size list is the APS-H format used on some sophisticated Canon models, namely the EOS-1D Mark IV. Some call it a smaller sensor, whereas optimists say it's the second biggest. Both accounts are correct.

So what's the difference in size? Well, you need to multiply the focal length of any lens by 1.3 times. That makes a 100 mm lens more like a 130 mm lens.

Look at the differences between how each sensor would render the scene in Figure 2-2. The APS-C sensor used on many entry-to-intermediate-level cameras varies slightly in size. Depending on the manufacturer, they affect focal length because of their higher crop factor. Nikon, for example, uses a sensor with a crop factor of 1.5X, whereas Canon uses a slightly smaller crop factor of 1.6X.

Many aspects of DSLR operation come from the traditional film days, when there were the same focal length behaved the same on every SLR. That meant an ultra wide-angle 20 mm lens saw things the same on each camera system. By projecting an image onto the film plane that was a consistent size, 24×36mm to be exact, it meant that focal length was predictable.

But DSLR cameras use various sensor sizes that range from the full-frame 35 mm format to much smaller sizes. That means the predictability of a 50 mm focal length will differ with each sensor type. Smaller sensors record a narrower section of the scene than a full-frame sensor.

For example, if you were using a projection television and used an 8-foot screen at a set distance, the image would fill the screen. But if you only had a 6-foot screen, you would only project a portion of the movie. On a smaller film sensor, that narrow area of capture translates to increased magnification. The difference between the smaller sensor and full frame is known as the crop factor.

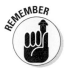

Knowing the crop factor allows you properly select the right lens. For example, consider capturing a cityscape using a 100 mm lens with a full-frame capture. Shooting the same scene with a camera using the APS-H sensor captures less of the scene. It's as though you used a 130 mm lens.

If you shot the same scene with the same lens using a Canon Rebel T3i, it would capture an even slimmer piece of the scene, as if you were using a 160 mm lens.

Figure 2-2: The coverage area of each type of sensor in relation to capturing the same scene.

Table 2-1	A Comparison of Different Sensor Types		
Sensor Type	**Frame Size**	**Coverage**	**Crop Factor**
35 mm frame	36×24 mm	864 mm	
Full frame, FX	36×24 mm	864 mm	
APS-H (Canon)	28.7×19 mm	548 mm	1.3X
APS-C DX (Nikon)	23.6×15.7 mm	370 mm	1.5X
APS-C (Canon)	22.2×14.8 mm	329 mm	1.6X
4/3	17.3×13 mm	225 mm	2.0X

Breaking Down the Numbers

Unlike still photography, movies adhere to a specific resolution, with full high-definition weighing in at 1920×1080 pixels. That measurement refers to the number of pixels that make up the image, measured horizontal by vertical. But although that's direct, the numbers that follow require some examination. For example, what exactly does 1920×1080/60i refer to? Glad you asked!

Sensor resolution for movies

Take a look at resolution first. It's the measurement of the detail that makes up the image. Here are the common sizes for making movies found on a DSLR:

- **Full high-definition (1920×1080):** Like the name implies, full high-definition is the big kahuna of movie resolution. Image size is composed of 1920 horizontal pixels and 1080 vertical pixels. (This is where the 1080 figure comes in when looking at HD television sets.) This file naturally has a 16:9 aspect ratio, which puts the wide in wide screen. Aspect ratio basically describes the difference between the height and length of the image and is usually assigned a numerical value.

- **HD 1280×720:** This is the old standard for DSLR HD capture, if two years old qualifies as old. Although it's still fairly high quality and better than standard definition, it is lower quality than full HD. Using the television analogy again, this was the old standard for HD and is still seen advertised as 720 in some TVs.

- **Standard definition (720×480):** Standard definition is the 4:3 format used on DV video camcorders. Many models included an anamorphic setting that changed the pixel shape, producing a widescreen 16:9 movie. Of course, the television or non-linear editing program must have the capability to read it for proper playback, otherwise the movie

plays back with a "squeezed" look that made your movie look like *The Coneheads.*

✔ **Standard definition (640×480):** Standard definition was the predecessor to high definition and was that slightly square 4:3 frame size that your camcorder would produce. This setting is found as the lower resolution variation on many DSLR cameras.

Frame rate

Frame rate pertains to the frequency with which the camera continually captures a scene and is usually the numbers that succeed the resolution. For example, 1920×1080/30P means the frame rate is 30 frames per second (actually, 29.97fps). The *P* refers to the scan type, which I explain in the next section. Frame rate standards in the United States differ than those in Europe.

For example, NTSC, the U.S. standard frame rate, is 29.97 frames per second, whereas the European standard, PAL, captures and plays back at 25 frames per second. That gets more complicated to play back effectively because some older DSLR models provided frame rates inconsistent with the broadcast standard.

From lowest to highest, here are some examples of frame rates along with a brief description:

✔ **24fps:** Motion pictures capture movies at a rate of 24 frames per second, whereas television plays back at 29.97 frames per second. Sometimes video is transferred to film. Do you see where I'm going here? It's not like fitting six pounds of sand in a five-pound bag, but it doesn't quite match either. Enter the 24 frames per second frame rate. Relatively new to video, this progressive format is used primarily for shooting video with the intent of transferring it to film. That's because it matches the rate of motion picture projection and provides a smoother conversion to film stock. Its purpose is to capture the sequence at the same frame rate as film for video that will be translated to film; otherwise, it won't make your movies look any better. If you're not planning on transferring to film, do not shoot at this mode. With that said, some DSLR shooters feel that shooting at that frame rate lends a movie a realistic "film look." In addition, that's the only choice on some DSLR models when shooting at full 1920×1080.

✔ **25fps:** This frame rate is used by some camera makers for HD video. It suffices for high-quality video, but the frame rate is still inconsistent with the 29.97fps used for broadcast in the United States. If you're editing in PAL, that's another story because it's the common frame rate for it. Otherwise, avoid using it if your DSLR captures a frame rate of 30fps.

- **30p:** Actually, this frame rate is more like 29.97fps, but let's not bicker over who added .03. Video capture in the United States has used this frame rate for years in the NTSC standard, but that doesn't mean that all DSLR cameras with full HD capability include it.

- **50i:** This is a higher-quality interlaced version of the PAL television standard.

- **50p:** 50p is a higher-quality progressive version for HD capture and playback that follows the PAL and SEACAM (used primarily in France) broadcast standard.

- **60i:** This is a higher-quality interlaced version of the NTSC television standard.

- **60p:** Here's a higher-quality progressive version for HD captures and playback that follows the NTCS broadcast standard.

Scan types

The letter that succeeds the frame tells you whether the mode captures in interlaced or progressive scan:

- **Interlaced scan:** An *interlaced scan* is best described as those vertical lines on your old television set. The process essentially provided the illusion of better quality by doubling the perceived frame rate by slicing the image into *spate fields* made up of odd and even lines. It's sort of like looking through flickering venetian blinds, albeit very narrow ones. They play back in alternate order, so the lines goon and off. Anyone who's ever tried to photograph a television screen or video record it knows what it looks like. In record and playback modes, it's denoted by a lower-case i.

- **Progressive scan:** Progressive scan is an improved version of interlacing. The scanned lines are displayed in a sequential order, meaning they do not alternate. This creates a smoother playback. In record and playback modes, it's denoted by a lower-case p.

Outlining the Main Functions on Your DSLR

While your DSLR is loaded with features, functions, bells, and whistles, only a few of them matter when it comes to making movies. Here's a basic primer on DSLR functions that matter to moviemaking.

Moviemaking shutter speeds

Video capture uses a small selection of the shutter dial, generally ranging from 1/30 of a second to 1/250 of a second. That pales in comparison to the range between 30 seconds and 1/4000 of a second for still photography. Although the video shutter speeds occupy a narrow band, they can still depict a low-light subject as well as depict the fast-motion gruesome detail of a zombie apocalypse. I discuss the effect of shutter speed on your footage throughout this book.

Key DSLR functions

Now that you have some idea of what the numbers mean as well as their functions, it's time to tackle the camera body. Current DSLR models do not look much different than the camera you're probably familiar with using. In fact, with the exception of replacing film with a digital sensor, it even retains that timeless SLR look. What has changed is what these cameras can do, and that is . . . drum roll, please . . . make movies. So when I point out main features of DSLR cameras, many of them revolve around movie functions.

The DSLR consists of two essential parts: the camera body and the lens. You need both pieces to take a picture or make a movie. Although lenses are discussed later in the chapter in the section, "The Eyes of the Camera: Breaking Down Camera Lenses," as well as throughout the book, I want to focus now on the camera body. I use the affordable Canon Rebel T2i, or 550D (as it's called in some markets) as an example, shown in Figure 2-3.

On the front, you have the following:

- **Handgrip:** Allows you to comfortably hold your DSLR when taking still images.
- **Main dial:** Lets you adjust shutter and other functions.
- **Mode dial:** Lets you make adjustments between exposure modes, including the movie mode.
- **Shutter release:** Activates the shutter when taking still photographs, but does nothing for movies.
- **ISO set button:** Used for setting sensor sensitivity.
- **Remote control lamp (infrared receiver):** Can communicate with wireless remote to control camera functions.
- **Flash synch hot shoe:** No, it's not that incendiary party trick of yesteryear, the hot foot. Instead, this term refers to the sliding tracks on top of the camera's viewfinder. How else do you think you're going to mount

that auxiliary microphone? You may as well: I doubt a flash is going to do you much good when you're making movies.

- **Microphone:** Captures audio.

- **Lens release button:** Lets you release interchangeable lenses.

- **Remote control terminal:** The electronic version of the cable release plugs in here and allows you to activate the shutter without touching the camera. Useful for many reasons, but time-lapse especially, when making movies.

- **External microphone terminal:** Allows you to plug in an external microphone. Can also plug in to a line mixer.

- **Audio/video out terminal:** For playback on non-HD televisions and monitors.

- **HDMI mini out:** Lets you display the Live View images on another screen, such as an external monitor or television. Also allows for HD playback of material captured on card.

- **Display:** Although the Rebel T2i does not have this feature, many DSLR models have it. This screen on top of the camera shows shutter speed, aperture setting, ISO, and other settings.

On the back, you'll find these features:

- **Menu:** The control center for the DSLR. Nested in its many menus and sub-menus are controls and settings for the camera, including white balance, custom functions, numbering, card settings, and dozens of other tools.

- **LCD monitor:** Allows you to preview the scene in the camera's LCD screen. It comes in handy for letting you position the DSLR when making movies. If you don't believe me, just try looking through the viewfinder when shooting your next sequence. It will not be pretty.

- **Quick control button:** Brings up quick access to select and control camera functions.

- **Movie shooting button:** Controls starting and stopping movie capture.

- **Aperture/exposure control:** Holding this button and turning the main dial lets you adjust aperture setting. It's also used to set exposure compensation when shooting in an automated mode.

- **Card slot:** For loading SD digital media cards.

- **Speaker:** Lets you hear audio playback without headphones.

Figure 2-3: The front and back of the Canon Rebel T2i.

Knowing Your DSLR

Just like "cheese in the crust" pizza, HD movie capture with a DSLR is relatively new, but nowhere near as messy. Introduced by Nikon in 2008, this function continues to improve with each generation of camera. Nikon's entry model, the D90, captures HD movies using a resolution of 1280×720 images at 24 frames per second, but it was quickly supplanted by the 1920×1080 image size.

Although the capture of HD remains consistent, each manufacturer varies with sensor type and camera features. Accessories, lens mounts, and functionality differ, as does movie file compression. For example, Canon and Nikon share the H.264 video codec, whereas Sony and Panasonic lean toward AVC-HD, although both can provide broadcast quality. Some high-end models even offer an uncompressed mode. By the way, Codec refers to act of encoding, or compressing, a video stream for transmission and decoding it for playback.

Here's a little breakdown of the most popular DSLR manufacturers and their products.

Canon

With a movie-capable DSLR to fit the budget of almost any set of hands, Canon is one of the leaders of the movement. Even its most basic model, the Rebel T2i, offers impressive HD functionality. It uses the APS-C sensor, which provides a 1.6X crop factor, and although that limits the wider focal lengths, it does take advantage of telephoto. The Rebel has a wide range of resolutions and frame rates from which to choose. And when you consider awesome Canon optics, the audience for your movie will not care how much the camera cost after seeing the quality of its output.

Models like the 60D and 7D reside on the next shelf. Besides slightly improved ergonomics and more sophisticated controls like an articulating viewfinder and alleged weatherproofing, respectively, found on each model, they have a more professional feel to them. With all that, they still have an APS-C sensor.

Another step up is the movie-friendly 5D Mark III, which is coveted by serious users and professionals alike. Some DSLRs offer movie capture, but are not suited to moviemaking: This is not one of them. Dedicated audio and video capabilities bring a high degree of control to serious moviemakers and professionals alike. It follows in the footsteps of the 5D Mark II. That model already has the distinction of working on feature films and a stint on the television drama *House,* where the entire episode was shot with that camera.

At the peak of Canon's line sits the new EOS-1D X. This full-frame beast boasts dual Digic 5 processors, uncompressed video output, and manual audio control. Canon also makes the 1D Mark IV, which uses the APS-H sensor size — somewhere in between full-frame and APS-C.

Nikon

With a rivalry twice as long-lasting as the Mac versus PC rift, Canon and Nikon have duked it out for years over market share in the pro arena. That battle continues with HD movie capability added to the mix.

Nikon beat Canon to the punch with the first DSLR with movie mode, whereas Canon was the first to offer 1080p capture. Each offers a similar line of DSLR camera bodies with HD movie ability for all price ranges. Nikon uses two sensor sizes logically named FX for its full-frame models, and the DX series that uses

an APS-C sensor. The difference between the Canon and Nikon versions is the crop factor. Nikon uses a slightly larger sensor with a factor of 1.5X.

For the budget conscious, the D3200, as seen in Figure 2-4, offers a similar feature set and price point as the Rebel T3i. The next class up includes the D5100 and D300s. On the high side, and FX-sized, the new D800 captures in both the DX and FX modes, and the D4 offers many of the same features as the Canon 1D-X. It's even priced similarly.

Both Canon and Nikon offer superior optics, so most of the time, your choice comes down to which model you already own lenses for.

Figure 2-4: The Nikon D3200.

Olympus

Although not a major player in the DSLR movie market, the company offers two separate lines with HD movie capability. The E-System resembles a traditional DSLR but only captures at 1270×720. The new PEN line models resemble the offspring of a DSLR and a point-and-shoot. They offer full HD capture with superior optics and interchangeable lenses.

The line has a rich legacy as one of the most popular of the half-frame cameras in the 1960s and 1970s. It featured a simple rear-winding mechanism, a Zuiko lens, and a cool design. Users were able to get twice as many exposures from a 35 mm roll of film. Now the camera is back, and it's a unique player.

Olympus stands out with its sensor system using a micro 4/3 type that is smaller than an APS-C. The sensor has a crop factor of about 2, making focal lengths twice as long as they would be with a 35 mm camera. Olympus does offer a full set of lens for each system that compensates for the crop factors with focal lengths starting at 7 mm (creating a 14 mm ultra wide-angle view) to 300 mm. Although PEN and E-series lenses differ, you can use E-series on a PEN camera with an optional convertor.

Pentax

Down to a single DSLR model, the K-5 series holds the line for Pentax. Available in several configurations including a limited-edition anniversary model, it offers a weather-resistant body (though I have no idea what that really means), the ability to capture stereo with an external microphone, and full-frame HD video. The caveat, however, is that in 1920×1080 mode, the frame rate is only 25fps. Not bad if you're shooting PAL but not as advantageous for footage on a 29.97fps timeline. In the 1280×720 mode, the camera captures 30fps. On a unique note, this model is one of the few to use the shutter button to start the movie.

Sony

The most ubiquitous name in electronics has been making digital cameras for some time to complement its rich line of consumer-level camcorders and high-end video cameras. Although Sony isn't a traditional SLR manufacturer, its Alpha line is a credible choice, and the camera is actually a DSLT (digital single-lens translucent).

While using an interchangeable lens system and offering the full functionality of a DSLR, Sony's cameras use a translucent mirror, instead of the standard pellicle mirror. That allows autofocus while shooting in Live View mode.

Sony offers three models, beginning with the affordable a57K, as seen in Figure 2-5, the a65VK, and topping out with the a77VQ. They use a sensor Sony calls an APS-HD, which basically covers the same space as the Nikon DX format. It has a 1.5X crop factor.

Figure 2-5: The Sony a57K.

Panasonic

Panasonic versus Sony is another rivalry to put on the fight card with Canon versus Nikon and Mac versus PC. Panasonic offers its own unique line of cameras. Based on their places in the video market, chances are users are not traditional photographers.

Panasonic's version of the DSLR is a little unorthodox, mainly because it's not a DSLR by definition (it lacks a mirror, which essentially is the "reflex" part). That aside, the GH2K model, as seen in Figure 2-6, has some awesome features.

The third generation of its mirrorless line offers a 16.7 MP sensor in a much smaller package than its counterpart, using a nice selection of lenses and some pretty cool features. It also includes a micro Four Thirds sensor, developed by Olympus and Kodak purely for newly designed digital cameras. CMOS sensors tend to be retro-fitted to classically designed SLR bodies that are now digital.

The touch-enabled LCD screen simplifies menu selection, whereas the auto-focus-tracking mode for video is a nice feature for occasional use. Of course, the full HD capture makes it a serious contender.

Figure 2-6: The Panasonic GH2K.

The Eyes of the Camera: Breaking Down Camera Lenses

In the digital world, technology seems to dominate the conversation more than a co-worker on a double-shot espresso. But camera technology represents only part of the equation. Without a lens, you have nothing but a really cool, albeit expensive, paperweight.

While essential, lenses do more than capture an image or control focusing the scene; they're also an important tool for creating composition and controlling perspective.

DSLR cameras use an interchangeable lens system that allows you to choose the best focal length for each situation. Focal length determines the magnification of the image. It's judged on the following factors: optical quality, which dictates the sharpness; lens speed, which determines how much light comes into the lens; and focal length, which decides the actual magnification.

Once upon a time, focal length was easier to explain because all SLR cameras shared the 35 mm format, and therefore was consistent in image magnification.

When it comes to focal length, the actual magnification depends on the sensor format in your camera. Remember, all but the full-frame sensor are smaller than the 35 mm film frame, so the actual magnification of the same focal length differs in size.

Here's the breakdown:

- **Normal lens:** The age-old question of "What is normal?" applies here. This lens reproduces a field of view with a natural perspective, very much like our eyes. In mathematical terms, that's about a 40-degree angle of view when you're holding the camera horizontally. In the 35 mm format, or full-frame sensor in digital-speak, that is equivalent to a 50 mm lens. When using a camera with an APS-C size sensor, that 50 mm lens behaves more like a moderate telephoto in the 80 mm range. Normal for this format includes a 28 mm lens, which renders the respective equivalent of a 45 mm lens, as seen in Figure 2-7.

- **Wide-angle lens:** Any focal length that provides an angle of view greater than 60 degrees is considered a wide-angle lens. Of course, depending on the sensor size of your camera, the effects differ. That's the biggest drawback with making movies with DSLR. The APS-C sensor makes your wide-angle lens behave more like a normal lens, and even those cool ultra wide-angles lens are merely wide angle.

- **Ultra wide-angle lens:** The biggest misconception about ultra wide-angle lenses is that you use them to include more of the scene. Quite the contrary: These lenses are more suited to getting really close to the subject for either an abstract capture, or for dealing with a crowded situation like a red carpet.

 Basically, an ultra wide-angle lens with a field of view 84 degrees, or around a 20 mm lens on a 35 mm camera, qualifies as an ultra wide-angle lens. But remember, the same lenses that used to provide an expansive, beautifully distorted view on a full-frame sensor act much less wide angle in the APS-C format, as seen in Figure 2-8. (This figure was shot with a 14 mm lens.)

- **Telephoto lens:** A telephoto lens enlarges distant subjects. But more than that, it can manipulate subject distance by compressing the space between near and distant objects. The telephoto range begins with an angle of view less than 25 degrees, which is around 85 mm. Here's a case where the limitations of the APS-C format become the strengths, especially when shooting sports and natural scenes. That 85 mm lens acts as 135 mm, as seen in Figure 2-9. It was shot from the same distance as the normal and wide-angle versions. This also works well with distant subjects where the 200 mm setting on your zoom lenses now becomes a staggering 320 mm.

- **Zoom lenses:** The most noticeable difference between a DSLR and a video camcorder lies in the zoom lens. DSLRs do not have a lens built in to its body with servo-power (motorized zooming) like a dedicated camcorder does. They cover a moderate wide angle to extreme telephoto

range. Unfortunately, DSLR lenses generally cover a much narrower ratio, and certainly do not have powered functionality.

Even when on a full-frame DSLR, common lenses like an 18-55 mm zoom provide a slightly wide to telephoto view. In addition, when you use a lens with a greater range, you add excess weight, and often limit maximum aperture, making the camera less usable in low lighting. Of course, you usually have sharper optics, at least when compared to the consumer level.

Figure 2-7: A wide-angle lens acting as a normal lens on a Canon Rebel T2i.

Figure 2-8: A 14 mm ultra wide-angle lens acting as a 21 mm on a Canon Rebel T2i.

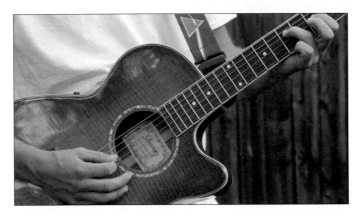

Figure 2-9: A 100 mm telephoto lens providing the effect of a 160 mm on a Canon Rebel T2i.

Discovering the Tools of Tapeless Capture

Scratch the popular phrase, "Let's go to the video tape," because the camera records your video on a memory card, not a tape, and "Let's go to the memory card" is not as charming to say. Digital storage devices have replaced film and tape as the go-to media. These digital media cards are available in three basic formats:

- ✓ **CompactFlash (CF):** Commonly used in mid-range to high-end models, the CF card provides the most storage and fastest speed classes. Because it uses internal contacts, the card is larger and beefier than any other. Some feel that it's more stable, but studies show that it is no more stable than an SD or Memory Stick. The real advantage of a CF card lies in the speed. The UDMA 7 CF card holds 256 GB and has a speed rating of 7. Although this is the largest and fastest format on the market, not all DSLR models support it. (If you're not sure why speed and size matter, read the next section.) Check to make sure it's compatible with your camera.

- ✓ **Secure Digital:** Having the distinction of being the most ubiquitous memory card with applications in a wide range of devices, the SD card is smaller than both CompactFlash, as seen in Figure 2-10, and Memory Stick. An SD card's contacts are on the outside, so it's also flatter. SD cards are available in various capacities and speed classes. Currently, manufacturers rank them with a class distinction. For example, a Class 2 card is acceptable for still images, whereas a Class 10 allows you to smoothly capture high-definition video. Even faster cards are available in their UHS series, but check your camera model before purchasing.

Cards in this class include the following types: SDHC and SDXC (Secure Digital Extended Capacity).

✔ **Memory stick:** Despite its long rectangular appearance, which looks a bit like a stick, the Pro-HG Duo HX is both fast enough and large enough to capture a substantial amount of HD video.

Figure 2-10: CompactFlash and Secure Digital cards.

Size matters and so does speed

You'll quickly know if you have the right card for your camera when it fits (or doesn't fit) in the slot. But that doesn't mean you have the correct type for DSLR moviemaking. Depending on the speed of the card, you may not be able to capture HD video. The very first time I shot a movie on a DSLR, I was quickly schooled when that inexpensive SD card that I scored the bargain of the century on would not record more than a few seconds. I was forced to switch to standard definition to record a longer sequence. Use a card that captures around 10 MB per second. Faster cards capture up to 300 mps. Conversely, a card that captures 2 MB per second works for still photographs, but cannot capture movies, especially in HD.

Protecting your card

Digital media cards are not light-sensitive like film, but that doesn't free you from taking care of them, especially if you want to retain any footage from your shoot.

Here are some tips:

✔ **Keep your card lean and mean:** Delete content after downloading to your computer. Few things are worse than going to a new shoot and running out of space on the card before you expect to. That happened to me once while on assignment. My videographer forgot to empty her

cards for a long shoot. After the cards filled up, the random deleting of old files claimed some footage from the day's shoot as a casualty.

✔ **Format your card regularly:** Video files require a lot of space and a lot of speed. Formatting helps keep them healthy by maintaining stability. Nothing is more disappointing than shooting a couple of important scenes, only to find that the card is corrupt and the files cannot download. Formatting the card regularly also allows you to use the same card in a different device, although I don't recommend it. Make sure everything from you card has been transferred to the computer because formatting erases everything. Although the formatting procedure is the same for every card, each manufacturer may differ slightly on where they locate this feature. See your camera manual to learn more.

✔ **Lock your media card:** Write-protect it after caching important footage. This way, you never accidentally modify or delete its contents. Most cards have a slider to prevent recording, as seen Figure 2-11.

✔ **Take care of memory cards:** Although digital media cards are not light-sensitive, prolonged exposure to sunlight and excessive heat can damage them. Dust and moisture can also cause damage. Also, be careful to not touch the contacts of the card. Oils and dust from your fingertips can have a corrosive effect. Whenever you take the card out of the camera, it's a good idea to place the recorded card back in its little case.

✔ **Magnets are not your friend:** Keep the card away from strong magnetic fields. That obviously includes magnets, as well as anything that contains them, like your desktop speakers and television set.

Figure 2-11: A locking slider on a Secure Digital card.

3

Keeping Your Camera Steady

In This Chapter

▶ Keeping the camera steady
▶ Knowing your tripod
▶ Breaking down the camera rig
▶ Different types of stabilization

*T*alk is cheap when it comes to boasting about camera features, but if you can't keep your DSLR steady while you're making movies, all those virtues are cancelled quicker than a sitcom with low ratings.

Compared to a video camcorder, which is designed specifically to wrap around your wrist, gripping a DSLR, let alone holding it steady while shooting a movie, is much more cumbersome. You clearly need some assistance.

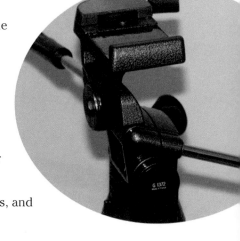

Mounting the camera to a sturdy tripod can keep the shot stable and help with framing the scene. It will even eliminate the bounciness in your movie that may cause viewers to run for their airsickness bag.

Tripods work well for maintaining stability for most situations, but needing to keep your subjects planted in front of it can get old quick. Although steadiness starts with a tripod, it gets more practical with a host of camera rigs, stabilizers, and other accessories that help move the camera smoothly. More sophisticated means of mounting the camera and controlling its movement include dollies, cranes, and other tools.

Using a Tripod

The tripod is your three-legged friend for many reasons, the most prominent being that it allows you to keep the camera steady. Camera steadiness is often the difference between a crisply shot movie and a blurry mess. Although all tripods have three legs, there's a big variety when you consider the number of models currently on the market, along with all the tripods already out there in photographers' and filmmakers' closets across the world. They cover a diverse range, which makes it hard to pick the right one.

True, they all do the same thing, and yet each has its own purpose with specific situations. Take a look at the criteria to find the best one for your needs:

- ✔ **Price:** With a range in price from very affordable to ultra-expensive, most tripods do the same job; yet vary when it comes to size and durability. Sturdy models on the affordable side tend to be heavier than more expensive counterparts.

- ✔ **Materials:** The cost of a tripod goes up as the weight goes down. A model that would cost around $100 made out of aluminum suddenly costs $500 when it's made of the more durable and lighter metal alloys like carbon fiber.

- ✔ **Size:** Moviemaking requires a tripod with a height that at least meets your eye level; otherwise, it's not going to be comfortable to use. That doesn't mean raising the center post. It's there for making minor height adjustments, but extending it all the way up, just because you can, doesn't help create a steady image.

- ✔ **Controls:** The controls for extending your tripod are important to consider. Some lock by turning; others use clips or control knobs. When you can, pick a model with controls that change quickly and seem intuitive to you.

- ✔ **Separate pieces:** Less expensive tripods are usually sold as a whole unit with legs and head, whereas more sophisticated models, as seen in Figure 3-1, are purchased separately. Affordable video tripods work well with DSLRs, but if you feel your needs warrant it, buy the legs and head that suit your needs.

Keeping a good head on your shoulders . . . er, sticks

Tripods come on a variety of sizes and types and are constructed of various materials. Not every one works well when it comes to making your movie. Size and weight are important, but often the deciding factor depends on the type of head used by the tripod. That's what attaches to the camera and provides the ability for accurate positioning.

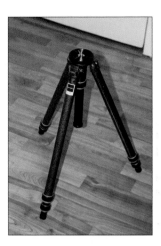

Figure 3-1: Gitzo tripod legs.

Here are a few basic types:

✔ **Video heads:** These are big heads with lots of controls used specifically for supporting and controlling large video camcorders. But hold on a second: Just because your DSLR produces the equivalent quality of a big heavy camcorder doesn't mean that it needs to sit on this type of tripod head, seen in Figure 3-2, especially when you consider their price range. Sure, these heads start at less than $100, but costs can go higher than $1,000. Because DSLR bodies are relatively lightweight, the lower end of the spectrum will work just fine.

On the plus side, you get well-dampened motion for smooth pans and tilts, bubble levels to more precisely balance the camera, and geared rotation adjustments for precise positioning. The downside is that the weight of your DSLR usually doesn't warrant the extra cost, especially when you can get the job done with a lesser-priced fluid head.

✔ **Fluid heads:** These are a more practical solution for DSLR moviemaking. As the name implies, this type of tripod head uses a sealed fluid to create a hydraulic-like dampening for smooth motion. The large handle and dampening reduces any jerkiness or vibration, especially when you follow a shot with a pan or tilt.

✔ **Pan/tilt head:** This head, shown in Figure 3-3, is the most common type of tripod head and allows for control on both horizontal and vertical axis. But what these heads offer in versatility, they often lack in smoothness. Because the head is not dampened, the results are not as precise as the ones you get with a fluid head. On the plus side, you'll be able to

mount the camera on an angle and even shoot a vertical if you need an angled view. On the downside, unless you want your movie to look like it was shot on an iPhone, there's little reason for a video tripod head to hold the camera in vertical orientation.

- **Ball head:** Although they're versatile, ball heads aren't that great for shooting DSLR video. They mount the camera in a stationary position, so don't expect to be able to pan or tilt.

Simplifying with a monopod

Three legs are good, but sometimes, one is best. Enter the monopod, as seen in Figure 3-4. It's one of the simplest ways of holding your DSLR steady while still maintaining control. Its single leg allows you to reduce shake and movement with comfort and flexibility. You can even use it as a body pod by shortening the pole and anchoring it in your waist. Essentially this is like handholding the camera, except that it's braced on you. Other times, you can mount the camera, hit record, and hold it over your head for a higher vantage point.

Figure 3-2: A video tripod head.

Figure 3-3: A pan/tilt head used for still photography.

Figure 3-4: Using a monopod for shooting a movie with a DSLR.

Creating stability without a tripod

Not every situation requires an expensive piece of equipment to keep the camera steady. Here are several solutions that range from free to relatively low-cost:

- ✔ **Rest the camera on something (free):** Use a ledge, mailbox, curb, barricade horse, or anything flat and level. It's not perfect, but it's an alternative to handholding your camera.

- ✔ **Beanbagging it (just north of free):** Although a beanbag is not an ideal solution, it's helpful when you have nothing else and need to rest your camera on a flat surface. Just plop the camera on a simple bag of beans, adjust the camera's position, and press Record. Although accessory manufacturers offer their own versions, a simple beanbag purchased in a novelty store can also work.

- ✔ **Gorilla Pod (still affordable):** Although it's not a traditional tripod, this flexible, segmented leg accessory is one of the most unique stabilization devices on the market. Its bendability allows you to shape it around just about anything. It has magnets on its feet so it even sticks to metal surfaces. Available in several sizes for different weight classes, the DSLR version works pretty well. It's more of an adjunct than a main player when it comes to holding the camera steady, but it's still an essential tool in your bag.

To Have and To Hold

Like singing karaoke, handholding your DSLR is never as good as you think it sounds, at least not when you attempt to hold the camera in front of your face expecting the result to be steady footage. That's no different than getting up in front of a crowd and belting out lyrics on a television screen.

But it doesn't have to be that way. You *can* hold the camera while shooting. Not in that "grasp camera near your face as if you were taking a snapshot" technique, but rather with accessories that provide help in keeping the camera steady.

Numerous devices for holding the camera steady are currently available, with the most common being the customizable shoulder rig setup. Often, you'll see video journalists holding this unique apparatus. Then there's the Steadicam, the Academy Award–winning technology used in motion pictures. Other devices include stabilizing handles, camera grips, chest pods, and numerous others.

Camera rig systems

I've got to be honest: The first time I saw someone making movies with a DSLR rig, it reminded me of someone strapped to a jet pack with hands extended outward, clutching the handles for dear life. But after trying it, I was hooked.

Think of it as a human tripod, a two-pod, if you will, using your own legs to make up the base, as seen in Figure 3-5. It rests on your shoulders, supporting a host of accessories. The camera being mounted in front of you allows for more fluid movement.

Many rigs use a dual rail system that allows you to move the camera forward and backwards on the rails. Though bulky, it allows the DSLR to behave more like a bona fide movie camera than a video camcorder.

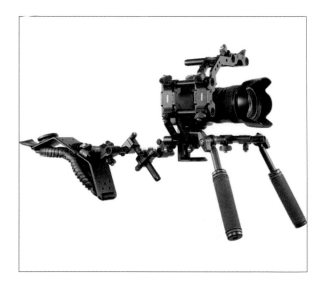

Figure 3-5: A camera rig system.

Breaking down the rig components

How to configure your camera rig varies with each user with regard to size, needs, and accessories. Here are some of the pieces that make up the rig:

✔ **Rails:** Rails are the backbone of the rig system and the platform that the components are attached to. Typically, the base is made up of two rails made up of a strong material like metal or carbon fiber. Although they vary in size, most range from 10" to 24" long.

- ✔ **Camera block:** The camera block is the mounting place for the DSLR. Each system differs slightly, but most allow you to move the camera on the rails.

- ✔ **Shoulder mount:** Most rigs hold steady by balancing on your shoulder. Available in several variations, most shoulder mounts are adjustable, allowing you to angle the rear end of the rig higher or lower as best suits your needs.

- ✔ **Front handles:** Although the rig rests on the shoulders, your arms keep the whole thing steady. By adjusting the rails and handles, most models accommodate the needs and arm lengths of each user.

- ✔ **Matte box:** Besides making your rig look cool, this boxy attachment acts as a shade. It limits glare by blocking the top and side light that hits the lens. You can also insert filters in front of the lens with it too.

- ✔ **Larger external display:** Face it . . . bigger is better, especially when it comes to your display for monitoring live video. Because the rig is already on your shoulder, you may as well take advantage of a larger monitor.

- ✔ **Follow focus:** Because focus on the fly is not a DSLR trait, you'll need to improvise with accessories. Mounted on the rig, this device allows you to achieve a full range of focus while shooting the scene. Shifting focus in the scene is a key ingredient in movies, and this tool lets you do it. They range in price from a few hundred to a few thousand dollars, yet all do the same basic thing. Attach one to your rails and change focus like the big boys.

- ✔ **Video light:** Bringing light to the party is easy enough with your rig with enough real estate to mount a light and battery pack. Besides illumination, it maintains color balance, and most importantly, alleviates the worry of light placement.

Here are some tips for selecting the right rig:

- ✔ **Ask yourself what you need:** Basic uses warrant a less expensive model, whereas more commercial application requires a specific model and accessory capability.

- ✔ **Get a feel for it before you buy:** Because they range in price from very little to very much, go to the store and actually try it on before you purchase it.

- ✔ **Limit how much you add:** Just because you can doesn't mean you should.

- ✔ **Build your own:** If you can't afford a rig, numerous sites on the Internet offer step-by-step instructions to building your own from PVC or other commonly found materials.

- ✔ **Sometimes it's too much:** Because rigs include some many accessories, it's not unheard of spend thousands of dollars on it. At that point, you may want to consider a traditional video camera.

Other handheld devices

Although rig systems are commonly used to steady a camera, they're not the only game in town. One option to consider is the Steadicam, which is a relatively new invention that allows motion picture camera operators to move through the scene holding the camera without showing any indication of handholding. Invented by cinematographer Garrett Brown, the Steadicam works on the principle of keeping the camera steady even when the operator is bouncing around. Although the type used in motion picture cinematography is expensive, there's an affordable model for DSLRs called the Merlin, as seen in Figure 3-6, which uses the same gimbal principle but is held in front of the camera operator.

Figure 3-6: The prosumer-level camera stabilizer Merlin.

Here are some other stabilization devices to consider:

- **Stabilizing handle:** Mounting the camera in this U-shaped holder allows you to shoot steady video from waist-level. It's inexpensive and comes in handy for mid- and low-level shots.

- **Chest pod:** The camera on its plate, the strap around your neck, and the resting pad for your chest provide a three-point solution to reducing vibration and shakiness when handholding the camera.

- **Shoulder pod:** This variation to the chest pod rests the camera on your shoulder.

- **Tabletop pod:** The tabletop pod is a small flat mounting base with rubber feet for your DSLR that lets you place the attached camera on a flat surface. It accepts various accessories like gimbals and heads, or can be used in conjunction with a beanbag.

- **Steady pod:** A steady pod is an inexpensive device that attaches to the bottom of your DSLR and uses a retractable cable that you anchor with your foot or attach to your belt loop to create an upward tension.

- **Hand grip:** A hand grip comes in various sizes and configurations. Basically, it lets you hold the camera from the bottom to alter the center of gravity.

Moving the Camera with Support

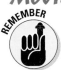

Although feature films use some of the aforementioned techniques to move the camera through a scene, a great many shots are done using more sophisticated apparatus like a camera dolly or crane.

Camera dolly

This rolling camera platform is used in film and television production to create smooth movements through the scene. It's also known as a *tracking shot*. On a motion picture set, the camera is often mounted to the dolly, which moves through the scene like a small train on tracks. Some dollies have rubber tires and don't require tracks. Read more about using a dolly in Chapter 6.

Here are some of the terms for using a camera dolly:

- **Dolly shot:** Moves the camera toward or away from the subject.

- **Tracking shot:** A dolly move that moves perpendicular to the subject.

✔ **Dolly zoom:** This technique refers to using a zoom lens and zooming out (focal length getting wider) while moving the dolly toward the subject (zooming in while moving away). The technique produces an interesting change in perspective that has been used in numerous motion pictures to depict an unsettling effect. Alfred Hitchcock used it in *Vertigo* to show Jimmy Stewart's character's fear of heights.

Using a crane or jib

Maybe it's that shot going over the crowd at a football game or the sweeping aerial that ends a movie. In either case, the shot was comprised with a camera mounted on a long arm riding over the action. An accessory known as a *crane* does it.

You'll notice the term *jib* being bandied about, and those two terms are the source of much confusion. So here's the dirt: The crane and jib basically operate on the same physical principle and even do the same thing, but with one major difference: The crane carries an operator and is usually built bigger and sturdier than most jibs.

As the name *crane* implies, the camera is attached to a boom arm above the action. Professional cranes either carry the camera operator or are controlled remotely.

The jib is a long extension for your DSLR that allows you to move it above and through the scene. It attaches to a tripod or dolly and uses a counterbalance on one side and a mounting plate for the camera on the other. Its long arm is controlled manually by an operator, usually at ground level. Because the camera controls are at the other end of the boom, it's necessary to use a remote control for the camera and have an LCD screen to monitor the action.

4

Audio Matters

*T*he better your movie sounds, the better it looks. Think of it as a feast for the ears and eyes, with one supporting the other. Don't believe me? Check out well-shot video with poor audio and see if you regard it highly.

But good audio is not always easy with a DSLR. Although it provides amazing picture quality, audio capture leaves much to be desired.

That's because it was never intended to do more than capture quality images. Since DSLR technology came on the market, its sensor speed has climbed steadily along with the ability to capture HD movies, but somehow it left audio capture in the rearview mirror. Instead, audio functions were more of an afterthought, and even then, mostly just to provide reference when taking photographs.

That's too bad because less-than-perfect video is less noticeable when the sound is clear and balanced. That doesn't mean that noisy, poorly composed, soft focus images are all of sudden forgotten when the rest of the footage sounds good, but good audio and video do play well on the senses.

The good news is that although DSLR out of the box lacks real audio capability, a wide range of accessories are available that allow you capture superior sound.

Deciphering Audio Capture Choices

Your DSLR captures audio in several ways, with the most basic using the camera's internal microphone. (You know, the one I called a microdot in Chapter 1.) I wasn't being kind, and neither should you when it comes to using it as more than a reference.

In addition to less-than-stellar sound recording, these microphones also pick up sounds made from camera operation. The click from turning knobs and controls, as well as the servo sound of autofocus affect audio capture.

If you aren't going to use the camera's internal microphone, you have two basic choices for capturing audio. The most prominent uses a separate microphone of some type (more on those later). It plugs in to the camera or mixer and captures audio directly on the camera's memory card.

The other means of recording audio uses a separate device that records sound independent of the card. Basically the audio recorder captures sound as a separate file, and then uses a plug-in to match the audio from both the recorder and camera file. Both have advantages, and each has some draw-backs. I discuss both in the following sections.

Internal audio

Internal audio refers to any means of taking sound through the camera, rang-ing from microdot to microphone. Audio records directly on the memory card and plays back in synch (the video matches the audio).

Portable digital audio recorders

Although the DSLR does a great job capturing movie footage, it does have some limitations when it comes to audio. The idea of using a separate device such as a portable digital audio recorder to capture sound seems compli-cated, but its optimal quality audio means that the rewards outweigh the inconvenience. Captured independently of the video, the audio easily comes together in postproduction with a plug-in or sound application. It provides the best of both worlds because you can capture optimal video with your DSLR and pristine audio using the audio recorder. You can read how to mix audio channels in Chapter 10.

Another reason for using a separate audio source is the Automatic Gain Control on most DSLR cameras. This function continually adjusts the audio levels as ambient sound changes. In situations with lots of white noise, your levels may be inconsistent. Capturing audio with a dedicated device allows you to fully control audio on your shoot.

Explaining Microphone Flavors

Microphones come in so many types and price ranges that sometimes it's difficult to determine the right one for your needs and budget. Because most DSLRs have a mini-plug connector for internal audio, you can theoretically use any microphone with a mini-plug connector.

The most common type of DSLR microphone mounts to the cameras hot shoe and plugs directly into the camera. It's definitely an upgrade from the microdot, but its position isn't always the best for all situations. Still, it offers decent sound reproduction in many situations. Before I go into detail about why, take a look at the basic microphone types:

- **Directional:** The most recognizable microphone on the planet, seen in Figure 4-1. It's the same type that singers use onstage, comedians use in clubs, and television news reporters hold in front of interview subjects. It's held close to the mouth to isolate ambient sound. These cost anywhere from less than $100 to several hundred dollars or more.

- **On-camera microphones:** These small microphones attach to the top of your DSLR in the flash hot shoe, as seen in Figure 4-2. Why not? You're not going to use a flash when shooting movies, anyway.

- **Shotgun:** This long narrow microphone picks up audio directly in front of it, but not necessarily close to it. Basic models are found atop everything from prosumer to professional camcorders, whereas more a dedicated version, as seen in Figure 4-3, is used in television studios or atop a boom pole at a movie shoot or on a red carpet. Think of it as the sound version of a telephoto lens.

- **Lavalier:** A lavalier the lapel microphone commonly used on television. Basically this tiny device clips, as shown in Figure 4-4, to the subject close to the face and is wired either directly to the camera or to a transmitter on the subject. When used correctly, this microphone provides great audio and isn't obtrusive in the shot. Conversely, when it's used improperly, it results in a rustled, muffled mess.

Figure 4-1: A directional microphone.

Figure 4-2: An on-camera microphone.

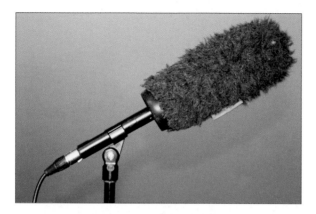

Figure 4-3: A shotgun microphone on a stand.

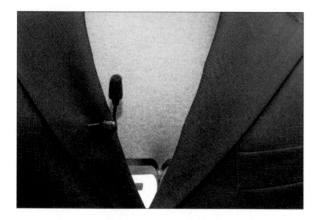

Figure 4-4: A lavalier microphone on a lapel.

A microphone designed for DSLR

Many specialized microphones are made for DSLR moviemaking. They mount the camera's hot shoe and plug-in to the external audio jack. These range in size, performance, and price. Although they're not perfect for all situations, they're great if you plan on doing a lot running and gunning. (That's slang for quickly capturing a subject on the move.) Whatever kind of microphone you decide to use, it's a good idea to have one of these in your bag.

Microphone accessories

Here are some microphone accessories you may want to investigate:

- **Boom pole:** An extendable pole that allows you attach a shotgun microphone and hold it over the subject, out of camera range
- **Windscreen:** A foam cover that goes over microphone to reduce wind noise
- **Microphone holder clip:** Handy device that lets you mount and clip a microphone, or several microphones, to just about anything on the set

Connecting Your Audio Device

Professional moviemaking and video production depend on optimum sound quality. That's why high-end video cameras and audio equipment use high-quality XLR cables. Conversely, your DSLR has a 3.5 mm mini-plug. But the difference between plugs and cables isn't the only reason you'll need an adapter.

- **Mini-plug:** DSLRs use a 3.5 mm mini-plug for audio input. Microphones sold specifically for DSLR have a mini-plug input. This is the same type of plug that's on the headphones for your iPod or computer.
- **XLR connection:** Three-pin XLR connectors are the industry standard for balanced audio signals. These heavy-duty cables come in a variety of lengths and male/female combinations.

DSLR cameras use a mini-plug for audio input, whereas professional quality microphones use three-pin XLR cables.

Although you can produce acceptable audio with mini-plug, it's just not versatile enough when you're using higher quality microphones or plugging in to a soundboard.

If you want to use a professional-quality microphone with XLR, you need to get an adapter to make them play nicely together. It's a relatively affordable accessory that costs anywhere from a few dollars to several hundred. Not only does this device connect microphones to the camera, but it also plugs the camera into a soundboard for optimal recording of events such as concerts, performances, and parties.

This small, lightweight box shown in Figure 4-5 lets you attach a professional XLR microphone or other audio signals to a camera with only one 3.5 mm mini-plug microphone input (Figure 4-6). These adapters upgrade and expand the audio capabilities of the DSLR to the level of a professional video camcorder.

Another reason why it's a good idea to use this device: Your DSLR audio input allows you to use only one microphone because the camera has a single input with an impedance tolerance to interface with only one microphone. Don't try patching two microphones into this input with a Y-cable — it throws off the impedance balance, resulting in really bad, unusable audio.

Line mixing adapters come with various features. Some models supply condenser microphones with phantom power. They require little electricity to operate. The device that the microphone is plugged in to often supplies the small amount of power. Some models send power out through the microphone cable to power the connected microphone. Others allow you to switch their inputs to accept either *mic-level* or *line-level* signals:

- ✔ **Line level:** Line level is a stronger signal used for transferring audio from another source like an audio mixing board as opposed to an external microphone.

- ✔ **Mic level:** Set the camera to this setting if you're using an external microphone. Microphones require a lesser signal to record audio. If you set the adapter to Line, it reproduces the sound as loud and distorted.

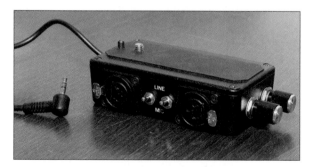

Figure 4-5: A side-by-side comparison of mini-plug and XLR connectors.

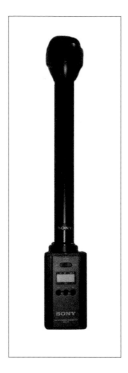

Figure 4-6: A mini-plug to XLR line mixer.

Understanding Wireless Transmitters

Up until now, we've discussed using cables for audio capture, but sometimes it's not convenient to tether the camera to a microphone with cables. Sometimes, you need to use a wireless microphone. These are not any different than what I've already covered in this chapter, except instead of plugging in to a cable, you're using a transmitter attached to microphone and a wireless receiver connected to the camera or adapter.

As the name implies, a wireless microphone captures audio without a physical cable connecting it to the camera or adapter. Wireless microphones require two main pieces: a transmitter attached to the microphone instead of a cable, and a transceiver connected to the audio input of the camera or adapter.

Here are some of the benefits of a wireless set-up:

- **Freedom of movement:** Wireless microphones allow you to move independently of the camera as long as you are within range of your microphone receiver.

- **Safety:** Because you're not tethered to a cable, you don't have to worry about cables everywhere you move. That means no tripping over or stepping around them.

- **Less cable wear and tear:** Wireless requires less use of XLR cables, so the ones that you're using don't get stressed and stop working.

A wireless set-up does have its downsides, however:

- **Limited range:** Some models don't allow you to move too far out of range. On average, they transmit up to 300 feet from the receiver, although the signal breaks down much closer than that.

- **Breaks in audio:** Dead spots, interference, and noise can affect the recording.

- **Wireless devices may not work together:** If too many wireless microphones are using the same frequency, it can lead to unusable audio from noise, hum, or static.

Recognizing the Importance of Monitoring Audio

Earlier, I mentioned the importance of audio quality in your video. Part of that has to do with listening to it while you're capturing it. All too often, people pay a lot of attention to watching the scene and not much to listening to it. Listening to your audio lets you avert problems ranging from a disconnected microphone to frequency issues with wireless devices.

The first step to monitoring audio begins with remembering your headphones. With the advent of iPod and other portable audio devices, we always seem to have headphones at our disposal, so use them. Here's some of the types that are available and how well they'll work for you.

- **Ear buds:** The same headphones for your iPod can work with your DSLR. The audio quality is acceptable, and most likely you're always carrying them around anyway.

- **Ear pad:** These used to come with your portable CD player. These inexpensive small over-the-ear headphones are adequate, but they don't isolate ambient sound.

- ✓ **In-ear:** These isolate a lot of extraneous sound, but they're jammed in to your ear, making them an unlikely choice to quickly monitor audio.

- ✓ **Clip-on:** Basically they're headphones without the headband. They clip to your ears. They come in handy, especially when you can use them on one ear.

- ✓ **Full-size:** These are large cups that cover your ears. These seemed better suited to listening to your music while relaxing in an easy chair.

- ✓ **Noise-cancelling:** These block out other sounds. I don't recommend these for audio monitoring because although listening to audio is important, you need to still pay attention to ambient sound, too.

Part II
Control the Camera, Control the Movie

*D*SLR moviemaking shares more in common with fundamental filmmaking than it does with traditional photography.

Part II begins by covering basic shot structure before getting creative with varying angles. After that, it's on to techniques like time-lapse, green screen, and basic and advanced lighting technique. Of course, none of that matters too much if the shot is not properly composed. I cover that too.

And then there's audio capture, which makes the movie look better. You'll see why.

Shooting Video with Your DSLR

In This Chapter

▶ Shooting video with your DSLR

▶ Getting exposure right

▶ Keeping the camera steady

▶ Maintaining variety with each shot

*F*orget everything you know about still-photography cameras. I'd also say forget what you know about video camcorders too, but DSLRs differ so much in operation anyway that it won't be necessary.

That's because still photography and moviemaking are much different, even if they use the same the camera. The camera is not so much multi-purpose as two different cameras in one device.

The big mistake people make comes from trying to make movies with a DSLR while using the mindset of a camera used for taking still photographs. By abandoning its original purpose of taking still photographs, you'll be able to concentrate on the camera's unique functions, so you can adhere to the core fundamentals of moviemaking and video production. If you're new to moviemaking, pay attention. Even if you've done it before, still pay attention.

Nailing the Fundamentals of the Shoot

Taking your time to accurately measure exposure, white balance, and focus outweighs is much better than haphazardly shooting scenes and having little usable material in postproduction. The extra time you take

during each part of the process is often the key ingredient to a successful film. That means taking a few extra moments to make sure the shot is technically perfect. It means double-checking all the basics so you don't have to go back and re-shoot. It means shooting all the scenes at a particular location, regardless if they're in the order you plan to show in the film.

That's why movies are never shot in order. Sometimes the beginning isn't shot until the end, or the middle scenes may be amongst the first captured. The order you shoot each scene doesn't matter.

While you're capturing footage, pay attention to effective variations of each shot in the scene. At the very least, include variations of subject size and angle. This makes it easier to choose shots in the editing process. Conversely, if you shoot few scenes and don't change your camera position, you'll be stuck when it comes time to edit, and no audience wants to sit through long tedious shots that don't communicate visually with them. Basic shot structure, like framing variations and camera movement, are discussed in this chapter. You can also read about advanced camera placement in Chapter 6 and effective frame composition in Chapter 9.

Some people just put gas in their cars and drive, until one day their cars keel over. Turns out that paying a little bit of attention to fluid levels and routine maintenance prolongs the life of your car. The same applies to making movies.

What?

Do you know why one sequence comes out blurry, dark, and bluish and another is crisply focused, well exposed, and nicely colored? I'll give you a hint; it has to do with continually checking the fundamentals.

That's how professional filmmakers work. They leave nothing to chance. They take a few extra moments before each shot to make sure exposure, focus, and white-balance are all right for the shot.

Every time something changes in the scene, or you move the camera, you have to make adjustments for it. That's how the pros do it. Great movies are made by hand, or in this case, with manual control. Taking the easy way out by setting your DSLR to automatic eventually leads to uneven exposure, wandering focus, and inconsistent color balance.

Here's a breakdown of each function and how it impacts your shot:

 ✔ **Shutter speed:** Moviemaking uses a much narrower range of shutter speeds. Still photography covers setting durations that run from 30 seconds to 1/8000 or more. The standard shutter setting for video is 1/60 of a second. Because the subject in Figure 5-1 was relatively static, that was

an appropriate shutter speed for this image. By using a higher shutter speed, say 1/250, you can more clearly capture fast-moving subjects that require crisp rendering, as seen in Figure 5-2. You can even use a lower shutter speed, 1/15 of a second, if your camera permits, for a blurred effect. When the camera is steadily positioned on a tripod and you shoot a fast-moving subject, you can capture it as a blur. Any static elements in the scene, such as a tree or a wall, render as sharp. The effect looks similar to the fighting scenes in the movie *The Hunger Games.*

✔ **Aperture setting:** On the DSLR, you altering exposure using the aperture setting. Videographers call it *iris,* but it's technically *aperture,* and that's what I call it here. Basically, it's the camera's main means of controlling exposure by changing *f-stops,* which are each equivalent to double or half the exposure, depending on whether you require more or less light. So the aperture adjustment refers to the opening in your lens and how much light it lets in.

✔ **White balance:** White balance is the means of adjusting the color temperature of each scene by setting the camera's sensor by balancing to reproduce white under a specific temperature of light. Every form of light has its own color temperature that ranges from the warmth of late afternoon sun to the coolness of an overcast day. Color temperature is based on the Kelvin scale with daylight at around 5500K. By setting white balance, you can match the proper color of the scene. When set on daylight (5500K), warmer light sources render with a deep orange cast, and cooler light sources with a bluer than normal cast.

Your camera's white balance is usually controlled one of three ways. The most common requires you to do nothing: It's the automatic setting and it adjusts white for each scene. But it doesn't work well, as seen in Figure 5-3. Then there's the Preset mode, which lets you adjust the sensor for specific conditions like daylight, tungsten, fluorescent, and so on. To use the manual mode, hold a white card in front of the lens, as seen in Figure 5-4, and adjust to it each time you change locations or when the light changes. This is a custom reading of the card to provide a mathematical reference of color. Although it's a bit complicated, it's how the pros do it. Figure 5-5 shows more realistic color. Check your camera's instruction manual to find out how to set white balance.

✔ **Manual focus:** Years of evolution in focus technology are put on hold when you shoot movies. That's because autofocus does not play well with movie modes. To keep things clean and neat, set the lens to manual focus, zoom all the way in, focus, and then pull out to the desired focus. This is how the pros get a grasp on focus. Also be aware that every time the camera is subject to distance changes, you need to readjust focus.

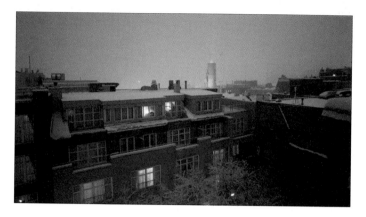

Figure 5-1: Using 1/60 shutter speed for a static scene.

Figure 5-2: Using 1/250 shutter to capture a faster movie subject.

Figure 5-3: The white in this image has been improperly balanced.

Figure 5-4: Holding a white card in front of the camera to take a white balance reading.

Figure 5-5: Improved white balance after manual reading.

Understanding exposure

Exposure derives from the trinity of aperture setting (the opening of the lens), shutter speed (the duration it stays open), and ISO setting (the standard used for measuring sensitivity of the sensor).

Measured in f-stops, many lenses show the following numbers: F2.8, F4, F5.6, F/8, F11, F16, and F22. Each one represents an entire stop of exposure. They allow less light into the lens as the numbers get higher, and more light when they get lower, known as *closing down* and *opening up,* respectively. For example, changing from F4 to F5.6 decreases the amount of light striking the sensor by one stop, as seen in Figure 5-6.

Shutter speed has a similar approach to adjusting exposure with a reciprocal relationship to aperture that allows you strike the right balance between shutter speed and aperture combination.

Measured in fractional seconds (camera dials don't include the fraction), applicable moviemaking shutter speeds include 15, 30, and 60, 125, 250. As you can see, they also have exponential variations that affect exposure by one full stop by doubling or halving with each change. Higher numbers allow less light to hit the sensor, whereas lower numbers let more light in.

The ISO setting affects the amount of light required for exposure and adds noise as it becomes more sensitive. The art is to use the lowest ISO setting as possible to assure image quality with the least possible noise.

The reciprocal nature of shutter speed and aperture becomes obvious when you need to balance exposure. For example, say that you're at a high school football game and you're shooting an interview with a cheerleader. Your exposure setting is 1/60 of a second at F8, and it looks great. Now say you want to capture game action, rendering sharp detail. If you change the shutter speed to 1/250, you underexpose the scene by two full stops. That's a value that borders on unforgivable because it will appear too dark.

In order to make things right, you need to compensate for the two stops' less light on account of changing the shutter speed to 1/250. Add two stops more exposure by changing the aperture setting to F4 to shoot the game action.

Figure 5-6: The difference of one stop of exposure.

Putting it all together

Before you park yourself in the director's chair, here's what you need to know and do to get ready for each scene:

1. **Prepare to shoot.**

 Set up the camera on your tripod and compose the scene.

2. **Set shutter speed.**

 Use 1/60 for general situations. Higher shutter speeds can be used when you want to depict detail in action sequences or when the lighting is extremely bright. It's not a bad idea to wait until after setting aperture to deal with adjusting shutter speed.

3. **Balance exposure.**

 Raise or lower your aperture setting until the scene looks well exposed.

4. **Set white balance.**

 Hold a card or paper and manually change it. Refer to your camera manual for specific instructions on setting manual white balance.

5. **Focus on the scene.**

 Make sure autofocus is turned off. If you're using a zoom lens, set the focus at maximum telephoto, as seen in Figure 5-7, and then reframe with the proper focal length, as seen in Figure 5-8. This helps ensure that focus remains sharp.

6. **Press the movie button.**

 Always start recording before the action takes place and don't stop recording until after it's done. If you're not sure why, you'll know when you start your edit when your footage starts and stops too late or early, respectively.

7. **Repeat these steps for every shot.**

 Although cumbersome, taking these steps increases the probability of having usable footage when it comes to assembling your movie in the editing process.

Figure 5-7: Zoom in to focus.

Figure 5-8: Pull out to the desired focal length.

Keeping the Camera Steady, Eddie!

Although these tips contribute to the success of the shot — and eventually the scene and the movie — make sure the camera remains steady. While I mentioned using a tripod as the first step in the previous section, sometimes using a tripod isn't practical, or you simply don't feel like lugging it around with you. (Tsk, tsk.)

You see, some people have a misconception that they can hold their DSLRs steady in their hands while making a movie. It's the same mindset some have at the carnival when they believe it's easy to climb the rope ladder, only to find that it's not as easy as it looks.

Holding a camera steady for any extended period of time takes me back to my childhood when I would help my dad work on furnaces. At 8 years old, I was regularly given the job of holding the flashlight. I heard "Hold it steady, already!" so many times you would have thought I was hopped up on double espresso. Holding anything stable for a span of time without bouncing around the target is physically difficult.

The same applies to handholding a DSLR when it comes to making movies. That makes a tripod or some other stabilization device a necessary evil for the situation. If you're simply opposed to three-legged stabilization, or you're not permitted to do it (some places forbid using one unless you have a permit), consider a handheld rig, which I mention in Chapter 3, to help facilitate steady shooting. These days, you'll even see some shooters mounting their DSLRs to a handheld rig. They offer great results and keep everything organized. You'll look like a one-person band, but as long as it works, who cares? The operative words are "as long as it works." If you're not familiar with how to use it, it won't help you.

Handholding like an SLR doesn't work

DSLR moviemaking doesn't lend itself to handholding. Besides the difficulty of holding a camera steady for a long period of time, you also have to hold a DSRL away from the body so that you can see the Live View monitor. When all you have for stability are extended arms, you're in trouble! It's hard to maintain composition when holding the camera straight out. Even if you think it's steady, as soon as you adjust a control, it renders video that looks like it was shot on the high seas.

But desperate times call for desperate measures, so for those times you don't have a tripod or some other device, here are a few tips to improvise:

- **Rest the camera on a firm surface.** It's funny how a window ledge, park bench, or curb works when you don't have a choice.

- **Make a solid connection.** When crouching, kneeling, or lying down, rest your elbow on a solid place to reduce motion while shooting.

- **Use the poor man's stabilizer.** You can use a piece of twine to hold the camera steady when shooting your movie. Tie a string around your camera and put it on the floor. Step on it with your foot and pull upward to create tension while shooting.

Not wanting, but needing, to use a tripod

Saying that a tripod is a necessary evil sounds a bit harsh, just as calling it cumbersome is a bit of an understatement. But carrying one around and not using it properly, well, that's just a waste of time and energy.

Simple things like making sure the legs are properly tightened and maintaining a level horizon go a long way toward a quality shot when you plant the subject in front of you. Barring any intentional creative device, an evenly balanced horizon is necessary.

Here are some other tips:

- **Place the tripod on level ground.** Be sure the model you're using is durable and everything is appropriately tightened. Adjust the dampening on the video head before beginning your shoot to ensure smooth movement. *Dampening* controls the smoothness of movement and can range from tight to very loose.

- **Find your composition first.** Because it takes a fair amount of time to set up a tripod, find your composition first, and then worry about where to place the tripod later. Walk around and explore the scene from different angles. It helps to look through your viewfinder as you do this to help you see exactly what the composition will look like.

- **Position one of the tripod legs toward your subject.** Pointing one of the legs toward the subject provides room to stand behind the other two legs (helping prevent you from kicking over the tripod), and it can add additional stabilization for the camera when it's pointed toward the ground for a high angle or bird's-eye view shot.

- **Keep the tripod balanced.** To ensure the weight of your camera is evenly distributed between all three legs, make sure the center post is vertical and perpendicular to the ground. Consider using one of those bubble levels that attach to the center post. They can help tremendously to level the tripod. These bubble levels, if they're not already included on your tripod, are usually specific to each tripod model and available for less than $10.

- **Avoid extending the center post.** True, it makes the tripod higher, but also makes it significantly less stable, so only use the center post as a last resort. This often causes some frustration in setting up your tripod to that perfect height. Sometimes, you need the shot higher than the extended legs can provide.

Using a rack system for steady holding

With apologies to George Orwell's *Animal Farm,* "Three legs good, two legs better?" That's quite possibly true when they're your legs and a camera is attached to a rig supported by your shoulders.

When you don't want to use a tripod, but would still like to maintain a sense of steadiness, consider using a shoulder rig (as mentioned in Chapter 3). You'll be able to maneuver the camera and keep it steady using your own body. As I mention in Chapter 3, rig systems support a lot of accessories and are customizable enough to put all the right tools at your disposal.

This makes it essential to arrange your camera light, microphone, monitor, and whatever else you choose to use in the most comfortable manner.

When using a rig for handholding, consider the following:

- **Use your body.** Slowly guide the rig with your body using a smooth motion.

- **Avoid moving too quickly.** Move at a deliberate pace. DSLRs cannot process quick motions and movement effectively. When you move too quickly, it produces an effect known as *JELL-O-cam* that causes a skewed, wobbly picture.

- **Arrange your rig.** When your accessories are in a comfortable place and within easy reach, you'll fumble less and shoot more effectively.

- **Bend your knees.** The bent-knee position provides a smoother transition when you need to elevate, adjust angle, or change position.

- **Attach the rig to your tripod.** Your three-legged friend can help you because rigs are not just for handholding. You can connect a rig to a tripod and support all your accessories.

Shooting to Edit

We've all heard the axiom that great films are made in postproduction. That's only half true. The other half depends on how effectively you capture each scene, or more accurately, enough variations of each scene so you can make more informed decisions in postproduction. These deviations of the shot make up the foundation of powerful editing. That, of course, leads to cohesive storytelling. But there's a reasonable threshold. If you overshoot, you'll spend too much time going through the footage and second-guessing yourself. That's why many filmmakers use a technique known as *shoot to edit*.

Basically, you have an idea for the structure of the movie, or the amount of scenes you wish to include, and create three or more variations of it. In its simplest form, that means a wide-angle view, normal, and close-up for each intended scene. But it gets a little more complicated, as you'll see.

Shooting Just Enough Variations

You should approach shooting scenes for your movie like you would an all-you-can-eat buffet. Make sure that you've had enough of the food you wanted, but didn't overdo it.

Okay, maybe it's not entirely the same, but capturing a healthy variation of each shot is the spice that flavors any movie and assures your editor doesn't hate you.

When you have a fair number of shot variations, it provides alternate choices when you're putting the movie together. That helps with the movie's visual rhythm and gives it a nice flow. Don't be stingy when it comes to shooting those scenes. It's not unusual for a movie to have a 20:1 ratio (or greater) of shots captured to shots used.

And before you think that sounds like a lot of wasted content, take a step back and think about the alternative: limited variations for each scene, all shot from a similar position with little vetting before you go on to the next. Trust me, it's not what makes a good movie, but that's not to say that the amount of footage you shoot needs to be excessive.

Making sure you've covered enough variations of each scene is not the same as haphazardly capturing whatever you see and expecting to turn it into a cohesive movie. Instead, carefully decide the content of your film, and then make sure that the technical and aesthetic settings match your intentions.

Think of those relationships between wide-angle, tight shots, and others to determine how they visually speak to the viewer. For example, panning the camera provides a sweeping vista that tells the viewer the direction of action or the expanse of the location, just as the tilt from shoes to head of an actress on a red carpet screams, "Check this out!"

After that, it's all about you and the magic of Adobe Premiere Elements. But the better you do in the shooting, the better you will do in the editing.

Watching and Learning from the Movies

Next time you're watching a movie, analyze the shot structure. You'll see some of these basic shots:

✔ **Establishing shot:** Generally, a wide-angle shot that lets the viewer get a sense of the landscape, place, or logistics of a scene, as seen in Figure 5-9. This is usually the opening shot of the movie but can also be used when location or time changes in the movie.

- ✔ **Wide:** An expansive view of the scene that shows the subject in relation to his environment.

- ✔ **Medium:** It's the average perspective: not too close, not too far. It's excellent for shots that include dialogue and sound bites, as seen in Figure 5-10.

- ✔ **Close-up:** A magnified view of the scene. Sometimes it brings distant objects closer; other times it's used to create a close-up. It's also used to emphasize important details.

- ✔ **Pan:** A sweeping motion of the scene that goes side to side.

- ✔ **Tilt:** It's the camera's version of looking up, down, or up and down.

- ✔ **Dolly (zoom):** A means of using the focal length to draw the subjects closer or further away while shooting the scene.

Figure 5-9: An establishing shot provides a sense of where the scene takes place.

Figure 5-10: Medium shots are great for subjects talking on camera.

Varying Focal Length

Each of the previously mentioned shots are performed either through camera to subject distance, focal length, or a combination of two.

- **Wide-angle lens:** On a full frame, it represents focal lengths up to 35 mm. It's mostly used for wide shots, but sometimes, you can shoot normal-range and even close-ups with it. That depends on the camera-to-subject distance.

- **Normal lens:** The 35-mm camera and the full-frame DSLR use a standard lens in the 50-mm range. It produces a perspective similar to human vision, so it's entirely possible, though not recommended, to shoot an entire movie with this lens. Camera-to-subject distance then varies with each type of shot.

- **Telephoto lens:** A focal length that magnifies the scene and makes distance objects closer. For the most part, you can capture close-ups with it, but other shots still are influenced by the camera-to-subject distance. For example, when you're using a medium telephoto lens (say, 135 mm on a full-frame camera), you can use a telephoto to make a medium shot of a scene if it's far away, or even a wide shot if it's really far. Why would you do this? Maybe because of a unique angle you want for the shot, or if you wish to exaggerate the distance between foreground and background elements and compress the scene.

Mastering Shot Structure

Often considered the spice of life, variety is also good when it comes to shooting scenes for your movie. By capturing each scene with varying angles and framing techniques, you can visually tell your story and make a strong case for your edit. Shooting each scene using a wide, medium, and tight composition of the scene makes a strong foundation for editing, just as capturing the action from front, side, and maybe someplace in between helps too.

Consider your key scenes and shoot several variations of each by changing the camera distance, focal length, and angles or by moving the camera. The variations in each type of shot help you create visually appealing content for editing.

A basic approach is using the core shot types by using a wide, normal, and telephoto lenses or setting on your zoom lens. You can show the main subject with the normal version, a detailed shot with telephoto, and a wide shot that places the subject within her environment.

For example, Figures 5-11, 5-12, 5-13, and 5-14 show these variations on a series of images featuring cable cars.

Figure 5-11: A wide shot of a cable car.

Figure 5-12: A medium shot of a cable car.

Figure 5-13: A tight shot of a cable car.

Figure 5-14: An overhead shot of a cable car.

Maintaining Continuity Between Shots

The difference between making a feature film and a theatrical event like a play is that only one is presented in linear fashion. Whatever happens in the play takes place with natural progression. Conversely, the film is shot out of sequence and put together in postproduction like a giant puzzle. Sometimes when you assemble the movie, the consistency between different parts of the same scene is compromised.

Most continuity errors are generally borne out of shooting out of sequence. Isolating every detail makes for a logistical nightmare. Throw in the fact that movies rarely follow linear progression, and it's easy to see how these mistakes get by. Most of the time, the mistakes are minor, and in the past, audiences wouldn't notice them. Of course, the digital world changed that with frame-by-frame clarity.

People have turned error-spotting into a cottage industry. Sometimes a continuity error is a simple difference of glassware placement from one shot to the next. Other times, it's more noticeable, like a clean baseball uniform after a dirty slide into home plate, or a completely different model car being blown up.

In order to avoid these problems in your film, consider the following:

- **Maintain a detailed record of the scene.** Use a screen grab of each shot if you're not shooting scenes in succession.

- **Watch for the subject's primary movements.** Be sure they remain consistent. For example, your actress has her right hand on her hip in the wide shot, and you cut to the medium shot and see her left hand is on her hip. These minor breeches can still break the suspension of disbelief in your movie, so be aware of them.

- **Keep the traffic flowing, consistently.** Although successful editing depends on the rhythm between shots, you have to make sure that they're plausible. Don't show a sequence of someone getting into a car and then show it moving in the wrong direction because it looks better.

- **Do not breech the 180-degree rule.** Using a football analogy, it's the line of scrimmage for moviemaking, meaning you cannot break it. You can do anything from behind it — just don't move to the other side without expecting to confuse the audience. That's because this rule establishes subject placement for the audience and lets them experience the space. It's part of a necessary rhythm for creating plausibility between scenes. When you break it, it confuses the viewer. Sometimes it's done for effect, but for the time being, try to honor it.

.

6

Getting Creative with Your Shoot

In This Chapter

▶ Controlling depth of field

▶ Positioning the camera

▶ Using filters to enhance the look of your movie

▶ Getting creative with shooting effects

Respecting the basics of filmmaking (such as exposing your scene properly and keeping the camera steady) definitely boosts the potential for capturing quality video. But at the same time, those basics are like a scoop of vanilla ice cream. It hits the spot, but it's still just vanilla. Now I don't know about you, but when I have a bowl of vanilla ice cream in front of my hungry eyes, my first inclination is to add chocolate syrup, sprinkles, and whipped cream. Think of this chapter as the toppings for your movie sundae.

I'm not proposing you pour Hershey's syrup all over your camera. Instead, do it metaphorically by taking the basics to the next level. For example, when adjusting exposure, consider an aperture setting that controls depth of field to your liking. Want to get more dramatic? Reposition the camera so it's higher or lower than eye-level. Effects, you say? Go old school and break out lens filters. Trust me — they're still relevant when it comes to DSLR movie-making. Don't forget that playing with the duration between captured frames creates a time-lapse, which allows you to depict your own unique universe. And did I mention green screen effects? Yup, those too. None of these go well with Häagen Dazs, but they can certainly take the vanilla out of your movie.

Controlling Aperture for Effect

Your aperture setting only allows a select amount of light into the lens. Think of it as a doorman at an exclusive nightclub. When you dictate aperture selection, you control the level of focus in the scene much like the guy behind the velvet rope selects who gets in.

As I mention in Chapter 5, *aperture* refers to the opening on your camera's lens and how much light it allows onto the sensor. Under low-light conditions, the aperture, or *iris* (take your pick, they are essentially the same) accommodates more light into the lens by widening the opening. Conversely, brighter-lit situations require a narrow setting, altering the area of focus in the scene.

Understanding depth of field

When you focus the camera on a desired point in the frame, the area of sharpness varies. That variation refers to the *depth of field* in the scene. Sometimes it appears as though the entire image is in focus, and other times only a narrow area escapes the blur.

This level of focus in the scene depends on several factors including subject distance, focal length, and, of course, aperture setting.

When the aperture is wide open (letting in the most light into the lens), the level of focus becomes extremely limited. Figure 6-1 was shot with a 50 mm lens at its maximum aperture of F1.8 with the subject several feet from the camera.

Known as a *shallow depth of field,* this level of focus doesn't usually go beyond the focused area of the subject. In a portrait, the subject appears in focus, whereas the rest of the scene appears soft or even blurred. This works well for situations where emphasis is paramount. It's also referred to as *selective focus.*

Stopping down the lens (letting less light in by using a higher aperture setting) provides a greater depth of field. This works best with brightly lit situations when you wish to render every part of the frame in focus. Figure 6-2 shows the effect of using a higher aperture setting.

Figure 6-1: Selective focus with wide aperture.

Figure 6-2: Increased depth of field.

Reciprocity at work

The democratic nature of exposure provides a reciprocal balance between the amount of light that comes into the lens and duration the lens stays open. In photography terms, this refers to aperture setting and shutter speed, respectively.

Reciprocity defines the balance between shutter and aperture in regard to creating exposure. The sensor sees exposure in its purest form. But as I previously mentioned, you can alter the shutter or aperture setting to accommodate your needs. When you open the aperture of the lens, say from F5.6 to F4, you need to limit the duration by one stop, going from 1/30 to 1/60.

How our eyes are like lenses

Our eyes share many similarities with a camera lens. Both adjust the iris to dilate or constrict based on light levels. With our eyes, the retina renders the image, and on the DSLR, the sensor does it. And just as a camera lens can have a limited depth of field under low-light conditions, so do our eyes. Have you ever noticed the limited area of focus under dim lighting? Or when lighting conditions are brighter, how that level of focus increases? Squinting in bright sun is essentially the same as stopping down the lens.

Thanks to reciprocity adjustment, you can adjust the aperture to *open up* the lens to limit depth of field, or *stop it down* to increase it. Of course, the shutter speed must be changed to compensate. A manual exposure of 1/250 @ F4 translates to 1/30 @ F11. Table 6-1 shows the shutter/aperture combination ranging from selective focus to maximum depth of field. Each column represents the same exposure.

Be sure to have the camera in the full manual mode because automated DSLR automatic modes like Shutter Priority do not work in the movie mode. The automatic setting selects everything including the ISO. If you want to control depth of field, you'll need to shoot in manual mode.

| Table 6-1 | | Reciprocity Chart | | |
Selective Focus				*Maximum Depth of Field*
1/500	1/250	1/125	1/60	1/30
F2.8	F4	F5.6	F8	F11

You can capture a low-light subject that requires a little more exposure by using a lower shutter speed like 1/30, or a fast-moving subject that requires a higher shutter speed at 1/250. However, for most situations, it's a good idea to adhere to the 180-degree shutter rule that basically means you should strive to keep your shutter at double your frame rate. So, if you're shooting a 29.97fps, 1/60 makes your video appear as lifelike as possible.

Factors that affect depth of field

"One size fits all" does not necessarily apply to depth of field. In principle, a wide-open lens provides a shallow level of focus, whereas a stopped-down lens increases it. As for predictability, factors such as subject distance, focal length, and overall illumination play their parts in the amount of focus between the foreground, background, and subject.

Here are some things to consider about depth of field:

✏ The closer you are to the subject, the more focus differs at foreground and background points.

✏ Wide-angle focal lengths provide a much greater depth of field.

✏ Telephoto lenses produce a more narrow depth of field.

Finding the Best Angle

A few years ago, while working on a photo story about dairy farms — and capturing too many mundane images along the way — I decided to seek out the most unique angle I could find. That was the underbelly of a dairy cow. Why not? It's the heart and soul of the milking operation and a perspective not everyone gets to see. So, after I got past my fear of possibly being trampled, I measured exposure and made the picture. What I got was udder-ly amazing. (Insert sound of rim shot here.)

My point: Eye-level shots are necessary, but too many can lead to terminal yawning from your audience. To spice things up, try changing the camera position to a higher, lower, or even a tilted position.

Where you position the camera speaks volumes (in visual language, without subtitles) about the message you're trying to convey. When you add these effective variations, it provides a nice supplement to the wide, normal, and telephoto shots of each scene. That comes in handy when you're editing your movie.

Try including some of these shots in your next movie:

✏ **High angle:** Through an informal survey of my own, the first choice for adjusting angle seems to raise the camera high and angle it down toward the subject, as seen in Figure 6-3. Besides a unique perspective, it can make the audience look down on the subject, perhaps to depict weakness. This elevated perspective often provides a graphical composition of the frame.

✏ **Birds'-eye:** Alfred Hitchcock loved this shot and not just for *The Birds*. Positioning the camera high and directly above the action allows the viewer to dissect elements in a 2D view, often making common objects unrecognizable. Although it's hard to shoot, the perspective in Figure 6-4 makes for a powerful opening or closing scene.

✏ **Low angle:** Setting the tripod as low as possible and pointing it upward provides another dynamic option for your movie. With this perspective, you can change the horizon (or even eliminate it) in the shot, as seen in Figure 6-5. Low angle also privies the viewer with something they don't normally see (for example, the udders). A slightly low angle also makes

a short person seem, well, less short. But more importantly, it makes the subject seem superior, almost in a "Look up at me" sense. It can also lead to the opposite effect, showing life through the perspective of a small person, namely a child, which can depict powerlessness of the character when paired with a high-angle shot.

✔ **Dutch angle:** This creative device is a pleasant variation for your movies. As you can see in Figure 6-6, it's a tilted frame that provides an interesting "break" to conventional viewing. Popular in horror flicks, indie films, and music videos, this perspective can depict alienation, uncertainty, and tension. Although it's a "cool" way to frame the subject, use it sparingly. For one, it will lose its charm if overused. Worse than that, it can have your audience tilting their head like your dog does when you say something he doesn't understand.

✔ **Over the shoulder:** This shot puts the viewer in the heart of the action by positioning them behind one subject, while showing a full version of the other. Figure 6-7 shows a nice variation to use when subjects are in dialogue because it shows character interaction and sets the tone of the scene.

Figure 6-3: High angle.

Figure 6-4: Bird's-eye view.

Figure 6-5: Low angle.

Figure 6-6: Dutch angle.

Figure 6-7: Over the shoulder.

Employing angles effectively

The classic film *Citizen Kane* has a shot where the camera was placed in a hole in the floor to emphasize an unusual perspective. I'm not suggesting that you rip out a floor and dig a hole big enough for your tripod to produce the ultimate low-angle perspective, but I am suggesting you think of how to use the surrounding to your advantage.

For example, climb up a flight of stairs and shoot downward. Or try situating yourself on a terrace or embankment to capture a high angle or a bird's-eye view. The same applies for low angle: Find a low position and shoot upward. Some tripods, especially those designed for still photography, allow you to spread the legs wide like a three-legged spider, leaving you with a perspective inches from the ground.

When you shoot a movie, the key is variation. Be sure to vary your angles and types of shots so that you can edit your movie in a cohesive manner. For example, if you emphasize a subject from a high angle, be sure to have some low-angle and eye-level shots as well. Don't forget to break things up by shooting with wide, normal, and telephoto lenses.

Let the camera do the walking, er . . . moving

The camera can't always behave like a wallflower. Playing it safe by passively locking it down on sticks is like never taking the training wheels off your bicycle. Trust me — sometimes the movie yearns for the camera to come out on two wheels and make its own statement. Professional cinematographers address this need by mounting the camera on a movable cart called a *dolly* and pushing it in and out of the scene.

With a few exceptions, professional moviemakers rarely use a camera's zoom function. Why, you ask? Because moving the camera either toward or away from the scene emulates the perspective used in our daily lives. Our eyes don't zoom in to get a better view; instead, we move closer. Because zooming simply magnifies the scene, it appears two-dimensional.

Shots similar to a dolly shot include

- **Tracking shot:** Cousin to the dolly shot, this has the camera moving side to side. Similar to a camera pan, this method eliminates the arc that you get from turning the tripod head on a circular axis.

- **Crane shot:** Many variations to this shot exist, depending on the rig used, but all allow the camera to "float" into the scene. The version most

accessible to the budget-conscious moviemaker combines a high tripod-like stand, balancing arm, and boom head. This shot treats the viewer to a bird-like perspective. In one application, the camera can move with the subject and then rise above, revealing a wide expanse of landscape.

Although a professional-quality dolly can takes its toll on your budget, an improvised version still gets the job done. Essentially, anything with wheels and the space for mounting a tripod potentially qualifies as your next piece of equipment. You can find hundreds of do-it-yourself suggestions on the Internet.

Here's some suggestions for using items you may find in your own garage, or a garage sale:

- **A moving dolly:** This wood frame with wheels and ratty patches of carpet on either side is most often seen helping movers get heavy furniture from their trucks to a house or apartment. It has nothing in common with a professional dolly, other than a common name, but it can still work in a pinch. To keep the legs in place, simply add three section of wood at a 90-degree angle, as shown in Figure 6-8.

- **A baby carriage:** Back in my film school days, I used my sister's old baby stroller for a dolly shot. I adjusted each tripod leg so that the tripod head was level. Then, by using some metal strapping and a few nuts and bolts, I was able to create a stable dolly and had a comfortable handle to push it into the scene.

- **A child's wagon:** Why not? By positioning the legs in the corners, you can make an instant dolly with a handle to pull it.

- **Skateboard dolly:** By taking the wheels from a skateboard and attaching them on a 3'×3' piece of ¾" plywood, you can build a rolling base to place your tripod. See the "Build your own" sidebar for more information.

- **A wheelie bag:** I once used an old rolling duffle bag as a dolly. Just about any kind of bag can work, providing you can get a tripod to fit. And don't forget, it has a comfortable handle too.

- **Human bi-pod:** Essentially, this method balances your camera on two legs of the tripod with the third being the brace that you provide. Leaning the camera in and out of the shot simply requires a forward or backward motion. For a crane-like effect, you can extend the legs to maximum length and lock the feet into your torso for a controlled high-angle view using your arms and body to smoothly move in and out of the scene. It's not pretty, but it can get the job done.

Build your own

It's easy to build your own dolly — it's just a base with wheels. If you need specific instructions, check out these websites and YouTube links:

 www.softweigh.com/video/diy.html

 www.youtube.com/watch?v=x095qg1RJ_Y

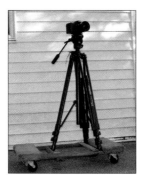

Figure 6-8: An ordinary moving dolly with tripod.

Playing nice with your dolly

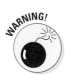

Now you're ready to roll your dolly with a tripod unsecured and positioned to its relatively lightweight base over an uneven surface. What could possibly go wrong?

Did I tell you that tremors make for a great special effect? Of course, that's only if you're trying to recreate an earthquake. Otherwise, the goal is to capture the scene with a smooth, even motion. To accomplish this task, the unbridled nature of the makeshift dolly requires some finesse.

Here are some valuable tips to consider:

- ✔ **Rehearse before each shot.** Practice makes perfect when it comes to movements and timing.
- ✔ **Make sure the front wheels are pointing forward.** Anytime you have swiveling wheels, like a shopping cart, you need to make sure the wheels cooperate.

✔ **Weigh the dolly down to reduce camera shake.** The relatively light-weight dolly often works against gravity. Get radical by using something heavy like a bag of sand. It will make the shots smoother and help you control the dolly more deliberately.

✔ **Mount the tripod low.** When you lower the center of gravity, you assure the potential for less motion.

✔ **Adapt to rough surfaces.** Because you won't have a heavy-duty track system, use a piece of plywood or thick mat to provide your own smooth surface.

✔ **Be smooth while moving.** Use tape or markers for start and end points and push or pull with a steady pace.

Here are some types of dolly shots:

✔ **Push in:** Brings the audience closer to the subject and can emphasize the character's mental state.

✔ **Pull out:** Exaggerates the environment by showing the character in relation to the background.

✔ **Expansion shot:** When a character walks in or out of a moving shot.

Using Camera Filters

Back when I was knee-high to a grapefruit, special effects came from a filter mounted on the front of the lens. In movie terms, camera filters were like pre-CGI special effects. Back then, they were as prominent as sunglasses and even made it acceptable to see the world through rose-colored glasses.

Filters that made your pictures look surreal were in vogue toward the end of the conventional photography era. They added everything from color casts and increased saturation to spectral stars and rainbows. The advent of digital photography brought about a decline in usage image correction and made effects easy to apply post-production using Adobe Photoshop. It was perfect for still images but not when making movies.

Basic movie-editing software allows you to make a pretty decent movie but hardly provides enough image control in post-production. Yeah, they'll be some cool effects, but most are limited, and some take forever to render. Slapping a filter over the lens for a desired effect, however, becomes an instant fix or enhancement.

Camera filters come in a variety shapes and sizes, so here's a crash course on how they work and what they can do for you:

- **Neutral density (ND):** Behold the sunglasses of the lens world. These colorless filters reduce the intensity of light. Why? Because sometimes the scene is too bright to capture. Other times, ND filters control depth of field by limiting light, forcing you to use a wider aperture making it the best way to control depth of field in bright conditions. It connects to the front of your lens and gets darker or lighter as you spin it, essentially acting like a stepless iris and allowing you to keep your iris set at whatever you want. These filters come in several strengths and can reduce exposure up to 13 f-stops.

- **Polarizer:** Another filter, another sunglasses analogy. This one makes aspects of bright light less distracting, and it's adjustable too. By rotating the outer ring on the filter, you can reduce glare from non-metallic objects, like a store window in sunlight. You can also use it to enhance color saturation, such as deepening the hue of a blue sky.

- **Graduate:** Without the luxury of "burning in" a bright sky (like you would in the photo printing process to compensate brighter areas of the image) filmmakers resorted to a graduate filter to balance wild variations in exposure. For example, if you're shooting on an overcast day, the difference between the subject and background may be so different that either the subject will render in shadow, or the background will be bright and white. One solution is to use the graduate filter, which is darker at the top and clear at the bottom. These come in both neutral density and colored versions. For example, you can convert a bright sky to a bluish tone that gradually fades down and does not affect subject color (see Figure 6-9).

- **Contrast enhancement:** For years, black-and-white photographers relied on colored filters to enhance or de-emphasize tones in the scene based on complimentary or like colors. For example, a red 25 filter would filter out the blue light of an afternoon sky, making it darker and more ominous. Conversely, a blue filter would lighten the sky. These filters make a great option if you're planning to produce a stylized black-and-white movie.

- **Diffusion:** Diffusion filters are the number one filter for capturing older actors onscreen. By softening the harshness of facial features, this filter is the best friend to anyone who no longer has that baby face. It also provides a dreamy effect. Diffusion filters come in various grades and can also be made using a variety of materials: everything from crumpled cellophane to a smear of Vaseline on a protective lens filter.

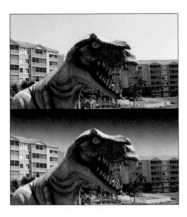

Figure 6-9: Before and after using a graduated filter.

Mounting filters: The choice is yours

Not all filters are created equal. Some are round, threaded, and specific to the lens, whereas others are made of a flexible piece of gelatin that you tape on. Yet other creative filter systems use square plates that slide into a holder. See Figure 6-10.

Here's the breakdown:

- ✔ **Threaded filters:** These screw into the front of the lens and are the most common. Usually made of optical glass, each a specific thread size measured in millimeters (that is, 52 mm, 67 mm, and so on) that coincides with the thread size on the front of the lens. If you have a wide assortment of lenses, with different thread sizes, this often presents a problem. On the positive front, optional step-rings can adapt minor size variations in either direction.

- ✔ **Square filters:** Used on any size lens, square filters rely on a three-part system for mounting on your lens. The coupler that screws into the lens thread comes in specific sizes, but you'll only need one filter holder. Slide one or more filters in the holder for effect. One caveat: Wide-angle lenses may present a problem with vignetting, especially when using wide aperture settings. This problem occurs when the lens records the edges of a frame as shadows.

- ✔ **Kodak Wratten filters:** The most popular professional series filter most commonly comes as a 3×3-inch cut of gelatin. Users place filters in a metal frame placed in front of the lens either in a holder or taped on. They're expensive (some costing close to $100), but these filters work on all cameras.

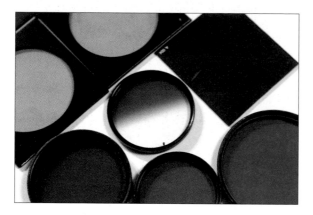

Figure 6-10: Various filter systems.

Shooting day for night

Did you even wonder how Harry Potter looks so clear in the series' numerous night scenes, while *your* nocturnal sequences are reminiscent of *The Blair Witch Project?*

That's because the boy wizard is not shot at night or even in the dark. Instead, the movie wizards behind the scenes use a technique called *day for night.* Not only does it provide a clear advantage to shooting in darkness, but it also ensures that the scene is less grainy, the tones are more balanced, and the focus more precise.

After setting the scene under well-lit conditions, as seen in Figure 6-11, it's then filtered and underexposed to lend that nighttime feel shown in Figure 6-12.

To keep off the moors and stick to the road, make sure you take the following steps:

1. **Determine your location.**

 Try to pick a place with even illumination and make sure to compose the shot in such a way that nothing gives away the fact that it's not nighttime (streetlamps, bright sky, clocks).

2. **Read the scene.**

 Using your DSLR in the full-manual mode, adjust focus and determine exposure. And make sure it's on a tripod, please.

3. **Make it blue.**

 Hollywood cinematographers have several tricks for this technique. The most common involves placing a blue gel (filter) over the lens. For your movie, you can use a blue filter too. But if you don't have one, don't worry. Just change your camera's White Balance setting to Tungsten. In the menu, look for White Balance and convert to Tungsten, or lower if you're already inside. If you're not sure, refer to your owner's manual.

4. **Tweak the scene.**

 There's one more key step. Go back into your exposure settings and underexpose the scene by one to three f-stops. (If you're not sure how, refer to Chapter 5.) You'll be able to see how far to go by looking at your DSLR's live view monitor.

5. **Shoot your scene.**

 After you're happy with the composition, color balance, and exposure, it's time to press the Record button. When reviewing the footage, if you feel the exposure is still too bright, you can make an adjustment in Premiere Elements by going to Edit⇨Adjust⇨Brightness and Contrast and fine-tuning exposure to your liking.

Figure 6-11: An overcast day makes a perfect environment to transform into a night scene.

Figure 6-12: Making the necessary adjustments gives a night look without fumbling in the dark the old-fashioned way.

Tooling with Camera Effects

It's safe to say that as a movie-watching culture, we've gotten so spoiled by special effects that there's hardly anything special about them anymore. That's about to change for you because instead of watching special effects, you'll be making them. Two simple special effects motifs that beginning videographers can try are green screen and time-lapse shots.

Keen on green screen

Whether it's being used for making E.T. fly across the moon, too many scenes to mention from *The Matrix* trilogy, or the weather report on the nightly news, chroma key is one of the most dynamic tools of visual production.

Also known as *green screen, chroma key* is a process that combines two separate video sources into one. It often places the subject in the middle of the action to make him appear as though he's flying, in the midst of battle, or showing a cold front coming in from the west.

And while it appears as the subject stands in conflict with destiny, the reality is he's standing in front of a green or blue screen blindly going through the motions.

Once a feature limited to high-end production houses, producing a chroma key segment is now not only affordable, but also simplified for the masses (make that *slightly* simplified).

You'll often hear the term *green screen* bandied about, but the truth is that a blue one works too. The main difference between the two depends on what colors you're looking to key. On a practical level, green works best because the nearly phosphorescent is not usually a color staple in most people's wardrobe. That makes "clashing" less likely than if you go with blue.

Shooting your very own chroma key

When you experiment with chroma key, expect it to be just that, an experiment. Even under professional conditions, it often requires some tweaking to get it right. The following steps should set you on the right path to green screen heaven. (Okay, blue too.)

1. **Plan your shot. Consider what the subject is doing and how she interacts with the background as seen in Figure 6-13.**

 At this point, you should also have your background movie or image. If not, get shooting because you can't compose and light the scene without knowing the background image.

2. **Set up the background screen (it could be paper, canvas, or even a green blanket) and evenly illuminate it.**

 The idea here is to pretend that you're depicting the background as is, as opposed to attempting to creatively illuminate it with a graduated falloff. (That's when the background lighting goes from dark to light, or vice versa.) Notice the even illumination in Figure 6-14. If you're not sure about lighting, skip ahead to Chapter 9 and read up on it.

3. **Use subject lighting in a way that's consistent with the background.**

 Be sure the intensity and direction of the light compliments the background so the key looks realistic. For example, if you choose a twilight background, make sure the subject's lighting is soft and warm.

4. **Make sure the camera angle of the subject matches the background scene.**

 For example, if the chroma background depicts a downward angle on a snowy mountaintop, be sure the subject is at a complimentary camera angle.

5. **Ingest your footage into the computer.**

 Each editing program handles chroma key a little differently, so check instructions before merging your footage. Premiere Elements is fairly simple to use.

6. **After creating a new project, drag the foreground footage, your chroma key subject, into Track 2 of the timeline.**

Both are side-by-side as seen in Figure 6-15.

7. **Drag the background image below the subject layer on the timeline.**

 Make sure that this content is slightly longer in duration to provide flexibility with positioning the subject.

8. **Go to Edit➪Effects➪Green (or Blue) Screen.**

 Voila! You have simple chroma key movie sequence, as seen in Figure 6-16.

Figure 6-13: The subject in front of the green screen.

Figure 6-14: The footage used for background in the green-screen effect.

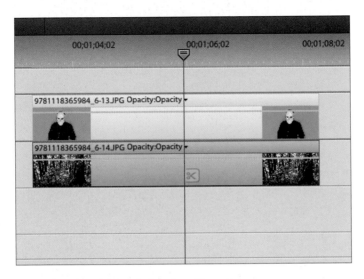

Figure 6-15: Both images in Premiere Elements.

Figure 6-16: The chroma key image in Premiere Elements.

Using Time-Lapse Photography

Sometimes the world moves too fast, and sometimes we can make it move even faster. Time-lapse photography allows us to control the universe within our movie by capturing a situation in a fraction of the frames, and then playing it back at normal speed making it appear as though life is zipping by.

Inexpensive solutions for chroma key

Don't worry about spending a lot of money for chroma key equipment. Here are few shortcuts:

- Use a fluorescent light for illuminating the background. Not only is it an affordable and effective light system, but the slightly different color balance of warm white or mid-range tubes offset the tungsten light used on the subject and reduce any crossover effect.

- Improvise a green or blue screen. You can substitute a green blanket, or blue, to produce the same effect.

- Use gaffer's tape, tacks, or inexpensive spring clamps to hold and pull the background taut.

Instead of 29.97 frames per second, you may capture one frame per second, or per hour. At this point, the process is closer to still photography than moviemaking, and what better camera to accomplish this task than a DSLR? Basically, you'll capture the scene as a series of individual frames that, when put together and played back at that 29.97fps rate, renders the world as though it's on a couple of gallons of high-octane java.

Most DSLRs require an optional digital timer remote shown in Figure 6-17 for automated operation. Also known as an *intervalometer,* this accessory allows you to take photos automatically at scheduled intervals. It's relatively inexpensive and easy to use. You can buy either the manufacturer's own device or from a third-party vendor. Because many of the newer DSLR models use either a 3-pin, micro plug, or USB, be sure to get the model with the proper connector for your camera. Figure 6-18 shows a segment shot for a music video at one frame per second.

Figure 6-17: An inexpensive digital timer you can find on the Internet for about $20.

Figure 6-18: A few successive images
shot at one frame per second.

Making a time-lapse movie

The operative word here is *time*. A blooming flower, traffic moving on a busy intersection, or people filling a stadium all takes a healthy investment in time to uniquely depict. But that's the price you pay when you transform minutes, hours, or days into a matter of seconds. To make it time well spent, you'll need adequate preparation and the right equipment.

What you'll need:

- Any DSLR camera (HD video capability is not required)
- Digital timer
- Sturdy tripod
- Fresh batteries
- A good book to pass the time

Follow these steps when making your time-lapse movie:

1. **Determine your subject matter.**

 You'll need to figure what you want to capture and how long it will take to show the proper activity. For example, a flower blooming can take several weeks, whereas people embarking or disembarking public transportation may last for only a few minutes.

2. **Place your camera on the tripod and lock down the legs.**

 There's nothing worse than having movement during capture because you didn't tighten the legs or head on your tripod.

3. **Set your camera to a narrow aperture for maximum depth of field.**

 With a camera on a tripod and hours of recording ahead of you, you may as well use an exposure setting conducive to capturing maximum depth of field.

4. **Perform a white balance.**

 You don't want to invest all that time and wind up with an unflattering colorcast. It's best to take a manual reading by holding a piece of white paper a short distance away from the lens.

5. **Shoot in manual mode.**

 If you worry light values will shift too much, try the aperture priority setting. These work because we're not using the movie mode. It maintains a consistent aperture by adjusting shutter speed when light values change. It's not perfect, but it's the lesser of the other evils.

6. **Calculate the time.**

 After you figure how long it will take to capture the scene, determine the length of the movie. As a general rule, when time-lapse movies extend past 30 seconds, they lose their zest. After you've determined how long scene capture will take, calculate the duration between each frame. For example, if you want to show a stadium filling up before the big game, and make a 20-second film, you would need 600 frames. If you shoot one frame per second, it will take ten minutes of shooting to make your movie.

7. **Set your digital timer (also known as your intervalometer).**

 If you're not sure on what to set it on, one frame per second renders the action 30 times faster than normal.

8. **Wait for the right moment.**

 No sense in shooting aspects of the scene not critical to the movie. Conversely, don't start shooting after the action starts.

9. **Capture the scene as JPEG.**

 You don't need to shoot at maximum quality; just make sure the files are 1920×1280, and you'll be able to save the movie in high definition.

10. **Push the button.**

 Stay nearby or at least make sure your camera is safe. After you import the files, study what you've done and make the necessary adjustments next time out.

Calculating your time

Either you can randomly select the duration between each frame, or you can determine it ahead of time, no pun intended, using a formula.

Say you're trying to create a 30-second time-lapse movie of cars filling the parking lot before the big game. You're already planning to capture the three hours it takes to fill up, but you're just not sure about the duration. If you use the "guesstimate" rate of one frame-per second, that would make your sequence around six minutes long. And that's about 5 minutes past my bedtime.

Instead of guessing, try the following formula to let you know exactly how many frames you'll need:

1. **Determine the desired length of the sequence and use this formula:**

   ```
   (Desired duration in seconds) × (Frames per second for
          playback) = Amount of frames for playback
   ```

 A 30-second sequence that plays back at 30 frames per second would require 900 frames (30 × 30 = 900).

Watch your image sequencing

If you plan to capture a scene that requires both a lot of time and image frames, it's a good idea to reset the image sequencing on your camera. It's that number assigned to each photo (that is, IMG_2345). Because it turns over on most cameras after 9999, you should reset it using your camera controls. You can also use a Digital Asset Management program like Extensis Portfolio, which sequences images based on capture time.

The camera progressively assigns a number to each image, and if your camera has been used frequently and captured lots of images, it's conceivable that it can "turn over" like a car odometer and start over. That would place the latter images shot with the newly reset number ahead of the first ones captured, making it evident when you play back the sequence in order.

2. **Next translate the total time into seconds with this formula:**

   ```
   (hours) × (60) × (60) = seconds
   ```

 A three-hour interval would use the following:

   ```
   (3 hours) × (60 minutes) × (60 seconds) = 10,800 seconds.
   ```

3. **Divide the time in seconds in Step 2 by the amount of required frames as calculated in Step 1 to come up with your frame duration.**

   ```
   (10,800) / (900) = 12 seconds.
   ```

 To make a 30-second movie, set the digital timer at one frame every 12 seconds and find something to do for the next three hours.

7

Breaking Dawn Over Light Sources

In This Chapter

▶ Breaking down light sources

▶ Understanding incandescent lighting

▶ Working with artificial light

▶ Overcoming problems with illumination

Clouds need moisture, mosquitoes need blood, and your movie needs light. Shooting a scene without light is called radio, so unless you want your audience to feel like they're wearing blinders, make sure you effectively light it.

But there's quite a difference between having enough light for the scene and effectively illuminating what you choose to capture. One makes your movie look bland and boring, whereas the other speaks visually to the viewer. Yet, before you can successfully control lighting, you first need to understand it. I help you to do that in this chapter.

Understanding Why Lighting Is Critical

"Let there be light."

It's hard to imagine an older phrase — or, when it comes to making movies — one that's more profound. But light by itself won't translate a series of shots into a successful scene, just as a plate of raw meat doesn't satisfy your hunger. Need proof? Then chew on this: A bare, overhead bulb

provides enough light for your room, but wouldn't a lamp (or two) create a cozier feel for the space?

But all too often, filmmakers fail to use lighting effectively, or simply consider it as an afterthought, especially after getting caught up in the technology. Non-linear editing programs deceive some users into believing that most problems are fixable in postproduction, but it's always better to take a little time before shooting to correct or adjust the issue.

Light is the key ingredient for filmmakers (and photographers) to express their intentions on their canvas. Think of it as the virtual paint you brush over the scene. Quality is much more important than quantity when it comes to effective illumination.

Did you ever wonder why Hollywood movies and television shows begin shooting at dawn? It's because early morning light provides an intoxicating mystique to the scene.

For example, that subject shot in the middle of the day who looked average suddenly comes to life when bathed by the soft, warm illumination of early morning or the late afternoon. Even when the light is close to perfect, professional filmmakers strive for absolute perfection by fine-tuning it with reflectors, fill lights, and diffusion.

I don't deny that it's hard for a single filmmaker to compete with an entire movie crew — even if you brought along a few buddies to help. But you can still do a pretty decent job, providing that you understand the nature of light.

If you don't feel like waiting for the sun to do right by you, you can actively control the light by bringing your own. Location and studio lighting allow you to actively control position and intensity. But it's not always practical, leaving you at the mercy of ambient light. While natural light presents some challenges, it's still predictable, but all bets are off at the end of the day when the sun retires for the evening.

Artificial illumination takes over on the night shift. With dozens of lighting types, it can be hard to master, especially if you're not sure what you're up against. Colorcasts dominate the landscape. Sometimes you'll be able to take advantage of them, whereas other times, artificial lighting will have you in a chokehold as you scream "uncle" to no avail. That's because many artificial light forms do not produce a full spectrum of color. You're often stuck with its yellow or green cast because there are no other colors if you remove them.

Understanding the intricacies of each form of light will help you master it. Everything begins with the most basic form of light of all: the sun.

Taking Advantage of Natural Light

Mirror, mirror on the wall, what is the greatest light source of all?

"That would be me," the sun would say. Nobody argues this point because sunlight is bright, diverse, and complimentary. Not only does it flatter the subject with illumination, but it's also free. No electric bill or any maintenance required. But that doesn't mean there isn't a slight price to pay.

Because it's a passive light form, you have no control over it. You have to accept its direction, the shadows it creates, and its quality. That's a fair price to pay when you consider what you get in return.

One day, the light renders warmly against a rich blue sky, and the next day it's completely different. Maybe it's slightly cooler, or that the background sky is paler than the day before. The same goes for cloud cover. That's because the sun is always in the sky, but that stuff in between (also known as clouds and haze) can affect what it does on a predictable basis.

Consider the following:

- **Try to use sunlight from a lower angle.** This creates the most flattering illumination, and it's generally warmer too, as seen in Figure 7-1.

- **Avoid overhead light.** When the sun is beating straight down on the subject, it's not flattering and creates harsh shadows.

- **Take advantage of an overcast day.** Direct sunlight is sometimes harsh on the subject because it creates shadow and texture. Enter the clouds: By acting as giant diffusers, they present the subject in a more flattering illumination. (Just watch out for white patches of sky.)

Figure 7-1: Ironically, this sunny face on an outside display for a gift shop was illuminated by a warm swath of late afternoon sun.

Looking at Passive Versus Proactive Lighting

Passive control over the light source — meaning that you can't change it, only adjust to it — provides one of the biggest challenges to making your movie. Obviously, the sun falls in this category because you can't power it down or move it around, unless of course you're Zeus. Because you most likely aren't Zeus, you're at the sun's mercy. But through observation, you can at least predict its behavior and make adjustments to it.

The same applies to street lighting, and while I'm at it, home illumination, too. The opposite of passive lighting is known as proactive, and this includes studio lighting or any type that you bring to the scene and can turn on and off.

A proactive light source not only allows you to control lighting, but also build it exactly the way you want. Whether it's a single light setup or an entire bank, you can create the perfect scenario for your subject.

Seeing Why Not All Light Is Created Equal

Human vision adjusts to light with a "business as usual" demeanor. Our eyes adjust to colorcasts, light ratio, and dim illumination. Even our visual memory kicks in to construct the scene in our mind. The camera has no such luxury. Instead, it relies on science and physics to recreate what's in front of it based on camera settings. In other words, it's as relentless as a robot bean counter from the animated series *The Jetsons*.

Of course, you can set the camera on automatic and let it adjust to each circumstance, but there's no guarantee that successive scenes are going to match. That means you're better off adjusting the camera manually. That's not necessarily a bad thing because the key to dealing with light (and making movies) is to understand it.

Color temperature

Since the early days of color photography, colorcasts of some images have sometimes looked "off." Maybe a cityscape takes on a green colorcast, resplendent of suburban Mars, or a yellow street scene comes to resemble a view through shooting goggles.

"What happened?" you'd wonder. Of course, you usually only noticed the problem after you took the picture — way after. Remember, back in the days of yore, or about ten years ago, serious photography was captured on transparency film and sent to the lab for processing. You usually didn't notice

problems until the prints came back from the lab (a day later if you were lucky, but up to a week in many cases). Digital photography made capturing the subject more predictable but didn't necessarily eradicate the problem.

That's because there's a disparity between the color temperature of the scene and the white balance setting. If you shot on film, you often got variations in the daylight-balance the film was engineered to capture.

With video, the onus falls on the white balance setting. So if the difference between the color temperature of the scene and the white balance setting differs, you have a colorcast.

This color of light, or more appropriately, its *color temperature,* is defined by a unit of measurement called the Kelvin scale. It's named after a guy who liked holding pieces of metal over an open flame to see what color they turned at various heat settings. Apparently he was on to something, creating the measure (no pun intended) for color temperature.

This thermodynamic scale measures the amount of heat reflected by different light sources under controlled conditions. Although the Kelvin scale is a measurement of temperature, a K, as opposed to a degree symbol, follows the numbers. Color temperature ranges from a candle at 1,800K to an overcast sky at 11,000K, as shown in Table 7-1. Figure 7-2 shows a warmly illuminated theater interior. It has a Kelvin color temperature in the high 2,000s,

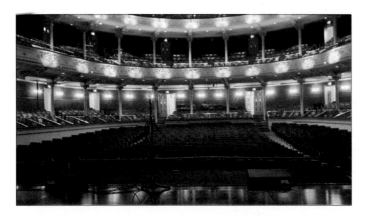

Figure 7-2: The view from the stage of the Philadelphia Academy of Music shows the warm glow of tungsten illumination.

Table 7-1	Color Temperature Chart
Light Conditions	*Measured in Kelvin*
Candlelight	1,800K
Sunrise/sunset	2,200–2,800K
Household bulb	2,800K
Tungsten	3,200K
Daylight	5,500K
Overcast skies	6,000–8,000K
Shady area	7,000K
Cloudy conditions	8,000–10,000K

When the Kelvin number is lower, the image renders warmer, or more orange. And when it's higher, the scene is cooler, or bluer.

The daylight spectrum

Shooting outdoors covers a wide range of color temperatures, or more appropriately, white balance settings. As the most common light source for your movie, daylight deserves some close enquiry.

The quality of light changes continuously throughout the day. That means that both the intensity and color of the light change. Although understanding why daylight renders a certain way at a specific time is important, taking frequent white balance readings is even more vital.

Hypothetically, if you begin shooting at the crack of dawn to capture the scenes that benefit from the soft quality of warm morning light, the fact that you didn't change your white balance setting isn't going to matter. Sure, the scene renders warmer than normal, but it should still be flattering.

After bathing the subject in early morning light, you can move to the next scene. Now say it remained sunny in the morning: The color balance of footage renders on the warm side but still looks normal. But then clouds roll in, making it overcast in the afternoon. Figure 7-3 shows an example of taking advantage of cloud cover. Without changing the white balance, you can render the scene with a cooler tone. It's especially evident in the shadow areas.

Later in the day, say the sun breaks through the clouds. The color balance of the footage takes on an exaggerated look again (as it did in the early morning), reproducing with a warmer than normal appearance, contrasting the overcast footage that has a dominant blue tone.

Daylight has a wide spectrum, making it critical to continually adjust white balance.

Figure 7-3: This artwork actually benefited from the cloud cover in the sky.

From dawn to dusk

The earliest bits of light at daybreak reproduce with a much warmer color balance than light during the middle of the day. The quality of early morning light becomes less intense as the sun rises higher in the sky. Light temperature increases as the day goes on. If there's a clear sky, it stays within the daylight range (2,200K–5,500K). If it's overcast, it can go much higher. After the sun reaches its highest point in the sky, the color temperature starts to rise, and the light gets warmer as dusk approaches. Figure 7-4 takes advantage of window light.

Figure 7-4: Charlie the cat lying on a bed illuminated with diffused afternoon light.

Understanding Incandescent Light Sources

Sunlight is the ultimate form of light for making movies. It's also the ultimate *incandescent* light source, or source that produces light by heat. Although its actual color temperature varies widely depending on its position and atmospheric conditions, it still produces a full spectrum of color. That means you can adjust the color balance of the scene to eliminate a colorcast. Later in the chapter, you find out that's not always possible with other types of light.

While sunlight is the big kahuna, it's not the only light produced by heat. Here are a few more to consider. Ever touch a light bulb or light a match? Oh, yeah.

Candlelight

While candlepower worked for the Flintstones, it's merely a metaphor here for the basic form of incandescent light, and by default, the warmest type. In fact, all light sources are rated in footcandles. On the Kelvin scale, it's sub-2,000K. The good part about it is that warm light never seems to get old, instilling a warm and cozy feeling in our hearts and ultimately the viewer.

If for some reason you choose to go *Flintstones* on your movie with a candle-light scene, take this into consideration:

- **Be careful.** It is fire and it can burn.
- **Use the light as the subject.** For a table scene, measure the exposure from the candle and don't worry too much if the subject is a bit underexposed.
- **Find strength in numbers.** A single candle isn't usually enough, but a group of them becomes a force to reckon with. Use a candelabra or multiple candleholders for soft, warm illumination, as seen in Figure 7-5.

Figure 7-5: One candle doesn't . . . well, hold a candle to six for nice soft illumination.

Tungsten illumination

Tungsten lighting produces light by heating the metal tungsten filament inside the bulb until it glows. In a sense, each bulb operates as a miniature sun. This form of illumination covers a wide swath of incandescent lighting types that produce a light temperature ranging from a household bulb at 2,800K to standard location lighting at 3,200K.

Household bulbs

Just about every room in your house or apartment has a bulb, making it possible lighting for your movie. These bulbs' effectiveness, however, depend on several factors, including wattage, placement, and positioning. Brightness ranges from the 25-watt bulb in your refrigerator, to the 75-watt bulb in your lamp, on up to a 100-watt recessed light. Outdoor spot and flood lighting can even give you 150 watts.

Household bulbs can provide a fair amount of light, but they're not always positioned for a flattering effect. Of course, with some strategic maneuvering, they can work well to illuminate some of your interior scenes, as seen in Figure 7-6.

Here's what you do to take advantage of it:

- **Take a white balance.** Household bulbs produce a color temperature of 2,800K, making them slightly warmer in appearance than tungsten.

- **Remember that its light falls quickly.** Although you can get great illumination from room lighting, keep in mind that it's relatively low in intensity and exposure changes when the subject takes even one step away from the light source.

- **Watch out for hot spots.** Although household lighting isn't incredibly bright, it's still relatively bright. If you include the light source in the scene, be careful it doesn't reproduce a bright spot in the scene or flare into the lens.

Figure 7-6: Household bulbs provide soft, warm illumination.

Working with Location and Studio Lighting

Compared to household bulbs, which are relatively low in power, tungsten studio lamps are much brighter and provide a lot more control. Tungsten even has a color temperature named after it. That's 3200K for tungsten, and it ranges in intensity from 250 to 1,000 watts or more. Many tungsten light heads have variable power (a dimmer) to adjust to the right amount for each scene.

Tungsten lighting comes in many forms, including those giant lights that we've become accustomed as iconic on a movie set. Some are ten feet or more in size and are wheeled around from scene to scene. Besides these monolithic models used for feature films, they come in various sizes, including models that fit in your bag. Many of these lights use a uniquely engineered glass lens called a Fresnel. Developed centuries ago to extend the range of a lighthouse lamp, they allow you to maximize the light's potential.

On the low-end side of the spectrum (pun intended), the most basic lamps resemble giant household bulbs. Some manufactures offer a very large light bulb that fits in a standard socket. Generally, these work in conjunction with inexpensive reflectors. More professional quality lights use a halogen bulb that plugs in to the socket.

Location studio light choices produce a full spectrum of color like the sun, but instead of being passive (giving you no control over it), they are pro-active. You can move the lights and mount them to a stand, rack, or frame to use as a main source of light, fill, background, accent, and hair light. Figure 7-7 shows a Lowell light head on a stand.

If the light is too harsh, consider one or more of the following:

- **Move the light away from the subject.** Sometimes problems with intensity occur because the light is too close to the action.

- **Reduce overall brightness.** Use a *scrim* (a grid that goes over the light source), neutral density gel filter, or lower-wattage lamp.

- **Fine-tune the light.** To control how much of the light illuminates the subject, control it by using *barn doors,* which are frames that allow you narrow the light beam.

- **Soften the light.** Turn the light around and bounce it into a reflective umbrella. You can also use a soft box to get close to the subject without being harsh. On the budget-conscious side, diffusion material over the light source works pretty well to soften the light. You can purchase diffusion material in a photo supply store, or use just about any sheer material. And finally, you can simply turn the light head around and bounce it off the wall or ceiling.

- **Have a few colored gels available.** These colored pieces of acetate work well for spicing the background, but more importantly, you can use a blue filter to compensate for variables in color temperature when lights are dimmed.

Figure 7-7: Tungsten studio lighting makes for warm, flattering illumination.

Dealing with Artificial Illumination on the Scene

The Great Barrier Reef is one of nature's most majestic wonders, but beneath its surface, it's a watery killing field where only the fittest survive. Well, that's tame compared to trying to shoot your movie after the sun goes down. That's because artificial illumination plays by its own set of rules, which wouldn't be so bad, except there's so many different types, each with its own behavior.

Gone is the predictability of sunlight. Also gone is pro-active control of studio illumination. What's not gone is your anxiety when it comes to figuring how to make the light work to your advantage.

Unlike sunlight or your own lighting, street lamps are passive, and most can't produce a full spectrum of color. In other words, forget about completely removing that colorcast like you can with incandescent light.

Here are some bugaboos of artificial illumination:

- **Annoying colorcast:** Not all light sources can produce a full spectrum of color. Depending on the lighting, the scene may render with a yellow-ish cast or cyan tint so that even a meticulous white balance will void the scene of color. Figure 7-8 illustrates the possible result when you attempt to remove the cast.

- **Harsh shadows:** Sometimes they're on the face; other times, they create too much contrast on the scene. When you adjust for them, the high-lights get blown out. Fix the highlights, and the middle tones become shadowy and the shadows just black.

- **Unpredictable results:** Sometimes you don't notice the effect of color or contrast in the Live View window until it's too late. Get used to judging color and exposure in both the viewer and timeline.

Figure 7-8: A sculpture illuminated by sodium vapor streetlamps. The cast is dominant (right), and a color correction leaves it nearly monochromatic (left).

Night light, dark and bright

Artificial sweeteners, coloring, and flavors are examples of synthetic alterna-tives in our food supply. Their intent to replace natural ingredients with fake ones aims to reduce calories or imitate flavors, but in doing so, they some-times cause side effects. Just read the package, and you'll see the disclaimer. Well, artificial light isn't much different.

When the sun hits the sack for the night, artificial lights come on duty for our benefit, you know, to prevent us from walking into walls or tripping over the curb. That's helpful to avoid stubbing a toe, but it doesn't do much for capturing a scene without a dominant colorcast.

On the bright side (pun intended), they provide intensity at a low cost. But on the other side of the street (pun intended again), they also have side effects. Earlier in the chapter, I discuss tungsten illumination, which, although artificial, is not that different from natural light in that it produces light as a by-product of heat and still creates a full spectrum of color.

But tungsten is not very efficient, nor does it last that long before burning out, so it's not a great long-term solution for illuminating wide-open spaces like Main street or a large parking lot. Forget about lighting a small stadium: The amount needed to do the job would generate too much heat. These situations require a brighter, longer lasting, more efficient form of light known as a *high intensity discharge lamp* (HID). See the section "Working with High-Intensity Discharge Lamps" later in this chapter for more on these.

On a less epic level, fluorescent lights are another efficient light source. These long-tubed lights range from monochromatic to full-spectrum color and just about every variation between. Some are even used in studio lighting. There are so many different kinds. Next time you look at an office building, observe the varying colorcast from window to window. You'll notice variations in color.

Shadows and highlights

The challenges associated with shooting a scene with a single light source (such as the sun) include harsh illumination, deep shadows, and lens flare. You can work around these problems by either waiting for the sun to change position or by simply changing the angle from which you're shooting the scene. But imagine if you had more than one light to contend with. Well, that's what you have with many night situations. With each light source doing its own thing, it can frustrate even the most patient of moviemakers.

Here are a few tips to take the edge off your nerves:

- **Limit your camera work.** Tightly compose the shot to avoid light flaring into the lens and to reduce harsh shadows.

- **Use on-camera light.** Although this small, harsh narrow circle of light is not usually flattering, sometimes it's necessary to open a part of the scene or highlight a person in the scene.

- **Shoot day for night.** See Chapter 6 for more on shooting your movie earlier in the day and then altering color and exposure to make it look like it was shot at night.

Working with High-Intensity Discharge Lamps

Artificial light requires power to function, and when used for massive spaces, the need to make it both cost- and energy-efficient becomes important. That's why high-intensity discharge (HID) lamps were created. Instead of using heat to create light, they have a glass envelope (the glass tube part) where gasses are excited and produce light. But that light is created solely by this illumination and provides little or no benefit to your movie if you don't understand how they work.

HIDs come in three basic varieties, each with its own behavior.

Sodium vapor

Used primarily for streetlights, they emit a yellowish cast. You notice it when you study the street at night. They produce a colorcast that isn't correctable because they don't conform to a full spectrum of color. Instead, they correspond to a single wavelength. If you were to correct it either by taking a white balance, using a blue filter, or taking out the yellow in postproduction, all that would remain is a monochromatic rendering of the subject. That's because it only produces a single color of light.

Here's how to make sodium vapor lighting work for you:

- **Remember that white balance doesn't always work.** If you slightly reduce the yellow in the scene, you're still left with an overwhelming colorcast, but it can pass for a street scene, especially when you have supplemental light coming from store lighting, neon signs, and the red taillights of passing cars.

- **Shoot at twilight.** This time of day still has ambient light and a purplish sky that looks great when you position your subject against it, seen in Figure 7-9.

Figure 7-9: Illumination for the Seattle monorail system uses sodium vapor lighting. Although the scene has a yellow colorcast, the twilit sky adds complimentary color.

Mercury vapor

These monochromatic lamps (producing a single color) are less efficient than sodium vapor and far more problematic. These make light by exciting mercury in their glass envelopes, and they're used for street lamps, parking lots, and other spaces where simple illumination is all that's required. On average, they have a color temperature around 4,200K but only produce a cyan-greenish illumination.

Try these tips to capture movies under this illumination:

- ✔ **Don't depend on manual white balance.** Because the light doesn't produce a full spectrum of color, the end result can produce a red-tinted or colorless appearance. Instead, try setting to tungsten and let it go warmer.

- ✔ **Use a UV filter.** It can help counteract some of the dominance with colorcast. The colorcast won't disappear, but you'll be able to take the edge off.

- ✔ **Remember that it's not flattering to humans.** At least, not in the conventional sense due to its cyan greenish colorcast. On the other hand, if you're looking to depict something alien or evocative, it's not a bad choice.

Metal halide lighting

With a mixture of mercury and metal halides excited in their tubes, these highly efficient, color-corrected lamps are designed to produce a full spectrum of color. They're used for lots of situations, including stadium and arena lighting. Without them, you can't have night games on television. Here are some tips for getting the best out of metal halide lighting:

- ✔ **Shoot at a slower shutter speed.** With some lamps, capturing the scene with too high of a shutter speed may produce a colorcast. Using a 1/60 to 1/125 usually works fine.

- ✔ **Take a white balance.** Depending on the specific type of lamp, color temperature ranges from 3000K to 20000K. Color temperature may also vary, even with the same type of lamp.

Loving the Way That Neon Glows

Popular signs like "Eat at Joe's" and "Second Hand Rose" are glass sculptures with colored light running through their veins. Neon is not just the name of this unique type of lighting: It's also the chemical element. You may remember it as Ne on the periodic elements chart.

Neon is an inert gas. For our purposes, it looks pretty good in the shot thanks to its colorful glowing light, as seen in Figure 7-10. Neon conjures up imagery of film noir, with the likes of Sam Spade sitting at a roll top desk, taking a swig of some bottled libation.

Here are some aspects to consider:

- **Use a wide range of exposure.** Neon light is quite flexible when it comes to exposure. I've found that it has a several-stop range of acceptability, not for any special reason other than varying levels of exposure. Underexpose it, and you get rich, saturated color. Overexpose it to open up the ambient portions of the scene without losing much color from the lamp.

- **Take advantage of reflections.** Neon light is not overly bright; still, it reflects its rich colors on nearby surfaces. And when it rains, the effect is exponentially powerful.

- **Use it to establish a location.** Scenes that take place in a cocktail lounge, restaurant, hotel, or even bowling alley are nicely established with a neon sign.

Figure 7-10: I used this animated neon sign over a Seattle restaurant for a music video.

Coping with the Unpredictability of Fluorescents

Fluorescent lights, those long sticks of light, are perhaps the weirdest anomaly in the world of illumination. They're efficient, effective, and found everywhere. From basement illumination and garages to commercial interiors and

office buildings, fluorescent lights are as diverse as the places they're found (Figure 7-11).

Available in dozens of variations and color temperatures, it's hard to nail down the exact behavior of each without knowing the numeric color code. (That's how they're differentiated.) But one thing is for sure: They don't create light the same way as a household bulb. They don't get hot, and they're not very predictable.

They make light through a jolt of electric exciting mercury vapor in the tube. But think back to mercury vapor lamps for a second and remember the unflattering greenish color light they emit. So does that mean fluorescents don't work for movies? Not exactly.

Remember, there are numerous types producing all sorts of colorcasts, but a few were engineered to produce a full spectrum of color, and those are used for television lighting and movies too.

Here's what you need to know about fluorescent lighting:

- **Daylight-balanced tubes can be grouped together.** Although comparatively lower in output than an incandescent bulb, when bunched together, daylight-balanced tubes provide a mass of illumination, as seen in Figure 7-12. Sometimes four separate tubes can produce the same output, albeit by using a wider, more collective approach.

- **Mixed lighting is a plus.** Look at any office building and notice the variations in colorcast. Lighting your movie with tungsten and allowing the variations of fluorescent light in the background to produce a complimentary cast work to your advantage.

- **It's flattering.** Because fluorescent illumination comes from a wide bank of soft lamps, it produces a nice soft illumination. As a result, it hides minor blemishes, making it a favorite of many actors.

- **It causes no heat build-up.** There's a reason these are also known as "cool lights." Trust me, they're a welcome alternative, especially when using a multiple-light tungsten setup. The studio, or location area, gets unbearably hot. Fluorescent illumination doesn't create excess heat, and you can touch the bulbs.

- **It's not always predictable.** Fluorescent illumination can provide a color shift at times, as well as flicker if your shutter speed is too low.

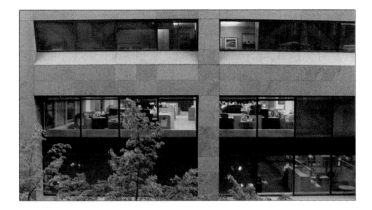

Figure 7-11: Notice the variations in color in this scene lit predominantly by fluorescent illumination.

Figure 7-12: A four-tube fluorescent lighting array.

Making the Scene Look Better

Although artificial light becomes problematic at times when you're shooting a movie, you can counteract its unflattering appearance and maybe use it to your advantage.

As I said in Chapter 6, natural light is most flattering early and late in the day, and then the sky disappears. Artificial light takes over when the sun goes down, leaving much blue ambient light on the scene. Street lighting provides a single color balance, sometimes yellow. Hmmm.

Then comes twilight, the narrow span of time between sundown and dusk where although the sun is sinking below the horizon, it still emanates some light for a little while. Although its duration is short, it's the "sweet spot" of the night thanks to its rich blue or purple background.

When the subject illuminated by artificial light is positioned against the twilight sky, it provides an incredible juxtaposition of the warmly lit subject and its cool, saturated background, as seen in Figure 7-13.

Figure 7-13: This street scene was captured at twilight. The twilight sky makes the scene dynamic by showing color from different light sources.

But that only lasts for around 20 minutes, so you have to act fast.

Here are some more tips about how to make lighting work for you:

- ✔ **Plan for that moment in time.** Wait for the right light, or lack thereof, but be ready to go. You have a short window and must take advantage of it.

- ✔ **Take advantage of the light.** Dominant colorcasts have their places; it's just a matter of understanding when they work for you. For example, the normally unflattering cast of mercury vapor can emulate an otherworldly experience, just as a street scene lit with sodium vapor can lend warmth to a subject.

- ✔ **Create a symphony of monochromatic light.** It's also possible to take advantage of artificial light after the sky goes black. Although each type of light form produces a dominant color of illumination, when you combine them, they show a scene with various colors. Put it against a twilight sky, and you have something unique and possibly beautiful, as seen in Figure 7-14.

Figure 7-14: Always look for color. This high-angle shot of Providence uses various light sources without the aid of a twilight sky.

8

BYOL: Bringing Your Own Light

In This Chapter

▶ Mastering basic lighting techniques

▶ Getting creative with light

▶ Taking advantage of non-traditional light sources

▶ Using accessories to manage illumination

*F*rom torches used at the dawn of civilization and gas lanterns of more than a century ago to filament-based bulbs of the 20th century and the changing colors of an LED light panel, the most basic function of light is to keep us from walking into things. But somewhere along the line, photographers and filmmakers realized that they could use light more creatively, much in the way a painter uses paint to set the mood and atmosphere.

But having the right light at sundown or buying a sophisticated light kit doesn't guarantee success any more than buying a carton of milk guarantees it will automatically turn into a fine cheese. You have to not only have the right materials but know how to use them too. I don't profess cheese-making as a specialty, but as for lighting a scene — well, that's another story.

When lighting is done correctly, the audience hardly notices any individual effect. Instead, they absorb the movie as a whole, with lighting, action, and sound quality working together to sustain their attention.

But that's not to say the lighting shouldn't grab them, either. Consider the tinges of blue light that make Tim Burton's films so identifiable. Notice the theatrical approach that director Elia Kazan takes in that iconic cab scene in *On the Waterfront,* where Marlon Brando mutters the classic line, "I coulda been a contender." These examples, and many others, prove lighting is far more deliberate.

So whether you're a Zen lighting master, have a thumb glowing like E.T., or are completely clueless after hitting the switch, you've come to right place to learn more about lighting.

Selecting Lighting Solutions à la Carte

Having the sun at your back when you're shooting proves that you only need a single, powerful light source to bathe the subject in intense, colorful illumination, as seen in Figure 8-1. But shooting your movie at the same time every day and hoping the light's going to look the same as it did yesterday isn't exactly a plan for success. That's because for all the sun's amazing qualities, physics plays against your needs by continually revolving the Earth each day. Throw in some atmospheric conditions and celestial changes, and the predictability factor is right up there with wondering if your dog will have an accident on the day you stay away from home for an hour longer than usual.

Figure 8-1: Soft, warm sunlight falls nicely on the subject in the late afternoon.

You can easily counter the inconsistency by using artificial lights. Just set them up and control them as you see fit to produce impressive results. But if you're not sure how to use them properly, you can end up with an unnatural look and not the creatively intentional kind. Instead, you may wind up with one that's of the haphazard, messy variety as shadows across the face and spectral highlights rear their ugly heads.

That's why it's so important to understand both the nature of sunlight and the proper use of your light kit. Many situations are a combination of the two. Don't believe it? Next time you see a picture of a location for a movie or

television series, notice the giant lights and reflectors on the set, even in the middle of the day.

So whether you bring your own lights to the scene, take advantage of what's already there, or mix and match light under your control with the ambient lighting, it's important to know the behavior and limitations.

Using on-camera video lights

Despite the above-average performance of a DSLR when it comes to low-light situations, sometimes you need to add a little more light on the subject, and neither the sun or a light kit is at your disposal. Enter the on-camera light, a continuous-powered light source that has traits similar to the electronic flash unit. Both sit atop the camera and blare light at the subject. Maybe it's not the best method, but it's often the difference between getting the shot and looking at a murky mess. Effective uses include static shots, interviews, and other darkly lit remote areas. On the downside, it creates a hot spot on the face, it doesn't cover much distance, and the straight-on lighting shows no depth.

Besides sitting in the same spot, these lights share the same "love" for the subject as a flash unit thanks to their harsh output and narrow field of coverage, as seen in Figure 8-2. Of course, actual results vary based on subject distance, ambient light conditions, and the specific unit.

Inexpensive models tend to be spectral in output, showing the subject in a pretty unflattering light that acts more like a flashlight than a soft box (more on soft boxes in the "Lighting kits" section later in this chapter). But some models are clearly better than others. More refined models include a light control and a wider output. Many of these L.E.D. models produce brighter output with more evenly balanced illumination as well as offering more versatility over intensity.

Even the most sophisticated models, however, lack perfect output. That's a condition of position as the light hits the subject head on. Unless the subject is framed tight and the camera is at the proper distance from the subject, it can make the footage look like an early morning police raid. By the way, that coverage range is up to about 10 or 15 feet, depending on the model. Usually, six to eight feet from the subject works best.

Battery life is another issue. Though many lights use rechargeable power, they suck the life out of the batteries faster than that boat in your driveway drains your bank account.

So while they're not perfect, on-camera lights are manageable, providing you know their limitations and behavior.

Consider the following:

- **Understand the nature of the light source.** Some lights offer a very narrow output, whereas others offer wider coverage. Keep in mind that they are bright close to the subject, but the light falls off as the distance increases, so lights work best when the subject is at a fixed distance.

- **Try to balance with ambient light.** After you establish the distance, adjust the light or camera setting so the natural and camera light match exposure. Some lights have a dimmer control, which makes it easier. If not, manipulate balance through the camera-to-subject distance. The closer you match the on-camera light with the ambience of the scene, the more natural it appears.

- **Consider color temperature.** Each model differs in output color, varying from the tungsten-balances 3200K to 5600K daylight. That's right, some can go that cool. The good news is that most include conversion filters to adjust back to tungsten or daylight.

- **Use filters for more than correction.** Most models include a conversion filter to correct for either tungsten or daylight (depending on the color temperature of the bulb). But you may need to tweak color, and they work best when the subject is at an affixed distance. For those situations, slap on a gelatin filter to slightly modify the tint or color cast. Filters do more than just change color temperature or hue. They also affect light output, so a light with a filter on it, regardless of the filters intended use, requires more wattage to produce the same amount of light as a light with no filter.

Figure 8-2: Using on-camera light for a nighttime interview produces less-flattering light.

Exploring lighting kits

There's nothing like having the sun warm your head as it brings the subject to life, and preferably at a low angle. Unfortunately, that perfect dose of soft, warm illumination lasts about as long as the cool side of the pillow. No need to worry — you can bring your own lighting kit and exercise proactive control at the scene.

Light kits range in price from a few hundred to a few thousand dollars. You can also buy them used for significantly less money.

Here's a list of the components in a lighting kit and what they do:

- **Light head:** Using either a quartz lamp or LEDs, these high-output lights provide up to 1,000 watts of power or more.

- **Barn doors:** This standard accessory attaches to the front of the light and uses four hinged metal doors to shape its beam as well as preventing the distinctive scatter of light.

- **Stand:** Pretty self-explanatory. Stands support the head and allow you to position the light at various angles and heights. Varying in size, they go from stout to quite high.

- **Umbrella:** Reflecting light off an umbrella softens and diffuses the light and produces a flattering illumination for the subject. Umbrellas come in various sizes and reflective surfaces. (See more on reflectors later in the section, "Using reflectors to complement lighting.")

- **Soft box:** A large box-like enclosure that goes over the light head. When the light reflects off the interior surface, it comes through the diffusing material at the front of the box, creating a soft, even illumination, as seen in Figure 8-3.

Figure 8-3: The gentle illumination of a soft box provides a wide coverage area with limited contrast to produce a flattering appearance.

Using non-conventional lighting

If you enjoy non-conformity, why not consider a non-conventional light source from time to time? After all, a certain light may not be designed for illuminating your movie, but it may easily work with a little ingenuity. You can improvise with just about anything that emits light. Here are a few examples:

- **Work lights:** Tungsten-based light sources used for working interiors or at night. They often have stands and reflectors. Although the light is harsh, it's not that hard to smooth it out, and because they're so cheap, you should certainly consider it if your budget is near nada.

- **Flashlight:** Before writing off using a flashlight to light your movie, consider that it works in some situations, especially when you use more than one. That's the only way you'll get enough wattage to provide relatively decent illumination for low-lit areas.

- **Chinese lanterns:** Diffused paper-enclosed lamps that essentially use a household bulb to provide soft illumination. Because their illumination falls off pretty quickly, the subject can't move too far from the lantern; otherwise, exposure values shift to the dark side quicker than Anakin Skywalker. For control, you can hang a series of lights throughout the scene, or even mount them to a boom pole and have someone move the light with the subject.

- **Television illumination:** It's hard to imagine a softer, more interesting light source. Just put the TV on a non-broadcast channel and position the subject close to it. It certainly makes for an ironic statement.

- **Glow sticks:** Yes, this is a stretch, but there are situations where they come in handy. Use them as a subject, recording their illumination on a moving subject but exposing only for the glow. Or, if you have enough of them, you can use them as an interesting light source, especially when they're close to the subject.

Understanding the Basic Nature of Lighting

When you no longer are bound to a single light source, you can use a few to create the proper lightscape for your scene, but there's a vast difference between creating a symphony of illumination and using a bunch of lights. One radiates light in all the right places, whereas the other makes you want to cringe. Getting in touch with the former and avoiding the latter require a fundamental understanding of using light effectively. That task revolves around controlling the shadows and creating a sense of depth between the subject and the background.

Mastering three-point lighting

The most common technique for effectively lighting a subject relies on a three-light setup. Working together, the subject is lit from one side, the shadows filled on the other, and a third light provides depth by separating the subject from the background, as seen in Figure 8-4.

Rooted in still photography, this method works just as well with your movie. When you place the lights in a stationary position, you can capture an on-camera interview (a big part of documentaries), descriptive action and b-roll (footage to support the movie or segment), and even many situations with a live-action film. So this method is a keeper. For moving subjects, you can use a modified light array to produce the same effect. But first, I want to break down the function of each light by understanding the role it plays in illuminating the scene.

Figure 8-4: This three-picture composite shows the building of light with the background, main, and fill light respectively creating three-point lighting to make the subject more than a talking head.

Discovering main light

A *main light* is, uh, the main light in the scene. The most well-known main light is the sun. On the pro-active side of the fence, consider a main light to be the main artificial light used to illuminate the subject. This light works best when it's positioned near the camera at about a 45º angle from the subject so it broadly covers one side of the subject's face. The other side renders in shadow, either appearing quite dramatic or as half of a face.

Working with a fill light

The naming convention for the role of this light is spot-on because that aforementioned shadow on the opposite side needs a little exposure to show some detail. Just a little — any more than that and the fill light no longer

lives up to its moniker. Like the main light, you also position it at a 45º angle from the subject, only on the opposite side of the camera from the main light. Depending on the subject, you can position the fill light at either a higher or lower angle than the subject to effectively "fill" in the shadow areas. The fill can also be a reflector that redirects illumination from the main light. When you're shooting outdoors, this comes down to being a large white reflector bouncing sunlight back on the subject.

When you're using an artificial light for fill, be sure it doesn't overpower the main light. You can do this several ways:

- Use a bulb with less wattage.
- Adjust the dimmer to output less light.
- Place a neutral density filter over the light.
- Move the light further from the subject.

Using a backlight

After the front of the subject is adequately covered, put some light behind them to add depth and separate the subject from the background. Position this light high and off to the side behind the subject at a 45º angle. Also called the *hair light,* a *backlight* illuminates the subject from the side and provides separation from the background, exaggerating the feeling of depth.

Looking at four-point lighting

Using a *background* light, not to be confused with a backlight, illuminates the background and not the subject. This serves several functions, including creating an interesting visual effect and a means for further reducing background shadows.

Discovering even more lights

Sometimes, the more the merrier, but other times, less is more. In any case, I want to talk about some of the lights you can use to enhance a scene:

- **Dedicated hair light:** The "back" part of three-point lighting serves many functions, including as a hair light, but having a light specifically for hair is the real deal. That's because its only purpose is to highlight the locks. Unlike the generic backlight, which uses a broad swath of light, this light either has the barn doors narrowing the beam, or it uses a snoot. (A *snoot* is a tubular attachment that goes over the light, focusing it on a narrow area.)

✏ **Accent lighting:** Accent lighting is similar to a hair light. Its sole purpose is to bring attention to a detail in the scene. You can use a single accent light or a group to bring attention to details in the scene.

✏ **Using background patterns:** All too often, we think of the background as a passive scene, or a boring piece of seamless paper, but you can effectively use light as a background element. Shining a beam to create form from the light or using a gobo in front of the light produces an interesting effect. (A *gobo* is a perforated metal slide that comes in a variety of patterns. Some resemble venetian blinds; others form geometric shapes.)

Using reflectors to complement lighting

Sometimes the light on the scene needs some assistance filling in the nooks and crannies. That's where a reflector comes in handy. By reflecting light off its surface, the reflector fills in shadowy areas while controlling highlights. This shiny or white flat accessory comes in various shapes and materials, but they all do the same thing when you hold them opposite the light source: redirect light to open up shadow areas in the scene. You can mount the reflector to a stand, clip it to whatever a clip fits around, or have an assistant strategically hold it. Basically, it takes on the function of a fill light without you needing to power it up.

Reflectors come in a variety of shapes, sizes, and reflective surfaces:

✏ **White:** Provides a clean bounce to balance highlight areas and add exposure to the shadow without affecting color balance.

✏ **Silver:** Its reflective surface produces an increased reflection value.

✏ **Gold:** Produces a warmer reflection. Excellent for capturing people, this provides a little boost when ambient light is on the cool side of the color spectrum.

There are many uses for a reflector. Here are few that work well:

✏ **Use it just below the subject's face.** This opens up the shadows and can provide more depth to facial area.

✏ **Move it evenly with the subject.** For those situations where the subject is moving through the scene, be sure the assistant holding the reflector mirrors the subject's movement.

Improvising a reflector

Maybe your budget can't cover the cost of a reflector, or maybe you only need one from time to time. The good news is that you can find a suitable alternative or make your own. Here are some ideas:

✒ **Find a white foam core board.** These white boards found in art supply stores cost a couple of bucks and are pretty durable for simply diverting light to the subject.

✒ **Cover a white board with tin foil.** Need a little more reflective power? Cover the board with tin, er, aluminum foil, as seen in Figure 8-5.

✒ **Try a car shade.** Those windshield sunshades work wonders as a reflector. They are light, flexible, and many have a highly reflective silver surface. They're pretty inexpensive, and if you already have one, it's free.

✒ **Use a white sheet.** Wrap it around a board, pole, or anything that it fits and fill in large sections of the scene.

Figure 8-5: A white board covered in aluminum foil can be used as a reflector.

Making Dramatic Lighting Easy

Understanding the concept of dramatic lighting is a start, but theory only gets you so far. It's not going to mean much unless you know how to create compelling illumination. Traditional three-point light provides for a great staring point. From there, things get more interesting.

Making Rembrandt proud

When you think of the most dramatic portrait lighting, it's hard to not have the Dutch master topping the list. Characterized by an illuminated triangle under the eye of the subject, Rembrandt's style has become one of the most recognizable techniques in portraiture, and it also gives a nice touch to your movie.

Although it's true that Mr. van Rijn commanded the oils and canvas, he probably would dabble in the photographic arts if he were alive today, so perhaps DSLR moviemaking wouldn't be that much of a stretch for him to apply his namesake technique.

Light ratio

The term *light ratio* refers to the comparison of the main light and the fill light. If both were equal, the ratio would be 1:1. More likely, it's 4:1, meaning that the main light is twice as bright as the fill (two stops). The higher the ratio, the more contrast you get in the scene.

But that shouldn't stop you. All you need to do is practice. Just place the key light slightly higher than the subject and off to the side, letting it bathe one side of the face in light. Since the bridge of the nose dips low near the eyes, some light spills over to the other side of the face and creates a triangle underneath the eye. All it takes are a single light and a reflector to add detail to the less illuminated side of the face.

Here are some aspects to consider:

- **Keep the triangle reasonably sized.** Don't make it too small on the face so that it looks like the eye up against a peephole. Or too big that it loses form. Another good idea is to never make it longer than the nose or wider than the eye.

- **Control the effect.** This technique is altered by both the light source to subject distance and intensity of the light.

- **Use a reflector (or fill light).** While a face in shadow appears dramatic, it looks better when you "open it up" a little to show some detail. You can either use a fill light, with about two f-stops less exposure, or by holding a reflector on the shadow side just out of shadow range.

Playing the angles

How you position the lights makes a strong statement of your intentions. But that's not always represented by basic lighting technique. That's generally when the main light illuminates the subject above eye-level from an angle. Rembrandt lighting provides a creative device, but it's not for every situation. Then there's the less-than-flattering, though only-game-in-town on-camera light that strikes the subject head-on and often leaves little depth, but still gets the job done. And while these are prominent, there are some other methods that work too.

Consider the following:

- **Horror lighting:** For a dramatic flair, try lighting the scene in the style of the old black-and-white horror films like *Dracula, The Wolf Man,* or *Frankenstein.* Next time you see one of these classics by a director like James Whale, observe the eeriness of the lighting. Positioning the lights

low and pointing them upwards often create an eerie, spooky look. If you're intent on making a horror film or paying homage to *Frankenstein*, position your lights low.

✔ **Light on the run:** When the subject is moving through the scene, it's not practical to set up a dozen lights when you can track them with one.

✔ **Backlit subject:** If there's enough light on the scene, use backlighting. It defines the subject with a rim of light. You can use a reflector for the face. This effect is commonly used in movies.

✔ **Secret witness style:** If you've ever seen a whistle-blower on a TV news program, you know that all you see is a bright background with a silhouette of the person. This is done with just a background light.

Doing a simple green screen illumination

Tricky, this one is, as Yoda would say. That's because the intent of green screen illumination is to create even illumination for the background. But at the same time, the foreground lighting needs to show both shadow and depth while matching the tone of the keyed background.

Each situation differs based on the background and subject, but here are a few things to consider:

✔ **Make sure the green screen is evenly lit.** You can eyeball it, but it's probably better to use a light meter (your camera will work too) to be sure the corners and center are reasonably close in terms of brightness. How close? A half-stop difference goes unnoticed, but a two-stop difference is quite noticeable.

✔ **Study the background footage.** Before attempting to light your subject against the green screen, assess the direction of light so you can match it with the subject. The angle, direction, and intensity of light should match closely.

✔ **Emulate the color of light for the subject.** After figuring out the direction and intensity of the light needed for the subject, use a colored gel or change the white balance to match the color for both the subject and background.

Complementary color

Another interesting light effect happens when you exploit the contrast of colors on the scene. For example, at twilight, the ambient color temperature has a blue cast; you can use a warmer light source to create a complementary play between the colors.

Here's a basic rundown of complementary color:

- ✔ **Blue/yellow:** This most commonly occurs with the naturally lit twilight sky and warm artificial illumination like tungsten or sodium vapor lamps.

- ✔ **Red/cyan:** Can occur when a low-quality fluorescent light is combined on the scene with either a warm tungsten bulb or a lighting setup with a red filter.

- ✔ **Green/magenta:** Makes for an interesting contrast of color, although you need to manufacture this one with gels, at least on the magenta side. You can find green casts anytime when you encounter certain high-intensity discharge lamps.

Avoiding Lighting Pitfalls

The difference between great and not-so-great lighting often comes down to a few inches. Sometimes a few minor tweaks make the difference between effective and ineffective illumination. This includes adjusting the barn doors in front of the light source to best direct its flow; turning the power down a smidge on one of the lights; or shuffling the light stand around a little to fully cover the subject. Other times, it's a matter of corralling the subject from being too close to the light, positioned at the wrong angle, or standing in shadow. Being aware of these potential dilemmas reduces their likelihood and allows you to make a better movie.

Remaining diligent of all lights in the scene

Pollution goes beyond littered streets and dirty beaches to the interplay between your lights. That spill from the coverage area of one light to the next can produce hot spots and odd shadows. Although the cause varies with each situation, one common thread involves having lights too close to each other. That's why it's important to strategically set them up, especially when two lights intersect. The main light is important, but so are the other lights. For example, if you're using a hair light for interview position, you need to make sure it's adjusted for each subject. The same setting on the light offers different results with the following subjects: a woman with long, curly blond air, another woman with short brown hair, and a bald man will render differently. That's why it's a good idea to tweak the lights with each scene.

Consider the following:

- ✔ **Make sure lighting efficiently covers the scene.** Sometimes a portion of the light doesn't reach the subject. Either it strays out of the way due to improper bouncing or it's not bright enough. Make sure the light is properly directed to the subject and close enough to be effective.

- ✔ **Deal with problematic ambient light sources.** Whether it's a window streaming light five stops brighter than your lights or a glaring streetlamp, stray light can ruin your shot. Combat it either by moving

the subject out of the way, bringing the key light closer to balance exposure, or using a reflector fill light to "open up" the subject's face.

✔ **Make lemonade from.** You're going to be thrown lemons, so try to turn them to your advantage whenever possible. For example, stray light from a window on the set is difficult to overcome, especially on a bright day. Use it to your benefit by turning the subject around and using the ultra-bright portal as a main light. Or if you're up against a glowing streetlamp in the scene, strategically move the subject against it, positioning her head against it to create a halo effect behind her.

✔ **Build the light gradually.** Turn the lights on one by one, starting with the backlight. After tweaking the backlight's position, move on to the main light, and then the fill. If you have others, turn them on next and make sure they're doing what they're supposed to do.

Seeing why too much texture may get you in trouble

If you took a poll, most people would say that seeing the close-up texture of their faces onscreen ranks just above banging their big toe on a wrought iron gate in the middle of the night in terms of fun. Your subjects' responses to seeing their wrinkles and blemishes onscreen may range from rolled eyes to a not-so-gentle grip placed on your throat. That's what makes this technique of photographing them with textured lighting something to consider for specific circumstances, objects notwithstanding. Some elements of the set benefit greatly when texture is exaggerated. But with people, that's another story.

For example, a middle-aged person showing the early signs of facial wrinkles likely won't be agreeable to being captured with anything but the most flattering light, and even diffusion material over the lens. Conversely, a person who has already embraced old age may see wrinkles as a badge of honor, showing wisdom and realizing the unique beauty of aging.

Regardless of your subjects' egos, here's how you show texture effectively:

✔ **Analyze the texture.** Observe the surface and position the light to skim across the grain. Be sure it creates shadows on the textured areas, with highlights on the edges.

✔ **Position the light source to the side.** Letting it skim across the face creates this effect.

✔ **Soften the effect.** Use a fill light or reflector on the other side to reduce the textural contrast.

Situations where texture works:

✔ **Razor-stubbed face:** Conveys the character's ruggedness or despair.

✔ **Wrinkles:** Show the beauty and wisdom of an elderly face.

✔ **Fabric pattern:** Emphasize that linen blazer, corduroy jacket, or sweater pattern.

✔ **Scene details:** Use the texture of the background to help the subject stand out against a distracting background. Just blur with selective focus (see Chapter 6) so the subject stands out.

Keeping your eyes on the subject's face

When making a movie or documentary, all the beautiful scenery in the world doesn't matter if the main subject is either in shadow or blown out (way overexposed). That's why even in night scenes, the subject's face is still recognizable. Sometimes all it takes to lighten the face is a little repurposing of the light with a reflector or a fill light. At the end of the day, nobody is going to tell you that the background sky looked spectacular even though the subject's face was in deep shadow.

Consider the following:

✔ **Make sure the face is defined.** Don't worry too much if the background is slightly lighter or darker than normal. It will go unnoticed, at least compared to doing the opposite: exposing for the background and rendering the subject unidentifiable.

✔ **Exposure is too dark.** Use a light or reflector to add detail to the face. It doesn't need full brightness, but you should have enough detail to recognize it as a face.

✔ **The face is too light.** Adjust exposure to match the ambient light. If the rest of the scene goes too dark, try to use some fill lights; otherwise, the background goes dark. As long as the subject looks good, the scene will be all right.

✔ **Move with the subject.** If the camera moves through the scene, have an assistant hold a reflector or light in the scene and move with the action. That's how the pros do it, as seen with this TV crew in Figure 8-6.

Figure 8-6: An assistant moving with TV camera for a subject on the move.

Watch out for lens flare

Whenever you deal with light, you run the risk of producing lens flare by getting the lens axis too close to the light, as seen in Figure 8-7. Sometimes this acts as an artistic device; but mostly it looks like you weren't observant enough.

Consider the following:

- **Be cognizant of light position.** Use the Live View on your camera to judge the scene. Move as close as possible to find the flare area and then back the camera up a bit.

- **Use a lens hood.** Also called a *lens shade,* this protruding plastic or rubber accessory attaches to the front of the lens to reduce lens flare and loss of contrast. Most lenses include one, but if it doesn't, you can buy one based on the filter thread or lens front size. Just be sure to use the correct one for the focal length that you're using to avoid vignetting.

- **Attach a matte box.** Far more effective than a lens shade, think of a matte box as similar to a beach umbrella. You know, something you can move and adjust to keep the sun off your face without missing out on the view of the ocean. It includes a movable flap on top like the bill of a cap, yet it moves like a barn door (the lighting and not the farm kind). More properly, the movable piece is called a *French flag,* and it shields stray light from the top and bottom. It also has side wings that do the same. The matte box not only shields the lens from direct light, but it also provides slots for filters. The ones designed for your DSLR generally allow you to use either 3×3 or 4×4-inch filters.

Figure 8-7: A lens flare.

9

Reigning in the Frame

Maybe you wanna be Tim Burton. Or perhaps Hitchcock hits your cinematic nerve. Both have unique signatures in telling their stories.

And that's the ultimate goal, isn't it? Not imitating great directors, but eventually becoming one too. But this "cinematic touch" doesn't come with just education: You also have to constantly experiment with the visual part of storytelling.

Great filmmakers have a distinct style that goes beyond letting dialogue and a few props tell the story. Instead, they opt to communicate with the viewer on a more visual level — one that the viewer understands simply by watching.

Effective moviemaking technique is not born overnight. The great film auteurs developed their styles over a long period of time, so it's unlikely your style will emerge any more quickly. Let me dig through the cliché bin for a second. Ah, here's one: The journey of a thousand miles begins with the first step. Think about books. Great writers learned about letters first, and then moved on to words and sentences, long before using them to eloquently write their masterpieces. The same applies to visual literacy.

The great filmmakers clearly have a handle on their craft. Their beautifully shot films take advantage of lighting, color, and scene arrangement to tell a compelling story. That's a lot better than every movie looking the same in terms of shot types, lighting, and composition. That makes the movie bland, or just like every soap opera you've ever seen. (Soap operas have entertained for decades with sensational plots, but not much visually distinguishes one from the other.)

You Got Framed!

Despite the technology, what happens in the confines of each shot is truly all that matters. Think about it: The visual part of the movie is what draws the viewer. Close your eyes and think about your favorite films, and I guarantee a scene from the movie pops into your head.

The horse head from *The Godfather* and Rosebud from *Citizen Kane* are iconic for a reason. Creating an effective series of shots is hard because each of us sees the world a little differently. In the next few sections, I break down the components of visual technique.

Considering proper composition

The first rule of composition is there are no rules, just guidelines and suggestions, and the reason is simple: What you find dramatic, someone else may deem trite. Subjectivity rules, with each filmmaker having her own ideas of how to occupy the frame. Regardless of rules, er, guidelines, if a shot looks good to you, try it.

The basic shot structure I discussed in Chapter 5 illustrates variations in subject size and is controlled either by the focal length or camera-to-subject distance. Those ideas make a statement, but how you compose the frame lets the screen image finish the thought. Figure 9-1, a shot of a store mannequin, demonstrates how an otherwise boring subject draws the viewer into the scene. Elements ranging from the time of day and juxtaposition of warm and cool color balance to the tilted frame and upward angle all compel the viewer.

There is a psychology to arranging a shot, and it's quite simple: Our eyes travel left to right and top to bottom. Positioning the subject on the bottom right side of the frame can draw the viewer to it. Conversely, placing the subject on the top left pushes the viewer away from it to the bottom right as if there's something awaiting his inspection. Most composition tips are influenced by this concept.

Figure 9-1: Take advantage of perfect lighting to make this store window come to life.

Using the rule of thirds

This time-honored technique serves as a guide for arranging elements in the frame by placing the subject along an imaginary line. Basically, it's all about dividing the frame into three parts, both horizontally and vertically, like a hash tag or tic-tac-toe board. You then place your subject in the crosshairs of intersecting lines. The ancient Greeks called it the *golden mean* and used it in architecture (check out the Parthenon). This creates one of the most common ways of arranging a scene and is used for television and documentary interviews. Watch, and you'll see the subject is never in the center of the frame.

Consider the following tips on how to balance a frame:

- ✔ **Be careful with that horizon.** Place the horizon on one of the dividing lines, not smack in the middle of your shot. The bottom section emphasizes more of the background, showing off a dramatic sky or other interesting backdrop. The higher spot does the same for foreground, making it effective for subjects at ground-level, as seen in Figure 9-2.

- ✔ **Leave some room on the top but not too much.** "Off with the top of their heads" is not the motto here. No flat tops, please, unless they're intentional. Make sure there's a breath of air between the subjects and the top of the frame.

- ✔ **Use the frame to lead the viewer.** Negative space is the area in the scene that can either show the viewer something she needs to see or set a mood. If you position your subject on one side of the frame and have her move across the span, don't have her walk out of the frame, unless that's your intention.

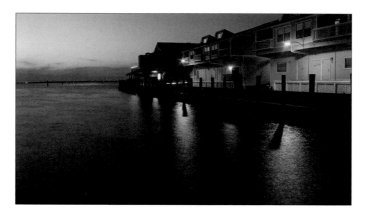

Figure 9-2: By putting the horizon higher, I captured the reflection on the water.

Remembering the people aesthetic

When shooting an interview, documentary, or news segment, remember the following:

- Follow the rule of thirds when it comes to placing the subject in the frame, meaning don't put him in the middle.
- The subject should never look directly into the camera. Instead, he should look across the frame, as seen in Figure 9-3.
- A narrator or anchor does look into the camera.

Figure 9-3: The subject looks across the negative part of the frame as he answers a question.

Keeping the frame simple

Less is more when framing your movie. You don't want to include any more visual information than necessary. When the shot is concise and the viewer clearly understands the center of interest, chances are your movie is on the road to success. Consider the following:

- ✓ Make sure the subject is not competing with other parts of the scene unless it's intentional.

- ✓ Control depth of field, as mentioned in Chapter 6, to keep the center of interest exactly where you want it.

- ✓ If the camera follows the subject, such as a person running across a grassy field, be sure it doesn't lead the viewer into a minefield of extraneous clutter, like the high-tension wires next to the field. Recompose if necessary.

- ✓ When the scene concentrates on the subject, try to frame her against a plain background, even if the scene takes place in a busy area.

Using the background

Sometimes the background is your friend; other times, it's your bitter rival from high school. Colorful, simplistic, or picturesque backgrounds fall into the friend category and can enhance the quality of the scene. Busy, converging backgrounds with extraneous elements can ruin the scene by distracting the viewer.

The human eye can effectively distinguish elements in the scene thanks to depth perception. But sometimes the discrepancies between the foreground and background go unnoticed until you're viewing the footage.

When dealing with backgrounds, consider the following:

- ✓ Make sure trees, poles, or other stick-like objects don't converge with the subject, giving the appearance of an unusual appendage or a shish kabob protrusion.

- ✓ A movie scene appears more compressed than our eyes see it. The human eye naturally recognizes depth and mentally separates the foreground from the background. The camera flattens it, compressing the subject to make it appear that the background and foreground are much closer. This becomes problematic with stationary tripod shots because the background remains constant.

- ✓ Use a wide aperture setting to blur the background enough to let the main subject stand out.

Art Directing the Scene

Although the basic techniques I discussed previously are a great place to start, there are more advanced approaches to arranging a scene.

Framing the subject

Using foreground objects to frame the scene works as another creative device that makes for an interesting shot. Whether it's a doorway, archway, tree branch, and peephole — or just about anything on the periphery of the shot — this technique can define the center of interest in the frame, as shown in Figure 9-4.

Consider the following:

- **Maintain attention on subject.** Keep *it* in focus. Don't worry if the framing elements are out of focus (that is, a tree limb, porthole, and so on).

- **Frame with people too.** If you frame the main subject with people (a crowd or group), it's best to have them look into the frame, as opposed to out of it. This makes the audience look at what the people on the screen are looking at.

- **Don't place the subject on the edge of the frame.** Although putting a subject dead-center in a frame is often a faux pas, it works with this type of shot because the eye crops out the foreground as if it were a split-screen image.

Figure 9-4: Using columns to frame this Montreal street scene makes for an interesting shot.

Being creative with shadows and reflections

Shadows and reflections are excellent composition fillers because they help unify a scene. Reflected images tend to grab viewer attention, just as the rich textures of the shadows lead the viewer to the center of interest. Balancing the frame with a shadow or reflection serves many purposes, as seen in Figure 9-5, including making a drab subject look interesting. It can also make a statement about the subject.

Here are some things to consider when using shadows and reflections in your shot:

- If the shadow or reflection is the center of interest, focus attention on it instead of the subject.

- Treat the shadow like any other subject either by including it in its entirety or by defining a segment (shape, form, or feature).

- Focus on it and stop down the lens (see Chapter 6) if you need to maintain sharpness. Shadows and reflections don't look good in soft focus.

Figure 9-5: Light and shadow transform an otherwise empty shot into something more dynamic.

Taking advantage of symmetry

Balancing elements such as color, shape, and light in the frame provides a legitimate order for the viewer to process the intention of the scene. One method uses the contents of the frame as a balance beam, placing subject matter on both sides to form an even composition, as seen in Figure 9-6. Then there's *asymmetrical balance.* That's where the subject shares the frame with

negative or blank space to depict vastness or difference. When you're balancing the frame, beware of vertical lines near the middle of the frame. They can lead to the appearance of a split screen. The juxtaposition of color is another way to make the scene look interesting. You can position a warmly lit subject against a cool, blue backdrop or use other cool color combinations.

Here's each primary color and its complementary color:

- Blue/yellow
- Red/cyan
- Green/magenta

Figure 9-6: The artist hanging a painting uses balanced symmetry to make a visual impact.

Beginning mise-en-scene

Mise-en-scene is a poetic way of visually conveying the intention of a scene. The message is created a variety of ways, but mostly has to do with the arrangement and lighting in the scene, but sometimes it's created in the editing process. One example is when the subject begins to visibly show anger, and it's manifested by a cutaway of a train whistle blowing.

Here are a few others:

- Using cool, blue lighting depicts the subject's despair.
- The subject looking up to the sky after a confrontation may suggest looking for guidance from above.
- The subject walking out in the early morning can alert the audience to the start of something new.

Breaking Down the Shots

I cover basic shots in Chapters 5 and 6, but you have many more types to consider when you're making your movie. Great filmmaking weaves a variety of shot types together to tell a story. In this section, I give a more in-depth description of various shot types and their commonly used abbreviations.

Naming the type of shot is a bit more complex than you may imagine. The *wide, normal,* or *tight* part of the description is a relative comparison. (Be aware: A 16:9 composition is quite wide.)

- ✔ **LS (long shot):** Also called an *extreme wide-angle shot,* this shot shows the subject in relation to his surroundings. Often this expansive view establishes the scene as the first shot. It's not always necessary to include actors in this shot. An expansive shot of the landscape, as seen in Figure 9-7, with few identifiable subjects is an example of this type of shot.

- ✔ **VWS (very wide shot):** A VWS is not as expansive as an LS, but it's still pretty wide in the frame. It can also work as an establishing shot.

- ✔ **WS (wide shot):** Also known as a full shot, a WS is the next logical step in the wide world of shots, but this type also includes one type of shot that isn't all that wide, as seen in Figure 9-8. The subject is clearly seen, usually from top to bottom. It's frequently used because it sets up medium and close-up shots.

- ✔ **MS (medium shot):** Otherwise known as the normal shot, the MS shows a more pronounced view of the subject. Depending on the subject, it shows more of it than a wide shot and less than a close-up. When a person is in the shot, she's shot from the waist up.

- ✔ **Two shot:** This arrangement shoes the interaction between two subjects in a conversation or confrontation. Sometimes it shows the subjects' full figures; other times, it's only from the waist up.

- ✔ **MCU (medium close-up):** One way to think of an MCU is as a close-up for people who don't like close-ups. An MCU captures the entire face, but with a little bit of neck and chest. Objects shot in an MCU usually dominate the frame.

- ✔ **CU (close-up):** A CU usually refers to a frame showing the subject from mid-chest up. It shows the head, hair, and face, usually without showing pores and blemishes, although not in the case of Figure 9-9.

- ✔ **ECU (extreme close-up):** An ECU gets right in there to show detail on inanimate objects, or a range of emotions on the human face, as seen in Figure 9-10. Of course, it may also be the shot that gets you hit over the head with an inanimate object if your subject doesn't approve.

- ✔ **POV (point of view):** A POV shot shows the scene from the subject's eye. It makes for great editing fodder.

✓ **CA (cutaway):** If you watch reality television, you've seen CA shots. They're the ones that have little to do with the story. Maybe it's the subject's home, some random inanimate object, or a city or village scene. Some even get creative and show a time lapse. On a red carpet, a CA can be the other television crews shooting the star or photographers taking pictures. Whatever the content, it informs the viewer of the subject matter as well as serving as a buffer to manipulate the passage of time.

✓ **CI (cut in):** A CI shot shows details essential to the subject such as the subject cracking his knuckles, picking up a glass, tapping fingers — you get the idea.

Figure 9-7: The set-up shot for a beach scene in Florida.

Figure 9-8: A full shot of a unique museum in Toronto.

Figure 9-9: This subject didn't mind the close-up.

Figure 9-10: An extreme close-up of these lips were captured with a macro lens for a music video.

Moving the Camera the Wrong Way

So far, the techniques I've described help make each shot, and ultimately, the move, look better. Here, I take it from the other side and point out the things that make a bad shot, and ultimately, a bad movie.

Too much camera movement

Nothing is worse than watching a video that looks like the camera was placed on top of a washing machine during the spin cycle. It's not bad if you want to reproduce the effect of an earthquake, but it's not good for much else.

Reason: Shakiness usually occurs because the operator is holding the camera by hand, especially when using a telephoto lens.

Solution: Use a tripod or some stabilization device. See Chapter 3 for more information.

Too much zoom

Either your audience feels as though they're inside a trombone, moving back and forth, or they're riding the brake hard on a crash course. In either situation, it's not a pleasant experience.

Reason: The lens zooms too much.

Solution: Lock down the desired focal length and press Record. If you want to bring the subject closer, capture at least ten seconds of footage before you zoom in. And when you do zoom, leave it there.

Panned and panned and panned

The camera moves side to side as if the action were the finals of the U.S. Open. Too much head movement makes you dizzy.

Reason: Someone who's forgotten that movies are put together in the camera but not edited in-camera.

Solution: Make sure the subject stays in the frame by rehearsing and then watching the take closely.

Tilting frames

When you look at the movie like your dog responds to a new word, something is probably wrong, and that's a tilted frame.

Reason: The camera showed a level horizon when you pressed the Record button, but that changed at some point, either from the tripod head not being tight enough or the tripod being accidently moved.

Solution: Always check that the horizon is level before shooting the scene. If your intention is a Dutch angle, make sure it's properly exaggerated so it doesn't look like a mistake. (A *Dutch angle* is when you intentionally tilt the fame for effect.)

Subject disappears from view

The subject moves across the frame, getting dangerously close to the edge until it consumes the top of her head, which makes the audience wonder if that was an outtake.

Reason: Errors in camera blocking cause the subject to walk out of the frame.

Solution: Rehearse subject movement and watch each take.

Objects disappear from the edge of the screen

It's that pesky problem of parts of the shot being cut off again.

Reason: What the camera records and what different screens show are sometimes two different things. Sometimes, entire parts of the scene are absent. What shows up on one monitor may disappear off the edge of another.

Solution: Stay inside the television-safe area. If your viewfinder doesn't display a TV-safe border, just leave a little extra room on the edges.

Making the Most of Audio Capture

▶ Surviving the built-in microphone

▶ Using microphones effectively

▶ Getting effective audio from a variety of subjects

▶ Adding sound effects

The so-called symbiotic relationship between audio and video quality remains nothing more than a concept unless you take the proper steps with each and — for this chapter's purpose — those steps focus on capturing audio. Of course, that covers a pretty wide swath.

Sometimes it's as simple as being cognizant of ambient noise on the scene, or perhaps, using a specific microphone technique. Other times, it's about plugging a cable between the camera and a soundboard at an event to reproduce the most clear audio signal in your movie. Whatever reason, a perfect sound recording puts the cherry on the cake.

To satisfy your craving, in this chapter I examine the concept of location recording (when you shoot your movie at a place that is not a soundstage or studio).

Recording Sound on the Scene

It seems so obvious that capturing sound on location is the right thing to do. And why not? It's engrained in your mind's eye from every movie you've ever seen. But think for a second. Have you been successful up until now?

Recording sound on location is normal when shooting home video. But when it comes to serious moviemaking, it can give you nightmares. If you had to pick a movie title that describes capturing sound on location, *The Good, the Bad, and the Ugly* would be fitting.

For all that, location shooting does add to the movie's realism. It's certainly more interesting than shooting in a studio or on a soundstage. On the downside, you'll have to contend with a host of problems, including competing sounds. But you can't pick and choose the ones you want — some natural sounds work well with the movie, as in the case of a babbling brook. Other situations, like a passing fire engine or hum of appliances inappropriately interrupting your scene, require careful placement of the microphone. Other times, blaring horns and screaming voices on the scene become so distracting you may pull your hair out.

That's why the pros capture audio separately, and sometimes even rerecord in postproduction for optimal audio. Sound specialists take advantage of natural sound some of the time, and add, edit, and enhance it other times. Of course, they have time to prepare and use sophisticated equipment specifically designed for audio capture. There's quite a benefit to having a well-staffed crew and adequate budget, as opposed to having to rely on your cousin Vinny holding a boom mike.

Each type of moviemaking has specific audio needs. Because the goal of feature filmmaking is creating an artificial reality, things like crystal clear audio, sound editing, and sound effects become a factor. Of course, that varies with each film. For example, a movie like *As Good As It Gets* requires much less audio wizardry than an action flick like *The Dark Knight.*

Documentary and television reporting come a little closer to home with minimal sound, if any, added in postproduction. Instead, this type of moviemaking depends on voiceover, enhancement, and soundtracks. Television and documentary crews use several microphones, and usually an audio mixer captures sound on location directly to the card or tape. It's not much different with a DSLR, which records directly to the card or a separate audio recorder.

Whatever advanced techniques you use, they're still quite different from capturing the audio using just the camera's built-in microphone. Capturing sound with your DSLR's built-in microphone is the antithesis of effective audio capture and at times seems like a force bent on destroying the quality of your movie.

Capturing sound with the camera's built-in microphone

Without a built-in microphone, you'd need an external microphone or you'll get silence. But when you're using that very basic inclusive microphone, you get movies with the class of an amateur video. That's much less than you bargained for — or maybe more — when you consider honking horns, barking dogs, and helicopters flying overhead while you're trying to capture a specific bit of dialogue. And even then, the sound quality lacks depth and range for no other reason that the intent of that microphone on a DSLR was never intended for serious audio recording. Its original purpose was to allow still photographers to provide notations for photographs, so it's hardly a good choice.

Using a camera-mounted microphone

Mounted proudly atop your camera, a camera-mounted microphone is an effective accessory that is a definite improvement over that "dot" of a microphone found on your DSLR. But it's still not completely without limitations. The problem is not necessarily about sound quality, but more about how it relates to camera-to-subject distance. Subjects closer to the camera capture cleaner audio than those further away. The reason: The microphone captures everything else between the two. Although imperfect, sometimes it's the only game in town. When that's the case, here are some dos and don'ts to make the best of a camera-mounted mike.

 ✔ **Use your ears.** Aside from holding sunglasses on your head, your ears are also great for picking up sounds, lots of different ones! Take a second and listen before hitting Record. It pays off.

 ✔ **They work best for ambient sound.** Camera-mounted mikes are ideal for picking up natural sounds on the scene — for example, automotive traffic, the whoosh of a babbling book, or rhythmic tones from an assembly line. They also work well with talking heads, but only when close enough to the camera, say four to seven feet.

 ✔ **Stay away from noisy locations.** The microphone picks up everything. That means a little of the stuff you want, along with a lot of what you don't need. Airports, train stations, and high-traffic situations are a few situations that look great in films but are nightmarish to capture.

 ✔ **Don't try to capture dialogue from a distance.** Unless the subject is close to the camera, as previously mentioned, you're going to pick up every sound between the camera and the subject. The sound quality is still usable, but doubtfully optimal. Instead, use a shotgun microphone or a wireless model closer to the subject.

- **Get close to the subject.** I can't overstate this advice. The closer the subject is to the microphone, the clearer their voice records, and the more the voice rises above competing environmental noises.

- **Make sure levels are not too high.** There's no sense in capturing audio if it's going to clip, meaning that levels are so high that everything becomes irreversibly distorted.

Taking a step up to a separate microphone

Although it's convenient, the camera-mounted microphone pales in comparison to its free-moving brother, a separate microphone. Whether you're looking to capture natural sound using a shotgun microphone, using a stick mike for a grabbing a sound bite, or picking up sound from a boom pole over the subject, there are clear advantages to using a separate microphone held away from the camera. Here some commonly used separate microphones:

- **Lavaliere:** It's the clip-on microphone often associated with television interviews. Also called a *lapel mike,* it attaches to the subjects' clothing about six to nine inches from the mouth. Because it's hidden between garments, it often picks up a rustling sound when not properly positioned, especially at a point where fabrics rub against each other. Gone unchecked, the rubbing adds an abrasive tone to the sound bite.

- **Shotgun:** This long directional microphone that has a narrow field of capture and can pick up distant subjects. Point it directly at the subject or sound source without worrying about picking up too much stray sound from its periphery. Shotgun microphones also work well when capturing dialogue or sound bites, especially when there's more than a single person. Of course, it has to be aimed at the subject for effectiveness.

- **Stick microphone:** Used in a variety of situations ranging from public address, music performance, and on-camera reporting, these microphones work best when held close to the mouth and accurately pointed. Basically it's a standard, handheld omnidirectional microphone. Although stick microphones all look the same, each specific type is internally different. What they all have in common is that they are designed to be held close to the subject to get clear audio. Various types exist, and their prices range from affordable to astronomical. One more thing: Don't bother using it if you're not close to the subject; otherwise, it's not much different than the camera-mounted type.

Identifying Audio Problems

Although using a separate microphone offers clear advantages, no form of audio capture is free of problems. Location work in particular provides many dilemmas. For example, shooting outside of a controlled environment can

lead to some sound-related problems, with the most problematic being the one that blows past you: the wind. Depending on the gusts, it can impede the impact of sound in your movie or ruin it altogether. Better-quality microphones help reduce some problems with wind, just as many traditional camcorders include audio controls to help curb the problem, or a wind filter that reduces its impact.

Unfortunately for the DSLR, audio control was an afterthought, but that doesn't mean it's an excuse to capture ineffective audio. After all, you can't stand up in front of your audience and tell them your sound is bad because it was too windy outside, or worse, tell them that your DSLR wasn't really designed for that. The good news is that many sound-related dilemmas are correctable through technique and accessories.

Consider the following when you attempt to shoot:

- **Use a pop screen.** A pop screen is that circular foam accessory that clips in front of a microphone, generally in a studio or soundstage setting. Besides looking cool, this inexpensive attachment reduces *plosive* sound, which is the vocal "pop" sound that happens sometimes when people say words beginning with *B* or *P* or *T*. (You know, the same sounds that cause some people to "spray" when they talk.) Without using a "pop screen," plosives are the voice equivalent to nails on a chalkboard.

- **Put a windscreen over a stick microphone.** In addition to reducing plosives, a windscreen cuts down on heavy breathing. Oh yeah, and it can reduce the whistle of the wind when shooting outside too.

- **Use a wind muff on your boom microphone.** From a distance, this "wooly" accessory appears as though you're dangling a comatose squirrel on a pole over the subject. Its function is to reduce windy noise and plosives by nearly 10 dB. On the downside, it slightly diminishes high-frequency response, but that's hardly noticeable and acts as a fair tradeoff to the potential wind noise, pops, and whoosh.

- **Use a blimp.** Resembling a miniature version of its namesake, it comes in handy when conditions are really tough, like when you're recording a "poppy" talker or in a howling wind. Basically, it's a big hollow tube that fits around the microphone and creates a pocket of stillness around it by absorbing wind vibrations.

- **Stay out of the wind.** And now for the "keen sense for the obvious" portion of our show. Although all these accessories help reduce the intensity of wind when recording, there's no substitute for avoiding it when you can. Although the scene in Figure 10-1 looks serene, it was very noisy.

Figure 10-1: The audio from this Toronto scene shot from an airplane was too noisy to use and was replaced by a "cleaner" sounding track.

Using a Separate Sound Recorder

After you've decided what type of microphone works for your needs, you have a choice as to where you want to capture the audio. Some use a line mixer to accommodate a high-end XLR microphone and record directly to the same card capturing the image. Others opt to record audio separately on a specially designed device. Why would you want to record audio in a separate place? It provides the most control. That's why the pros do it that way.

Cameras used for making motion pictures are silent. Audio is captured on a separate deck for optimum quality. If it works for movies, it can work for you.

When using an audio recorder, consider the following:

✓ **Capture on the card too.** It's essential to record audio track on the camera card so that you can use it as a reference to match the better-quality audio in Premiere Elements before discarding the "weaker" track.

✓ **Choose the proper audio format.** Because audio capture is the primary function of a sound recorder, it offers a wide range of audio format choices. You need a format that works in the Premiere Elements timeline. Your best bet is to choose a .WAV file. You can capture an MP3, but the audio quality is not as good as a WAV.

✓ **Decide whether you want two or four channels.** Unlike the single channel of audio that many DSLRs allow you to capture, a dedicated audio recorder lets you decide on the number of channels and type of audio. You can select four-channel if you want — it provides more control at

various levels within the recording before *mixing down* (combining multiple channels).

✔ **Fine-tune your audio levels.** Before recording your audio, look at the meter on the unit to make sure levels are within range. Be sure the meters peak no higher than the +12 dB–level mark; otherwise, you'll get distorted sound. The art is finding the sweet spot on the meters that give you the best signal-to-noise ratio for each situation. Some recorders offer automatic gain control (to compensate for low or high audio levels), but like many automated controls, it can cause more harm than good when it's fooled by certain situations.

Getting Around Those Audio Pitfalls

Now that I've established that good audio enhances good video, here comes the hard part: actually getting good audio. Sometimes that's easier said than done, but things may not be as bad as they seem. If audio weren't an art, no one would need specialists like sound effects editors, sound mixers, and other pros who deal with all things auditory.

Working around limitations

Make no bones about it: So many things can go wrong when capturing audio that often success is often measured in eliminating as many "gremlins" as possible as opposed to getting rid of them all. The most irritating predicament comes from unwanted background noise. No matter where you are, something can ruin your audio capture. In urban areas, it's problems like screeching truck brakes, police sirens, or hum of an air-conditioning unit. In the country, it's rustling tree branches, crickets, or other animal sounds. Regardless, out on location, your microphone picks up an assortment of unwanted noises that distract from the primary audio. It's your job to reduce as many as possible.

To reduce these issues with white noise, try the following:

✔ **Keep an ear out.** Listen for noise patterns so you can shoot between traffic or wind gusts. Don't attempt to shoot near appliances, machinery, or air conditioning.

✔ **Get up close and personal.** At least with the microphone, that is. The more it's dominated by the subject's voice, the less chance there is for extraneous noise to affect recording.

Maintaining proper levels

In a perfect world, sophisticated sound capture comes from both watching the audio meters — so that levels don't peak — and listening to what you're capturing. Unfortunately, most DSLRs don't have a built-in meter. Of course, if you're using a separate sound recorder, you can watch its meters. You should also use headphones to monitor the sound.

Watching the meters

They look cool, bounce to the music, and have pretty colors, but those colors mean something. When levels rise, they hit the yellow area. And that's a great place to be. It means you have a reasonable level for the loudest sounds. When levels are too high, they hit the red. That's not good.

Normal audio levels generally ride under the 12 dB, but that doesn't mean that all levels are right smack at 12 dB. If that were the case, a scream and a whisper would have the same sound level. That's why you need to monitor levels so they are loud enough to be heard but soft enough to avoid *clipping* (distortion from audio levels that are too high). When they're recorded within range, you can easily adjust them in postproduction.

Using headphones

Regardless of whether the camera or mixer has an audiometer, you should always use headphones when recording and listen for unwanted sounds and distortion. If levels are too high, and there's no control to reduce it, you can move the microphone further away from the subject or be prepared to fix it in postproduction.

Staying close to the subject

There's a great line in the 1974 Academy Award–winning film, *The Godfather II,* when Michael recalls something his father, Don Corleone, told him: "My father taught me many things here. He taught me in this room. He taught me: Keep your friends close, but your enemies closer." Think of that advice when using a microphone. The closer the microphone is to the subject, the less chance there is for extraneous noise to pollute the audio track. That's why the pros use a microphone on a boom pole over the subject.

Here are some situations you may encounter and the right microphone for the job:

- **Capturing natural sound with a camera-mounted microphone:** It's important to get as close to the source as possible to record the best-quality audio. But that's not always possible, especially when you're using a telephoto lens to bring the action closer. It works for the visual aspect, but unfortunately it does nothing for the sound. So when you're using one of these little guys, it's important to stay close to the sound.

- **Stationary talking subjects:** If the subject is sitting, or at least not going to move away from the show, use a lavaliere microphone to assure the microphone is positioned at a consistent distance. This way, if the subject is far from the camera, at least the microphone will not be far from the subject.

- **Interviewing a moving subject:** Or any subject not sitting down. A great example is a red carpet interview or someone leaving a courthouse. Here you can use a stick microphone in front of someone's face. Be sure it's about six to nine inches from the subject's mouth, and be consistent. When you come closer or pull away, you alter the audio level, which is similar to raising or lowering the volume. You can also have your sound person hold a boom microphone over her.

- **Shooting a movie scene:** Be sure the sound person holds the boom microphone over the subject and out of camera range. Also, it should be held a consistent distance from the subject.

Seeing why two channels are good, four channels are better

The added task of using a separate device for capturing audio is well worth the trouble. Unlike the single audio track you capture on the camera card, a dedicated audio recorder gives you lots of choices to accomplish your audio goals.

One of its most prominent functions lies in an audio recorder's ability to capture up to four channels of audio. Depending on the model, you can use separate microphones or the DSLR's built-in microphone. Even when you're using the built-in mike, you can still capture four channels of audio. Although the recorder can make mono, one-channel, or four-channel recordings, the latter obviously uses twice the amount of memory as a two-channel stereo recording. Many users enhance the two tracks that work best for the movie and discard the others.

Audio file types

When you record directly to the digital media card, you don't need to worry about audio format. As long as you select the proper setting, say 44.1 kHz 16-bit or mono, you're good to go. But when you're using a dedicated, digital audio recorder, you have far more choices for file formats. Ah, decision, decisions.

Here's a brief rundown of audio formats work that with Adobe Premiere Elements:

- ✓ **AIFF:** The Audio Interchange Format is an uncompressed audio file type developed by Apple. You can select a variety of bit rates. Regardless of which one you choose, it works in your timeline to match up with your movies.

- ✓ **MP3:** Although it's an option on audio recorders, it's not a good one for capturing sound for your movie. The MPEG-2 Audio Layer III encodes audio in a lossy format, which slightly diminishes the quality.

- ✓ **WAV:** What AIFF is to Apple, the Waveform (WAV) audio file format is to Windows. This common, uncompressed audio format works on Macintosh and Windows computers and can be used in a variety of bit rates.

Adding Sound Effects

There's a big misconception that movie sound effects are all about crashes and explosions. Not true. In fact, every clear detailed sound you hear in a movie is often the result of sound effects editing. These include that crackling sound when the subject takes a draw from a cigarette, the clanking of wine glasses, or the accentuated sounds of someone typing on a computer. Although they often go unnoticed, these little sound details add to the overall effectiveness of the movie.

After you shoot your movie and are about to edit, feel free to go out there and find some "replacement" sounds for your movie. There are several ways you can go about this task.

Finding sound effects

Most sound effects can be sourced from sound effects libraries where they're often cataloged with precise descriptions such as *ricocheting bullet* or *rope*

with heavy weight swinging. You can also discover the perfect sound while perusing through some non-linear editing software applications, compilation compact discs, and on a plethora of free online sound effects sites.

Popular sound effects include

- Accelerating car
- Airplane sounds
- Beating heart
- Body blow
- Explosion
- Falling rain
- Glass breaking
- Honking horns
- Thunder
- TV channels changing

Here are a few web sites that offer free sound:

- www.soundbible.com/
- www.freesound.org
- www.audiomicro.com/free-sound-effects

Making your own sound effects

Although Hollywood movies have budgets that can support a large crew and specialist, chances are you're going to shoot your own movie and edit it too. Because you're wearing most of the hats, you may as well be sure you have the proper sound in your movie.

Here are some ways to create custom effects for your next movie.

- **Bats flying:** Open and close an umbrella to emulate the wing sound.
- **Blood and guts being torn out:** Get your inner zombie on by recording yourself gargling milk.
- **Breaking bones:** Gather some tree branches about a half-inch thick and use a bat to break them either by pushing or hitting. You can also break pieces of celery.

- **Crypt door opening (or closing):** Record this one in the bathroom by slowly sliding the lid across the top of your toilet tank.

- **Elevator door:** Instead of waiting in the lobby, you can produce a similar sound by closing a file cabinet drawer. And if you tap a bell, you can finish the effect.

- **Galloping horse:** Nothing works like clapping halves of a coconut shell.

- **Glass breaking:** The best way to make a glass-breaking sound is to drop a set of metal wind chimes on a hard surface. Afterwards, you can tweak the audio in Premiere Elements to match exactly what you need.

- **Kissing:** Take a sip of water and kiss your forearm. Alternate the sounds and sloppiness of the kiss to fit your needs.

- **Prop airplane:** Record a household fan from several different angles and layer them in Premiere Elements to get a multiple propeller effect.

- **Punching sound:** There are several ways to create this sound, including smacking a rolled wet newspaper with a rolled newspaper, or strike a watermelon with your fist. You can even slap pieces of celery.

- **Thunder:** Shake a large piece of sheet metal or acetate to create a thunderous sound.

- **Walking through leaves:** Crunch some potato chips or cornflakes.

Part III
Fixing It in Post

*S*cenes become much more effective when they're put together in a deliberate order. In Part III, I show you how to do that with Adobe Premiere Elements.

First you have to have an editing suite, and I cover how to make sure you have the right equipment and software for this processor-intensive chore. Then I show you how to import and arrange clips, add titles and transitions, and tinker with audio. Finally, I give you some suggestions for how to share your movie with others, and how to archive your movie files.

11

Building Your Editing Suite

In This Chapter

▶ Breaking down operating systems

▶ Understanding processors

▶ Selecting the right hard drive

▶ Choosing the right editing software

*N*ot too long ago, an editing suite actually required a suite. I'm talking about a room filled with so much electronic equipment that the electric company would smile each time someone turned it on, and where the wires would hum the theme from *Star Trek* while you were engaged deep in thought.

Inside this high-tech rat's nest were numerous video cassette decks attached to a bank of monitors. Between them was a controlling console with knobs and illuminated buttons resembling the helm of the ship in *Lost in Space.* Speakers, scopes, and piles of videotape adorned the area. And cables . . . lots and lots of cables!

Motion-picture editing used a similar-sized room but with very different equipment. Some had large handles with a pair of cranks mounted with film reels strung across either side of the bench with an illuminated viewer between them. Others used a *movieola,* which resembled a giant movie projector turned on its side. Whatever setup occupied the room, strips of film littered the floor. The table was littered with razor blades, glue, and a chopping device, and the smell of spirits pervaded the air. (Not the alcoholic kind — the kind for cleaning film and removing tape or glue.)

Turnkey video-editing stations

Turnkey video systems are dedicated editing machines that include the proper hardware, software, and peripherals. The idea is to buy it ready to use. (Actually, they're installed by a few over-priced technicians, but humor me for the sake of simplicity.) These ready-to-use systems also include advanced hard drive systems called RAIDs (redundant array of inexpensive disks) and dedicated PCI (Peripheral Component Interconnect) boards to access various video decks. Popular turnkey video-editing systems include Media 100 and Avid. Although they're still available, most users can build their own systems with relative ease.

Jump ahead to today. The computer sitting in your office can most likely accomplish those aforementioned tasks, in a virtual way, anyway, with the end result being not much different, and in some ways better, than editing done the old-fashioned way. All it takes is a machine with enough power under the hood (many of the newer consumer models are capable of it), along with little extra "juice" like a super-fast processor, an abundance of RAM, and some extra cache. With such a powerful machine, it's possible to discreetly recreate an editing suite on the top of your desk.

The desktop computer revolution brought non-linear video editing into the mix, but the transition didn't come easy. In the beginning, non-linear editing (NLE) was cost-prohibitive, with turnkey systems like Avid and Media 100 costing more than a luxury car ($50,000 or more). By the early 2000s, Apple's Final Cut Pro and Adobe Premiere emerged as viable alternatives thanks to fast computer processors and hard drive arrays fast enough to capture and play back video.

These programs, along with some more consumer-friendly applications, changed the landscape, allowing would-be moviemakers to edit their DV footage in the confines of their personal space as opposed to renting an editing suite. Then, advancements in laptop computer technology allowed news videographers to shoot and edit their packages in the field. We've come long way, baby.

Before I help you decide the best computer for the job, I begin by discussing the two primary operating systems: Mac OS and Windows.

Picking the Best Computer for the Job

The legacy of taking sides began somewhere between the time man first walked upright and lit the first torch. With such a lengthy appetite for "discussion," it makes the debate over Mac OS and Windows-based personal computers, or PCs, as they're affectionately called, seem fresher than summer linens just out of the dryer, despite decades of trash-talk.

Before I go any further, let me be completely transparent. I've been a Mac devotee since I bought my first Mac Plus back in the late 1980s. But I come to you as a diplomat of computer-based video editing. Working on both Macs and PCs for everything, including video editing, I'm not here to promote one over the other; rather, I want to discuss the virtues of each.

Computer platforms share much in common with candidates running for election. Sure, both have the same goal; they just happen to go about it differently. Vote Macintosh. Or choose PC. It doesn't matter which you choose because both are capable of getting the job done.

Although creative input comes from you, the computer needs to do its part facilitating the work behind the scenes, whether it's to create graphics, edit photos, or in this case, make a movie. Both platforms offer power at the core of your editing system; if you have a newer Mac, use that as your editing machine. Maybe you've always used a PC. If it supports the software, by all means, use it.

Although Macs and PCs get the job done, they do so differently, which begs the following questions.

Are you a Mac?

Or do you just think differently? Maybe you're a PC user taking a bite from the Apple. Whatever you feel, If you're a Mac aficionado, chances are, you'd rather fight than switch when it comes to your machine of choice for video editing, and for good reason. If you walk out of the Apple store with a computer, chances are you can start your movie not long after you plug it in.

I'm not saying it's not possible with a PC too, but it's not as likely. It has nothing to do with the integrity of the machine. Rather, it's because so many manufacturers make them using a potpourri of similar parts and different components as opposed to Apple, which is the sole maker of Macs.

Sleek and powerful, and with built-in software too, the Mac acts like a professional machine in the hands of anyone who chooses to tap its keys. If you just bought it, you've definitely already met the first aspect of moviemaking requirements.

Here's the current Apple lineup:

- ✔ **iMac series:** This popular all-in-one desktop computer, shown in Figure 11-1, includes enough computing power to edit HD video right out of the box. Available in two screen sizes, 21.5 and 27 inch, and a few configurations of the Intel Core processor, these aesthetically pleasing models are serious editing machines.

✔ **Mac Pro:** The big Kahuna comes in a tall aluminum tower and offers power robust enough to produce feature films or process CGI animation. But it's not light on the pocket, and you have to purchase the monitor separately. It's a durable workhorse for serious moviemaking, but for anyone breaking in, it is a bit overkill.

✔ **Mac Mini:** Once upon a time, or ten years ago, the aforementioned Mac towers were the only game in town when it came to moviemaking, and usually as part of a turnkey solution. That world still exists, but instead of a tower, it's a white cigar box called the Mac Mini. Be aware that the size and name are all that's diminutive with this one. With a healthy array of high-speed connections, you can attach fast-running hard drives, additional monitors, and other peripherals to these versatile machines.

✔ **MacBook Pro:** On the portable side, it's hard to have a more dedicated machine than the MacBook Pro. The Mac version of the laptop brings the power of a Macintosh to the field for capturing and editing anywhere. It comes from a long line of portable computers and includes a DVD burner and FireWire, Thunderbolt, and USB2 inputs. The MacBook Pro is available in three screen sizes: 13-inch, as seen in Figure 11-2, 15-inch, and 17-inch models. Each has a few configurations of processer speed and hard drive size.

✔ **MacBook Air:** The MacBook Air is a powerful, agile computer that weighs next to nothing and fits easily in a small bag. The Air series lives up to it moniker by depending heavily on wireless connectivity. In other words, it has no DVD slot and a relatively small solid-state hard drive. Still, it's a functional option, maintaining similar processor speeds to its big brother, the MacBook Pro, especially when connected to a faster, external hard drive.

Figure 11-1: The iMac 21.5" with Intel Core i5 processor.

Figure 11-2: A PowerBook with 13-inch screen.

Or are you a PC?

That's not meant as a wisecrack suggesting you are the portly guy from the popular Apple television commercial. It's just that not everyone is a Mac fan.

Some users feel PCs are better suited for their needs. Gamers, accountants, programmers, and the budget-conscious make it their machine of choice. One of the rallying cries of PC fans is that the computers are cheaper than Macs and provide more flexibility when it comes to configuration. The numbers certainly don't lie.

Hypothetically, if you took a group photo of the entire Mac-using nation on one side, and PC users on the other, the PC side would have about ten times the number of users as the Mac. More people own PCs, plain and simple. But if you narrowed the groups down even further to include only computers that were built to handle video, the disparity between Mac and PC owners would narrow. Instead of worrying about that debate, look at what you'll need to make a movie. You need something that's fast enough to process the quick data rate of movies. Because some PCs are sold for general use, not all are up to snuff when it comes to movie-making.

Software choices present another issue. Remember, the ubiquitous editing software Final Cut Pro is only available for Macs. Users wanting that experience came over the Macintosh side; other migrated over to Adobe Premiere, which runs on the Mac and on PCs. If you're going to use Premiere on a PC, just be sure that your PC meets its requirements before you jump in to editing.

Naming conventions out the windows

Although it's easy to name all the current Macintosh models, it's not possible when it comes to PC models. Numerous manufacturers make PC models, so it's harder to isolate specific machines. That's because unlike Macs, which are made only by Apple, numerous manufacturers make PCs. For that reason, screen sizes vary wildly. Dell, Toshiba, HP, and Sony are just four of the many manufacturers.

PC models come in the following types:

- **Desktop:** Towers are still pretty common in one form or another. Various configurations are available, from sparse to fully loaded. Better components include faster processors, soundboards, and high-speed inputs like FireWire 800 or USB 3.0.

- **All-in-one:** Becoming more common, these streamlined all-in-one models feature fast processing power, HDMI connectivity, and a large screen in one package. Although specifications and internal components vary with each maker, many models support video editing including the Sony Vaio L-Series with touchscreen technology and the HP TouchSmart. They range in price from $500 to $2,000.

- **Laptops:** Another wide swath of the PC market includes the laptop, as seen in Figure 11-3. Some models excel at HD video editing, whereas others clearly fall short of the runway. Check the specs to make sure a laptop can run Adobe Premiere Elements before you buy a model for editing your masterpiece. Because these portable units are made by a variety of manufacturers, basic components differ. Screen sizes vary from 10 to 19 inches.

Figure 11-3: A Dell laptop computer.

Operating systems

Mac OS X: Each version of OS X has been cutely named after a big cat. The latest incarnation, Mountain Lion, better known as version 10.7, offers a smooth, stable, and very cool work environment. Older versions, including Leopard (10.5.8), can run Adobe Premiere Elements.

Windows: Version 8 is the latest operating system for PC-based computers, and it includes advanced functionality for media support. Computers with Windows XP and Vista can also run Adobe Premiere Elements.

The systems are not that far apart

Although the basic operation of Macs and PCs differs, their internal workings have more in common than you think. For one, both platforms use the same processor, namely the Intel Core. Of course, some PC models use other processors too, including the Pentium, Xeon, and the AMD Athlon series. If your current model suffices, there's little difference in running Adobe Premiere Elements on a PC or a Mac, with the exception of a few changes to the shortcuts and keystrokes.

Understanding Workstation Requirements

Not all computers are useful when it comes to making movies. Some are clearly better suited to the task than others. For example, Macintosh computers using OS 10.4 are not compatible for making HD movies with Premiere Elements. The same applies to PC models that don't meet the application specifications.

Instead of concentrating on the negatives, look at the positives. Here's what you need to make movies with your computer:

- ✔ **Use a relatively new model:** Some computers are clearly more replaceable than upgradable. Although older computers still may be up for the task, some may lack certain functions or not include some important components. For example, an older iMac that doesn't include a FireWire 800 connection won't be usable with your new FireWire 800 external hard drive. Maybe you have a PC model that has a slower graphics card, or perhaps the configuration doesn't include a soundboard.

- ✔ **Fast processor speed:** Measured in hertz, processor speed is the brains of the operation. Although many newer machines offer a fast processor, some still may not be fast enough. And even when they are, speed alone

is sometimes not enough. Other factors include cache, RAM, graphics card, and some other factors influence overall speed. If you're not using a newer machine, be sure that the one you're using exceeds the minimum requirements to run Premiere Elements.

✔ **Large monitor:** When it comes to video editing, what you can get away with and what you need are two different things. Get as much real estate as possible on your desktop with the biggest screen you can afford. On a laptop, you're a bit limited, but still can use a nice-sized screen in the 15-inch range. You can also connect an additional monitor, or two, to increase screen real estate.

✔ **Sufficient RAM:** Sometimes you can't have enough of the stuff. It's what lets you run your processor-hungry video-editing software while toning a picture in Photoshop and updating your Facebook status. Quite simple, the more, the better, and because HD movie files require a lot of memory, buy as much as you can afford. Premiere Elements requires a minimum of 2 GB, but I would suggest at least 4 GB to get better performance.

Minimum speed need not apply

Processing a continuous video signal is an arduous task for a computer processor. As a result, not every computer is suitable. Some older machines can have processors that are too slow. Although they play video from the timeline when you add transitions or titles, the demand pushes them over the edge, playing with hesitation and dropped frames.

Consider the minimum speeds for using Adobe Premiere.

Windows:

✔ 2GHz or faster processor with SSE2 support; dual-core processor required for HDV or AVCHD editing and Blu-ray or AVCHD export

✔ Microsoft Windows XP with Service Pack 2, Windows Media Center, Windows Vista, Windows 7

Look before you leap, er, buy a PC

Carefully evaluate the components in any machine that you plan on buying. Some of those PC models with fast processors that look like a bargain may use other pieces that don't work as efficiently. If you're not sure, check the minimum requirements for Premiere Elements and make sure your computer meets each of them.

- 2 GB of RAM
- 4 GB of available hard-drive space to install applications; additional 5 GB to install content
- Graphics card with latest updated drivers
- Color monitor with 16-bit color video card
- 1024×768 display resolution
- Microsoft DirectX 9- or 10-compatible sound and display driver
- DVD-ROM drive (compatible DVD burner required to burn DVDs; compatible Blu-ray burner required to burn Blu-ray discs)
- DV/iLINK/FireWire/IEEE 1394 interface to connect a Digital 8 DV or HDV camcorder, or a USB2 interface to connect a DV-via-USB compatible DV camcorder
- QuickTime 7 software
- Internet connection required for Internet-based services

Mac OS:

- Multicore Intel processor
- Mac OS X v10.5.8 through v10.7
- 2 GB of RAM
- 4 GB of available hard-drive space to install applications; additional 5 GB to install content
- Graphics card with latest updated drivers
- 1024×768 display resolution
- DVD-ROM drive (compatible DVD burner required to burn DVDs; compatible Blu-ray burner required to burn Blu-ray discs)
- DV/i.LINK/FireWire/IEEE 1394 interface to connect a Digital 8 DV or HDV camcorder, or a USB2 interface to connect a DV-via-USB compatible DV camcorder
- QuickTime 7 software
- Internet connection required for Internet-based services

Number of cores

The number of cores in the processor plays a big part when it comes to editing video on your computer. A high number of cores in the processor allows you to do multiple things at once without sacrificing speed. The newest processors, like the AMD Fusions, have up to ten cores.

The nexus of processors

Both Macintosh and Windows computers share the Intel Core processor. These things thrive under the pressure of video editing. AMD has the Athlon, Phenom, and Fusion series exclusively for Windows-based computers. As for the Intel Core processors, the latest version is available in three basic types:

- ✔ **Intel Core i3:** The most basic model plays nice with video. Using four-way multitasking, it lets each core of the processor work on two tasks simultaneously. Video editing benefits significantly from this functionality. Also includes hyper-threading technology, which simply helps deal with all the tasks you throw at the processor.

- ✔ **Intel Core i5:** This slightly more enhanced version includes Turbo Boost, activated by the processor when the OS has more information to process.

- ✔ **Intel Core i7:** Core i7 is the most sophisticated of the Core line, and ideal for video. It offers the best performance and includes more cache to more quickly execute instructions.

Graphic cards

Building the screen image pixel by pixel, this translator between the computer and the monitor generates images on the screen. Think of the graphics card as a private contractor hired by the processor to build, rasterize, and redraw the screen. In the case of video, it accomplishes this task at a rate of 30 frames per second. Although most newer graphics cards suffice, you should either add a second card to increase performance and to connect multiple monitors, or see if the computer you're about to purchase offers the luxury of connecting multiple monitors.

Random access memory (RAM)

Providing temporary storage and working space for computer-related tasks, RAM is the kind of thing you can't have enough of. The more RAM you have, the smoother your computer runs, especially when editing video. Premiere Elements requires a minimum of 2 GB, but it's better to have 4 GB or more. And because RAM is relatively cheap, you can buy as much as you can afford.

Cache-ing out

Cache perhaps is the most overlooked component in high-speed computing. Every time you do something on your computer, the CPU gathers instructions to honor the request. Cache makes the processor faster when executing an action than the RAM; the processor uses three levels of cache to accomplish the task. The first is L1 cache, which is relatively small, but fast at anticipating the need. It's like eating a chocolate bar when you're hungry. Satisfying, yes, but just for a quick burst.

Next comes Level 2, which has a little more memory, but is slightly slower. Rounding out the processing efficiency is Level 3 cache. It has more memory than the others combined and, although slower at processing than Level 1 and Level 2, it's significantly faster than the RAM. The lesson here: A processor with adequate cache, especially at Level 3, is significantly faster at executing instructions than a computer with more RAM.

Spin your hard drive at 7,200, please

Not all hard drives are created equal, and why should they be? After all, they're used for different reasons. For the most basic use, an average hard drive does fine. But video makes higher demands on a hard drive. That's because most spin at 5,400 revolutions per minute (RPM), which is fast enough for saving your PTA newsletter, but often not up to speed (pun intended) for making movies. It's like driving in the slow lane as everyone on the left zips past you. Video requires a transfer rate of 100 MB per minute, generally using a drive spinning at least 7,200 RPM. And by the way, this is independent of the connection speed. Just because you're using FireWire or USB3 doesn't mean your drive spins fast enough to run seamless video.

Here are the possible drives you can use or add to your system:

- **Internal disks:** It's already in your computer, whether it's a desktop or laptop. On the plus side, some CPUs let you add a secondary drive. Negative factors of internal drives include excess heat and that you have to replace the drive or switch it to a different computer.

- **External disks:** Independent of the computer, these separate hard drives are available in various sizes and connections. Benefits include the ability to use it on different computers and faster access speed than internal drives. In addition, some are self-powered (through the USB, FireWire, or Thunderbolt connection), as seen in Figure 11-4.

- **RAID array:** An acronym for Random Array of Independent Disks, this group of hard drives connected to one another acts as a single unit for increased performance and stability. Figure 11-5 shows a single drive from an old RAID array used for an early version of Final Cut Pro. These were common a few years ago when a single drive wasn't fast enough or stable. These days, RAID systems are used on some high-end systems.

- **Scratch disks:** Not a disk at all, a scratch disk is the space allocated on your hard drive for temporary files, cache files, imported video, and other actions from the timeline (transitions, titles, effects, and so on).

- **SSD drives:** Solid state drives have no moving parts because they use flash memory. These drives are common in some newer laptop computers, like the MacBook Air. Because the drive is smaller than a traditional hard drive and has no moving parts, it allows you to read and write faster to the drive.

Figure 11-4: A Lacie portable hard drive spins at 7,200 RPM.

Figure 11-5: A Glyph 160 GB RAID disk.

Port types

Not quite the desert wine, yet this port serves interface between your computer and peripheral devices. More simply, it's where you plug things in. Most computers offer several port types, with USB being the most common.

It connects keyboard, mouse, drives, card readers, and many other peripherals. The back of a new iMac, as seen in Figure 11-6, shows them in order from left to right: USB, FireWire 800, and Thunderbolt.

Here's a basic description of ports common to both platforms:

✔ **USB:** Properly known as universal serial bus, this is one of the most ubiquitous means of connecting peripherals, including hard drives. The USB 2.0 connector transfers data at rates up to 480 Mbps, making it acceptable for the use with video. The next generation USB 3.0 transfers data at 625 Mbps. Although backwards-compatible (when it comes to previous USB technology), the computer needs to support the proper card and drivers.

✔ **FireWire:** FireWire is a high-speed connection standard on Macintosh computers and some PCs. Sometimes this connector goes by the aliases IEEE-1394, I.LINK, or Lynx. FireWire 400 transfers data at a rate of 400 Mbps. FireWire 800 has since replaced it, moving data at — you guessed it — 800 Mbps.

✔ **Thunderbolt:** Faster than a speeding bullet and definitely more versatile, Thunderbolt is Apple's newest interface connection. This unique technology provides two channels on the same connector with blazing transfer speed. How fast? About 1.5 GB per second times two channels. That's more than ten times faster than FireWire 800, and it has a great deal of bandwidth to go along with speed.

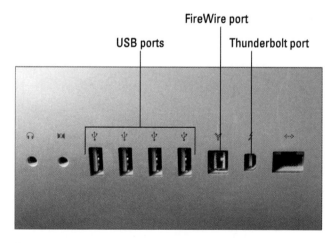

Figure 11-6: Multiple USB connections, a FireWire 800, and a Thunderbolt connection on the back of an iMac.

The Accessories Make the Outfit

When you go out on the town, you accessorize your wardrobe. Shouldn't the same be true for your workstation? Your workstation doesn't need watches or necklaces, but rather a variety of helpful peripherals.

Adding an additional monitor

When you're editing video, it's nice to look at something other the editing program's viewer windows. It's important to see the movie playing back on a slightly larger screen, especially if it's one that more closely resembles the type it will play on. The second monitor can be another computer display or a television monitor.

Adding a second monitor has gotten easier. Even if your computer doesn't have a connection on the existing video card or room for a second card, you can still connect another monitor using USB or Thunderbolt.

You can set the display as an extension of the desktop or as a mirror of it. In other words, you're either spreading the screen over two monitors or duplicating it. Both have specific uses.

Before adding another monitor, make sure your graphics card supports a second monitor or that the computer will accommodate a second graphics card for a monitor. Check to see whether it has a VGA, DVI, or Thunderbolt port. If so, you're good to go.

Here are some reasons for mirroring your desktop:

- Show your movie on a bigger screen.
- Demonstrate a lesson or task on your screen while it also plays on a larger one.

Why would you want to extend your desktop?

- Have more room for tools and extras when editing.
- Multitask without overpopulating your screen.

Connecting to a MacBook or Mac Mini

A second monitor easily connects to a MacBook using its Mini DisplayPort. Because it uses a smaller connector, you'll need a special adapter to make it work. On newer iMacs, the Thunderbolt port supports the Mini DVI port.

Use one of the following to connect an extra monitor to a MacBook or Mac Mini:

- ✓ **VGA (Video Graphic Array) adapter:** Lets you connect any standard analog monitor, projector, or LCD that uses a VGA connector.

- ✓ **DVI (Digital Visual Interface) adapter:** Allows you to connect a newer display that has a DVI connector. This provides better display quality than VGA.

- ✓ **Mini DisplayPort to VGA adapter:** Lets you connect a second display to a MacBook or any Macintosh with a Thunderbolt port.

To set up an additional display on Mac

Make sure you have the right connector and enjoy dual-screen bliss.

Here's how:

1. **Connect the display.**

 Use the appropriate connector and turn the display on.

2. **Go to the Apple menu and choose System Preferences.**

 You'll see a bunch of icons on the first monitor. By this time, you'll see your background image on the second monitor.

3. **Click Displays.**

 The main monitor allows you to select Display, Arrangement, and Color. The newly added monitor shows Display and Color. If it doesn't, select the Detect Displays button.

4. **Make adjustments on the second monitor.**

 Try your best to match the resolution, colors, and refresh rate of the first monitor.

5. **Decide what you need from the display — do you want the two monitors to mirror each other or for the second one to extend the first?**

 By default, the second monitor in the Display Preferences usually extends the first. You can even rearrange the orientation of the screens by dragging one over the other, as shown in Figure 11-7, by clicking the Arrangement button. Just drag and drop as you see fit. If you want both monitors to show the same screen image, click the Mirror Displays check box.

Figure 11-7: The Display⇨Arrangement screen.

Connecting to a Windows PC

Adding a second monitor to a PC is a little bit different than connecting to a Mac.

1. **Turn the computer off.**

2. **Connect the display.**

 Plug the monitor in the DVI or VGA port.

3. **Turn the computer and monitor on.**

 Windows looks for the monitors. Don't be alarmed if the new monitor doesn't turn on.

4. **Activate the second monitor.**

 Right-click anywhere on the screen and select Properties from the menu. Click the Settings tab, and you'll see two boxes that represent each monitor. Right-click the dialog for the second monitor and select Attached. Click Apply on the bottom dialog. After some churning, the second monitor comes on.

5. Decide what the monitors should do.

If you want to make a single screen between the two monitors, click the number two monitor and select Extend My Windows.

Keying in to keyboard types

Although the standard keyboard that came with your computer does the job, you may want to upgrade to one of the following:

- **Dedicated premiere keyboard:** With color-coded keys and written instructions, these keyboards familiarize you with shortcuts and keyboard action, plus they look pretty cool on your desk.

- **Wireless:** Bluetooth models free up a USB connection and allow you to move the keyboard out of the way without tangling cables.

- **Ergonomic:** Specialized keyboards designed to provide a more natural feel when typing and to reduce the causes of repetitive stress injury (RSI).

- **Keyboard overlays and stickers:** This inexpensive accessory lets you transform your basic keyboard into a customized one with dedicated key commands.

Of mice and men

In nature, an upgrade to a mouse is a rat. For video editing, it's called a shuttle, as seen in Figure 11-8. As an active part of the video-editing process, it guides you through the program interface, and of course the timeline, with relative ease. The jog shuttle is an important accessory because it lets you perform tasks closer to linear video editing — tasks that aren't possible with a mouse.

Reasons to use a shuttle control include

- **Easy scrubbing:** Lets you move through the content in forward or reverse (also known as *scrubbing*) more easily.

- **Preset application functions:** Instead of resorting to keystrokes for common functions, you can designate assignable functions.

- **Included on some keyboards:** Keyboards designed for video editing sometimes include a shuttle control.

Figure 11-8: A USB-powered jog shuttle.

Using a video cassette deck

These days, videotape is becoming scarcer than a telephone booth on a crowded street. Its demise is due in part to faster camera hard drives and Flash memory, especially with its ability to deal with high-definition video. But recording or digitizing from a video deck still has its uses. Also, at times, you'll want to mix footage types: For example, you may have a clip shot earlier in standard definition that you wish to include in your HD movie.

But sticking with tape doesn't mean using VHS. Put the VHS deck out with the bulk trash — that is, after you've digitized its contents on a stable hard drive. Here are two better options for staying with tape in the next short while:

- **HDV decks:** Relatively affordable and able to play back and record high-definition video, these come in handy occasionally, as seen in Figure 11-9. This format for recording high-definition video on DV cassette tape was designed as an economical choice for amateur and professional videographers. It easily connects to the FireWire port on Macs and PCs.

- **DV (Digital Video) decks:** At one time, Digital Video tape leveled the playing field between professional videographers and serious amateurs. The quality was marginally better than anything else that consumer hands could touch. That footage can be used in your movie, so if necessary, you can connect a DV deck.

Figure 11-9: A Sony HDV videocassette deck.

Picking the Software That Suits Your Needs

So many programs, so little time to learn them all. Basically, all non-linear editing software does the same thing. Use the correct program for your needs and budget, and your audience won't know or care how you did it. But there's quite a difference between producing a simple short film you hope to go viral and a more sophisticated documentary short. Here's a basic description of a few popular programs.

Checking out free software

If you own a Mac or a PC, you have a pretty decent moviemaking program already built in — iMovie for the Mac and Windows Live Movie Maker for the PC. That means in a pinch, you'll have something to edit your movie. But using these programs is on the same level as being hungry and settling for a bag of potato chips in the cupboard.

In any case, here they are:

- **iMovie:** Standard issue on Macintosh computers for more than a decade, iMovie, as seen in Figure 11-10, is a popular choice for amateur video editors for putting their movies together. It has tons of effects and full integration with other programs in the iLife Suite such as iTunes, iDVD, and iPhoto.

 Pros: It's easy to use and includes lots of functions and cool themes.

 Cons: It makes it hard to do more advanced editing like selecting a portion of a clip.

✔ **Windows Live Movie Maker:** Included with most Windows-based PC models, this powerful little program lets you easily make movies. It replaces Movie Maker, which was included on models before Vista.

Pros: It's intuitive to use and includes many fun effects.

Cons: It saves in only the .WMV format.

Figure 11-10: iMovie.

Using pro software

At one time, pro editing software was financially out of reach for many users. Then Adobe Premiere and Apple's Final Cut Pro came along and changed the landscape. Suddenly it was possible to bypass those mega-expensive turnkey-systems and instead install robust software on a fast-running computer to reap its benefits. And, the cost was affordable to serious users:

✔ **Apple Final Cut Pro:** Considered the *de facto* standard when it comes to non-linear editing, this is the one that defined the craft. Robust, powerful, and filled with every imaginable function, this complex video-editing program lets you do anything your creative brain can think of. And because it's open to capture or transfer just about any type of video format and export it with a great deal of flexibility, it's a necessary program to learn if you want to work in the business. No matter what you may use now, this one is the benchmark many employers consider when hiring.

Pro: If you can imagine it, you can do it with this hearty NLE on steroids.

Cons: It works only on a Mac. (Is that necessarily a bad thing?) Also, it has a steep learning curve to master.

✔ **Adobe Premiere Pro:** One of the oldest and most established non-linear editing programs on the market. Premiere was one of the first consumer-level, non-linear editing programs, and although it's gathered a devoted following, it's not had the impact of Final Cut pro. Still, Premiere provides the ability to help you edit professional-quality movies, and it integrates nicely with Adobe After Effects and Photoshop. Native DSLR Editing Presets on the newest version make it ideal for our kind of moviemaking.

> **Pros:** This full-function NLE runs smoothly on both Macs and PCs.

> **Cons:** It doesn't function well unless the workstation has more than the minimum requirement for RAM and a decent video card.

Exploring inexpensive options

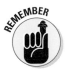

Besides Adobe Premiere Elements, which I use throughout the examples in this book, here are a few inexpensive non-linear editing programs that can get the job done. Although each varies in terms of features and operation, every one of them retails for less than one hundred bucks.

Check these out:

✔ **Sony Vegas Pro Movie Studio:** If you're looking for video-editing software that's affordable (around $69.99) and lets you edit pro-quality movies, there are worse choices than Vegas. Designed for the professional on the go, the program includes a healthy selection of effects for video, audio, and presentation to add the right touch to your movie. It also offers great audio capability to shape the sound of the movie, as well as a selection of "canned" soundtracks.

> **Pros:** It has lots of bells and whistles and 3D capability to boot.

> **Cons:** It doesn't offer the most user-friendly experience, but after you get the hang of it, you'll crank out some quality material. No Mac support.

✔ **Corel VideoStudio Pro X5:** An affordable program that handles HD video editing. Retailing for about $69.99, it provides quite the bang for your buck. Fast performance, multiple import and export choices, and 3D capability make it a viable option to edit your next movie.

> **Pros:** Affordable, powerful, and great stop-motion effects make it a great choice.

> **Cons:** It's a little cumbersome to operate, allows only four tracks of audio, and is available only for Windows-based machines.

- **Pinnacle Studio HD:** This consumer-level entry from Pinnacle offers a nice set of features. Don't expect it to have lots of bells and whistles, but what it does have assures you can make a successful movie.

 Pros: It's a solid performer with a wide range of features to create your movie.

 Cons: It's quite complex for an inexpensive program. No Macintosh support.

- **CyberLink Power Director 10 Deluxe:** One of the most feature-packed non-linear editing applications on the market. It's not just bells and whistles, but also an accelerator that works in conjunction with the computer processor for better performance. It's also quite intuitive to use. And did I mention it does 3D too?

 Pros: It has tons of functions and features for an inexpensive program.

 Cons: It only runs on a PC.

12

Getting to Know Adobe Premiere Elements

In This Chapter

▶ Discovering why Premiere Elements may work for you

▶ Setting up the program to match your needs

▶ Understanding the new features

After your footage is shot and your editing suite is set up, it's time to get to work. By work, I mean having fun making your movie. Putting it together is like assembling a giant jigsaw puzzle that you make up as you go along. Before you can get to the fun stuff, you have to set up the workspace to accommodate your needs before you can get to work on your movie.

Did I say work again? Well, it's fun work. Non-linear editing has the potential to be one of the most creative and accessible art forms. Think of your footage as nothing more than words, and the editing process is what helps shape the visual content to your vision. But in order to fully take advantage of it, you'll need to understand the landscape before fully immersing yourself in it. All too often, people import footage into a non-linear editing (NLE) program, assemble a couple of clips, and then wrongly assume they easily made a movie. Over time, they realize that only those basic actions are simple. It's not that these programs are really that hard to use. It's a matter of balancing an understanding of the software functions and limitations with the ideas you wish to present.

Premiere Elements can handle the task of making you look like a real filmmaker, and it does it rather smoothly. However, you must understand the landscape (the one on your computer screen with all the menus and commands) before you can take advantage of it. Think of it as walking before you run.

Getting the Concept of Non-Linear Editing

Once upon a time, video editing consisted of recording excerpts from one tape to another for assembling the sequence in the order that it should play. When things went well, it was a relatively quick process, but if the editor made a mistake, he would have to rerecord everything ahead of the point of change. It was reminiscent of the days of the audiocassette mix tape. If you wanted to add a new song after the opening track, you had to rerecord from that point.

In the motion picture world, there was a little more flexibility, but the movie was still put together in linear fashion.

Non-linear editing allows the user to assemble the movie in any order she chooses, if so desired. Start with the middle of the movie, and then work on the end before doing the beginning. Or add and swap scenes in a matter of seconds by simply dragging and dropping.

The reason non-linear editing works so well is because the movie file resides in a single place on your hard drive, and the program facilitates a reference though the clips in your project. You're not storing the actual movie there, just a proxy file. So you can drag it, drop it, cut it, copy it, and play it back smoothly as quickly as you can repeat what I just said.

You can play the movie from the program, but not anywhere else. The only way to play it anywhere else (web, DVD, another computer, and so on) is to export it. That's when the software puts it all together as a self-contained file.

Choosing from an Abundance of Non-Linear Editing Software

I doubt anyone has ever said: "I wish there were more non-linear editing programs." They're not in short supply. The market offers a wide range of applications that covers all price points from free to thousands of dollars, and a learning curve that ranges from intuitive to impossible.

And with good reason, because every user has specific needs for the software. For example, a professional editor requires robust software to facilitate her needs, whereas a novice looks to make simple movies based on personal documentation.

Some high-end, non-linear editing programs are so richly structured with features to accommodate the needs of the pro user, that they seem foreign even to some intermediate users, and completely leave the novice user in the dust. Conversely, some programs out there offer too little when it comes to features. Unless you just want to storyboard edit a series of clips and apply some

push-button effects to make it look cool, these overly simplistic programs are not for you either. Another deciding factor concerns the computer platform. Some software applications work only on a Macintosh computer, whereas others are written solely for Windows, thereby limiting your choices.

Deciding on Premiere Elements

With so many choices, why should you settle on Premiere Elements? The latest installment of Premiere Elements includes a wide range of improvements over previous versions related to both performance and capability. Among them is 64-bit implementation on the Mac with performance benefits in HD/AVCHD editing workflows. That means on a 64-bit machine, it can execute commands twice as fast.

New features include Temperature Tint, Opacity Blending, sharing to YouTube, AVCHD on DVD, and Object Tracking, just to name a few. You can read more in Chapters 13 and 14.

That's what makes Adobe Premiere Elements 11 a viable choice. It behaves the same on a Macintosh as it does on Windows. And although I show the examples in this chapter on a Mac, keystrokes and commands are similar on both Windows and Mac.

Breaking down the interface

The latest version of Premiere Elements offers a new user-friendly interface. It actually has two different looks, one for the beginner and another for the savvy user.

The interface consists of several parts:

- **Monitor panel:** It's where your movie plays in Premiere Elements. It shows various clip times and offers a full range of playback controls.

- **Interface drop-down menus:** Located at the top of the interface. It includes Add Media, Project Assets, and Publish and Share, as well as the buttons for Quick and Expert views. On the upper right, there's even a Save button.

- **Timeline:** The lifeblood of Premiere Elements is the timeline, where you drop, arrange, and enhance clips. The video at the *current time indicator,* or *CTI,* also known as the *playhead,* plays in the monitor panel.

- **Action bar:** The Action bar sits on the bottom of the screen and includes the following controls: the Organizer, Instant Movie, Tools, Transitions, Titles and Text, Effects, Music, and Graphics. You can also undo or redo an action.

- **Right side:** Provides access to the Adjust panel and Applied Effects.

Looking at the Quick versus Expert view

For beginners, Quick view presents a simplified interface with limited functions using a storyboard approach instead of a timeline. It allows new users to easily drop in successive clips and play them as a movie.

Advanced users work in the Expert view, which progressively exposes more complex workflows. Still, it's relatively streamlined in appearance, so it's easier to master without being confused. This quickly provides a comfort level with the software. This updated interface reorganizes features in two main views: Quick view and Expert view.

- ✔ **Quick view:** This simple approach, as seen in Figure 12-1, aggregates basic features that new users frequently use to edit their movie footage and share it with others. Users select options on the Action bar to accomplish common editing tasks. Movie clips are dragged into the timeline and appear as thumbnails, as opposed to various colored lines in the timeline that represent each clip.

- ✔ **Expert view:** Expert view provides advanced features and tools that professionals use to accomplish intricate video-editing tasks. Use the options in the Action bar to accomplish advanced tasks. Compared to the Quick view, the Transitions panel and the Effects panel in the Expert view, as seen in Figure 12-2, contain more options organized under various categories.

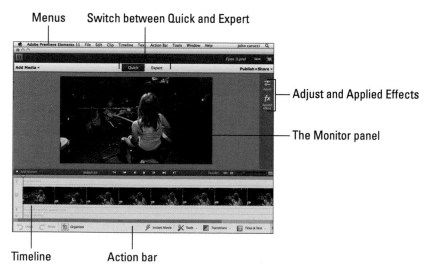

Figure 12-1: Quick view.

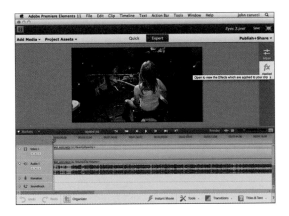

Figure 12-2: Expert view.

Checking out the new features in Expert view

The revamped edition of Premiere Elements offers many new features. Working in the Expert view, you'll notice the following new features. Many of these are also present in the Quick view:

- **Action bar:** Sits on the bottom of the interface and provides immediate access to common feature like Tools, Transitions, and Organizer.

- **Add media panel:** Provides quick access to adding media to project.

- **Adjust panel:** Lets you adjust the inherent properties of your clip using various controls.

- **Applied Effects panel:** Allows you to view the properties of effects already applied to your clip as well as providing options that enable you to modify those applied effects.

- **Drag-and-drop media in Quick view timeline:** It represents each clip as a thumbnail.

- **Instant Movie:** Lets you import clips to the project and has Premiere Elements do the work, theme and all.

- **Movie looks:** Provides effects that resemble the movies being shot on film.

- **Share panel:** Provides access to social media sites, DVDs, and others.

- **Split icon on current timeline indicator (CTI):** Lets you remove unwanted portions of the video clip directly on the timeline by splitting it removing the unwanted portion.

- **Time remapping:** Lets you alter the speed and direction of the clip.

- **Tools panel:** Provides easy access to tools simply by clicking button on Actions bar.

✔ **Tracks in timeline:** Allow you see them in Quick view and shows more in Expert view.

✔ **Transition contextual control:** Lets you tweak transitions in your clip.

✔ **Vignetting:** Adaptively adjusts the exposure of your clip, preserving the original contrast. It helps reduce the brightness or saturation of your clip at the periphery compared to the center.

Understanding the Requirements for Running Premiere Elements

With 64-bit support and advanced features, Premiere Elements works best on a relatively new computer. Here's what you need:

Windows

If you're running Premiere Elements on a PC, here's what you'll need:

✔ 2GHz or faster processor with SSE2 support; dual-core processor required for HDV or AVCHD editing and Blu-ray or AVCHD export

✔ Microsoft Windows XP with Service Pack 3, Windows Media Center, Windows Vista (all applications run native on 32-bit operating systems and in 32-bit compatibility mode on 64-bit operating systems), Windows 7, or Windows 8 (Adobe Premiere Elements Editor runs native on 32-bit and 64-bit operating systems; all other applications run native on 32-bit operating systems and in 32-bit compatibility mode on 64-bit operating systems)

✔ 2 GB of RAM

✔ 7 GB of available hard-drive space to install applications; additional 5 GB to install content

✔ Graphics card with the latest updated drivers

✔ Color monitor with 16-bit color video card

✔ 1024×768 display resolution

✔ Microsoft DirectX 9 or 10 compatible sound and display driver

✔ DVD-ROM drive (compatible DVD burner required to burn DVDs; compatible Blu-ray burner required to burn Blu-ray discs)

✔ DV/i.LINK/FireWire/IEEE 1394 interface to connect a Digital 8 DV camcorder

- ✒ QuickTime 7 software
- ✒ Windows Media Player (required if importing/exporting Windows Media formats)
- ✒ Internet connection required for Internet-based services

Mac OS

If you'll be using Premiere Elements on a Mac, here's what you'll need:

- ✒ 64-bit multicore Intel processor
- ✒ Mac OS X v10.6 through v10.8
- ✒ 2 GB of RAM
- ✒ 7 GB of available hard-drive space to install applications; additional 5 GB to install content
- ✒ Graphics card with the latest updated drivers
- ✒ 1024×768 display resolution
- ✒ DVD-ROM drive (compatible DVD burner required to burn DVDs; compatible Blu-ray burner required to burn Blu-ray discs)
- ✒ DV/i.LINK/FireWire/IEEE 1394 interface to connect a Digital 8 DV camcorder
- ✒ QuickTime 7 software
- ✒ Internet connection required for Internet-based services

Supported formats

Adobe Premiere Elements supported import/export formats include AVCHD, Blu-ray Disc (export only), DV-AVI (import/export on Windows, import only on Mac OS), DVD, Dolby Digital Stereo, H.264, HDV, MPEG-1 (import only), MPEG-2, MPEG-4, MP3, QuickTime, Windows Media (Windows only), and many more. Import/export of some formats may require activation via an Internet connection. Activation is fast, easy, and free.

Looking at the Timeline

Depending on the view, Premiere Elements shows different amounts of the timeline. In Quick view, the timeline basically shows a thumbnail of the clip. To keep things simple, it doesn't allow for much else than to assembly-edit your movie. (An assembly-edit is an unrefined edit.)

For your purposes, work in the Expert view so that you'll have all the features at your disposal. Click the Expert view at the top center of the main Premiere Elements window (refer back to Figure 12-1) to get the full timeline. The stock timeline supports three video and subsequent audio tracks along with a narration track and one for soundtrack, as seen in Figure 12-3. Adding media is as simple as clicking the giant billboard that sits in the middle of the interface. You'll have access to it until you import your first assets into the program. Other than that, it's a pretty standard timeline.

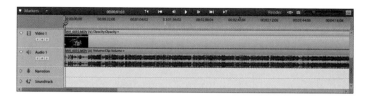

Figure 12-3: The Expert view timeline shows everything from transitions to audio waveforms.

The Organizer

Accessible directly through Premiere Elements, this organizational application shows the audio, video, and image assets available for your movie. It reduces the time needed to search for different audio and video clips. In addition, it allows you to create projects from those assets, as well as share them using a variety of services including Facebook, YouTube, and burning a DVD. It's accessible from the menu as well as the bottom of the timeline.

Tooling around

Premiere Elements offers a lot of cool tools, accessible either through the Tools drop-down menu or a button menu on the timeline. These include the following:

- ✔ **Adjustments:** Provides a series of tools to adjust the inherent properties of your clip like color, exposure, lighting, and others. And for quick fixes, the Smart Fix tool can easily enhance the quality of your video footage.

- ✔ **Audio Mixer:** Lets you control the audio of each track.

- ✔ **Beat Detect:** This feature enables you to adjust your scenes according to the beat of an audio track.

- ✔ **Freeze Frame:** Lets you to grab a single frame from a video clip to use as a still image in your movie.

- ✔ **Movie Menu:** Provides several template choices for making your movie a DVD.

- **Narration:** Accesses the tools needed to create a voiceover track for your movie.

- **Pan and Zoom:** Lets you apply the pan and zoom effects to your movie clip.

- **Smart Mix:** This audio mixing control facilitates automatic adjustment of the volume of the background music to enable hearing the foreground dialogs.

- **Smart Trim:** Enables you to enter the Smart Trim mode and easily trim clips.

- **Time Remapping:** Lets you play sections of your footage at variable speeds, such as slow motion, fast motion, reverse motion, or a combination of speeds.

- **Time Stretch:** Allows you to let the clip play faster or slower.

Bringing in the media

Adding media with Premiere Elements is as simple as firing up the program and clicking the Add Media panel in the middle of the screen. You can't avoid seeing it. It's staring you right in the face when you launch the program. And until you actually import something, it prominently stares in your face, daring you to add a file. Click it, and it prompts you.

But that's not the only way to add content to your project. Premiere Elements offers other ways to bring content into your movie. You can choose the pull-down menu at File➪Add Media From and choose a variety of ways to bring files from a variety of places.

You can import footage from the camera, transfer it from the media card, or import an existing file on your hard drive. These self-explanatory choices include

- Elements Organizer

- Movies from a flip or camera

- DV camcorder

- HDV camcorder

- DVD camera or computer drive

- Webcam

- Photos from cameras or devices

- Files and folders

Importing video files

You can grab content from lots of places on your computer, but more than likely, you'll be opening existing movie files or transferring directly from your camera. Files that you add to a project are visible in the Media view and are automatically added to the Organizer.

Ingesting from camera

When you plug your camcorder into your computer, you'll be able to import footage directly into the program. Just go to File⇨Add Media From⇨(pick the choice you need) and follow the prompts.

Setting your scratch disc

The key to building a successful video-editing suite lies in how well it's organized. That begins with setting up your scratch disc. A *scratch disc* is a place where the program saves temporary data. This is essential for non-linear editing programs, which require a lot of temporary and permanent space. In a perfect world, you should use a drive other than the one the software resides on as a scratch drive.

Whenever you edit a project, Premiere Elements uses hard drive space to store temporary information required for the project. The files of temporary information are called *scratch files.* These include video, audio, and conformed audio. The program uses the latter, along with preview files, to optimize performance, allowing real-time editing, high-processing quality, and efficient output.

By default, scratch files are stored where you save the project, but that's not always the best place for it. Ideally, you should use a separate hard drive to save your movie.

Premiere Elements allows you set scratch discs for the following:

- Captured video
- Capture audio
- Audio previews
- Video previews
- Media cache
- Disc encoding

To specify where the programs saves each scratch files, do the following.

1. **Go to Adobe Premiere Elements 11 Preferences⇨Scratch Disks as seen in Figure 12-4.**

2. **Click the Browse button and navigate to your external hard drive.**

3. **Repeat Steps 1–2 for the others.**

Figure 12-4: The pull-down menu for Preferences.

Implementing an Efficient Workflow

Organization goes beyond setting up your editing suite; it also pertains to putting your movie together. The more you know where your assets are located and named, the easier it becomes to efficiently make your movie. The first step to creating an efficient workflow is setting your preferences.

Setting Preferences

Go to Adobe Premiere Elements 11⇨Preferences.

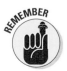

In the Preferences dialog, as seen in Figure 12-5, you can adjust many aspects of how Elements works. You can go with the default settings or adjust them to your needs:

✔ **General:** This panel controls multiple preferences. The most prominent ones allow you to alter the transition and still-frame duration. It's not a bad idea to extend both slightly, especially still frames, which at the default 120 frames stay on the screen for either two or four seconds, depending on whether you are working in 60 or 29.97 frames per second.

✔ **Audio:** The defaults here are fine.

✔ **Audio Hardware:** Controls whether you're using your internal speakers or audio output using a specialized board. If you're plugging in speakers, leave it on the default setting.

✔ **Auto Save:** Automatically saves a copy of your project at a duration that you specify in a separate subfolder titled Premiere Elements Auto-Save, which is located in the folder containing your current project file.

✔ **Capture:** Alerts you if the ingesting footage has dropped frames, and lets you decide whether to abort capture when it happens. Unless you're ingesting tape, you can ignore these settings.

✔ **Device Control:** Leave these settings on default, unless you're connecting another device like a deck.

✔ **Media:** Allows you delete cache or show, or not show, time code or media in or out points. The defaults here are fine.

✔ **Scratch Discs:** Lets you set destinations for video, audio, cache, and other aspects of the movie.

✔ **Stop Motion Capture:** Lets you adjust the opacity level, number of skins, and the playback frame rate.

✔ **Titler:** Offers a single field for style. The defaults are fine.

✔ **Web Sharing:** Allows the option to check for online services.

Figure 12-5: Premiere Elements lets you adjust a wide range of areas.

Setting up your movie

Now that you have your movie clips all ready to go, it's time to bring them into the system. After firing up Premiere Elements and setting your scratch disc information, if necessary, be sure to click the button to work in the Expert view.

It's a good idea to start a new project for every movie. Go to File⇨New⇨Project. When the dialog opens, name your movie and save it where you normally save your files, as seen in Figure 12-6.

Adding media is as simple as clicking that billboard in your face. Still, I prefer clicking the Import button on the left side because it doesn't disappear after the first import.

Select the type of media you're looking for, and a dialog pops up. For example, if you click Files and Folders, just navigate to the clip that you want and click Get Media. It goes into your project bin. After you drag all your assets into the bin, you can start work.

Figure 12-6: Navigating the File menu.

Customize your workspace

Because the Premiere Elements interface is relatively straightforward, you have little reason or ability to customize it. The interface consists of a series of panels. You can adjust their size and placement by dragging the edge of the panel, as seen in Figure 12-7.

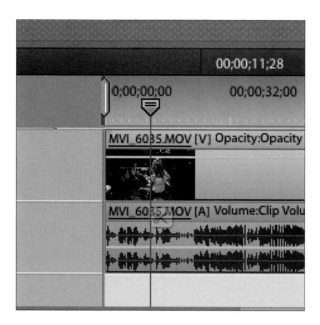

Figure 12-7: Grabbing the bar allows you alter panel sizes to increase or decrease timeline and monitor sizes.

Save early, save often

I can't overstate this: Name your project right away and save it often. This way, you'll protect yourself when the gremlins of power surges come calling.

Looking at Premiere's Key Features

Take a look at some of Premiere Elements key features so that you can dazzle your audience with your next movie.

Instant Movies

No doubt you're looking for an easy way to edit movie clips. The Instant Movie feature is pretty cool. Putting a movie together takes lots of time, and for some, that's a reason to leave the days' take in the Land of the Misfit Clips — they have no time to edit.

Premiere Elements simplifies the process with its Instant Movie effect.

All you need to do is

1. **Import the clips into a project.**

 Make sure they all are related to your movie.

2. **Click the Instant Movie button.**

 It's on the Action bar at the bottom of the interface, as seen in Figure 12-8.

3. **Choose one of the themes.**

 The themes range from Fairytale and Broadway to Music Video and Newsreel, as seen in Figure 12-9. The first time you select one, the program downloads content for the effect. This may take a few minutes.

4. **Personalize the movie.**

 You can name the movie, add personal information, and even tweak the music, speed, duration, and theme parameters, as seen in Figure 12-10.

5. **Check out the effect.**

 In the Comic Book mode, notice the panels created by the program, as seen in Figure 12-11.

Figure 12-8: The Instant Movie button.

Figure 12-9: Instant Movie offers more than 40 choices.

Figure 12-10: Instant Movie lets you add information and tweak the instant process.

Figure 12-11: A comic book–style movie, created with Instant Movie.

Transitions

Transitions are a marriage between two shots without the disagreements of a real one. They are key to your movie, and Adobe Premiere Elements provides a nice selection, such as 3D Motion, Dissolve, Iris, or Page Peel. A search box lets you enter the name of the one you're looking for, as seen in Figure 12-12.

Figure 12-12 shows the available variations of the NewBlue Motion Blends Elements effect, which include Roll, Shake, Shear, Smear, and others.

Premiere Elements offers the following sets of transitions, each with variations of the effect:

✔ 3D Motion

✔ Dissolve

✔ Iris

✔ NewBlue 3D Explosion Elements

✔ NewBlue 3D Transformation Elements

✔ NewBlue Art Blends Elements

✔ NewBlue Motion Blends Elements

✔ Page Peel

✔ Picture Wipe

✔ Slide Wipe Audio Transitions

Figure 12-12: Some choices for transitions.

Video effects

For such a low price, Premiere Elements has an abundance of features. It has functions that improve video quality such as Image Control, Color Correction, and Video Stabilizer. Creative effects include Keying, Stylize, and Perspective. In addition, three different NewBlue plug-ins are built in to Premiere Elements. These include Art Effects, Cartoonr, and Film Look.

Here is the complete lineup of effects for Premiere Elements 11. Each offers multiple choices:

- Advanced Adjustments
- Blur and Sharp
- Channel
- Color Corrector
- Distort Generator
- Image Control
- Keying
- NewBlue Art Effects
- NewBlue Cartoonr Plus
- NewBlue Film Look
- Perspective
- Render
- Stylize
- Time Transform
- Video Stabilizer
- Video Merge
- Audio Effects
- Presets
- Film Look
- My Presets

Audio features

It's no secret that without audio, video has little impact. But great audio depends on many factors. Fortunately, Premiere Elements provides lots of control when it comes to audio. The timeline includes audio waveforms under each clip to not only show you the peaks and valleys, but also allows you to adjust overall volume. Other audio controls allow you to fix noise, add a sound effect, or record a voiceover track.

Found under the Effects button, here are the audio transitions:

- Channel Volume
- Delay
- Fill from Left
- Fill from Right
- High Pass
- Invert
- Low Pass
- NewBlue Audio Polish
- NewBlue Auto
- NewBlue Cleaner
- NewBlue Hum Remover
- NewBlue Noise Fade
- NewBlue Noise Reducer
- Notch
- Swap Channels

Making titles

Just about every movie from documentary and features to shorts and news segments uses titling. The Titles and Text, as seen in Figure 12-13, includes a wide range of static and motion titles to add a little pizazz to your next movie. Use them to identify people onscreen, make rolling movie credits, or make a motion graphic like you see on television. It's all possible with a little understanding and a lot of practice.

With this feature, you can

- Make a news ticker.
- Apply specific titles for special occasions.
- Use templates for music video, Broadway, and television themes.

Figure 12-13: The Broadway title theme is one of many choices.

Making Your Movie

*A*fter you have a lay of the DSLR land, it's time to begin making your movie. But that process doesn't involve just slapping a bunch of clips together and calling it a night. Well, it does, if you're looking for the fast-food equivalent of a movie. You can go that route, or you can properly organize all of your elements. It's sort of a pay now or pay later kind of thing.

The road to moviemaking bliss begins with creating a project for all the elements of your movie. That means you should gather all of the movie clips, audio, and photos that are relevant to the movie together in the same place. Understanding how to get those clips into the system becomes the first of many steps to making a digital movie. If you've never done it before, you may find the path daunting.

After you've got your clips organized, you can pursue the fun side of the process; in other words, putting the movie together. This chapter covers the basics of making the movie, starting with the project, and ending with the title.

Creating Your Movie Project

You can't haphazardly import random clips from your hard drive and then drag them into a movie timeline and expect something good to happen. Here's a little secret . . . it won't!

Instead, you need to use your organizational skills. Or better yet, take advantage of Premiere Elements and keep all the assets from a particular project in the same place. That means you should create a separate project for every movie you want to work on, publish, or save for later.

Starting a project is easy. Just go to File⇨New⇨Project to make a new one. After that, you have to give it a name, preferably one that has something to do with the movie. You can call it *The Last Kiss* or *Debbie*. It doesn't matter. Just name it and click OK.

Some things to note about projects:

- **Open one at a time:** You can only have one project open at a time.

- **Don't mess with the file:** The project file references the videos, pictures, and titles in the project. When you reopen the saved files, you'll notice that the project file is relatively small. That's because it doesn't include the actual *assets* of the project; instead, it just references those files. That's why you should never, ever move, delete, or rename the saved file. Otherwise, Premiere Elements won't able to find them.

- **Use Recent Projects:** It keeps track of the last five projects you've opened.

Whenever you create a new project, Premiere Elements uses a pre-determined profile or preset. It's actually a default of the last one you created, if you created one. These settings determine the properties of your project assets, including audio and video. These determine file format, the source of the file, and the aspect ratio. Other settings include Bit Depth, Audio Sample Rate, Frame Rate, and Field Dominance (upper or lower field first).

To access these options, click the Change Settings button after beginning a new project to modify profile settings. After opening, you'll see the New Project dialog, as shown in Figure 13-1. It lets you name the project and save it in a specific place. In addition, it allows you to modify profile settings.

Some things you should consider:

- **Use the DSLR profile:** If you're going to primarily use footage captured with your DSLR, choose the DSLR profile.

- **Be positive of the setting:** You can't change the project preset after you start the project, so verify the format of your source footage before selecting a project preset, as shown in Figure 13-2.

✔ **Find ways around the preset commitment:** If you specify lower-quality settings for output, you don't have to worry about tinkering with the project settings. Instead, change your export settings.

✔ **Understand that the selected preset becomes the default:** After you change the preset, all new projects default to using it.

✔ **Realize that Premiere Elements adds presets:** When you add a movie clip whose preset does not match the project's preset, a message appears asking to let the program change the project's settings to use the closest available preset.

Figure 13-1: Project settings.

Figure 13-2: Premiere Elements offers many profile choices.

You will have no problem converting or rendering footage shot with your DSLR. Just be sure to select DSLR 1080P preset when creating your project. Make sure you choose the setting that matches the way you captured the footage.

You have three choices, as seen in Figure 13-3. Make your choice and click OK:

- ✔ DSLR 1080p24
- ✔ DSLR 1080p30
- ✔ DSLR 1080p30 @ 29.97

Figure 13-3: The DSLR mode also offers other resolution choices.

Putting It All Together

After starting a new project, you're ready to assemble your movie. Now in a perfect world, that would mean you would just drag and drop clips on the timeline and finish the movie in no time at all. Actually, that's done in Instant Movie, but just as with coffee, instant isn't as good as the one that takes time to brew.

Successful movie editing starts with importing relevant content for the movie. That means all the clips associated with your documentary on the lady who collects John F. Kennedy memorabilia and displays it in her window like a diorama should not be confused with footage of your sister's dance recital.

If you use your DSLR to capture movies, you can capture directly from the camera or by using a card reader. Because a card reader is the primary means of importing content for DSLR moviemaking, I'll start with it.

Transferring content from the camera card

Depending on the camera that you're using, chances are that you're capturing your movie either on a CompactFlash (CF) or Secure Digital (SD) card. Many newer computers include a built-in SD card reader. If your computer doesn't have a built-in reader, or if you're using a CF card for video capture, you can easily use an inexpensive card reader.

Here's how to transfer video:

1. **Connect the digital media card.**

 Whether you're using the built-in reader or an external card reader, pop in the card.

2. **Make sure the card is mounted.**

 Go to Add Media From⇨DVD Camera or Computer Drive. The Video Importer dialog appears, as seen in Figure 13-4. It shows you thumbnails of the importable clips. It even has a viewer to go through them. In addition, this dialog includes options to make an InstantMovie or import directly to timeline. Leave both boxes unchecked.

3. **Import the clip.**

 After clicking the clip or clips that you want, click the Get Media Button, and the footage is ready in the Project Assets folder.

Figure 13-4: The Video Importer dialog.

Importing movies from a hard drive

Another source of movie content comes from clips you've captured in the past that now reside on your computer hard drive or an external drive. Importing these clips is relatively easy. Just do the following:

1. **Go to Add Media From⇨Files and Folders.**

2. **Navigate to the desired files and select them.**

 To select more than one, hold down the Apple key on a Mac (as seen in Figure 13-5) or the Ctrl key on a PC as you click the desired files.

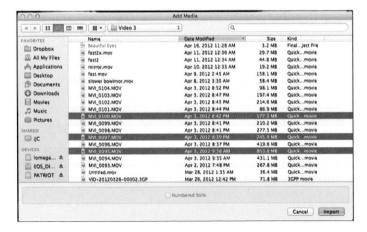

Figure 13-5: Selecting multiple files.

Dragging and dropping in the timeline

After loading your Project Assets folder with content, it's time to get to work. Making a movie is as simple as finding the proper clips and dragging them to the timeline in the order you want them to play. Just mouse over the desired file, click the mouse, and hold it while dragging to the desired spot.

Setting ins and outs

Rarely will you ever need to use the entire clip. True, some situations warrant it, but most of the time, the essential part of the scene is sandwiched in between parts of the scene that you have no plans to use. In order to isolate the key part of the footage, set In and Out points. These refer to parts of the scene that you want the clip to begin and end, respectively. The changes are only for reference and not permanent. In other words, the footage outside the In and Out points is not deleted, so you can change the In and Out points to have access to the entire clip if you change your mind.

To set In and Out points, do the following before dragging the clip into the timeline:

1. **Double-click the selected movie file in the Project folder.**

 A dialog pops up with a preview window, as seen in Figure 13-6. It shows the clip and controls like those of a VCR or tape recorder

2. **Determine the starting point of the clip.**

 Drag the CTI (Current Time Indicator) to the point that you want the clip to begin, as shown in Figure 13-7. It looks like a blue home plate shooting a red laser. You can also drag the Trim handles to the desired start and end points.

3. **Set the In point.**

 Click Set In on the bottom of the dialog, or simply type the letter **I**.

4. **Determine the ending point of the clip.**

 Click Set Out on the bottom of the dialog, or simply type the letter **O**.

5. **Drag the clip to the timeline.**

 Repeat for the others.

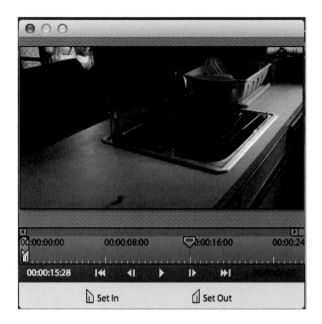

Figure 13-6: The preview window.

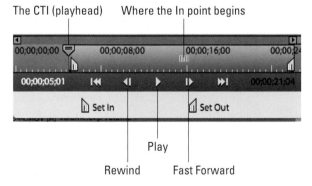

Figure 13-7: The rakehead-shaped icon shows where the In point begins.

Trimming it, scrubbing it

In a limited way, Premiere Elements allows you to scrub through video and audio footage (play potential clips faster to find key spots). You do this to quickly find the part of the clip you wish to include in the video. Just double-click the video in the Project Assets folder. When the preview window controls, as seen in Figure 13-8, pop up, do one of the following:

✔ Click the Play button for playback.

✔ Click the step buttons to move forward or backward (depending on the one you select) a single frame.

✔ Fast forward or rewind to go through the clip. Click on the button to speed it up and scrub through timecode.

✔ You can use the J, K, and L keys on your keyboard to rewind, play, and fast-forward, respectively.

Figure 13-8: The preview window controls.

Using Smart Trim

There are many reasons for isolating a clip section, including finding an exact moment. But another more common reason has to do with problematic foot-age. Maybe the camera work was shaky in the beginning or the tripod head drooped. It doesn't matter what happened — your only concern is to keep it out of your movie. At the same time, you can manually select the "prime" part of the scene. Premiere Elements offers many ways to accomplish this task. You can do it the aforementioned manual way by setting ins and outs and dragging the good stuff into the timeline. Or you can let Premiere Elements do the job for you, with the Smart Trim feature. It can automatically handle blurred, shaky, low-quality, and low-interest sections of your video clip. Of course, with all automated functions, it's not perfect. Still, it can separate the wheat from the chaff on long clips.

There's two ways to use this feature: automatic and manual. I would suggest opting for the latter. This way, you can specify the parameters for selections. Using the automatic mode, the program automatically determines sections you can trim.

To use the manual Smart Trim, do the following:

1. **Access the Smart Trim feature.**

 Go to the Actions Bar and click Tools. After the panel pops up, navigate to Smart Trim, as seen in Figure 13-9. By default, Manual Smart Trim Mode is enabled. It will analyze the clip.

2. **Adjust the feature options.**

 Click the Smart Trim Options button on the top right of the interface, as seen in Figure 13-10. After the dialog opens, adjust the slider to

specify the options as well as setting it for automatic or manual smart trimming. Depending on the Quality and Interest values you choose, it highlights sections of the clip. Striped patterns emphasize the areas to trim. Quality factors include blur, shaky, brightness, focus, and contrast. Interest factors include faces, camera moves, and close-ups.

3. Select the trim sections.

Double-click the clip to select all the area you can trim in a single clip. You can also select sections in multiple clips by dragging the marquee over the desired clips and right-clicking or Ctrl+clicking (Option+clicking on the Mac) the trim sections. You'll see the selected trim sections are highlighted. When you select a section, all trimable sections turn into blue-striped sections, as seen in Figure 13-11.

4. Make a selection.

After right- or Ctrl/Option+clicking the selection, the Smart Trim options, as seen in Figure 13-12, pop up on the screen. Select the one you need for the clip or just click the striped part and delete.

Figure 13-9: The Smart Trim feature.

Figure 13-10: The Smart Trim dialog.

Figure 13-11: Blue stripes represent areas deemed trimable in manual mode.

Smart Trim Options

Quality Level:

Interest Level:

Mode
◉ Manual ○ Automatic

Cancel Save

Figure 13-12: Smart Trim options.

The Smart Trim Options button appears on the upper-right corner of the interface. Here are brief descriptions of these options:

- ✔ Trim: Trims the selected trimable section
- ✔ Keep: Retains the selected trimable section
- ✔ Select All: Selects all the trimable sections in the current selection
- ✔ Smart Trim Options: Provides the same access as clicking the button

Other things you should know:

- ✔ **Smart Trim is not perfect.** It often designates parts of the clip that are technically acceptable for removal. For example, panning the camera and movie subjects can confuse it.

- ✔ **You cannot use Interest as the only factor.** Interest and Quality factors work together. Trim sections get shorter when you move the slider from right to left. A clip that is low in Quality or Interest gets trimmed. A clip that is high in Quality or Interest doesn't get trimmed.

- ✔ **You can also trim clips using the Delete key.** Just select the clip and press Delete.

✔ **Undo the previous trim action.** Right-click or Ctrl+click the clip and select Undo Smart Trim.

✔ **Exit the Smart Trim mode.** Click the Done button.

Adding tracks

One of the perks of working in Expert mode is the ability to add additional tracks in the timeline. The timeline represents your movie project as a series of vertically stacked video and audio clips, with the video clip on the top track taking precedence. You can layer video or audio and add effects, titles, soundtracks, and more. Multiple audio tracks let you add narration, background music, and sound effects to different tracks. The movie combines all the video and audio tracks and plays them in sequential order.

You can add tracks by going to Timeline➪Add Tracks, inputting what you need to add in the dialog, and clicking OK, as shown in Figure 13-13. Under the same menu is the option to Delete Tracks as well.

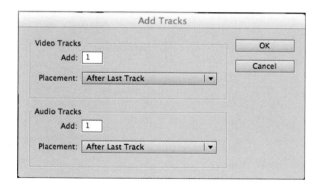

Figure 13-13: The Add Tracks dialog.

Reasons to add multiple tracks include

✔ Creating a transition

✔ Adding special effects

✔ Superimposing two clips

Here's more information on tracks:

✔ **Markers:** You can add markers for reference purposes, found on the top left of the timeline. You can set various markers, including numbered ones, through Timeline Marker mode.

✔ **Default setting:** In Expert view, the timeline consists of three videos and one audio track. It also includes a narration and sound track.

✒ **Zoom controls on timeline:** Found on the right side of the timeline, this set of buttons and slider let you see all the arranged clips without scrolling through the timeline.

Resizing tracks

When it comes to track sizes, we're all a little like Goldilocks: We don't want them too big or too small, but just right. Some of us like them big, so to see them more clearly. Others like them small, especially when they're working with multiple tracks on the timeline and don't want to have to scroll all the time.

For that reason, they come in three basic sizes, as seen in Figure 13-14. They include

✒ **Small:** Ideal for projects with layers of multiple tracks

✒ **Medium:** The default size offers something for everyone — well, almost everyone

✒ **Large:** Great for viewing clip thumbnails and adjusting the volume and opacity directly

To change track size, right-click or Ctrl+click an empty track on timeline and choose Track Size.

You can also display clips in the timeline based on your preference. For video tracks, you can show the thumbnail image at the beginning of the clip or for the entire duration. Audio tracks show the waveform by default, but you can hide it too.

Click the Set Video Track Display Style button or the Set Audio Track Display Style button at the left corner of the track. Each time you click, the track's display style toggles to a different view.

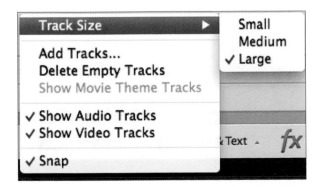

Figure 13-14: Track size choices.

Assembling the edit

You can work in whatever order you deem acceptable, but it's a good idea to build the movie in sequential order. You can always add stuff in specific places later. The simplest way to accomplish this task is to work on a single video track and two audio tracks.

To make a movie in this style, do the following:

1. **Set In and Out points on the clip.**

 Just double-click the desired clip in the Project Assets folder and pick the desired selection.

2. **Drag clip to timeline.**

 Drag the clip to Video Track 1. When you insert a clip into the timeline, clips on all tracks move over to accommodate it, so the audio and video remain in sync.

3. **Repeat this procedure and drag next to the previous clip.**

4. **Add transitions between clips.**

5. **Add titles.**

6. **Make rolling credits.**

If you're not sure if a clip works in a specific place, you can do the following:

- Click Undo on the Actions Bar.
- Cut the clip using the handle shown in Figure 13-15. It makes the cut wherever you place the CTI.
- Use the standard undo, either from the Edit menu, or the ⌘/Ctrl+Z on Mac and Windows, respectively.

Figure 13-15: Scissors mean cut on the Premiere Elements timeline.

Using the Snap option

When you use the Snap function, the clip you drag into the timeline automatically aligns with the edge of another clip like a magnet and a metal spoon. Snapping also prevents you from inadvertently overlaying over a previous clip. You can access it by going to Timeline⇨Snap, as seen in Figure 13-16.

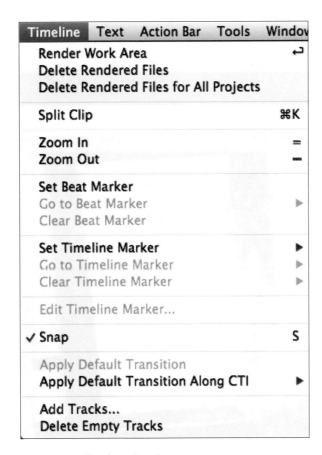

Figure 13-16: The Snap function.

Negotiating Audio Matters

Making sure the audio is just right is a necessary part of the editing process. Unfortunately, sometimes audio capture is inconsistent with each clip. Sometimes the audio levels are slightly higher than optimal; other times, they're too low.

Mixing audio

The key to video that sounds just right lies in the audio mix. Mixing the audio involves adjusting the volume levels to maintain proper sound and making sure the other audio channels proportionately match it.

Get those levels right

The first thing you should do is open the audio meter by going to Window⇨Audio Meters, as seen in Figure 13-17.

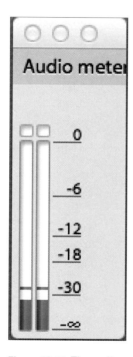

Figure 13-17: The audio meter.

Premiere Elements offers several ways to fix it:

- ✔ **You can fix it on the timeline.** If you look at the audio track, you'll notice a waveform and yellow line running horizontally across the audio

track of each clip. By mousing over the line and grabbing it, you can pull it down to lower the volume or raise it to increase it.

✐ **Use the audio mixer.** Go to Tools➪Audio Mixer and adjust each clip using it.

Consider the following when adjusting volume levels:

✐ **Keep audio levels from peaking.** When levels are too high, *clipping,* a tap-like distortion, can occur. Make sure levels are within range on every track to avoid this problem.

✐ **Use Gain.** Go to Clip➪Audio Options➪Gain. Change the numerical value. Remember, a level of 0.0 dB is the original volume. Changing the level to a negative number reduces the volume, and changing the level to a positive number increases it.

✐ **Make key frames.** Sometimes the volume level differs on the same clip with one part too loud and others too low. Key frames allow you to isolate a portion of the track to make changes. Raise and lower the volume on them as needed. You can do this right on the timeline by putting the CTI over the desired area and clicking the middle "diamond" to the left of the track. Make as many as you need and then raise or lower them appropriately.

Separating tracks

The audio and video tracks are synched together so they don't separate when you move them, but in some situations, you want them separated. For example, maybe you want to show a clip of a subject talking about the old neighborhood, and discussing, say, the grocery store that sold milk for a dime, and then you would use his audio track under the footage of the busy avenue. Other times, you may want to use audio from one clip with video from another. In order to do either, you need to separate audio from video.

To do so, go to Clip➪ Unlink Audio and Video.

Observe audio with your eyes through waveforms

Those squiggly lines on the audio track, as seen in Figure 13-18, may look like the cardiogram from your last physical, but they are actually a visual representation of the audio levels in the movie clip. Besides looking cool, they come in very handy when making your movie. These waveforms

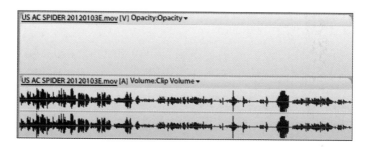

Figure 13-18: Audio waveforms.

- ✔ Let you know where the sound begins and ends
- ✔ Give you an idea when audio levels are too low or too high
- ✔ Provide a great guide for making an accurate cut on the clip

Dressing Up Your Movie

Up until now, the emphasis has been on constructing the movie by fine-tuning each clip before it goes in the time, and then playing them sequentially. That's most of what you need to do for success. Adding a few accessories to your movie — much like you would wear jewelry or a scarf — can help enhance the message. These include using the right transition and the proper titles.

Transitioning one clip to the next

The transition between movie clips acts as more than a buffer between cuts: It speaks a visual language. Most films, television shows, documentaries, and music videos deliberately use some sort of transition to help convey a mood or suggest time passage. Most of these transitions allow you adjust its alignment between clips and duration. The most common transitions include

- ✔ **Dissolve:** Perhaps the most common of all transitions, it blends one scene into the next. Depending on the duration and the content between the two scenes, it can create the illusion of the passing of time. Premiere Elements offers a healthy variety of dissolve types and variations, as seen in Figure 13-19.

- ✔ **Wipe:** The best use of this transition was in the *Star Wars* saga. Remember the unique transitions between many key scenes? The program includes several types of wipes, including a Push and a Slide.

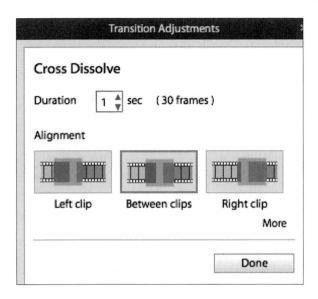

Figure 13-19: The Transitions Adjustments dialog.

Titles make the movie

A movie without titles is like a house without a door. Yeah, you can live there, but it's not complete. At their most basic, titles tell us the name of the movie, who worked on it, and what actors are starring in it. On a more necessary level, they let us know what's going on. Can you imagine a documentary that didn't identify the people talking on camera? It would change the entire experience.

Adding a static title to your movie

Premiere Elements provides a wide selection of title choices, from lower thirds to locator information. Locator information is like those IDs used in news segments and documentaries to describe the person or place in the scene. With a person, it consists of two lines: name and description. For example, *Charles Dickens/Writer,* or *Charles Dickens/Kent, England.*

Adding a title is pretty easy. Just follow these steps:

1. **Find where you want to add the title.**

 Position the playhead, or CTI, at the point on the clip where you want to add the title. Select Text⇨New Text and choose Default Still. You can also access it by clicking the Titles & Text button on the bottom of the interface. After you do that, you see the text tool in the monitor panel, as shown in Figure 13-20.

2. **Type the desired title text.**

 In the monitor panel, you can either backspace or retype; drag and press Delete, or use *Add Title* as your title. (Okay, just kidding on the last one.) Type the desired text, as seen in Figure 13-21.

3. **Make adjustments to the text.**

 In the Adjustments panel, you can alter font type, size, color, and a variety of other choices, as seen in Figure 13-22.

4. **Place the title.**

 When you're satisfied with font and size and other stuff, click the Select tool on the Adjustments panel and drag the title to the appropriate place on the image, as seen in Figure 13-23.

5. **Alter its screen duration.**

 The default setting for a title is about a half of a second. You need to extend its time based on your needs. For a lower third, or identifier, it's normal to keep it up for about two seconds. Other situations require a longer duration. To change the length, simply grab the end of the title in the timeline and drag it to extend the time it stays on the screen.

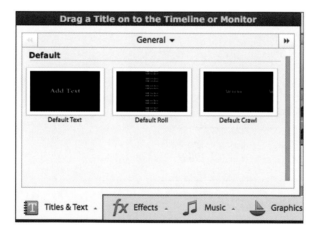

Figure 13-20: Accessing the Text and Titles.

Figure 13-21: Working in the Monitor panel.

Figure 13-22: The Adjustments panel.

Figure 13-23: Moving text.

Create a rolling or crawling title

Most of the time, a static title works for your needs. But occasionally, you'll want to make your titles move. *Rolling titles* move characters vertically up the screen and are commonly used for production credits. They always move from the bottom to the top of the screen. Think of the end of a movie and the credits that quickly pass by.

Sometimes you want to let the text crawl across the screen. *Crawling titles* move characters horizontally. You can use them several ways, including as a ticker on the bottom of the screen.

To make either type, try the following:

1. **Place the CTI where you want the moving title to play.**

 Select Text➪New Text➪Default Crawl. You see it in the monitor panel, as shown in Figure 13-24.

2. **Type the desired text.**

 In the Monitor panel, input the text. You can either backspace or highlight and retype it.

3. **Make adjustments to text.**

 Use the Adjustments panel to alter font type, size, color, and a variety of other choices.

4. **Place the title.**

 When you're satisfied with the font and size and other stuff, click the Selection tool on the Adjustments panel and drag the title to the appropriate place on the image, as seen in Figure 13-25.

5. Alter its screen duration.

To change screen time, grab the end of the title in the timeline and drag it to the desired time. For more precise control, go to Text⟿Roll/Crawl Options and adjust the settings as you like, as seen in Figure 13-26.

To help control the moving titles, here is a breakdown of the Options dialog:

- **Title Type:** Refers to the type of title (still, crawl, or roll).
- **Direction:** Applies to crawl and lets you pick the direction of the crawling text.
- **Timing/Frames:** Lets you start and end the text on- or off-screen.
- **Preroll:** Specifies the number of frames that play before the effect begins.
- **Ease-In:** Determines the number of frames the effect takes to get to proper playback speed.
- **Ease-Out:** Determines the number of frames the effect takes to get to proper playback speed. Specifies the speed going out of the effect.

Figure 13-24: The Text/Crawl function.

Figure 13-25: A title dragged to the desired position.

Roll/Crawl Options

Title Type
- ○ Still
- ○ Roll
- ◉ Crawl

Direction
- ◉ Crawl Left
- ○ Crawl Right

Timing (Frames)
- ☑ Start Off Screen ☑ End Off Screen

Preroll	Ease-In	Ease-Out	Postroll
0	80	80	0

[Cancel] [OK]

Figure 13-26: Precisely controlling the effect.

14

Taking Your Edit to Infinity and Beyond

Assembling your movie based on a series of clips gets the job done, but sometimes you want to add more pizazz to dazzle your audience. So, if you have a basic understanding of how to use Premiere Elements, it's time to step up the game and take advantage of the program's more advanced features.

I start by showing you how to add metadata to your clips. That's a fancy way of saying you're going to put a few keywords on the clips so you easily find them.

Premiere Elements has some really cool features that simplify the special effects and features in the program. This stuff puts your video over the edge, but too much will detract from your movie, so the key lies in moderation.

After your movie is complete, your choices for exporting it and sharing it with your friends, family, and the world are boundless.

Making Elements Sing

Making your first movie is kind of like whistling a tune. It sounds okay, but it sounds better when you add more instrumentation. Premiere Elements can

easily set you on the road to performing a symphony — the visual kind, not the orchestral.

The program provides enough functionality to make your movie come to life. Up until now, the idea has been to assemble clips in a cohesive matter, and maybe throw some transitions between clips. Add a little music and essentially let the movie play out straight. But because Premiere Elements does a bit more, I want to explore some of those functions and examine how they can work for your movie.

Using keywords for metadata

By now, maybe you've noticed that the camera generates movie filenames using a series of letters and numbers that don't mean very much. But even if you could name the file, it wouldn't provide all that you needed to differentiate from the hundred others on your hard drive.

One way around that is to personalize the video using keywords. Using words like "New York" and "Night" and "Broadway" to describe the clip makes it easy to find exactly what you need and retrieve it quickly. That little bit of time spent logging and entering keywords is nothing compared to the time it saves you when you use them.

Tagging in Organizer

After importing, ingesting, or scouring your hard drive, you'll be able to see thumbnails of each video clip in the Organizer. You can open the program separately or click the button on the Action Bar to access it.

After it's open, you can navigate to the desired file to apply information and keywords:

1. **Click the video thumbnail.**

 You'll notice two tabs: Tag and Information. Start with Information, as seen in Figure 14-1.

2. **Add information on the file.**

 You can write a caption and notes in the General area.

3. **Add a keyword tag.**

 As you can see in Figure 14-2, you can click a few basic choices. But you can also create new keyword tags, under any category or subcategory, to organize media files you've recently added to your catalog. Click the green + sign on the upper right in the Keyword Tags panel to bring up the New Keyword tag.

4. **Input your information.**

 In the Name box, type a name for the keyword tag. Additional information about the clip can go in the Note box.

5. **Add as many keywords as applicable.**

 Click OK and go to the next one.

Figure 14-1: Adding tags and other metadata.

Figure 14-2: Adding a tag.

Smart tagging

Using movie quality and content as a criterion, this unique feature provides another means of easily organizing and finding your movie files. It uses an Auto-Analyzer to automatically assign smart tags to media files. It measures each scene based on factors like shaky, dark, or bright. Analysis for this feature can be fully automatic or manual. When set to the automatic mode, the feature analyzes and assigns smart tags. In the manual mode, you can assign smart tags to selected assets yourself.

After selecting the movie file you want to attach a smart tag, to manually assign a smart tag, do one of the following:

✓ Drag the tag from the Smart Tags panel onto the selected media file.

✓ Drag the media files onto the tag in the Smart Tags panel.

To attach Smart Tags to multiple media files, do one of the following:

✓ Drag the tag from the Smart Tags panel to the selected media file.

✓ Select one or more smart tags and drag onto movie files.

Some things you need to know:

✓ You cannot create, edit, or delete smart tags. The program created that criteria, and you cannot make your own.

✓ You can remove or apply smart tags from the individual clips after they were automatically assigned.

Changing a clip's speed by using Time Stretch

The duration of your video clip represents the length of time it plays from start to finish. In the linear world, you alter the length by lopping off frames. For example, instead of the subject walking into the frame, through a long passage and out of the frame, you can trim the point when she's walking and out of the frame.

The alternative to that method is to change the *speed* of the clip to make the subject move faster through the scene or in slow motion, if you choose.

To create a fast- or slow-motion effect, you can change clip speed. Sometimes you can make the scene move slightly faster, or slower, to fit into a specific place, for example, if you're making a music video. Other times, you may want to show a quick passage of time. Notice how reality shows use this

effect by speeding up an establishing shot to show a passage of time. Other times, you may do the opposite and slow the scene down to let the audience savor details they may have missed at normal speed.

To slow down a clip that has another clip on its right in the Expert view timeline, drag it to an empty track or to the end of the movie. This way, you can stretch it without bumping into an adjacent clip.

Follow these steps to alter the time of your clip:

1. **Select the desired clip in the timeline.**

 Just click the clip to highlight it, as seen in Figure 14-3. Choose Clip⇨Time Stretch. You can also click the Tools panel on the Action bar and choose Time Stretch.

2. **Stretch the clip (or contract).**

 In the Time Stretch dialog, as seen in Figure 14-3, type a percentage for Speed. Remember, 100 percent is the baseline, so values less than 100 percent slow the clip down, whereas higher values speed it up. That means at 50 percent the clip plays at half the speed. At 200 percent, it's twice as fast as normal.

3. **Decide if you want to maintain pitch.**

 Normally when you change the video speed, the audio changes too. A clip at 200 percent usually makes your actors sound like Alvin and the Chipmunks. Sometimes that's an acceptable effect, but most of the time, you want to shy away from changing the speed of spoken dialogue. When it comes to ambient noise, speeding up a clip can give you that fast-forward sound. In order to eliminate that, check Maintain Audio Pitch in the dialog so the audio sounds normal.

4. **Remember the clip changes size in the timeline.**

 When you slow the clip down by 50 percent, the clip represents that much more space in the timeline. Make sure that you move the clips to the right to accommodate the size before you change the clip speed.

5. **Preview your changes.**

 After you make your adjustments, watch the clip and click OK if you're satisfied.

Figure 14-3: The Time Stretch dialog.

Sometimes you want to alter the speed of more than one clip. If the duration is the same, you can apply the Time Stretch function to multiple clips.

Here are several ways you can select multiple clips:

- Shift+click each clip.
- Drag a marquee around the selected clips.
- Select all the clips in the timeline, either by using the keyboard command ⌘/Ctrl+A or by clicking the timeline and selecting Edit⇨Select All.

Reverse the playback of a clip

A common effect in moviemaking involves playing a scene in reverse. When used sparingly, it can spark viewer attention. For example, if you're showing a subject diving in to the pool, you can quickly reverse it to show the unusual perspective.

Premiere Elements makes this effect relatively easy:

1. Pick the clip in the timeline.

Choose Clip⇨Time Stretch. If you want to change the speed of the clip, now is the time to do it. Just type a percentage for Speed in the Time Stretch dialog. Your preference may vary, but a factor greater than 100 percent increases the speed of the action and adds to the effect.

2. **Select Reverse Speed.**

 After selecting the Reverse check box in the Time Stretch dialog, click OK.

3. **View your clip.**

 You can always go back and tweak it by undoing the last action.

Using Time Remapping

Time Remapping, a new feature, gives you more control over the time-space continuum (well, the one in your movie, anyway), allowing you to alter time in different ways throughout the same clip. For example, say you want to start the clip at normal speed, slow it down for a special effect, speed it up after that, and reverse a section. And that's all in one fell swoop.

1. **Select a clip.**

 Make sure it's long enough to add all the effects you'll need and click it to select it.

2. **Open the Time Remapping tool.**

 Access It through the Tools menu on the Action Bar. As you can see, in Figure 14-4, the control occupies the entire screen.

3. **Select the part of the clip you want to add.**

 You'll notice the bottom of the screen contains thumbnails of the selected clip. Drag the CTI over the point where you want to add a TimeZone. That's the speed, or the direction, you want the clip to move.

4. **Decide how much of the clip you want to change.**

 Click the Add TimeZone button. It creates a transparent lime-green box. Grab the handle, as seen in Figure 14-5, and drag it to the desired length.

5. **Determine the speed.**

 You'll notice check boxes, as seen in Figure 14-6, let you assign a speed that's either faster or slower. You can also leave the speed and reverse the clip.

6. **Repeat for other parts of the video.**

 After you made all of your changes, click done.

Click to add a TimeZone

Figure 14-4: The Time Remapping interface.

Figure 14-5: Grab either handle to extend, or contract the size of the area you wish to change.

Figure 14-6: Adjust speed on the bottom of the interface.

Grabbing a Freeze Frame

Sometimes you want to make a still image from a video frame. Here are some reasons to create a still frame from your video:

- ✔ To make a photograph from a video
- ✔ To use it in your movie as a still image
- ✔ To create a special effect where the video freezes for a period of time to emphasize a point

Whatever reason you choose, it's pretty easy to accomplish this task in Premiere Elements:

1. **Select a clip in the timeline.**

 Highlight it and scrub through it to find the desired frame. Place the CTI over it, as seen in Figure 14-7, so it shows up in the monitor.

2. **Go to the Actions Bar and select the Freeze Frame option from the Tools panel.**

 The image appears in the Freeze Frame window.

3. **Export the frame.**

 Just click Export. In the Freeze Frame dialog, give the image file a name and location and click Save. You can also click Insert in Movie to put it on the timeline. It goes wherever the CTI is placed.

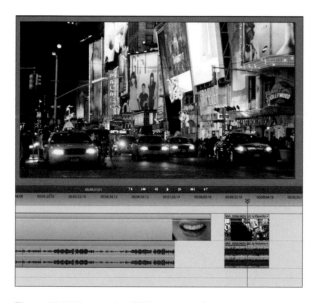

Figure 14-7: Moving the CTI over the desired clip.

Exporting Your Movie

After you've put your movie together, applied every possible effect to help tell your story, and even saved it, you still can't play it outside the program until you export it as a self-playing movie. After that, you can play it back on

your computer, somebody else's computer, or some computer connected to the Internet.

Premiere Elements provides many ways to export your files to support a variety of devices, as well as accommodate different sizes and formats. Exporting and sharing are performed by clicking the Publish and Share menu on the upper-right side of the interface. You'll see the choices for sharing, shown in Figure 14-8.

- **Web DVD:** Build web movies for computer viewing
- **Disc:** Create movies destined to burn to DVD
- **Online:** Make videos ready to upload to sharing sites like Facebook, YouTube, and Vimeo
- **Computer:** Export files to view on your computer or any computer, for that matter
- **Mobile phones and players:** Have your movie file ready for your phone, iPad, iPod, or other device

Figure 14-8: Publish + Share.

Although sharing your file is important, most of your needs revolve around exporting the highest-possible quality movie. The AVCHD export lets you export a high-definition video to your computer in the MP4 or M2T format.

1. **Export the file.**

 From the pull-down menu, select Computer. After the menu pops up, select AVCHD as seen in Figure 14-9.

2. **Select the proper export setting.**

 Save your movie as a full HD file as either an MT or MP4 using the 1920×1080 setting, as seen in Figure 14-10.

3. **Name your file.**

 Enter a name for the movie. Specify a location in the Save In option. Click Advanced to specify more export settings as required and click OK.

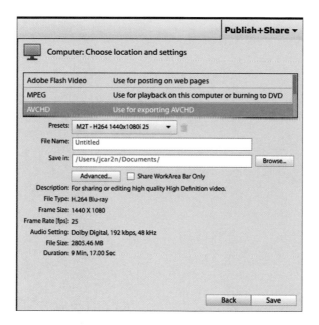

Figure 14-9: Select AVCHD.

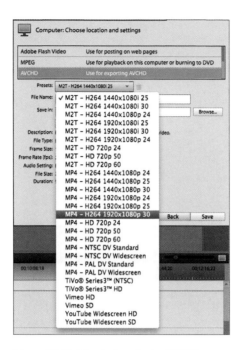

Figure 14-10: File choices in the AVCHD export mode.

15

Presenting Your Movie

In This Chapter

▶ Presenting your masterpiece

▶ Converting files

▶ Sharing and protecting content

▶ Uploading to video sites

*Y*ou've saved your movie project for the last time, and it feels pretty good. Now comes the nervous anticipation of showing it to an audience. How do you plan to dazzle them? Will you send a DVD? Upload it to YouTube? Or maybe you want to send over a live stream through a hosting site. The possibilities are endless. But before you can share it with the world, you need to get it out of the timeline.

In Premiere Elements, the movie plays in the program's time-line, where you can add, drop, drag, and play the movie. But that doesn't make it easy to show others because it only plays through the program.

It's like a twisted version of *The Boy in the Plastic Bubble,* only it's your movie file that has no life on the outside. In order to make it work outside the program, you need to make it into a self-contained unit that can open in any program and work on various media. In a perfect world, you'd click export and be done with it. Of course, that's also a world where all files play in every medium without regard to size.

Far less forgiving is the reality. You can do so many things with your files and send them so many places that you'll surely need more than one file type and size for it.

Creating a Self-Playing Movie

The first stop to presentation begins with exporting the movie file in an uncompressed format that retains the integrity of how you captured it, as well as what you've witnessed on the timeline. Remember, any movie that plays outside the program is considered a self-playing movie, but that doesn't mean it's an uncompressed file. With so many file format choices with Premiere Elements, rest assured an uncompressed self-playing movie is not the one you try to send over the Internet or upload to YouTube. That only works if you have an infinite amount of time and enough bandwidth to hear your own echo.

That's clearly not the file format for online delivery because it's way too big. How big? For HD movies, it translates to approximately 1 GB (gigabyte) per minute, so a 15-minute video occupies about 15 GB of space. To sum it up, an uncompressed file makes for the best quality export, but not the one that you can use for every situation. Think of it as the master file that you can use to spawn off more size- and format-specific movie files.

Technology has launched motion-picture recording into the stratosphere. With a DSLR camera, you can make a movie that plays in a wide range of places, from a movie theater and Blu-ray disc to an online video-hosting site and downloadable movie file. Although the limits are boundless when it comes to places to share your movie, each situation has specific requirements.

When it comes to exporting practical-sized files, there's a wide range of acceptability. Although Premiere Elements lets you export a variety of file formats and sizes, you're better off using software specially designed to accomplish this task.

Controlling File Size

With so many ways to present your movie and the variations needed for movie files, you'll need to consider saving copies in a variety of formats and file sizes.

Using a conversion program

Even if you decide to export an uncompressed file, you'll still need to send smaller files from time to time. Dedicated conversion programs convert video files in one format to make them viewable in another format. Convert your uncompressed file into an MP4 or transform an AVI to an FLV for embedding on a web page. Whatever you choose, this software does the work.

If an adequate program has to be both cheap and powerful, the free software MPEG Streamclip fills the bill on both accounts. Better encoding programs exist on the market, but they're not free, and this one handles multiple formats and sizes.

Because it's designed exclusively for exporting and encoding files to a number of formats, MPEG Streamclip lets you get the job done quickly. It includes some basic editing functions too, but other than setting ins and outs, you should use it for what it's designed to do, and that's encode your movie in the proper format.

MPEG Streamclip can play numerous file types as well as convert them to a wide range of encodes. It supports the following formats: MPEG, VOB, PS, M2P, MOD, VRO, DAT, MOV, DV, AVI, MP4, TS, M2T, MMV, REC, VID, AVR, M2V, M1V, MPV, AIFF, M1A, MP2, MPA, and AC3.

You can download it at www.squared5.com.

After installing and launching the application, you simply open the desired movie file and apply the appropriate setting for the desired format. To create an MP4 from an uncompressed movie, do the following:

1. **Open the desired file.**

 Go to File⇨Open Files. Navigate to the file you wish to encode. Select it and click the Open button, as shown in Figure 15-1.

2. **Decide if you want the entire clip, or just select a portion of it by setting in and out points.**

 It's found under the Edit menu. If selecting a portion, set the In and Out points, as seen in Figure 15-2, and go to Edit⇨Trim.

3. **Pick the desired file format.**

Go to File⇨Export to MPEG 4. When the dialog pops up, as seen in Figure 15-3, choose the appropriate settings. From the Compression drop-down list, select H.264. It's also important to select the resolution. Will you need to export to full-frame size at 1920×1080? Or will a smaller file size suffice? For our purposes, pretend the idea is to send the file to YouTube at the 1280×720 setting. Select the appropriate radio button under Frame Size. After all the selections are made, click the Make MP4 button, navigate to the desired folders for saving, and click OK. In a short time, you'll have another version of your movie.

Figure 15-1: Navigating to the desired file using MPEG Streamclip.

Figure 15-2: The in and out points are represented by the dark line in the play track.

Checking out your movie

After you export or convert a movie file, you must watch that version for quality control. Make sure that the file format and size you wanted look good. Unfortunately, it doesn't always work that way because some movie compression schemes take away too much information.

Figure 15-3: The MPEG Streamclip dialog.

Sharing and sharing alike

The idea of sharing movies has changed since the early days when would-be moviemakers made copies of their 8 mm reels to send to family, friends, and film competitions. That spirit remains alive today, except instead of a physical movie, you're sending a virtual one. And it's not going to just one person, but many maybe millions.

Here are some of the places you can share:

✔ Social media

✔ Video-sharing sites such as YouTube or Vimeo

✔ E-mail

✔ DVD

Other choices for conversion programs

If you need a little more horsepower for translating your files than MPEG Streamclip offers, here are a few options for some reasonably priced programs:

- **AVS Video Converter:** It handles an extensive list of video file types with a wonderful array of tools and effects. You can even convert to and from Blu-ray format. Unfortunately, it works only on Windows. The company has an array of video-editing, imaging, and conversion programs, and when you purchase one, you can download any of the 18 products for no additional charge. The license lasts for one year and costs about $60.

 You can download a trial version at www.avs4you.com.

- **Xilisoft Video Converter Ultimate:** A robust conversion program for Macintosh that handles most file types and support for devices like PSP, iPod, PS3, iPhone, iPad, Apple TV, Zune, and mobile phones. It sells for about $60.

 You can download a trial version at www.xilisoft.com.

- **Prism Video File Converter Plus:** It handles conversion from and to the most common video file formats, including Windows Media Players files. You can also grab files from a DVD and convert them. It costs about $50.

 You can download a trial version at www.nch.com.au.

Considering Intellectual Property Rules

Being able to easily share your movie over the Internet also means that someone can use it without your permission. There's not much difference between physically being robbed and having your content stolen online. Both are violations and threaten what you've worked hard to accomplish. Remember, you are the creator of your work, and when someone uses it without permission, it's not just frustrating. It's also stealing. Although putting your work in the public domain presents some challenges, you can take some steps to both lessen the chances of theft and go after the people who take it if it does happen.

Here are a few ways to protect your video:

- **Monitor where you send it.** Don't just upload video to every place that tickles your fancy. Instead, limit where you send video and keep a log of the time and place.

- **Use a watermark.** Sometimes it's distracting, but a watermark may discourage content thieves from using it in the first place, and it lets you confirm that it's your content. For serious parties — like those acquiring movies or administering competitions — you can send a "clean" version upon request.

- **Periodically scour the web.** You'd be surprised how many users purloin content and retain your original filename. Regardless of whether they're

brazenly ripping you off or just being ignorant, when you find they've done it, you must let them know. Measures range from sending them a cease and desist letter to taking legal action.

Burning to DVD

The DVD is alive and well and living large, for now. Unfortunately, its needs are also diminishing with high-transfer rate video streaming, online HD playback, and a low bar for acceptable quality. But for the time being, the small shiny disc continues to be a popular choice for entertainment. And now with Blu-ray on the scene, it's going to be a while before people watch all of their movies from a virtual source.

One area where DVD use continues to thrive is transferring movies to disc to send out or pop in the household DVD player. But the stability factor back in the day seemed to produce more drink coasters than movies. Times have gotten better, with the process getting both easier and more stable. Thanks to the ubiquity of DVD burners and multiple generations of them, it's become perfected. Of course, it's a great medium for physically sending and giving away movies. And with some computer systems offering the option of an HD Blu-ray disc, it's still got some life in it.

Here are some suggestions to keep from hearing Eric Idle asking to bring out your dead DVDs:

- ✔ **Use reliable media.** This one is a no-brainer. Brand-name DVDs from manufacturers like TDK, Verbatim, and Maxell (to name a few) provide consistency from burn to burn; sometimes discount brands by companies you never heard of lack stability. Unstable media translates to winding up with a lot of unusable DVDs to use as drink coasters, and even then, the hole on the bottom defeats the purpose.

- ✔ **Be sure the disc is clean.** You'd be surprised, but sometimes a smudge can corrupt the burning process and cause errors. Keep blank media in the package or case until using and make sure your hands are clean. Even if they are, grab the disc by the sides.

- ✔ **Dedicate space to the processor.** Because burning a DVD requires a lot of processor work, be sure to close unused applications and windows during the process. Don't start typing and web surfing on the same computer during the burn. There's no reason to tie up memory and bog down the processor to check your fantasy football scores.

- ✔ **Put some thought in it.** Don't just burn your video as a continuous playing movie. Instead, take the time and make chapter markers for different scenes. Add extras like behind-the-scenes chatter, outtakes, and bloopers. You can read an entire book on making a DVD, but you can wing it because most software is pretty intuitive, and you already know what a DVD should look like.

Movie files are big, but hopefully, you've compressed yours enough to upload on the Internet. Although each site has specific file format and size specifications, you can usually still upload a HD movie, providing the file is properly encoded.

Showing Your Movie on Facebook

With around 1 billion active users, the social media site Facebook certainly provides a forum for your video. Of course, how many people actually see it depends in part on your friends list, and how you can get others to check out your movie. Facebook allows you to directly upload a video from your computer to the site, or you can add a link to YouTube if your video is posted there.

If you want the video to play on your page, you need to be sure you're using an updated browser and have Adobe Flash loaded.

Current Facebook restrictions are as follows:

- The video should be less than 1,024 MB in size.
- Video length cannot exceed 20 minutes.
- The video must be yours, or you must have permission to share it.

Uploading a video to Facebook is relatively easy.

1. **Make sure the video is properly formatted.**

 Just because you can upload a short, uncompressed QuickTime file doesn't mean that it's a good idea. Sometimes the file is too big. Instead, make an MP4 movie file and use the H.264 video codec and main-profile AAC for audio. Make sure your video doesn't exceed the size or time limits you see on the upload page.

2. **Click Add Photo/Video at the top of your home page.**

 Click the Add Video pane and select Upload Photo/Video, as seen in Figure 15-4. Navigate to the desired file.

3. **Post the video.**

 The filename resides on the dialog. Click Post and grab a cup of coffee. Actually, you can add some information like a description of the movie, as seen in Figure 15-5.

4. **Share the movie.**

 Determine who gets to see it and tag them. It's pretty self-explanatory because you already know Facebook; otherwise, why would you post a video?

Figure 15-4: The Add Photo/Video pane.

Figure 15-5: What you type here is what viewers will see.

Sharing Video on YouTube

When it comes to sharing video, the online sharing site is the de facto standard. The video-sharing website lets users upload, view and share videos. It uses Adobe Flash Video and HTML5 technology to display user-generated video content like viral video, music videos, and movie clips. Content is provided both by media corporations and individuals. YouTube has more than 3 billion video views per day. That means your content has the potential to be viewed by a lot of people. Of course, they can only watch if they know it's out there. If you're not ready for such an audience, you can make your movies private and send would-be viewers and invitation to see it.

Some things you should know about YouTube:

- It supports a variety of file formats and allows for some formats to upload in full HD.
- Video length cannot exceed 15 minutes, unless you verify your account.
- The videos you upload must be yours, or you must have permission to share them. If you do not have permission, YouTube can remove it at the rights-owner's request.

✔ YouTube provides basic analytics to all, as seen in Figure 15-6, on the lower right. These include the number of page views, user comments, and the amount of "likes."

Uploading a video to YouTube is relatively easy.

1. **Log in to YouTube.**

 Enter your username and password, as seen in Figure 15-7.

2. **Go to top of page and click Upload.**

 The upload screen appears.

3. **Select the video you want to upload.**

 The site offers several choices, including Upload Multiple Files, Record from Webcam, and Select Movies from Your Computer. Choose the latter, and then click that choice and navigate to your video.

4. **Add metadata while uploading.**

 Depending on file size and length, uploading can take an hour or more. Use this time to properly name the movie and fill out the Basic Info fields, as seen in Figure 15-8.

5. **Watch your movie.**

 Also keep an eye on the page views to see if you'll have a viral favorite on your hands.

Figure 15-6: You can see how many people have viewed your video every time you look at it.

Figure 15-7: When you select Upload, you'll be prompted to sign in.

Figure 15-8: The more information you add here, the easier it is for your movie to find an audience.

Sharing Video on Vimeo

The popular video-hosting site Vimeo (www.vimeo.com) acts as an alternative to sharing movies on YouTube. With a name that's cleverly derived as an anagram for *movie,* this video-sharing site acts as a more serious place for independent filmmakers to upload, share, and view movie content. Another notable difference between Vimeo and YouTube is that Vimeo demands that all uploaded content must be original and non-commercial.

Some things you should know about Vimeo:

- **It's much smaller than YouTube.** The site has 8 million registered users and attracts around 65 million unique visitors per month.
- **Vimeo provides several levels of access.** Although it's free to upload video to Vimeo, users are limited to 500 MB. An inexpensive Vimeo Plus account allows users a greater weekly upload limit, as well as the ability to limit advertisements before video, unlimited HD videos, and unlimited creation of channels, groups and albums. Vimeo PRO provides the highest level of service and offers large storage, third-party video player support, and advanced analytics.

Uploading a video to Vimeo is simple:

1. **Log in to Vimeo at** www.vimeo.com/.

 You can either use your Vimeo account or Facebook log in.

2. **Click the Upload a Video button.**

 It's large and sits to the upper right. After you click it, you'll see the message in Figure 15-9.

3. **Select the video you want to upload.**

 The site offers several choices, including a mobile app, desktop apps, and Dropbox. Click the Choose a Video to Upload button and navigate to the file on your computer, as seen in Figure 15-10.

4. **Upload video file.**

 Click the Upload Selected Videos button. Depending on file size and length, uploading can take an hour or more. Use this time to properly name the movie and provide the proper information.

5. **Admire your work.**

 You'll notice the sleeker presentation, as seen in Figure 15-11.

Figure 15-9: Vimeo takes content permission seriously, so heed the warning before posting.

Figure 15-10: For most situations, just click that big button.

Figure 15-11: The Vimeo player occupies a fair amount of screen real estate and lets you share video (check out the button on the upper right).

16

Archiving Your Movie Files

"*I*t was the best of times. It was the worst of times."

With apologies to Charles Dickens, in this context, this quote more appropriately deals with the love-hate relationship I have with keeping track of movie clips in the form of digital media files.

Yeah, digital media files have the virtual footprint of a dotted line, which keeps your desk pretty free of tape clutter. But not all messes are visible, and digital movie files are a prime example: They create virtual chaos within the hallowed halls of your hard drive.

Movie footage has always presented organizational problems due to its sheer volume and the necessity of logging of each scene. Movie reels and videotapes get misplaced, mislabeled, lost, or damaged all the time. That's probably why studios continue to find "rare" or "lost" footage all the time. The stuff is hard to keep track of, especially when content is shot day after day, week after week.

But DSLR movie files present a more serious problem because there's no physical container aside from the media card. This creates a worse dilemma than joining a seniors' ice hockey league and not having any health insurance. Unlike those videocassettes that pervade your desk, file cabinets, and repurposed shoeboxes, digital files are like spirits floating in cyber-land, and when they get lost or misplaced, they may be gone forever.

In the typical workflow, you upload your assets after each shoot and clear the card to make way for your next shoot. After you overwrite the card, you no longer have a physical representative of the content. The problem is compounded because the space on your computer is finite, no matter how big a hard drive you're rocking on your computer. As a result, some moviemakers squeeze files into anyplace they'll fit, whereas some editors frugally discard everything but the final edit.

Saving your files wherever they fit is not a very good solution; it's the virtual equivalent of running out of cabinet space and putting dishes in the pantry and linen closet. On the other hand, holding on to just the finished edit is shortsighted and will burn you down the road when you need an outtake for another project.

Your mission, if you choose to accept it, requires you to read further, or your movie files will self-destruct in 30 seconds. (Actually, they'll get erased, trashed, or lost on an old hard drive, but you get the idea.)

Finding the Best Archiving Solution

Saving media files is not much different than being a fugitive on the run. No matter how secure you feel, you're always looking over your shoulder. That's because John Q. Law is always on your tail — er, because technology so changes rapidly and is unstable at times. And if a sudden crash or file corruption doesn't hurt you, the next evolution of technology surely will.

Don't believe it? I have two words for you: Jaz drive. To refresh your memory, a Jaz drive was like a floppy drive on steroids, holding up to 2GB of content on a removable disk, as seen in Figure 16-1. In theory, it was a practical idea, but then again, so was the pterodactyl. Despite its killer design, that well-built prehistoric flying lizard was permanently grounded at the end of the Jurassic period. The Jaz drive lasted a little bit longer.

The problem with finding a stable solution is further compounded by imperfections with most of the methods at your disposal. There's more than one way to save a file, but that doesn't mean they all work for your needs. But video files take up a lot of space, and HD video takes up several times more, so you must find the right method for your needs.

As technology continues to progress, file formats come and go. That's why the first step to saving your beloved files is choosing the right file type:

- **MOV file:** This common file format created by Apple falls under the QuickTime umbrella. It's a versatile format that offers both compressed and uncompressed saving.

- **MP4:** Another Apple file format, this one lets you compress files securely — and depending on the level of compression — does so with little loss in

quality. This format uses the H264 codec. It can also playback on your iPad, iPhone, or iPod.

- ✔ **AVI (Audio Video Interweave):** Introduced by Microsoft. Saves in a variety of compressions and sizes. One problem is that it doesn't retain aspect ratio information.

- ✔ **WMV (Windows Media Video):** A streaming file format designed by Microsoft Corporation to support watching movies and Internet videos on personal computers.

Figure 16-1: An Iomega Jaz drive with disk.

Archiving with external hard drives

The secondary drive has become such a frequent addition to computers that it's hard to believe they didn't always go together like apple pie and ice cream. So when you consider the size of DSLR movie files, depending on another drive to handle the archiving is an obvious solution. There are a lot of reasons to use them, but the most apparent is that the internal hard drive is not big enough to accommodate everything we want to load and save on the computer. It's like that sign in the high school auditorium that shows maximum capacity. After it's full, no one else comes in until someone leaves.

External hard drives increase capacity by holding additional files. Think of one as your favorite band adding extra nights when it plays your hometown. As soon as one night fills up, it's on to the next one, or in this case, drive.

On the upside, these "accessory" drives are relatively inexpensive, but their volumes multiply more than a rabbit pen during a warm spring. With HD files occupying about five times the space of a standard definition file, that 2 GB drive you thought could never fill up soon begins gasping for air. HD also limits cost money more to save because the minutes of video-per-dollar ratio

(breaking down capacity with file size) hasn't quite caught up with HD video. Of course, after you fill one external hard drive, you can get another.

On the downside, external hard drives have been known to fail from time to time and can sometimes corrupt data, stop spinning, or burn out. You should always save important files in various drives and keep your fingers crossed.

Still, they offer the most versatility, allowing you to use them in a variety of ways:

- **Scratch disk:** For your movie capture
- **Raw files:** Save your capture material
- **Program projects:** Saved versions of the captured projects
- **Alternate takes:** Saved individual clips
- **Final movies:** Save your self-playing movie

Burning to DVD

Low cost, ubiquity, and cross-platform readability make the DVD a viable storage solution. You can burn a DVD relatively fast, but when it comes to HD video, it doesn't hold as many minutes because of the increased file size.

It also doesn't offer the same versatility as an external hard drive. You cannot read and write files simultaneously, nor can you move files around. Instead it serves as a means of storing important clips and final movies. The other issue is that DVDs are risky because, at some point, DVD drives will become obsolete.

But in the meantime, here are some ways they come in handy:

- **Saving as a self-playing DVD:** In other words, just like the movies you play in your DVD player. You can store a two-hour movie on a single disc. One caveat: If you need to use it for an edit, you need to convert the file because it's in the MPEG-2 format and not editable without conversion.

- **Saving raw footage as a file:** Possible, but not very likely because uncompressed HD video occupies approximately 1 GB per minute, and a standard DVD holds a little more than 4 GB. Unless the video is an incredibly whopping four minutes, a DVD is quite limited as a good idea for storage. Because camera files use H264 compression, you can fit about 12 minutes of raw footage on a DVD, depending on the camera and compression.

- **Saving as Blu-ray:** Gaining popularity as a storage device, these hold about 25 GB per layer. Current Blu-ray discs provide double-layered discs that obviously double capacity. Interestingly enough, 22 minutes of Standard Definition video fit on a standard DVD, and a similar amount of HD video fits on a Blu-ray, as seen in Figure 16-2. Once again, that increases by several times with camera files.

Figure 16-2: A Blu-ray disc.

Backing up to tape

Once upon a time, video files were stored on videotape. So, you can go old school and back your files up to tape. Of course, you'll need a camcorder or HD recording deck that still uses tape, such as the model seen in Figure 16-3. Professional production houses also back up to tape, although HD decks are becoming less common with the introduction of XD-CAM Professional Discs:

- ✔ **The upside:** Tape retains your footage and plays back on a television or monitor or computer. You can digitize it by playing it out into your non-linear editing program.

- ✔ **The downside:** As tape is phased out, the amount of decks for playback will diminish over time, making finding someone to digitize your tapes as hard as finding the Holy Grail.

Figure 16-3: An HD recording deck.

Considering Sony XDCAM

The Sony XDCAM has replaced the tape as the media used in professional-quality, Sony HD video cameras. It uses a removable optical disc system called Professional Disc, as seen in Figure 16-4, that has a storage capacity similar to a Blu-ray disc.

The XDCAM is becoming the media choice for many broadcasters for their ENG (Electronic News Gathering) crews and news production, thanks to its versatility when it comes to shooting footage, editing, and archiving. In fact, the company boasts that more than 200 reality and news programs use the Sony optical disc format. Sony also says it's a great choice for archiving footage long-term.

Although recording decks cost upwards of five figures, you can take your important files to a production house and transfer them onto a Professional Disc for about a hundred bucks. It's pricey, but its stability warrants consideration when it comes to protecting your best footage. Card readers are also available in the $3,000 range.

Figure 16-4: An XDCAM disc.

Using media cards

Although it's not the most ideal method, you can use media cards to retain your original files or as a storage backup. It does have some merit on a temporary level. Consider the plunging price, rising capacity, and increased access time of media cards (that's their ability to capture and play HD video files smoothly), and you'll see why you can't take them out of the equation as a viable alternative.

If you think media cards may work for you, here are a few tips:

- **Save as storage.** Don't try to play video directly from the card; just use it to save the files. Load the card, drag the files onto it, and then safely eject the card.

- **Use a fast card.** If you *do* plan to play video from the card for whatever reason, be sure to use a fast card. Not sure which speed works for you? Check Chapter 2.

- **Stick with common formats.** These days, that means CompactFlash (CF), Secure Digital (SD), and Memory Stick.

- **Be ready to transfer.** Because technology changes so rapidly, and peripherals lose stability over time, consider moving your files to new devices as they become available.

- **Keep them safe.** If the cards get wet, dusty, or stepped on, the content is lost.

Trying online storage

Until now, media storage was a local issue between you, your computer, and peripherals on your desk. But because space comes at a premium, it's not a bad idea to look to the cloud and consider online storage. For your storage needs, media files are uploaded to a large server in techno nether-land.

Most of these sites are free and provide a safe environment for your video and image files. These sites use secure servers that are proven to be more reliable than external hard drives. If your computer crashes, you have versions saved online ready for download.

But this wouldn't be the wonderful world of digital media if there weren't a downside too. Not all online storage sites are intuitive to use. Some make it hard to upload or find your files. And if those files are too big, or you need more space, you're out of luck or need to pay a subscription fee.

Another confirmation of nothing being truly free is that while the content belongs to you, some sites claim the right to display your images for their own purposes (in other words, advertising the site). While this is less of a problem for video than for still images, it does make you think. Just be sure to read the small print before clicking the Accept button.

Integrity is a concern too. Although some of these sites are full-fledged online businesses with an established foothold in the online community, other free sites are not as successful. Some make enough on ads, but the ones that don't go out of business. Stay current when it comes to site activity and be prepared to move your files at the first sign of it closing down.

Numerous sites exist, but here are a few credible ones:

- **Dropbox:** File-hosting service that offers online storage, making it easy to access or send files from one computer and access it on another one anywhere by using a common folder on the desktop. Basically, you drop files or folders into the Dropbox folder, as seen in Figure 16-5. You can allow others to access it by sending them an e-mail link to it. Don't worry if you're using a different computer than the one you originally created or saved the files — you can access files from the website. It includes 16 GB for free, but lets you add more with every referred user.

- **ImageShack:** Works similar to the others, except you don't even have to sign up to begin uploading. Also works well with Dropbox. Subscription plans start as low as two bucks a month.

- **Photobucket:** There's room in the bucket for video too, as shown in Figure 16-6. Aimed at digital photography and video users, it's a viable place to store your DSLR movie files. This online storage site allows you to easily upload your video clips for free and then share them, if you want, with friends and family through various forms of social media. You can upload up to 500 videos that are no bigger than 500 MB. Otherwise, you may need to upgrade to the monthly payment plan.

- **YouSendIt:** An online FTP site that allows you to save and share large file. It's a reliable service with a free version that caps off at 2 GB. If that's not enough, a premium site for around 15 bucks per month provides unlimited storage.

- **Video-sharing sites:** YouTube, Vimeo, and others let you upload your edited movies, as well as download them again to your computer or other devices. Of course, people can view the movie while it's there. Sometimes there's a loss of quality, but the file is still saved on their servers at the quality you uploaded it.

Figure 16-5: The Dropbox right-click menu.

Figure 16-6: Photobucket.

Managing Your Content

The more often you stop and start the camera, the more files it creates. And the more of that movie footage you transfer to your computer, the more content you need to keep track of.

Worrying about the volume of movie files should never discourage you from shooting as much as you need, but it does make organization necessary.

Due to their large sizes, movie files are a bit more complicated to manage than digital photographs. Regardless of the size of your hard drive, before long you're saving them across borders from your computer onto an external hard drive, burned to DVD, or uploaded to an online storage site. With the increasing volume and number of potential places to save them, it's easy to lose track of your movies.

Whether your biggest thrill comes from creating content or making magic in postproduction, the inability to quickly locate specific movie files can kill your buzz. Content management is a full-time job, but you probably barely have time to shoot your movie. Because you don't have endless space on your hard drive and are forced to save elsewhere, you need to come up with a system that keeps track of your movie files, and do it sooner rather than later.

Metadata simplifies content management

Metadata is a description of the contents of a given file. You input the information when you transfer the file to your computer, usually by filling out fields for location, description, date, and tags. The tags are important because they provide a means for cross-reference when searching.

Organization made simple

Knowing where each file and its content information reside is the basic goal of content management, at least from the 30,000-foot level. Closer to the ground, it's more about adding metadata, smart tags, and determining places you intend to save, so you'll be able to track it down when you need it.

Here are a few ideas:

- **Save important files in multiple places.** This way, if your hard drive burns out, you still can pull it off your external drive, DVD, or online space.

- **Make a database.** Whether you create a Word-based table or a fully customized Filemaker database, it's important to have a searchable reference.

- **Include as much metadata as possible.** The more you include, the easier it becomes to find exactly what you're looking for.

Using Adobe Elements Organizer

Not only can you keep track of your video files with Adobe Elements Organizer, but you can organize them too. Preview the content and open it directly in Premiere Elements, as shown in Figure 16-7. Elements Organizer acts as a browser that allows you to add metadata, smart tags, and keywords to help you search for files. This comes in especially handy when you have movies on your hard drive or other external disks and need to see what's on them. Elements Organizer lets you play back each movie directly through the program, as well as scrubbing through the clip to find exactly what you need.

Figure 16-7: Adobe Elements Organizer.

Saving graces

Whether you're using Elements Organizer or another browser program like Adobe Bride or Extensis Portfolio, consider some of the following:

- ✓ **Using a sensible naming convention:** Movies file are natively assigned an alphanumeric name like MVI_0094. Besides the succession of each file, this name provides little information other than letting you know it's a movie file. Instead of relying on camera-generated names, try something like this. (Location) (subject) (Year) (Month) (Day) (take). A file named CA_SFHILL_20110130_2 translates to a San Francisco hill being shot in California on Jan. 30, 2011, and it was the second take.

- ✓ **Using keywords:** Although the aforementioned filename convention helps you find a file in the future, the search ability is limited unless you want to create a filename that's as long as a paragraph. That's not even possible, but the point is that a filename provides general information, whereas keywords go much further into detail. For example, the previous filename can tell us the location, date, and subject, which are helpful but lack specifics. So if the filename refers to a San Francisco hill, the keywords may be *trolley, cable car, Powell Street, elderly twins with blue hair,* and so on, or simply *teeth*, as seen in Figure 16-8.

- ✓ **Smart tags:** Take advantage of smart tagging, explained in Chapter 14. It adds pre-assigned tags on photo and movie files. When you have smart tagging set on auto-analyze, the program goes through the photos and video and assigns the proper tags for image quality and audio type. It can even identify people in a picture. This allows you to find whatever you pretty fast.

Figure 16-8: Metadata and keyword input in Elements Organizer.

Exercising Common Sense

Protecting and saving your digital files are essential. There's no videotape to haphazardly place in a file cabinet. All you have is a numerical file that for complex reasons plays on your computer. Although it's imperative to save your files, the question of how much you should save arises. Maybe it's not necessary to save the entire take, especially if you've captured the scene multiple times. But if you're a skilled shooter, don't you want the alternate takes too?

An hour of movie clips from your DSLR occupies about 20 GB of space, and that's in its compressed H264 codec. A full-blown HD movie that size tops 60 GB. Capturing and delivering this much content week after week certainly adds up, leaving you the following choices:

- **Save the entire shoot.** For an hour of compressed camera footage, that adds up to 20 GB.

- **Eliminate the unusable stuff.** This refers to camera files created from stopping and starting the camera, blurred scenes, and bad takes.

- **Keep an entire key scene.** Everything that ends up in the final edit is saved.

- **Save the final edit.** Just save the exported movie.

Redundancy is redundant, and it works

Although saving the entire capture of every shoot isn't always necessary, and keeping only the outputted file is just plain crazy, you need to strike a balance that you live with.

At the very least, you should save the all the usable footage, so it's not a bad idea to go through every clip and trim the blurry, badly composed, or botched takes (at least the ones not funny enough to make it on a blooper reel).

For more personal stuff, you should probably save the entire take. Whether it's an important moment in a family member's life, an exclusive interview, or a historic moment, those clips need some TLC. Don't just save the really important interviews and footage — save it in multiple places.

For the most important files, you should do the same and make sure that the multiple saves are *not* in the same location.

Consider using at least three of the following methods for your most import files:

- Save on local hard drive
- Burn your movie to DVD
- Save a copy to an external hard drive
- Upload to the cloud
- Transfer to XDCAM
- Play out to tape

Staying current on backup formats

There's nothing worse than tucking away your prized movie clips only to find a few years later that you can't get them to play on your new computer. Maybe the operating system doesn't recognize your old peripheral, or the software you created the content on needs a specific plug-in that you cannot easily locate. These are common examples of how people get bitten by ever-changing technology.

Not too long ago, I was a victim of this gremlin when I attempted to open some news segments on the war in Afghanistan. Final Cut Pro was not able to read these QuickTime files because I never loaded the necessary transcoder extension (helps software communicate with older or specialized file formats). Fortunately, I had it on an old Mac PowerBook that was living past its twilight.

The lesson is that although it's not impossible to play old movie files, it gets more difficult as the technology evolves. It's like a ship that moves inches from the dock every year. At some point, it drifts too far out to sea, and you miss the boat!

Constantly migrate the important files

File survival often comes down to a nomadic existence. Constantly moving files to accessible places guarantees you won't become the victim of outdated drivers or operating systems that no longer support your old peripherals.

Just like the case with the Media 100 (a popular, non-linear editing system in the late 1990s) files, current methods will be phased out over time. Whether it's a change to the CF media files and the latest operating system on your computer not supporting the driver, or your new computer not supporting your FireWire 400 external drive, these changes can threaten the sanctity of your work.

Consider the following:

- **Move files frequently.** Back up your files regularly, and that doesn't just apply to the new ones. Eventually, external drives can burn out from all that spinning, your DVD won't play on a new computer, or the technology simply gets phased out. Nothing takes the place of keeping files saved on current technology.

- **Stay current on technology.** Because technology doesn't change overnight, it's important to stay ahead of the curve. Think back to the 1990s when the iMac stopped including a floppy drive. Savvy users began transferring their files to Zip drives. And when they lost popularity, those files went to CD, and so on. Make sure you transfer your best material whenever technology changes, so you don't have your prized movie clip on the new equivalent of a floppy.

- **Check on them every so often.** All kinds of problems can jeopardize your files: anything from a corrupt drive to a virus. It's important to make sure your files still play whenever you update your computer or hardware.

Part IV
Becoming a Filmmaker

The 5th Wave By Rich Tennant

The Levines Edit Their African Safari Album

"Do you think the 'Hidden Rhino' photo should come before or after the 'Waving Hello' photo?"

*P*art IV takes a look at what you need to know to become a true filmmaker as opposed to just a guy or girl holding the camera. I cover what you need to do to prepare for a shoot, the roles of the moviemaking process, and how to manage the day of the shoot.

And when you're ready to take that next step, I discuss film festivals and competitions you can enter to help your movie find a wider audience.

Doing the Preshoot Work

In This Chapter

▶ Understanding the screenplay

▶ Finding the perfect location

▶ Casting your movie

. .

*I*n some respects, making a movie doesn't differ much from building a house. Both require adequate planning, and neither stands for long without it. When it comes to your future humble abode, that means budgeting the necessary funds, having an architect draw the blueprints, and hiring the proper contractors to act on those plans. No one in their right mind believes a home comes together on a plot of land with the same ease as the one you build from Legos on your dining room table. That same logic applies to making your movie. (But you probably know that already.)

That's why it's important to adequately plan your movie, much like you find the right place for a house. But instead of wood, bricks, and mortar, movies begin with writing the screenplays, finding actors, figuring out the locations, and deciding what they'll wear.

Figuring What You Need

Like a good game of "Clue," the trick to making a successful movie lies in what you don't know. But soon the unknowns become known, providing you take it one step at a time. It all begins with an idea. It's that hypothetical notion that propels you in the first place. After that, the next step involves writing the screenplay.

Then what? Words alone don't get the job done, unless you're working in radio. So the screenplay is then followed by casting the actors, formulating a shooting plan, deciding what your actors will wear, and where they'll wear it in front of the camera. (That's another way of saying you have to select

locations.) The objective at this point is to gather as much information as you can to make sense of the project. It's kind of like a chef tasting spices and ingredients when thinking of a new dish.

Scouting locations

What if the classic 1960 film *La Dolce Vita* was shot in Rome, New York, instead of Rome, Italy? Would it have the same impact? Or would *The Devil Wears Prada* work if crucial scenes took place in a storefront office on the streets of Hoboken, New Jersey, as opposed to New York City? Before you even ponder that, the answer is "no." Where you shoot your movie is every bit as important as what you shoot. Just like the world of real estate, the top three requirements are location, location, and location. But that's easier said than done because sometimes it's a challenge to find the right place to do it.

Locations make the story. If not, every movie would begin (and end) on an empty soundstage (actually, some do). Places are one of those aspects that help tell the story, such as this New York City skyline in Figure 17-1. Think of your location as your movie's inanimate character actor because it helps set the tone.

Of course, there are exceptions. Some directors like to build sets from scratch, or shoot on the studio lot, which may contain suitable scenery. But for the independent movie, or a music video, as seen in Figure 17-2, it's a matter of finding the right spot.

Here are some tips for finding the right places to shoot your movie:

- ✓ **Go through the script.** Determine the types of locations and settings that the movie needs to fit your intended tone. Make a list of your dream locations and then figure out what's practical.

- ✓ **Pound the pavement.** Use your intuition and senses to seek out memorable places that enhance the story. You don't have to go far to find the right place, and sometimes, you'd be surprised at the locations that are nearby.

- ✓ **Put the word out.** Contact friends and family and ask if they know a location that matches your needs. Sometimes there are places "off the grid" that only the locals know.

- ✓ **Check out official location guides.** If you need to look for an out-of-town spot, many destinations have directories listing locations and services for filmmakers interested in shooting in their cities. Check these out even if it's your hometown or surrounding area.

✔ **Build it into the budget.** Your time may have an intrinsic value, but gas, lodging, and tools have a tangible one. Consider these costs when putting your budget together.

✔ **Stay organized.** Make a template and input information from each location regarding details and your intention. Be sure to list cross streets, interesting landmarks, and the behavior of the light, to maximize your efforts.

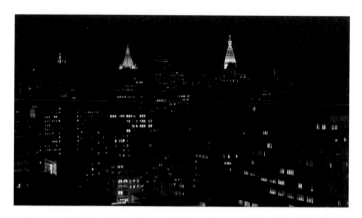

Figure 17-1: Establishing shot of midtown Manhattan taken at twilight.

Figure 17-2: The Market Theater in Seattle and its gum wall made for an essential location for a music video.

Hollywood directors have people to help them search for the right locations, but of course, on your movie, chances are you'll perform these tasks on your own:

- **Location scouts:** Studios hire experts to go out and find the perfect location for your movie. These days, that task begins with searching the web. It makes the process more efficient because you can have some idea of a place before actually pounding the pavement to check it out. Sometimes the producer, director, and cinematographer check out sites early in the process. If not, they certainly like to check it out as shooting dates near.

- **Location manager:** On a major motion picture, this responsibility goes to the professional who makes sure everything is in order for the day's shoot including the necessary permits and insurance. On your production, it quite possibly will be handled by you.

And when you finally find that special place, here are some things to consider:

- **Permits:** Some places allow you shoot with just verbal permission, whereas others require you to apply for a permit. Know this stuff before you begin shooting your movie.

- **Nearby facilities:** Sometimes a good location is only as good as its essential facilities to support you and your crew throughout the day. These include bathrooms, food, and refreshments. If not, all will *not* have a good time. If you plan to stay for more than a day, be sure there are overnight accommodations nearby. Don't forget to make sure there's parking close to the site. Some local ordinances do not allow parking on the side of the road. Also make sure you have electricity at your disposal, so you'll need to know if you need to bring a generator.

- **Environmental conditions:** Assess the area to determine the traffic and noise of the location before committing to using it. Unless you're smack in the middle of nowhere, chances are you're not in a perfectly quiet location, meaning you'll have to deal with ambient sound. If it's a busy spot, you may need to shoot at dawn to avoid conflict. Also monitor the time of day that natural light sets in the place that works best for you. Although it's unavoidable sometimes, shooting close to an airport, construction site, or highway is just asking for trouble.

- **Cellphone coverage:** Sounds silly, but it's pretty difficult to shoot a movie when you can't communicate with the outside world, or the inside world (of your crew), thanks to dead spots in cellular coverage. Rural areas are notorious for this. Although it's hard to know if you'll be facing this until you get there, one solution is to invest in a walkie-talkie set.

Although locations play a big part of where the movie is shot, often it's the *type* of places that make the movie special. Here are a mere dozen suggestions:

- Boat docks
- Bus and train stations
- A gazebo in the park
- A high point overlooking a landscape
- A high school football field with bleachers
- Iconic landmarks in major cities
- A large sailing ship
- An old-fashioned diner
- A rustic cabin in the woods
- A rooftop garden
- Small-town Main Street
- A wooded area

Shooting on a soundstage

Shooting on a soundstage is the diametrical opposite of finding a location. Instead, you just make it what you need. You probably think of a *soundstage* as a big, open, indoor space on a studio lot. But the reality is that almost any space can transform into a soundstage. Basically, it's a light-tight soundproof room where you can build your set and control, to the best of your ability, every aspect of the light and sound in the scene.

If you're fortunate enough to have access to such a space — either by renting or borrowing — you'll be able to shoot interior scenes with little worry of extraneous sounds interrupting your shoot. This open room, shown in Figure 17-3, was used to shoot a music video. It's different from an interior location because everything used in the shot was brought there intentionally. Another cool thing about shooting on a soundstage is that you can set up your set exactly as you need it. You don't have to worry about a wall being in the way, or, for that matter, being able to fit a dolly in the kitchen.

Familiar spaces that can double as a soundstage include a vacant warehouse, storage facilities, old storefronts, and large garages (even small, empty ones work). Just seek permission and have some understanding or agreement before setting up. And make sure to deal with the right person like a legitimate landlord or property manager, or you may find yourself in the same

predicament as the characters in the Kevin Smith film *Zack and Miri Make a Porno,* where they are fraudulently rented a warehouse, only to come back in the morning to find the structure is slated for demolition.

If you use a soundstage, the downside is that you'll need to build the set from scratch. That takes time, money, and expertise. If you're willing to take a chance, go for it. You can always design your space by begging, borrowing, and, er, not asking permission. (Not really that last one.)

To make a space work for your needs, consider the following:

- **Make it light-tight.** If a set has windows or doors, light can leak onto the set, but that's nothing that some black plastic and a roll of tape can't patch up. On second thought, you may not need to bother, especially if you're looking for a bright workspace and wish to take advantage of that soft light (providing there's windows and they have light). Just cover them with translucent material to let in the light onto your set. You can buy specialized material or improvise with a white sheet.

- **Quiet, please.** Normally, a soundstage has padded walls that absorb excess sound to eliminate echo or reverb when capturing dialogue. But chances are that impromptu space is not as acoustically sound (no pun intended) as you think. In the spirit of improvisation, you can use inexpensive foam sheets to absorb harsh tones. Another idea is to tack up pieces of carpet. Because color is not an issue, you can purchase remnants cheaply at a discount store.

- **Understand the electrical power structure.** Because your lights and gear require a lot of juice, make sure the electrical system can handle it. Check the size of the breakers and spread the lights over different outlets so you don't create a power surge.

Figure 17-3: One of the benefits of a soundstage is building the set for exactly what you need.

Considering props and costumes

Having the right script and a great place to shoot your movie puts you on the road to movie bliss, but you're not there, yet. The next step involves how you dress your actors — unless your movie is supposed to take place in the present, and that present is your own backyard. You need to think about what clothes make the actors look good.

In the movie world, clothes are called *costumes* even when they look like regular street clothes. The right costume provides authenticity to the period and region your movie is set in. For example, cowboy hats and jeans work for a movie taking place in Wyoming, just as a corset and bonnet are right for a turn-of-the-century period story, or a leather jacket and T-shirt fit a 1950s biker movie.

Here's some stuff to ponder:

- **Figure what you need.** Look at the script to determine what your actors should wear. After that, list what it takes to get it done. Count your actors and the total amount of attire you need.

- **Budget for what you need.** Having the right period clothes and tailoring them perfectly to each actor may be your objectives, but unless you have an open line of credit in the six-figure range, it's probably not in your future. Instead, have an idea of your actor's attire and discuss what's in her closet. That's what many independent films do.

- **Scour the thrift shops.** If you're going to buy clothes, you may as well get a bargain at a used clothing store. Plus, you never know what other ideas a trip through the racks will unearth.

- **Borrow costumes.** You may know someone who has that perfect "flapper" dress or full-length, black leather coat. It doesn't hurt to ask him if you can borrow it. Just return it safely and make sure it's clean.

- **Design your own.** If you're handy with a needle and thread, or better yet, know someone gifted with crafting clothing, you'll have an advantage to making your lower-budget film look better than expected.

Unless you're directing a movie with a bunch of mimes, you're going to need props. (Especially if you want to show a real box in your movie, not just one traced out by your leading mime.) These set objects are essential when it comes to telling your story. Think about a gangster flick without a gun or a story of two people who meet over the Internet without a computer. The movie prop industry is quite lucrative, and getting the props you need can be very expensive. Some are worth the cost, like say, a bottle you can safely break over an actor's head. Others not so much, like a bust of Beethoven.

Here are a few things to consider:

- **Make a list.** Peruse the screenplay and itemize everything that you need and what you already have. Be sure to check off the stuff you have already.

- **Keep them to a minimum.** Props play a big part in decorating the movie set, but when it comes to interaction with your actors, consider the time-honored axiom, "Less is more." Only use essential stuff on set so that the viewer doesn't get over-stimulated.

- **Look through closets.** You never know what you can find tucked away somewhere. For a scene in an early 1960s baseball movie, this vintage Yoo-Hoo bottle, as seen in Figure 17-4, comes in handy.

- **Consider the era.** Be sure that your 1950s doo-wop movie doesn't have a character using her iPhone, unless you're trying to be cleverly ironic.

Figure 17-4: A vintage Yoo-Hoo bottle is a great prop for a movie set in the 1960s.

The six Ps of production

Here's alliteration for you: Pathetically poor planning (leads to) pathetically poor production. Make sure you take the time to properly plan each aspect of your movie before jumping in. The foundation of a successful movie starts with a plan and slowly builds from there, long before you begin to shoot. Deviate from that and skip some steps, and chances are that the movie won't live up to expectations. Nothing is guaranteed, but you improve your chances of making a good movie with a comprehensive plan.

Gathering Your Assets, Er, Actors . . .

When it comes to theatrical productions, the living, breathing actor is a valued commodity. Your actors take each breath of the movie, so the key to success lies in their performances. And although their faces draw the viewer in, their actions in front of the camera dictate the story. The former depends on them, whereas the latter partially depends on your savvy as a director.

But before worrying about any of that, the first step is actually finding your actors. You can begin by putting the word out that you need people. Here are a few suggestions:

- ✓ **Talk to friends.** Just about everybody knows someone who acts and is looking to break in to "pictures." Of course, that also depends on where you live.

- ✓ **Contact a nearby college.** Plenty of student actors are looking for a chance to be in a movie, so there's a potential for finding a diamond in the rough.

- ✓ **Put an ad in the trades.** At one time, that meant the trade paper, but these days, it's more likely to be Craigslist. The format doesn't matter as much as getting the word out.

Taking the next step with your cast

You found some candidates, now what?

After you find your cast, make contact with your actors, preferably in a place that makes everyone feel safe. Thoroughly explain what you need from them. Field questions to see if the relationship can work.

Here are some tips to encourage actors to be a part of your movie:

- ✓ **There's no substitute for a good script.** If you build it, or write it in this case, they will come. At least, you hope so. When the screenplay is legitimately compelling, actors clamor to be in a movie. (The movie fitting into their schedules doesn't hurt either.)

- ✓ **Choose serious actors.** Make sure whomever you cast takes it seriously both in terms of her performance as well as being punctual and professional. Time is money, even if you're not making any early in the game.

- ✓ **Get comfortable with the cast.** Meet with them before shooting and explaining your intentions and expectations. Share a meal, have coffee, or go paintballing, it doesn't matter. There's no substitute for being on the same page before you get started.

Rehearsing your actors

Although Hollywood directors expect their actors to show up on set ready to perform, you may want to run thru each scene before committing anything to record. The reason comes down to inexperience on both your part and theirs. Besides, you can make sure that your ideas for the scenes are made clear during rehearsal. If you have a different idea of a scene than your actors, that creates more work thanks to retakes and setups.

It also reinforces the importance of knowing the lines of the script. No one wants to deal with an actor who has to stop every few minutes to say, "Wait. What's my line?" Instead, encourage them to research their characters deeply. Experienced actors do that all by themselves, but if your actors are still green, you'll have to help them along. That means coming to the realization that their roles are formed by a foundation of truth, rather than doing just impressions of the characters.

Doing a table read

Before you place your actors in front of the camera, it's a good idea to perform a *table read*. That's when the actors, along with the director and other crew, read the entire script at a table. Think of it as a dramatic board meeting. Besides familiarizing everyone with the story, it serves a way to fine-tune the rhythm of the scenes. You can also get a better sense of the dialogue when it's read aloud by actors.

Writing the Screenplay

Revisiting the homebuilder versus the filmmaker analogy, an architect works from a blueprint, and a filmmaker relies on a screenplay. Both professions are harder than they appear and rarely as glamorous as they seem. And yet, both are important callings. Success with either relies on following a universal format, so each craftsperson working on the project understands it on the same level through common language. I have no illusions about my architectural engineering expertise, so I'll defer to screenwriting tips from here out. One more thing: If you don't follow the film industry's very strict formatting rules, your script won't see anything but the sides of the trash bin.

If you look at just about any movie script, you'll notice how they uniformly follow the same margins and style. The screenplay consists of four main elements that include scene headings, character names, dialogue, and action:

- **Scene headings:** Appearing at the top of each new scene, it describes the setting for that particular scene and includes three key pieces of information. The first simply states if the scene is inside or out. The next

one describes the location, and the last alludes to the time. For example, INT, CASINO – AROUND MIDNIGHT, as seen in Figure 17-5, means it's an interior scene at the casino at midnight. The top of the heading can also include camera transitions (Fade In, Cut to, Dissolve, and so on).

✔ **Action:** Explains what happens in the scene as well as the establishing shot. Only what's seen or heard is included here. Using the previous example, it would say something like this: Johnny watches the roulette wheel spin while nervously twitching his eyes. It can also describe the parenthetical, which is what the character does while he speaks. For example, he speaks in a nervous tone.

✔ **Character names:** Character names are ALWAYS capitalized and centered, so it's written as JOHNNY.

✔ **Dialogue:** Dialogue is the words that the actors speak. They're written without quotations, unless they're actually muttering a quote. For conventional purposes, it's always written in a standard font. That's 12-point Courier, and it resembles the look of a typewritten page. The dialogue is centered on the page with the margins indented at 2.5 inches, but none of that should matter if you're using a dedicated screenwriting program.

```
INT.  CASINO – AROUND MIDNIGHT

Johnny watches the roulette wheel spin while nervously
twitching his eyes.

                       JOHNNY
          Fourteeen. C'mon one-four.

                       DEALER
          No more bets.
```

Figure 17-5: An example of a scene heading.

It's possible to write a screenplay with a word-processing program, just as it's possible to write a term paper with a dull, nubby pencil, but that doesn't mean it's a wise thing to do. Going back to the necessary universal formatting, it's cumbersome to maintain the various styles, making it time-consuming and counterproductive. An easier-to-use and more efficient dedicated scriptwriting program is simply a more logical choice.

But which one is best? That used to depend on your computer platform, with the PC, at one time, having a big edge over Macintosh, at least in terms of software written for it. But the field has leveled out over the past few years with multiplatform versions of popular software.

Here are a few choices:

- **Final Draft:** With the same dominant name-recognition as Adobe Photoshop, this time-honored screenwriting program likely occupies the hard drives of many working screenwriters. That's because it doesn't just adhere to formatting, but also meets the screenplay submission standards set by theater, television, and film industries.

 The application offers hundreds of templates to quickly get you started. The templates include the standard screenplay, the BBC script template, and the Warner Bros. template frequently used in Hollywood. At first, the software only worked on Windows-based computers, but now it's available for Macintosh and the iPad too.

 Download a free demo at www.finaldraft.com.

- **Movie Magic Screenwriter:** This is another long-running industry favorite. Because it's been around for a little longer than Final Draft, it has its own core user group. It offers all the necessary functions and templates, with minor differences in some non-essential features. The price point is similar too. What it comes down to is how comfortable you are with each interface.

 Download a free demo at www.screenplay.com.

- **Celtx:** Here's the wild card in the mix. It's a fully functional free application that at the very least can get you started. In some ways, it resembles a scaled-down version of Final Draft, but also includes other tools not found on it. Celtx combines both the screenwriting and pre-production processes, plus it lets you sync your projects so you can work on the same files on multiple devices. You can also allow others to share, review, and edit scripts if you choose. In addition, Celtx provides a community to share ideas, get information, and even find funding for independent films.

 You can download it at www.celtx.com.

Breaking Down the Screenplay

The first step in writing a screenplay lies in actually having a story to write. If you don't have a well-thought-out idea, it doesn't matter how professional your formatting looks. But say you've got a good story idea. Before going any further, you need to understand how your idea conforms to the structure of a movie.

Understanding character types

The characters in your movie fall into one of a few categories:

- **Protagonist:** It's the main character that ends up in conflict. You want the audience to root for this character. Think Luke Skywalker in *Star Wars* or Andy Dufresne in *The Shawshank Redemption*.

- **Antagonist:** An antagonist is the primary opponent to the protagonist. He's the character or characters (yes, there can be more than one) who enhance the protagonist's problem. Darth Vader in *Star Wars*, Bane from *The Dark Knight Rises*, and Commodus from *Gladiator* are all prime examples.

- **Flat characters:** These are the minor characters in the film. They help carry out the story without showing much of their personalities. Two-dimensional characters, if you will, are necessary parts of the story. Consider the club doorman, played by Craig Robinson in *Knocked Up*, the storm troopers in *Star Wars*, or Officer Franklin in *The Hangover*.

Discovering the three-act structure

Conventional storytelling takes place in three acts. The first establishes the main characters and introduces the conflict. For example, in the first act of the 1958 Alfred Hitchcock film *Vertigo*, we learn that Scottie, the character played by James Stewart, is a police officer who has suffered a traumatic experience that made him afraid of heights. He becomes a private investigator and, at the request of an old friend, trails a mysterious woman named Madeline.

In the second act of the screenplay, the conflict deepens. The stakes are raised for the protagonist, and the situation becomes more complicated. In *Vertigo*, Scottie falls in love with the woman he's following, but when she falls from a bell tower because his fear of heights prevented him from saving her, Stewart's character becomes the subject of a police inquest. After he's acquitted, he slips into depression.

The third act presents a turning point before the final confrontation of the story you're trying to tell. In *Vertigo*, that point comes when Scottie meets a woman named Judy who greatly resembles Madeline. From there, the plot twists are revealed and finally resolved.

Nobody says it needs to be a happy ending or that the acts are equal in length. In fact, the second act is often the longest and the third, the shortest. But that differs with each movie and screenplay. Think of the unusual structure of Quentin Tarantino's 1995 film *Pulp Fiction*. Even though it tells four different stories, they take place in non-linear time.

Writing the treatment

A *treatment* is a summary of the story that describes your characters and the conflict they face. This is incorporated into a simple story with a beginning, middle, and an end. This summation comes in handy when you're writing the actual screenplay.

Starting small and building

Screenplays, like other art forms, flowers, and children start small and grow expansively over time. With that idea, it's not a bad idea to write a simple, three-page version that is a breakdown of the first scene, last scene, and several in between. After that, you can build it until you've filled all the nuances between major points in the story.

Other things to keep in mind:

- ✔ **Make sure the title page is properly formatted:** It should have nothing but the movie name, your name, and, on the bottom left, your contact information, as seen in Figure 17-6.

- ✔ **Page length:** The way a screenplay is formatted generally equates to a ratio of one page to a minute of screen time, cover page not included. This makes it easier to pace your action and the length of your screenplay, which should be around 100-120 pages.

- ✔ **The spec script:** A spec script is written with the idea of trying to shop it, and not the kind you're writing to base the movie you'll make on. If you're writing a spec script, resist the urge to include camera directions and other production information. It's a common mistake that first-timers make when sending a script.

Crafting your character's dialogue in your screenplay

Real, life-like characters are the chief requirement for a compelling screenplay. That means that both your protagonist and antagonist should be fully formed three-dimensional characters. It's okay to show your hero's flaws as well as your villain's vulnerability. Consider Jarvet, the antagonist in *Les Miserables*. He mercilessly hunts the protagonist, Jean Valjean, throughout the story. He's not bad, however, just determined to do his duty. When you think of weaker films, many of the problems can be traced back to poor dialogue from cartoon-like unrealistic characters.

"The Dummy Strikes Back"
Written by
Dummy Dumpster

Dummy Dumpster
444 Dummies Way
Dummy, Ohio 55555
555-555-5555
ddummies@me.com

Figure 17-6: The title page for a screenplay.

Although character development is an ongoing process, here are some suggestions to help your script sing:

- **Make the dialogue snappy.** Sometimes real-life discussion takes time to get to the point. So unless you're paying homage to *Berlin Alexanderplatz*, a 15-hour, 24-minute German film (the longest film on record), it's important to make it flow. Of course, the real art is making sure it sounds real. One way to accomplish this is to listen to people's conversations and write to a rhythm. Great dialogue shares the same rhythm as singing.

- **Use characters to create conflict.** One of the best ways to tell a dramatic story is through the character's actions and words. An overly preachy approach rarely compels the viewer. Instead, it leads a viewer to close her eyes and tell her spouse she's not sleeping. But really, there's no

better way to move the story along a treacherous route and to eventual resolution than with your characters.

- **Create an individual voice.** Develop each character with his own personality and actions. Make sure his lines are consistent with how his character would really talk.

- **Develop character traits.** In real life, each of us conducts ourselves uniquely, and the same applies for your characters. These include habits like looking at her watch, twirling her hair, a penchant for a particular food, or some other behavior that helps the character seem real.

- **Profile your character.** Write some backstory about each character. It doesn't have to make it in the script, but at least it helps you understand how to write it and how actors perceive it. Was the dad in your script in the Army when he was younger? Was the judge a racecar champion? Or does your hero carry the emotional scars of an abused childhood? All these elements help you write the character without having to bring up the past, or at least not until it matters.

Roles in the Filmmaking Process

*T*he movie just ended, and the credits are rolling and rolling. For a moment you're eyes rove the screen in wonder. "What do all these people do?" Some jobs, you have no idea what they are. Others, you may think you know, but really don't.

For example, if you were to call central casting and request an iconic-looking, old-time film director, in no time, you'd have a room full of guys with berets looking through a hand frame made from their touching thumbs and stretched forefingers. They'd be waiting patiently right alongside some cops with Irish brogues and prisoners wearing black and white striped-jumpsuits and matching caps.

These are obviously typecasts: Not all cops sound like the Lucky Charms guy, prisoners don't carry around a ball and chain, and movie directors look pretty ordinary, with the exception of always wearing a baseball cap.

That's what makes a casting director so important. It's their job to find the right people for the part who look real and aren't a caricature of another era. But that's only one part of the equation: The other is an understanding of who does what to make the movie.

It's interesting how creative people find their ways into the industry. Sometimes, it's a conscious decision peppered with some luck; other times, an opportunity for employment guides you to a specific discipline. Whatever the case, in this chapter, I break down some of the jobs in the industry, starting with the bigger ones and working our way down.

Exploring the Behind-the-Scenes Roles

After you've had a taste of making movies, maybe you want to make a career of it. The smaller the film, the more hats you'll need to wear. Although understanding each aspect pays off in the long run, it's hard to wear them all. Yet, without trying some of them on, it's hard to know what fits you best.

Producer

In sports terms, a producer is the general manager of a team; in business lingo, you're the movie's chief financial officer. Sometimes the producer funds the project, but more than that, he likely raises the money from investors, who are then also given the title of producers.

Money aside, the producer acts as the liaison between the business and creative sides of the production. The producer and team work in various capacities that range from selecting the cast and crew to giving input regarding the overall tone of the movie or television show.

Producers vary so much in capacity that it's hard to nail down exactly what each one does. Part of the reason is that they come from so many different areas of the industry, including actors, directors, screenwriters, and others.

Here are two producer titles and their vague descriptions:

- **Executive producer:** Executive producers are responsible for the overall movie production but not involved in the technical aspects of the film. Often, you'll see names like Steven Spielberg, Tim Burton, and Quentin Tarantino serve this capacity on some films they aren't directing. Sometimes, it's their project; other times, they lend their name to increase the film's credibility.

- **Associate producer:** Associate producers are delegated with tasks from the producer, which can include just about everything from supervising an area of the film like the costume department or special effects to helping to raise capital for the project.

Director

Doing more than saying "Action!" and "Cut," the director acts as the head coach, to purloin another sports term. A director must know about every aspect of the production from helping the actors interpret their roles, visualizing the screenplay, to communicating visual ideas to the cinematographer.

The director's job is simple to explain and difficult to accomplish. Working the front lines, the director is responsible for shooting the entire film on time and on budget, making sure that the story is told effectively and as imaginatively as possible. In other words, directing is the creative act of putting the movie together using a crew to reach his special vision, or at least reaching his own vision *some* of the time. (Sorry, studio executives.)

The director has several assistants that expedite additional tasks:

- **First assistant director:** Although responsibilities vary, a first assistant director's function is to coordinate shots, location information, and scheduling. She also gets to say things like "Quiet on the set!" and "That's a wrap."

- **Second assistant director:** Assists the first assistant director as well as directs some cutaway scenes. It's not unusual for him to direct crowd shots, work with the extras, and even stage battle scenes.

Director of cinematography

The director of cinematography, also called the *cinematographer,* is the person in charge of shooting the movie. Working with the director, she considers the best way to capture the film based on the director's intent. On big movies, the cinematographer is responsible for a team of camera operators. Some movies have a single cinematographer who shoots the film, and maybe even directs it too.

Chances are that on your own movie, you're not only directing but doing the camera work too. Some established directors who began by shooting their own films still do it. For example, Academy Award–winning director Jonathon Demme (*The Silence of the Lambs*) has been known to still help with shooting.

Whether you're running a high-end Arriflex 35mm film camera, a Sony XDCAM HD video camera, or an accessory-packed Canon 5D Mark III, it's all the same.

Camera operators

Camera operators are, er, the people actually running the camera. Taking orders from the cinematographer, this person or team carries out the instructions for capturing each shot. Sometimes the cinematographer, director, and camera operator are the same person, which may lead the person holding a camera to talk to herself. Figure 18-1 shows a scene captured by such a person.

Figure 18-1: A street scene from midtown Manhattan used as a cutaway for a short film.

Screenwriter

Movies are not haphazardly made. Instead, they demand a great deal of structure. That process begins with the screenplay done by the screenwriter.

Think of it as part book, part play, and the rest overall idea. Shot descriptions, dialogue, and setting allow the producer, director, actor, or anyone else who works on the film to light a spark and play it in his head before committing it to the camera.

If you watch the Academy Awards, you know there are two basic types of scripts.

- **Original screenplays:** Written specifically for the screen. Some winning films in this category include *The Hurt Locker* (2010), *Little Miss Sunshine* (2006), and *Pulp Fiction* (1994).

- **Adapted screenplays:** The story comes from another source: often a novel or non-fiction book, but it can also be a stage play. It's written to conjure imagery and a setting, or to fit within the restraints of a feature film. An adapted screenplay also can come from a movie sequel, regardless whether the original was adapted from something else. Some Oscar-winning adapted screenplays include *The Godfather* (1972), based on a novel by Mario Puzo; *The Departed* (2006), adapted from the Hong Kong film *Infernal Affairs,* by Andrew Lau and Alan Mak; and *Driving Miss Daisy* (1996) from the Pulitzer Prize–winning play by Alfred Uhry.

Script supervisor

Remember earlier when we discussed continuity in Chapter 5? (If not, you may want to flip back and check it out.) Well, a script supervisor is the person tasked with making sure the sequences make sense. Because movies are shot out of order, you run the risk of continuity or placement error. The script supervisor oversees the activity to make sure the film matches as seamlessly as possible. It's one of those jobs whose success is measured by not being noticed. You can bet that if an apple changes from uneaten to half-eaten when the angle of a scene changes, or if the actor wears a different undershirt, someone will notice. Figure 18-2 shows a last take before break, while Figure 18-3 shows a different angle of the shot later.

Armed with a digital camera and an iPad, or if you're old school, a Polaroid and notepad, to check consistency from shot to shot; the script supervisor wears these hats and more:

- ✓ **Line auditor:** Makes sure the actors say the exact lines for each take of the same shot.

- ✓ **Fashion police:** Monitors the actor's clothes to be sure that everything is consistent and worn the same way (in other words, sleeves rolled up, pants cuffed, jacket zipped halfway, hat to the side, and so on, the same way every time).

- ✓ **Traffic cop:** Make sure the action moves on the proper path. This includes continuity of the direction the characters move.

- ✓ **Food checker:** Tries to maintain consistency when meals are consumed onscreen. A dinner scene can break continuity if a half-eaten plate of spaghetti miraculously has more food on it at the end of the scene.

Figure 18-2: Before break.

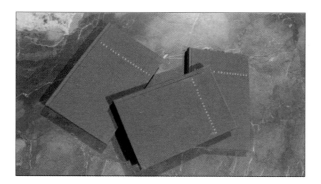

Figure 18-3: After break.

Sound technicians

If you ever passed a red carpet or a movie set, you've seen that person clad in headphones holding a tethered pole with something that resembles a squirrel with bed-head (or used Q-Tip) over the action.

But that's not the only function of a sound technician. Sound techs make sure that the audio levels are just right and monitor them with headphones on the scene. A sound tech generally uses a portable line mixer to balance the audio levels between the different microphones and ambient sound. *Ambient sound* is sound natural to the scene, like traffic, a flowing stream, or the clanking of tools.

Production designer

A production designer is responsible for the overall appearance of the movie from locations to sets to costumes. The set designer works with a team of creators, including the art director and set decorator, to maintain a visual sense throughout the film. The production designer works with the director before the film is shot to determine its look and feel.

The following assists this person:

- **Set designer:** Designs the ideas discussed in pre-production as blueprints for construction.
- **Set decorator:** Makes sure all furniture and decorations used in the scene work together and are properly placed. Furniture, drapery, and other accouterments fall under her responsibilities.
- **Art director:** Works with the team as a quality control expert to make sure the theme is properly carried out.

> ✔ **Property master:** The team responsible for acquiring any object used or touched by the actor such as a sword, rifle, computer, sports car, and so on. If the object is not touched or moved, it's considered a set decoration. The property master or prop department also handles that, as well any product used for placement, like M&Ms, Tide, or Pepsi.

Stunt coordinator

A stunt coordinator works closely with the director to cast stunt performers and choreograph stunts.

Casting director

Big productions use a specialist, a casting director, to find actors. After she narrows down the search, the finalists meet with the production team. This job saves valuable time for busy professionals.

Going Far Behind the Scenes

Many jobs in film and television production are not as glamorous as they seem, and others not as creative as you'd like, but they're still integral parts of the process of making a movie or show.

But equally important, they fuel your development. Working on a production in a variety of capacities puts you in a front-row seat to watch how others get the job done. Here are some of the less-glamorous jobs in the movie industry:

Production assistants

Movies, news programs, and television shows require a lot of help to accomplish their tasks. That's why one of the most important support jobs is a production assistant. The job has no definition other than doing whatever it takes to get the day's scenes shot. Frequent tasks include logging shots and keeping the shoot area clear of anyone who doesn't belong there.

Gaffers and cohorts

The term *gaffer* refers to that strong gray tape you can use for just about anything. But did you know that it's also the title of a key person on a film set? The head electrician is known as the gaffer. Any type of electrical issue related to lighting on the set is the responsibility of this important person.

Although each gaffer's job differs slightly from film to film, the main function is to deal with all things related to lighting. That means managing conditions for every scenario, from adjusting to changing light values to having the appropriate equipment.

In addition, gaffers make lighting consistent to the scene. Whether it's transforming the day into night, making the light on the subject's face emulate a passing car's headlights, or creating the effect of warm light coming through venetian blinds, chance are, the gaffer helped make it happen.

On bigger film sets, the gaffer has a crew to work with generators, lights, and cable, in addition to making sure the proper gels for balancing color are placed over the light source.

The job began in the heyday of film when overhead lighting equipment required a gaff to adjust. (A *gaff* is a long pole with a hook.) By the way, the tape, as seen in Figure 18-4, was named after the job because they use it for attaching just about everything.

These folks work with the gaffer:

- **Grip:** If it were your home movie, it's the grip's job to mount your DSLR to a tripod or homemade dolly. In the world of motion pictures and television, the grip's responsibility covers anything that moves on the set, hence the term *grip.* Most of the time, the grip's main duty is attaching the camera to supports that are stationary, as well as ones that move, such as a dolly, Steadicam, or jib. But it also covers more sophisticated work, like making sure the camera is good to go when it's attached to a gyro stabilized mount on a helicopter. Grips also work with gaffers and the electrical department to move lights in conjunction with the shot.

- **Best boy:** Despite how it sounds, it's not an apprenticeship for the top bridegroom job. This one's actually a little more fun, at times. A *best boy* is the assistant to the grip and gaffer. Accurately titled *best boy grip* and *best boy electrician,* think of these boys, who can be girls too, as administrative helpers. They deal with all the gophering and paperwork necessary to get the day's work done.

Figure 18-4: A roll of gaffer's tape.

Working with Talent

Over the years, the sometimes-tense dynamic between those in front of the camera and those behind has provided fodder for many jokes, from Alfred Hitchcock's notorious comment about treating actors like cattle to actors poking fun at directors for their "look" or the crew mocking actors' "artful" poses.

The truth of the matter is that in order to work well with others, you need to maintain a proper decorum. At the heart of this principle lies good communication and respect.

Some people only want to see a movie set from the front of a camera, and without actors, it would be hard to do what we do. If you want to understand how to work better with them, or take the occasional stroll in front of the camera yourself, here's some advice I've garnered over the years.

As integral to the movie as aluminum is to a screen door factory, the actor transforms theory into vision. As a director, you're at the helm in telling your actors exactly what they need to do, but it's an often-overlooked and some-times difficult task. Sometimes it works, but other times, the power can be corrupting, so don't be a jerk!

The power belongs to you as director, so be gracious with it and don't make unreasonable demands. Nobody wants to work with someone they don't feel comfortable with, or confident in their ability.

Here are some pointers to make dealing with those pretending to be someone else as smoothly as possible:

- **Research the actors as much as possible.** Narrow your search and meet with the few who match your needs. Unless you have a limitless budget of time and money, the goal is to find the best people for the movie in the shortest amount of time.

- **Know what you want.** You can maximize your efficiency by being conscious of exactly what you want from an actor. Some may come in reading a monologue that provides a glimpse of the actor.

- **Test them on your material.** Be sure they read a scene from *your* project, or have them read several parts to gauge their versatility and ability.

- **Find people who can take direction.** Be sure they can go through the process.

- **Look for confidence.** When you find someone willing to make bold choices and take risks, the chances for a great performance increase.

- **Connected mind and body.** The actor's voice and body are her instruments. Look for an actor who not only speaks her lines well, but also moves her body well.

Staying on top of acting lingo

If you've never worked with actors, you may be unaware of key phrases like "the subtext of the character," "don't break the fourth wall," or maybe, "here's her backstory."

Here are some key acting terms you should know:

- ✔ **Backstory:** The character's past that's not in the story.

- ✔ **Emotional memory:** Coined by its inventor, Konstantin Stanislavski, it essentially means that acting comes from the recollection of the individual's own feelings and emotions. Also known as *method acting*.

- ✔ **Fourth wall:** Breaking the suspension of disbelief to acknowledge the audience.

- ✔ **Given circumstance:** The conditions of exactly who the character is and his story. This information precedes the action or motivation in the scene.

- ✔ **Motivation:** What makes the character do what she does.

- ✔ **Organic acting:** A technique for letting the character into the actor's body and being him.

- ✔ **Subtext:** The underlying intent of the dialogue, add additional meaning.

- ✔ **Objective:** The most direct intent of the scene. For example, the actor's intention is to convince his girlfriend not to leave.

- ✔ **Super-objective:** What the character ultimately wants. If an actor's objective is to convince his girlfriend to stay, the super-objective is that she's a girl he wants to marry. Keep in mind, these words are never spoken, but merely used as a motivation for the scene.

Working with actors

Finding good actors for your no-budget film can present some problems. Most likely, they're inexperienced and have yet to develop their skills. Others may come unprepared, or even be clueless about the meaning of preparation. But there are some diamonds in the rough, and finding them, as well as dealing with those pedestrians that walk through your door, are all parts of the journey.

To improve your experience with actors, you should do the following:

- ✔ **Explain the scene:** Set up the scene for the actors. Remember, the movie is shot out of order, so it's your job to help them retain their motivation.

- ✔ **Guide the actor:** Direct them (no pun intended) to their placement on the set and their blocking. That's the exact movement and positioning of the actor for each scene.

> ✔ **Be courteous:** To quote a cliché, you get more bees with honey. (Just don't call your actress that.) Niceness is always better than being rude. Be polite, and you'll develop a respectful relationship with your actors, which often becomes the ultimate tool of motivation.

Finding actors

Although you can always find workers in the parking lot of a home improvement chain store, you're not going to find an actor, nor will they be hawking their wares outside the local bookstore. But there are ways for actors and directors to meet in just about any town.

For casting your next film, try the following places:

✔ **College drama students:** Check with the local university and introduce yourself to the drama department. Tell them what you're doing. Most of the time, someone will assist you in putting up ads around the school.

✔ **Local theater company:** Go down to the theater and ask if someone can post your notice and maybe even help you hold auditions.

✔ **Professional actors:** Put an ad in one of the local trades, or contact actors through Facebook or Twitter. Although you'll deal with rejection, you'll probably be pleasantly surprised to find actors willing to appear in at least a scene of your movie. Of course, this depends on the caliber of your reel and your charismatic approach.

✔ **Friends and family:** If they act, feel free to pull a "Coppola" and cast a family member. Friends also can work, but just be sure everyone understands what is expected of them before you get started.

Knowing the Post-Production Experts

Moviemaking is a lot like an episode of *Law and Order*. The first half deals with capture, either the movie or the suspect, whereas the second part covers the necessary closure. It's the same with movies; only the filmmakers don't usually go to jail. Just as the courtroom has its players (the judge, prosecutor, defense attorney, and witness), so does the second half of the moviemaking experience. They go by the titles of *film editor, sound effects editor,* and *music supervisor.*

Film editor

Here's a role that has morphed a bit. It used to be that the film editor did the physical work of assembling sequences for the film using a movieola (that large projector-on-its-side looking-device) or something even more basic (like a room with reels of film strung across two cranks and going through an illuminated viewer). In either scenario, the film was cut and integrated into a cohesive movie. See Chapter 11 to understand more about the importance of editing.

This job still exists, but it is being phased out more and more by high-end, non-linear editing setups.

Film editing differed from video editing in that it essentially took scenes from one tape and assembled them in order on another tape. Basically, it was like rerecording the movie scene by scene. If you later decided to replace an earlier shot, you had to either rerecord from the point of the tape where you wanted the change, or you had to cleverly replace the scene and make sure that it's length was enough to cover the preceding one and that it didn't take too much of the succeeding clip.

Non-linear editing changed the landscape by doing just what it sounds like — editing out of linear order. After the footage was digitized (converted from tape to an editable file), the editor could assemble the story and change the order whenever necessary without affecting the content after the insertion point.

These days, NLE dominates the editing world, with almost all television news, documentaries, and an increasing percentage of feature films using NLE. Video editors need to have a good sense of organization, storytelling ability, and an understanding of audio.

These NLE programs are very popular:

- **Final Cut Pro:** Currently the industry standard for editing news packages, documentaries, and even feature films. It's essential to have experience with this software if you're looking to find a job. As you can see in Figure 18-5, the Final Cut Pro Timeline is fairly simple, yet it has many functions nested in its menu and on the Timeline.

- **Avid:** Many feature films use this high-end turnkey system for editing. Although important to have on your resume, it's not used as widely as Final Cut Pro. Avid also makes a consumer-level non-linear editor.

Other film editing–related jobs include

- **Negative cutter:** Movie film is shot as a negative and sent to lab after editing. The negative cutter does that job as per instructions from the film editor.

- **Colorist:** Makes sure that the positive print from the negative film is consistent when using either the photochemical or digital intermediate process. The latter deals with computer enhancement, whereas the former is similar to making conventional photographic images.

Figure 18-5: A Final Cut Pro Timeline.

Special effects editor

If you don't notice the special effects editor's work, it means the effects are really great. This person (or team) does everything from enhancing the effects captured in the movie to completely fabricating effects in postproduction. Green screen sequences where two separate scenes are joined together (see Chapter 6) are a common example. Animated sequences using Adobe After Effects fall under this umbrella, as do computer-generated effects.

Sound effects editor

The sound effects editor adds proper sound effects to the film after shooting. During principal photography, the primary goal revolves around capturing the visual mood along with the dialogue. In a night shot, you're not going to have crickets chirp on cue, so those sounds are added in postproduction. These professionals usually have access to a sound library, but also often go out and capture their own. They can place them exactly where necessary, once again creating the perfect symphony between sound and vision, and they do it without the audience ever being aware of it. In the 1981 film *Blow Out*, that was job of John Travolta's character.

Other sound jobs include

- **Dialogue editor:** Works on the audio parts where people are talking in the scene.
- **Music supervisor:** Acts as a liaison between the production and the recording industry to secure rights to use popular music in the film.

Anytime you hear a Rolling Stones song in a movie or Bob Dylan on a television show, these are the folks who make it happen.

✔ **Sound designer:** Has the task of gathering, creating, and manipulating audio elements with the intent to produce a specific mood. Each project differs, with some movies using lots of effects and others requiring a simple balance between dialogue, ambient noise, and music.

Managing the Day of the Shoot and Beyond

*I*f you're ready to shoot, congratulations for doing all the pre-shoot work. And if you haven't, shame on you for your lack of preparation. The process goes much smoother when you do your homework. That's because making a movie goes beyond taking your camera out one day and shooting everything that appears in front of you. If the skill were an iceberg, the day's shoot is what's sticking out of the water. As you know, the majority of that breakaway glacier sits below the surface.

Ironically, so does the structure of your movie. There's a lot of preparation when it comes to making a movie, from writing the screenplay to casting the actors and finding locations. But up until now, it's all been theory. It's time to put it all to work. Whatever the situation, you've gotten this far, so you can't blow it. You want to make the best movie that you can, so it's game-on! That's easier said than done, however. You need to make sure that you have everything other control. It's game day.

Directors Direct

Sitting atop the movie production hierarchy lies the director. She runs the movie set and basically guides the actors through each scene, while at the same time looking at the "big picture" when it comes to cinematography, lighting, and audio capture. For example, the camera operator is only interested in what happens in the frame, the lighting technician only cares about effectively lighting the scene, and the screenwriter thinks about how the words and story unfold on paper. The director brings those pieces and many others together to bring cohesiveness to the film. And oh yeah: The director squeezes the best out of the actors by properly instructing them to what works for the scene, but the cast and crew must feel comfortable with the director's decisions.

Directing your movie and keeping friends

Directing a movie presents both the most fulfilling creative experience and possibly the most aggravating, often at the same time. As a result, it can make monsters out of normally rational adults. The ability to keep your composure holds relationships in the balance, but the bigger picture is earning respect as a filmmaker.

Most of the time you can chalk up problems on the set to a disconnect between the way you've as the director pre-visualized the scene, and the reality of what's unfolding in front of your eyes. Other times, it has more to do with getting the actors to do what you need for the scene. Maybe it's a discrepancy between your idea for a performance and the way the actor plays it. Perhaps your cinematographer has a different vision for a particular shot. When that happens, the only thing that you can do is show patience.

If one thing sums up successfully directing a film, it's good communication. It lies at the heart of directing a film because the real art has more to do with motivating people more than coming up with compelling shots and performance. Conversely, when you create tension on the set, you run the risk of losing your grasp on the cast and crew.

Understanding why directing is like politics

Think of a director as a politician running for reelection. He must do his job while listening to his constituents. If he ignores them, his base grows disenchanted and doesn't vote for him. If that politician doesn't respect his support staff, they'll eventually leave or not work as hard. And so begins the downward spiral.

That same sensibility applies to the movie director. If you see your role as a motivator of people and with a clear vision (minus the truth-telling part), then chances are your behavior will be contagious. If you do that, the cast and crew align with you, and ultimately, do the best that they can do. That's not the same as doing the best job ever. But with each film under your belt, you get better at directing, and more talented people will join you along the way. For now, the important task involves successfully directing your movie. Veer too far from that attitude, and you risk the project coming to a crumbling halt.

Each director differs in her approach, yet the goal is always the same: to make a great movie. To have that opportunity, it's important to follow some rudimentary guidelines:

- **Speak in a calm, even tone.** Raising your voice only shows weakness. Instead, always speaks to your cast and crew in a polite, even tone.

- **Gesture with natural body language.** This puts the actors at ease as opposed to what can come across as aggressive posturing.

- **Use action verbs.** Ineffective directors usually issue ambiguous instructions to actors. Instead, direct your actors with clear instructions that use verbs like *run, walk fast,* or *move quickly* as opposed to just saying *fast.*

- **Show openness to suggestions.** Filmmaking is a collaborative effort, so listen to your actors and try what they suggest if it's not that far-fetched.

- **Be gracious.** Make sure to thank your cast and crew and do it often. This cannot be overstated, especially when you're working on a budget with a low-paid or unpaid cast and crew.

Figuring out the importance of the clapperboard

The *clapperboard*, as seen in Figure 19-1, is iconic, looks cool, and is fun to clap. Also called a *movie slate*, *sync slate*, *time slate*, *sticks*, and various other names, this hinged board serves several important functions. For one, it's the primary means for titling each scene because the slate is captured on camera. But equally as important is that it serves as a marker when it comes to synchronizing of picture and sound. Because movie cameras only capture images and not sound, it's necessary to record sound on a separate deck. When the movie goes into editing, the editor matches the hard slapping sound captured by the audio recorder to the visual of the hinged top coming down. In addition, the clapping is accompanied by a verbal acknowledgement to identify the sound files. This technique works well with a DSLR and a separate audio recorder.

Part IV: Becoming a Filmmaker

Clapperboards come in various styles including electronic ones with LED readout, chalkboard slates, and surfaces that accept dry erase writing. You can buy one online or at a movie souvenir shop. Depending on the type you buy, the naming fields on the clapperboard may vary, although all gather the same information. Here's a breakdown:

- ✔ **Reel number:** Regardless of what it's called, what goes here is the name of the recording media, which in this case is a digital media card. It's important to name and number your digital media card. That's easily done in the software. As a naming convention, use successive letters or numbers (for example, 001 or AA).

- ✔ **Date:** The day the scene was shot.

- ✔ **Scene:** The scene name or number. Generally it's tied into your shot list and storyboard, as mentioned in Chapter 17.

- ✔ **Take:** The first take is one, obviously, and each time the scene is re-shot, the number progresses.

- ✔ **Production:** The working title of the movie.

- ✔ **Studio:** Sometimes the studio name is included.

- ✔ **Director:** The director's name goes here, although the other information is much more pertinent because movies usually have just one director. However, in the case of the epic fantasy *Cloud Atlas*, the director information came in handy because the movie had three directors, including Andy Wachowski, Lana Wachowski, and Tom Tykwer.

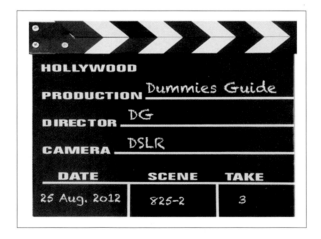

Figure 19-1: A typical clapperboard.

Shooting the Movie

The moment you've been waiting for has arrived. You've written the screenplay, found actors, rehearsed them, scouted locations, and now here you are. But the hard stuff is not out of the way. That's because no matter how well you prepare, on the day of each shoot, not everything goes according to plan. Some aspects are clearly out of your control, like a sudden change in the weather, as seen in Figure 19-2, or a traffic accident near your location. Other times, it's things you didn't anticipate, like a homecoming parade on Main Street. (And you can't even take advantage of it because your movie is about alien soccer mom zombies.) Maybe one of your actors comes down with food poisoning. Some problems are clearly your fault, like forgetting to bring a spare battery or some other camera accessory.

Figure 19-2: An unexpected rainy day can still work to your advantage.

Recognizing the need for multiple takes

There are two things Hollywood directors hardly ever do: attempt to shoot a movie in linear order — despite coming back to the same location later in the story — and to shoot a single take of each scene. The former relies on efficiency, but the latter has more to do with having a nice set of options.

By multiple takes, I mean multiple takes using a single camera, and not one take with multiple cameras. The benefit of capturing a scene with more than one camera means you have all the components from that perfect take – when the actors collectively nail the scene – to provide all you need for the edit. But each director approaches it differently.

Some directors take numerous takes of the same scene to get it just right. *Fight Club* director David Fincher has been known to hit the 100-take mark. Conversely, Clint Eastwood finds the first take the best and rarely shoots an abundance of takes. Multiple takes get expensive when shooting film. You need to pay for film stock and processing and those costs add up.

But when you're shooting on a digital media card, that's not an issue. Regardless of how Hollywood directors approach multiple takes, it's good idea to shoot multiple takes of each scene for obvious reasons because DSLR moviemaking does create some new dilemmas.

Here are some reasons to shoot the scene several times:

- **You're shooting with a single camera:** Although it's not unusual to shoot with a single camera, it does mean that you'll have to shoot key scenes several times in order to accrue the necessary variations needed for editing. If not, it looks like Junior's school play. (You know, consisting of a straight-ahead wide shot with the occasional bouncy zooms.)

- **You can compensate for inexperience:** That goes for both you and your cast and crew. I'm not saying that your first take won't work, but why take a chance?

- **You keep your options open:** After you get the shot the way you want it, feel free to experiment (providing you have the time) by shooting another angle, a different framing choice, an actor's expression, or whatever you want to try. Maybe it's not a bad time to take that suggestion your actor made.

Shooting your movie out of order

Movies are hardly shot in linear order. Instead, all the scenes from a particular location are shot in succession, despite the point they appear in the movie. It's done this way for both efficiency and budgetary reasons. But it can also get complicated when the scenes represent different time passages. In order to make sure you capture all the necessary scenes as well as maintain the proper continuity, make a list of all the scenes in each location and create a storyboard, including shot numbers.

Although budget and time concerns are the primary reasons for shooting out of order, there are some others too:

- **It helps with scheduling issues:** Sometimes the location is only available for a certain time. Sometimes the actors can fit it in because the time is condensed.

✔ **It enables the actor understand the character:** When actors experience the progression of their character over the course of the story, they're able to convey emotions more effectively.

✔ **I provides continuity:** Wardrobe, set decoration, hair, and make-up are all subject to slight variations in appearance when too much times passes. Anytime you come back to the scene, you run the risk of something being out of place.

Arriving prepared

Nothing else really matters if you're not prepared for the shoot. Barring any unforeseen circumstances, the objective is to hit the ground running, and the only way you can do that is to have everything ready on the big day. This one could make the list denoting the best day of your life, or can easily slide into one of the more regrettable when you didn't plan it out well.

Consider the following:

✔ **Check the weather:** Although it's not your fault when it rains, you are culpable for not checking the forecast night before and getting surprised by a downpour. If the rain works for your needs, be sure to bring protective gear for the equipment.

✔ **Prep the camera:** It's the star of the show because without it, all you'll have is some twisted version of live theater. Make sure it's working properly and that the battery is freshly charged.

✔ **Clean your lenses:** There's nothing worse than looking at your footage and noticing a soft spot over the scene because you never noticed that smudge on your lens, as seen in Figure 19-3.

✔ **Equipment check:** Test all of your equipment the night before to make sure it works. Load fresh batteries in the microphone and charge the camera battery. Do you have your rig, tripod, and other supports?

✔ **Bring plenty of spares:** Batteries, media cards, microphones, cord, and so on. Even if these accessories never falter for you, they will on the day you need them most.

✔ **Carry snacks and beverages:** Nothing is worse than the cast and crew being parched and not being able to get a drink. Remember too, some cookies easily smooth over some of those tense times.

✔ **Have your lists ready:** These include the shot list, the prop list, and the character list. Also be sure to have a copy of the screenplay. Break down each section in terms of location so it's pertinent to where you are shooting that day.

Lens smudge

Figure 19-3: The smudge on the lens created a soft spot.

Cleaning your lenses

Nothing is more frustrating than seeing the result of a lens smudge in your footage. That's why it's important to clean your lenses often. But it's not as easy as you think. You can do damage if you don't do it correctly.

Consider the following:

- **Don't wipe it with a rag:** You can scratch the lens surface and make the temporary abrasion a permanent one.

- **Wipe with a lens tissue:** If you do need to wipe the lens, be sure to use a piece of lens tissue. You can use lens-cleaning fluid. Gently wipe the surface from the center to edge. If you need to clean the rear element, be even gentler.

- **Microfiber cloth:** This allegedly safe material can be used, but use it sparingly and even more gently than you would a lens tissue.

- **Use a blower brush:** They're great for loosing debris and wiping it away. When you blow, be sure to do it from the bottom and be gentle.

Creating a shooting schedule

The most essential list of the day's shoot is the shooting schedule. This schedule, planned well in advance, can assure that movie production goes smoothly. The schedule consists of all the shots needed from that location, as well as the time allotted to accomplish that goal.

Working from a shot list

Created in advance of the day's shoot, a *shot list* is the list of each shot that makes up your entire movie. In addition to covering the scenes, it should also include the b-roll and cutaways needed for the movie. For example, you may want to include a variety of shot types of a landmark or details for your establishing shot. Figure 19-4 shows an example of a working shot list.

```
"Dummy and the Dummies"

8:00am              PICK UP crew at Mineola train station
9:00am              ARRIVE Long Beach boardwalk

10:00am-11:00am     SET UP

11:00-12:00pm       Dummies stars

                    Johnny
                    Jane

    1.     ESTABLISHING SHOT. Boardwalk and beach

    2.     WIDE SHOT. Down boardwalk

    3.     MEDIUM SHOT. Bench as Jane walks into frame

    4.     CLOSE UP. On JANE gazing outward.

    5.     MEDIUM SHOT. Of waves crashing.

    6.     CLOSE UP of JANE, "I see you."

    7.     TILT UP. JOHNNY grinning.
```

Figure 19-4: A working shot list.

Planning for Your Edit

Shot lists are essential for making sure that you get everything that you need for your need for the movie. That includes a wide range of shots, variations in camera angle, and key objects. But you can't plan for everything. Maybe when you were scouting the location, you didn't notice the cobblestone street around the corner or the period-era telephone booth. Even if these are for nothing more than a cutaway, you should take the time and try to include them.

Another dilemma happens when you have a brain freeze while making the plan, and later realize that the shot list favors a certain side or angle. You need to supplement some varying shots to balance the day's shoot.

Even if you've written up your shot list, prop list, and a list for the lists, you'll still make changes on the fly. But that doesn't mean you shouldn't keep track of those changes. Think of it as a constant work in progress.

So remember:

- **Take copious notes:** Make sure they match up with the shot info. Write down anything you need to modify.

- **Fill in the blanks:** If you notice a shot type that works better than what you planned, or it's something you didn't consider, by all means add that shot if you have the time.

Doing a sound check

Before you press the Record button, you must always make sure the basics are covered. That means to set a white balance, adjust exposure, and re-focus. Equally important is being certain that the audio levels are within range. Quite simply, sound makes the movie and often is that invisible factor for movies that don't turn out well. Take the time to make sure the sound on your movie turns out just right.

Consider the following:

- **Make sure microphones are properly placed:** There's nothing worse than capturing bad audio because the boom operator pointed the dead squirrel in the wrong direction. (If you don't know what a dead squirrel is, check out Chapter 10 for more on capturing audio.)

- **Monitor with headphones:** There's no substitute to listening to sound from the scene while it's playing out.

- **Capture a few minutes of background noise:** If you do it at each place you shoot, it helps immensely when you edit. The reason is that sometimes, you'll have some unwanted sounds like a blaring horn at a key part, as seen but not heard in the busy urban scene in Figure 19-5. You can alter the audio track in the editing process to include natural sound in place of the noise. Other times, you can add a continuous background track to compensate for scene changes, and the subsequent difference in sound with each one.

Figure 19-5: This busy traffic scene looks great, but it was nearly impossible to capture clear dialogue.

Logging each shot

You have a shot list and you're using a clapperboard for each shot. You should also keep a running list of each take and add notes so that you can more easily go through the footage when it comes time for editing.

Managing continuity

You have many challenges when it comes to shooting a linear story in non-linear fashion. When assembling the movie, the consistency between different parts of the same scene is often compromised. Maybe your actress is wearing a watch at the beginning of the scene and not at the end, or her hair is styled differently. Most feature films have a person dedicated to maintain the integrity of the movie's continuity. The script supervisor pays close attention to the needs of each scene. Because that most likely will be you, you need to add that job to your growing list of titles.

The following can help:

- ✔ Take digital photos of each scene
- ✔ Keep track of camera angles
- ✔ Be sure wardrobe, hairstyle, and props are consistent

Backing up your stuff

Although digital media cards keep getting bigger, HD video capture fills them up even faster. As a result, you're going to need a lot of cards to work with. I've been in situations where camera operators have run out of space and had no more cards with them, so they ended up deleting files to make room for a three-minute scene. Here are a few solutions to make sure that never happens to you:

- ✔ **Bring more cards than you need:** That's a no-brainer. It makes your life easier.

- ✔ **Transfer to a hard drive:** It's not a bad idea to do a field transfer of all your content to an external hard drive, but don't erase cards until you have backed up multiple versions.

20

Your Red Carpet Premiere Awaits

After putting blood, sweat, and tears into your masterpiece, it's time to show it off in style. Why not? This isn't 1985, so your options go beyond tacking a bed sheet to the wall and breaking out the movie projector.

Today, the choices are boundless. You can have an impressive screening at your place, enter your movie in an established film festival, or submit it to an online competition. You can even hope the movie goes viral on YouTube. Never before has the average user been able to make a professional-looking film and share it with the world as easily as in the HD era.

Holding a Private Screening

At one time, showing your film to friends and family took place in a basement, garage, or a spare room using a clunky projector. Charming, yes; breathtaking, no. That's because it bore little resemblance to the movie-theater experience (stains on the screen not withstanding). Special effects and the ability to add sound were out of the question. If you were savvy enough to own a VCR, you knew that VHS provided more detail than 8 mm film (see Figure 20-1). Of course, it looked nothing like the quality of broadcast TV even at the time, and the broadcast standard in the 1980s was pretty low-tech compared to current quality.

Today, sophisticated big-screen televisions with HD are everywhere, along with multiple speaker surround-sound stereo and some really good snacks. That makes it pretty easy to host movie night at your place and may even have advantages of going to a movie theater.

To make the experience for you and your guests as good as possible, consider the following suggestions:

- ✔ **Send out invitations.** Make that screening a memorable event by formally inviting your guests. Family, friends, and guests will know it's something that you're taking seriously.

- ✔ **Create a movie poster.** Choose a still frame from the movie, a photograph from set, or a portrait of one of your actors. Using Adobe Photoshop Elements, add some text and effects to make a photo-quality print, as seen in Figure 20-2.

- ✔ **Produce a full-featured DVD.** It's easy these days to make a professional-looking DVD with inexpensive, or even bundled software like iDVD. You can even break down chapters or markers in case you need to go back to key scenes later. Give your audience a real DVD feel with alternate takes, bloopers, and even commentary if you so desire.

- ✔ **Turn the lights out and movie on.** That means be ready to roll. Don't scroll through discs, tapes, or files when everyone is sitting around waiting for the movie to come on.

Figure 20-1: A VHS tape and 8 mm film reel.

Figure 20-2: A homemade movie poster.

Creating a virtual screening

Using an online video site, you can upload your movie and send invitations via a link. You can create a private link and decide who sees it, or make it public and hope the video picks up a following.

Check out the following online sites:

- **Blip.tv:** A video-sharing service aimed at users looking to produce web shows as opposed to uploading viral-video content. In addition, it includes revenue sharing to help independent producers make money from advertising revenue.

 For more information, go to www.blip.tv.

- **Vimeo:** With an anagram that spells *movie,* this video-sharing site with heavy emphasis on independent filmmakers allows users to upload, share, and view content. But unlike some other sites, all content uploaded to Vimeo must be original and non-commercial.

 For more information, go to www.vimeo.com.

- **YouTube:** The most common of the video-sharing sites, it lets users upload, share, and view videos in a variety of formats, including HD. You can even upload 3D video.

 For more information, go to www.youtube.com.

According to a 2011 study by Cisco, Inc., more content hours are uploaded to YouTube in a 60-day period than the three major U.S. television networks have created in 60 years. Online video sites also provide a community aspect. Not only can you get your video seen, but there are countless people who can give you advice and feedback, some nicer than others.

Dabbling in the festival waters

One of the dirty little secrets of the movie business surrounds how films are found, bought, and sold. Film festivals and competitions play more of a part than what the public assumes. Although most of the major film festivals qualify as a competition, you'll want to start small. And by small, I mean enter it in competition that is likely to accept your work, and at the same time doesn't demand an enormous entry fee.

I'm sure you've noticed there's never a shortage of drug-store chains like CVS or Walgreens, and the same applies to film festivals and competitions. Every country, city, and town gets in on the action, so there's one for everybody out there. It's a little bit like applying to college. Some take you and others reject you, and it's not always about you. So when it comes to determining the best one to get you recognized as a filmmaker, consider the following advice:

- ✔ **Know your audience.** Every festival has its own flavor, evident in what it prefers and accepts. Some cover a range of styles, genres, and subject matters when it comes to submissions, whereas others are more theme-specific. Do your homework before submitting. Chances are that your slasher/comedy/love story with a twist will not do well in a festival aimed at competition.

- ✔ **Finding a festival.** The more you research each festival, the better your chances of being accepted. If you work in a specific genre, try to find festivals and competitions that support it. If it's your first film, and you're still learning the craft, try not to jump right into a big competition only to find out it wasn't right for you, not to mention the rejection factor.

- ✔ **Submit your film.** Be sure to follow festival guidelines regarding file size, format, and method of delivery. Make sure it arrives on time. Remember, sending the wrong format can diminish your hopes of your film being accepted.

- ✔ **Keep track of your submissions.** Keep a calendar of deadlines and what you've sent. Be on alert for phone calls, e-mails, and postal delivery regarding their decision. Once a festival has accepted your work, it may also wish to invite you to attend, request a bio, or ask you to submit a poster. With some rejections come a review, and although you're disappointed when your film isn't selected, you can at least learn something from a thoughtful rejection.

- ✔ **Read the fine print.** Details may include regulations and disclaimers ranging from what other festival you can enter, exclusivity (that you can enter your film only in that festival), and their use of your material.

✔ **Go to festivals.** The more connected you are with the flavor of each festival, the better your chances for having your film accepted and screened. In addition, you can learn something from other filmmakers.

✔ **Consider online festivals.** These days, online festivals reach a wide audience, so consider them along with the festivals dedicated to a place. (See the section later in this chapter called, "Considering Online Film Festivals".)

Pondering the Film Festival Circuit, Major League Edition

While film festivals serve many functions, generating buzz climbs to the top of the list. A great festival stimulates public interest and entices business for filmmakers. Part of the reason for the numerous film festivals has to do with geography. Because they're a popular draw, fans and filmmakers don't need to go too far to get their fix. And if the film has a local flavor, that adds to the fun.

Theme is another aspect when it comes to differentiating film festivals. Some merely satisfy fan appreciation, whereas others celebrate the best films with a jury prize. For example, the Cannes Film Festival awards the Palm D'Or to the best film. Winning that one is quite a notch on your belt. Then there are the ones that provide a showcase of new films without the competition process, as in the case of the Toronto International Film Festival. Film festivals are like snowflakes: Each is similar and yet very different.

The Cannes Film Festival

Twelve days in May transform this small city in the south of France into the world's largest international film festival. This intense meeting of art, stardom, and finance attracts in the neighborhood of 27,000 film-industry representatives and countless tourists. Cannes is the number-one international market for first-time films, and multi-million dollar deals are signed there every year.

Some films compete, whereas others are shown with the hope of generating sales and distribution, so there's a lot of wheeling and dealing between producers, filmmakers, distributors, and other players.

The festival accepts thousands of entries from all over the world in a variety of categories. If your film is accepted, you'll get to hob-nob with cinema's elite. Of course, if it's not, don't expect to be much of an active participant.

Competing films vie for the Palm d'Or. Directors like Martin Scorsese (*Taxi Driver,* 1976), Steven Soderbergh (*Sex, Lies, and Videotape,* 1989), and Quentin Tarantino (*Pulp Fiction,* 1994) made early award-winning films at Cannes.

For more information, go to www.cannes.fr.

Sundance Film Festival

Every year in the middle of January, Park City, Utah, and a few other nearby locations host the mother of all independent film festivals. Conceived by the Sundance Kid himself, Robert Redford, in 1979 — using a reference from his 1969 film, *Butch Cassidy and the Sundance Kid* — the goal of the festival is to create a haven to nurture independent filmmakers.

Sundance has grown to become the largest independent cinema festival in the United States, showcasing a broad selection of American and international independent filmmakers. Festival selections include American and international dramatic films, feature-length films and short films, documentaries, and a bunch of out-of-competition selections. Some of the most successful films to come out of Sundance include the Coen brothers' debut, *Blood Simple* (1984), *The Blair Witch Project* (1999), and *Little Miss Sunshine* (2006).

Sundance has launched the careers of many filmmakers, including Kevin Smith, Robert Rodriguez, Paul Thomas Anderson, Darren Aronofsky, and Jim Jarmusch.

For more information, go to www.sundance.org.

Toronto International Film Festival

Every September, the Canadian city, as seen in Figure 20-3, hosts one of the most prestigious festivals, and ultimately one that's quite friendly to Oscar and his award-season cohorts. Though smaller in volume than Cannes, TIFF, as it's affectionately known, provides the launching ground for the upcoming awards season with many of the Academy Award and Golden Globe–nominated films. (And some winners, too!)

The unique thing about this festival is that there's no jury prize. The closest thing to a winning film is the public-voted Peoples' Choice award. That relieves the pressure for Hollywood studios and award-savvy producers looking for potential award season nominations and not a festival win. Instead, there's a great deal of dealing, and Oscar voters, among others, get a chance to see these films long before they're released.

Successful films at TIFF include Oscar-winning best pictures such as *American Beauty* (1999), *Slumdog Millionaire* (2008), and *The King's Speech* (2010). Then there's *The Hurt Locker,* which was bought at TIFF in 2008 by Summit Entertainment, officially released the next year, and won the Academy Award for Best Picture.

For more information, go to www.tiff.net.

Figure 20-3: The Toronto International Film Festival.

Other film festivals

Besides these festivals, some other prominent ones include

- ✔ **Berlin:** This big European festival seems to take a backseat to both Cannes and Venice as the continent's most successful film festival. Still, it churns out the occasional hit. Some former Golden Bear winners are *Rain Man* (1989), *The Thin Red Line* (1999), and *Magnolia* (2000).

 For more information, go to www.berlinale.de.

- ✔ **Slamdance:** Discovering new talent is the mission of this unique yearly festival. Held in Utah every year at the same time as Sundance, the Slamdance Festival seeks an even more independent sort of film than its neighbor. How much more? Try films with a budget of less than $1 million. Among the filmmakers who emerged from Slamdance are Christopher Nolan, Marc Forster, and Jared Hess.

 For more information, go to www.slamdance.com.

✔ **Tribeca:** This relatively new festival was conceived by Robert De Niro to help bring business back to his New York City neighborhood after the September 11th terror attacks. Growing each year, the festival attracts a healthy assortment of independent and documentary films. It's not shy about big movies either, hosting the *Spiderman 3* (2007) premiere and Marvel's *Avengers* in 2012.

For more information, go to www.tribecafilm.com/festival.

✔ **Venice:** Every August, filmmakers flock to the northern Italian city to vie for the festival's top award, The Golden Lion. Although it's not a major event for wheeling and dealing, it often gives the press a first chance to see potential award-season films ahead of the Toronto International Film Festival.

For more information, go to www.labiennale.org.

Considering Online Film Festivals

Not all film festivals take place at a physical location — some use online space as a venue. These online film festivals and competitions are sometimes associated with traditional festivals, as well as offered with online video sites.

With an increasing number of festivals springing up on the web, it's a good idea to frequently scour the Internet to find one that's perfect for you.

Some recent competitions of note include

✔ **YouTube:** The popular online video site holds a variety of competitions including the annual Your Film Festival launched by Ridley Scott. This new online contest sent ten budding moviemakers to the Venice Film Festival.

www.youtube.com/user/yourfilmfestival

✔ **TheWrap.com:** In 2012, working with MTV, The Wrap launched the first annual ShortList Online Film festival. The festival showcases 12 award-winning short films picked from the world's top film festivals of the past year.

www.thewrap.com

✔ **Vimeo:** Like YouTube, the online video website is now hosting an annual competition festival, including large cash prizes.

Part V
The Part of Tens

*L*ike the final part of every For Dummies book, this part is all about the top-ten lists: how to improve your filmmaking skills, how to create a music video, techniques for shooting a wedding video, and creating a documentary.

Ten Ways to Improve Your Filmmaking Skills

As Jean Renoir once said, "A director makes only one movie in his life, then he breaks it into pieces and makes it again."

I suppose being a great filmmaker and descendant of the great impressionist artist doesn't mean you always speak with a gender-sensitive tongue, but the director of *The Grand Illusion* does make a valid point. Although his quote is subject to interpretation, it's not off the mark to say it means that filmmakers learn how to make movies by making movies: sort of like finding that thing you do and doing it better and better. But in order to make the next movie better, you have to continually find way to improve your skills.

In this chapter, I break down the top ten things you should consider to make the best possible movie. Unlike the one from *The Late Show with David Letterman,* this top ten list doesn't come in any specific order. It's just about making a good movie.

Plan Your Shoot

You wouldn't build a house without plans, so why would you try that with your movie? Whether you're making a feature film, shooting a music video, or documenting a family documentary, the idea is the same: plan it out and stick to the plan. The alternative to strategizing the framework of your

cinematic art is haphazardly shooting some scenes, slapping them together, and calling it a movie. Whenever that thought creeps into your head, just say no.

When preparing your next movie, consider the following:

- **Work with a script.** It doesn't have to be a traditional screenplay, just one that provides enough structure to anticipate each shot.

- **Calculate your shots.** Think of ways to effectively capture the subject, or do the opposite: Figure what won't work and don't do it. Figure 21-1 was used as an important bridge for a music video.

- **Budget the necessary time.** If you have a weekend to shoot the movie, allow yourself enough time to get your shots done.

- **Prearrange cast and crew.** Make sure everybody understands the schedule and is available.

Figure 21-1: This unique glass door worked its way into the shooting script and provided a nice alternative to shooting the subject head-on.

Tell a Concise Story

Whether it's a feature-length film, film short, three-minute news package, or a simple sequence, the idea is the same: clear storytelling. Stick to the basics before going back and trying more experimental shots.

Shoot to Edit

If you've got the previous two points under your belt, this one shouldn't present a problem. Remember to shoot your movies with variations of the scenes

you plan to use. There's a misnomer that suggests shooting as much footage as possible, so you have a lot to put together later. Not the best plan. It will take you a long time to make sense of it, and you'll also find that you use the key scenes you intended to shoot anyway.

Instead, try to capture the necessary shots with the appropriate variations of camera angle, focal length, and camera-to-subject distance. So if you wish to depict the subject entering a key location, you can concentrate on the variety of ways that happens with an eye on how it comes together in editing.

For each scene, consider the following variations:

- ✒ **Vary the width of shot.** Wide, medium, tight: Shoot each scene with these variations, as seen in Figures 21-2, 22-3, and 22-4.

- ✒ **Hold each shot.** Whether you need two seconds in your movie or two minutes, always shoot the scene much longer than you anticipate on using it. A good place to start is recording each shot for at least 10 seconds.

- ✒ **Vary your angles.** Don't shoot the entire movie at eye-level. Instead, break up shots by placing the camera up high or down low.

- ✒ **Establishing shot.** Be sure to shoot a strong opening shot for the film as well as for each key scene.

- ✒ **Limit each take.** This is when rehearsing comes in handy. Try not to shoot more than three takes, unless you're looking to be David Fincher (*Fight Club*, *The Social Network*) He's notorious for shooting dozens of takes of every scene. Clint Eastwood, on the other hand, shoots many of his scenes in a single take.

Figure 21-2: Wide angle.

Figure 21-3: Then the medium shot.

Figure 21-4: And the close-up.

Use the Proper Tools for Stabilization

Normally, stabilization means using a tripod, but in the larger sense, it's anything that keeps the camera steady. After all, it doesn't matter for the movie as long as it works. This includes mounting it on a tripod, using a rack system, or choosing something a bit more adventurous like a dolly or jib.

✔ **Be sure to have a good tripod.** Make sure it at least reaches your eye-level and the legs are steady. Even the best tripods are susceptible to shaking, so be sure all the knobs are tightened snugly.

- **Make sure the tripod head is right for video.** Using a video or fluid head allows you to smoothly tilt and pan. Video heads are also designed for horizontal rendering and do not offer vertical orientation for obvious reasons.

- **Make sure the rig is comfortable.** Because the rig is adjustable, you can make sure everything is exactly where you need it.

- **Rehearse your moves.** Whether it's a simple as a pan or as complex as a dolly shot, practice your shots before hitting the Record button.

Understand Your DSLR Like the Stats for Your Favorite Team

Nothing is worse than fumbling with your camera in front of your cast, crew, or subjects. That little bit of uncertainty can hurt their confidence in your ability, not to mention break your rhythm. Remember, making movies is far more complex than just pressing Record. Your camera requires lots of settings to make it work right, and the default mode will not suffice.

Here are some key functions to consider:

- **Exposure:** Not all DSLRs have the aperture control in the same place, so get comfortable with its placement. Shutter speed generally changes on the right side.

- **ISO setting:** Depending on your light values, you may need to adjust sensor sensitivity, so it's important to know exactly where it's located.

- **White balance:** DSLRs are notorious for nesting this key function somewhere in the menu. Placement differs with each manufacturer and model.

- **Movie mode:** Because it's not the same mode setting or activation (only a few record using the shutter button) for stopping or starting a movie, get comfortable with it.

- **Other functions:** Formatting the card, changing image sequencing, using the Live View functions, and making numerous adjustments go more smoothly when you're familiar with them.

- **Study the manual, constantly:** Learning a function today will not assure you know everything. Each time you read the manual, you'll learn something else.

Bring Your Own Lighting

Waiting for the right light is like going to the Department of Motor Vehicles: It requires a lot of waiting, but you have to do it, so you may as well get used to it. Besides, there comes a point when you can't mooch any passive light. Face it, there just aren't enough situations that you can adjust for effectively when making your movie. So, consider bringing your own lighting.

Try the following:

- **Go with the on-camera light.** It mounts on your DSLRs accessory shoe and lets you bring light to static subjects that are relatively close to the camera such as interviews, details shots, and to emulate the view of a flashlight.

- **Bring a light kit.** They're inexpensive, powerful, and let you add the necessary accessories to give your movie the look of professional illumination. For more description on how to use them, see Chapter 8.

- **Use the poor man's light.** Set up some lamps or bulbs to light your subject and keep them out of the frame. Or don't, as I did in the shot for a music video in Figure 21-5.

Figure 21-5: Lamps with colored bulbs lit this entire scene.

Never Skimp on Composition

"Compose to create visual prose," is what I always say. Sadly, I'm no poet, and I know it, but I digress. How you fill the frame determines the strength of each shot, and, before long, the overall tone of the movie. The more you

consider what happens in that rectangular world, the better your movie will look. Remember, the audience never knows anything more than the visuals they see onscreen. You have the power to influence them, depending on how your arrange elements in the shot.

Remember these pointers:

- ✓ **Look before you leap.** Before pressing the Record button, check to make sure those elements in the scene are properly arranged. Make sure everything is where it belongs.

- ✓ **Don't forget the rule of thirds.** Plopping the subject dead smack in the center of the frame rarely looks good. Dividing the frame into thirds like a tic-tac-toe board and centering the subject on one of the intersecting lines helps prevent this *faux pas.* The subject never appears center square, as shown in Figure 21-6.

- ✓ **Watching for blocking.** Make sure that your actors move effectively through the frame. Use tape markers, paces, and other minor visual cues to keep them in the right places. For more explanation on composition technique, see Chapter 9.

Figure 21-6: This talking head is positioned on the left side of the frame, looking right for proper placement.

Remember to Get Plenty of Cutaways

Although they're not the main subject, the cutaway shot is an essential part of the sequence, and ultimately, the movie. A *cutaway* is best defined as that shot of anything other than the subject that either cues the audience to something they need to know or serves as an interruption to the action.

So many subjects, and parts of subjects, for that matter, fall into this category: for example, the tapping foot of a musician, or a hand pulling a set of car keys out of a tray.

Here's some other things to consider:

- **Crowd shots:** Think concert films and those fans mouthing the words.

- **Animals moving away quickly:** The flock of birds taking off, the cat running away, or a barking dog all let the audience know something bad is about to happen.

- **Exterior details:** Sometimes these are an address number, a lost object, or the unknown location of something spoken about in the scene. The neon sign in Figure 21-7 is an example.

- **Subject moving out of the frame:** That often provides a nice alternative for editing because when the subject moves out of the frame, it's plausible for you to cut to just about anything and have it appear seamless.

Figure 21-7: The neon sign in the Seattle Market provided a sense of location for a music video.

Don't Forget About Sound

A great movie doesn't just have sound, it has great sound. Take the time to make sure you're getting a clean, clear sound. Capture it as best you can using the proper equipment and then fine-tune it in postproduction. Remember the axiom of "garbage in, garbage out," because it applies here. Try to limit the use of your on-camera microphone, opting for one more suited for the task.

These include

- ✔ **Stick microphone:** These work great for interviews and when used close to the subject (no more than 12 inches away).

- ✔ **Shotgun:** This long, narrow microphone excels at picking up sounds directly in front of it and not off to its side. As long as you aim them accurately, they have a long range.

- ✔ **Lavaliere:** Clip one on your actor or subject, and have no worries about the microphone. The microphone is always at the proper distance no matter how they move or turn. Just make sure you position it correctly and hope the fabric doesn't create any noise.

- ✔ **Voice recorder:** Attach the microphone directly to the recorder and the pole or stand, depending on the setup.

Watch a Lot of Movies

Observing how different filmmakers go about structuring their shots shows you endless variations. From observing and trying different shot types, angles, and approaches to the subject, you begin to develop your own style:

- ✔ **Watch the masters.** Observe how Alfred Hitchcock uses visual language or how Woody Allen works with so many actors.

- ✔ **Break down really bad movies.** The idea here is to find the aspects that don't work well in the move, or perhaps almost work.

- ✔ **Have a healthy DVD collection.** You can watch some of these on cable television, but buying them at a discount store is your best option. Sometimes you can get movies you've probably never heard of for a buck or two. You can watch them frame-by-frame or in slow motion to learn from the best and the worst.

Ten Steps to Creating a Music Video

*B*ack in the early days of cinema, music gave dimension to the silent film by cueing the audience to certain moods. The music played faster when a train approached or changed tempos to help depict a scene, and that compensated for the lack of dialogue. And the music came from a guy at an upright piano playing live in the theater, proving that music has gotten much more portable over the years.

All kidding aside, it seems fitting that video returns the favor by making the songs a bit easier to understand. Think of a music video as miniature feature-length film that has an avant-garde slant.

You can thank MTV for changing the landscape in 1981 with the launch of its 24-hour music video channel. They ushered in a new era with the ironic clip for "Video Killed the Radio Star." Since then, reality television has become the network's focus, but it didn't kill the music video. It's still alive and well all over the Internet.

Since emerging on the scene, the music video has evolved and reinvented itself into an entirely expressive art form. At its core, there's a short, silent movie that uses a song as its soundtrack. Music videos are simple to explain, but there are no limits to how you approach making one.

Whether a video is a performance piece or something conceptual, the intention of its makers is to take viewers beyond the music: not too far, but just enough. But that doesn't mean it's easy. Telling a story in four minutes, give or take, and making sure it plays nice with the actual video part is a daunting task. You should approach it as you would any other project, while understanding its special needs.

When you get that big break from a local band looking to make a video from a song on its demo album, make sure you're in a position to say yes and do the best possible job. In order to make the most of your time, try to remember these ten tips to get cracking on making a hot music video.

Find the Right Song

Or even better, let the song find you. Sometimes you have control over picking the song; other times, it's decided by someone else. Maybe the band prefers a specific track, or the record company wants a video for the single. In any case, be sure to settle on the song before you do anything else. There's nothing worse than starting your video only to find that the song wasn't right for some reason. Of course, the right song is subjective. So how do you know if it's right? If, when you're listening to it, you begin to conjure images in your head, quite possibly, it's the right one.

Determine What It Takes to Produce It

Everything has a price, and that includes your time. Chances are your video will not have a large record label with an A-list budget behind it, but that doesn't mean it's not worth doing. Just be aware of the costs. Even when there are no monetary costs (props, plug-ins for software, studio times, and so on), time is still money.

Making a practice video

Feel free to experiment on a practice video for a song in your music library, but understand that it's for your eyes only. You're not allowed to publish it because you do not own the rights to the song. Doing so without permission can get you into trouble.

Consider the following:

- **Calculate your time:** Consider what it takes to produce the video in terms of shooting and editing time.

- **Figure your expenses:** Driving to the location, buying props, eating, and other costs add up. Try to come up with a budget before starting the video.

- **Consider location:** Distance and accessibility are the main factors here. In other words, make sure it doesn't take up all your time to get there. After you're set up, be sure you have enough time to shoot your scenes before you get thrown out.

- **Get the necessary permissions:** Nothing is worse than getting to a spot and being told you can't use a tripod without a permit, or that you're not allowed to shoot after dark.

- **Think about your reason for doing it:** What makes you feel strongly about the subject matter? Is it because you wanted to try your hand at something different? Or is purely your love for cinema? (If you're getting paid a lot of money, please disregard the previous questions.)

- **Think about being paid:** If you're going to be paid, calculate all your shooting days and estimated editing time before settling on a price. That's not to say you're going to make a fortune, but it should also be worth your while. If it takes you three days to shoot a video and two more to edit it, say like a 40-hour work week, and you're paid 500 bucks, you're working for 12.50 per hour. That's not bad, but it's not enough to pass up another job that pays more for your time.

Have a Concept for the Video

Before you start running and gunning with the camera, consider the actual intent of the video. Is it a story that you're trying to tell or enhance from the song? Or perhaps you see the story best told as a performance. Regardless, you need to have a plan before you start. Music videos are essentially short films, so the more expressive you become, the more cohesive the video concept is.

Ask yourself two questions: What visuals best serve this song, and what would make me want to watch this video? If you can answer those questions, you're on the road. But be prepared for some challenges to your concept. Band members, managers, and record label folks may have different ideas. And because you're not a hotshot director like Darren Aronofsky, you may not have complete control anyway.

Do the following to discover your concept:

- ✔ **Listen to the song.** Consider how it makes you feel and act on it.

- ✔ **Go with your instincts.** Instead of attempting to do what you believe someone else expects to see, go with your gut. You can modify it, but chances are it's the right thing for you.

- ✔ **Watch music videos.** Don't copy what you see; rather, see how professional directors approach their visions with the material.

- ✔ **Observe editing styles.** Consider whether you want to edit your video with quick cuts or flowing scenes. Whether you cut to the beat of the music, use the song as a soundtrack, or do a combination of both plays a big part in your music video.

- ✔ **Know your audience.** This way, if you break the rules intentionally, you'll do it with a wink. For example, a "tween" audience is not hip to certain camera or editing techniques, or an older audience may not appreciate soft focus, tilted frame, or jump cuts.

What Type of Music Video Do You Want?

After you've figured out the concept of your video, decide on a format. Some music videos use abstract visuals for their storylines; others rely on performance footage. Still others use actors (other than the band), animation, or stock footage to tell the story.

Here's a basic rundown:

- ✔ **The basics:** The full production, replete with costumes, props, and various locations. Many music videos are done in this style, as seen in Figure 22-1.

- ✔ **The live performance:** More like a live clip than a conceptual video, this method presents some dilemmas because the performance sometimes sounds different than the mastered studio version. Sometimes it won't matter. Other times, the band may need to play along with the song so that you can use the original recording. This happens frequently with music videos, as seen in Figure 22-2.

- ✔ **Narrative:** Using actors, a narrative video plays like a short movie that essentially uses the music as the soundtrack. Generally, the storyline conforms to the lyrics or idea of the song, but sometimes, it can be more abstract. Often the artist is a character in the video, and natural sounds and dialogue are present.

✔ **The stock footage video:** Basically, this has nothing to do with the band. It's just a slew of footage matched to the song. Although it's not one of my favorites, a stock footage video can come in handy, especially as a training exercise.

✔ **Animated video:** This video doesn't rely on live action; instead, it uses either CGI or Flash-based animation.

✔ **The studio video:** Think of it as the "headphones and soundboard video" because both are prominently shown as the artist records the song, as seen in Figure 22-3.

Figure 22-1: A clip from the "Beautiful Eyes" video.

Figure 22-2: A live performance video clip showing the artist's perspective.

Figure 22-3: A studio scene.

Break Down the Beats

Every song has a rhythmic structure, so figure it out before you begin to edit. You can always tap your foot and count, but it's probably easier to import the song into the timeline of your editing program to observe the peaks and valleys of the waveform. Read it like a cardiogram and determine how often the beats come. Maybe the song beats on the half second; maybe it's slower or faster. It doesn't matter. After you find it, you can lay the visuals over it and change scenes on the beat.

Consider the following:

- ✔ You don't need to change visuals on every beat.
- ✔ When changing scenes, do it on or before a beat, or it can look like sloppy editing.

Work from a Script

Whether you prefer coming up with a full script or just an editing plan, it's important to plan your video before you begin to work on it. This goes back to the Six Ps of Production I mentioned in Chapter 17.

Instead of writing it on a napkin, try one of the following:

- **Synopsis:** Write your intention for the video, kind of like you would write a synopsis of a short story. You can include areas where the visuals should match a certain part of the song.

- **Represent your intention:** By creating an editing script, as seen in Figure 22-4, you can break down the song by section, time, and beats. This way, you know the required duration of each segment and can make conscious decisions on paper before committing to the edit.

- **Write a traditionally formatted script:** Because your actual video won't have dialogue, except for possibly at the beginning and end, this script essentially sets up the scene and the shot types.

Time	Verse	Clip
	BEAUTIFUL EYES. A Ripley	
00:00:00	(((opening notes)))	MS Shower turned on
00:00:01		
00:00:02	where did	CU Shower head
00:00:03	you get	MS Shower head
00:00:04	those	Woman taking a shower
00:00:05	beautiful	Showerhead pans down
00:00:06	eyes	Woman taking a shower
00:00:07	if I'm a runner upper	CU Shower head
00:00:08	do I still get a prize	Woman taking a shower
00:00:09	cause I'm dog-gone tired	CU Shower head
	of all of your lies	Woman taking a shower
	so why can't I sleep	
	on the subway	

Figure 22-4: Excerpt of an editing script with the time broken down in seconds.

Use Light Effectively

An audience should never confuse a music video with the soundtrack for a soap opera. Instead of flat, even light, go for something more robust. Pretend you're a painter, an abstract one, no less, and paint with light:

- **Use color.** Especially with an HD palette, color looks better than ever before, as seen in Figure 22-5.

- **Be dramatic.** Don't shy away from using a single light shining up on the subject.

✔ **Remember that natural light is your friend.** Its soft hues and focus can set the mood nicely.

✔ **Take advantage of the sun.** There's nothing like lighting the scene with that big ol' free light in the sky. Early morning and late afternoon sunlight work best.

Figure 22-5: The saturated colors in this scene from the "Beautiful Eyes" music video take advantage of the HD color palette.

Get the Lip-Synching Down Pat Before Hitting Record

Considered a *faux pas* in just about every form of entertainment, this pantomime activity finds a home with the music video. Lip-synching is necessary with music video because it needs to match the mastered track for the song. But that doesn't mean it can be any less believable. People don't approve of lip-synching for a lot of reasons, but the main one usually is because they can tell the person is not really singing.

Don't let them see it. That's easier said than done, but the following tips may help:

✔ **Have the song playing loud and clear on set.** Hearing the song clearly helps the artist sing the song, and comes in handy when you're recording. You're not going to use it for the video, but you'll hear it well when it comes time to edit.

✔ **Be sure the artist sings with the song instead of mouthing the lyrics.** Yes, you can tell the difference. If the artist isn't really singing, at times, she'll look more like a guppy in a fishbowl than a rock star.

✔ **Practice, practice, and practice.** Then practice again until it looks perfect. Then press Record.

Follow Through on Every Sequence You Shoot

Maybe you're only planning a few scenes with the artist lip-synching to the track, or maybe you want to show a sequence of action to use for a scene. In any case, be sure to shoot more than you need:

✔ **For scenes:** Start the camera before the action begins, as seen in Figure 22-6, and yell, "Cut," er, press Record to stop well after it ends.

✔ **Lip-synching:** Have the artist sing the entire song. You never know where you'll need the footage when it comes time to edit.

✔ **Repeat (if necessary):** Do everything I just mentioned repeatedly until you get a result you like.

Figure 22-6: This scene started long before the subject walked through the frame.

Shoot to Edit to the Umpteenth Degree

More often than not, a music video lives and dies on the way that it's edited. Whether it's a barrage of quick cuts, plugging the right segment into the

timeline for a specific music passage, or matching an array of key scenes, the pace of the video is as important as the content.

To master the music video, think about the following:

- ✐ **Make the music track the first clip you import.** Place it low in the time-line (audio channels 5 and 6) so that your edits above it are not affected.

- ✐ **Place lip-synching clips above the audio file and match the audio.** It takes some practice, but because it's the actual song playing on the track, it's possible. After you're satisfied, turn down the audio of the synched track so that the master is all that's heard.

- ✐ **Try not to use lip-synch for the entire edit.** Something is always bound to go wrong, and like the theater, people try to find the wires if you show them the same thing for too long.

- ✐ **Working from an editing script makes the process breeze by.** After put-ting the video together, fine-tune it.

- ✐ **Make sure the beats match scene changes.** The changes should come smoothly. Watch the peaks of the audio waveform and cut appropriately.

- ✐ **Show your edit to a target audience.** Show it to your girlfriend, hus-band, sister, best friend, or anybody but the band. Watch it with them. Take their advice, and also observe their reaction to specific scenes and segments.

23

Ten Wedding Video Techniques

Maybe you're well versed when it comes to wedding reportage. Or perhaps you just got tapped on the shoulder to cover your sister's, friend's, or ex-wife's wedding? Oh, joy.

Covering a wedding — via photography or video — usually resides on the opposite end of the creative spectrum from making your auteur film. Instead of using a bunch of creative devices defined by French terms that sound nothing like they're spelled, the process often takes on a cookie-cutter mentality of rituals and expected shots. Now, in all fairness, the routine, and often epic, technique documents the happy couple's once-in-a-lifetime day.

Looking at it from the audience perspective sheds light on the subject. At some point, everyone has had to sit through nuptial footage, although some do it more bravely than others. Of course, watching a dreary wedding video is definitely worse than making one, so why not take advantage of both worlds by making a video that's fun to produce and entertaining to watch?

Here are the top ten aspects you need to consider to keep it lively when capturing this once-in-a-lifetime event.

Have the Right Equipment

You won't be able to make a wedding until you have the right stuff. Here's what you need:

- **Two DSLR cameras:** Leave one camera mounted to a tripod for overviews and room shots, and keep the other with you, preferably on a rack. Did I mention it's important to get a rack, or even build your own? (Dozens of YouTube videos show you how.)

- **Varying focal lengths:** A nice selection of lenses goes a long way in telling the story and keeping the video visually interesting. A zoom lens that goes from wide to moderate telephoto is a starting point that lets you go wide enough for the party antics and still get up close and personal for detail shots.

- **Proper lighting:** Nothing says "wedding video" like one of those on-camera lights interrogating the guests. But you can soften them up with diffusion material, or better yet, try one of those L.E.D. models, if you can afford it. One other solution is to have an assistant hold it off-camera.

- **A tripod:** It keeps the scene balanced, and it's great for mounting the camera and letting 'er rip during the reception.

- **A professional-quality microphone:** If you're not sure what you need, see Chapter 4.

- **Cables, connectors, lens shades, and other accessories:** If you don't think you'll need it, bring it anyway.

- **Extra batteries:** Weddings last anywhere from 5 to 10 hours or more, whereas a DSLR battery lasts about an hour. You'll run out of gas pretty quickly. Invest in an extra battery or two and bring your charger to keep them fresh. Also consider an optional battery grip; they sometimes last twice as long.

- **More than enough media cards:** You don't want to miss any part of the day because you only have a few minutes left on the card, nor do you ever want to delete any scenes without seeing them on a proper monitor during the editing process. Always bring more than you think you'll need.

Anticipate the Action Before You Can Follow It

If you've been to more than a few weddings, you should have some idea how they're structured, but that basic itinerary often has variations. Sometimes the ceremony is at a church or temple and the reception at another location;

or the reception takes place a day after the ceremony. Maybe it's a destination wedding, and there's a completely different plan. Whatever the case, you need to know these things before you begin to shoot.

Consider the following:

- **Communicate with the bride and groom.** Do this *before* the actual wedding day. Find out what they want and what's expected of you. Now's the chance to share some of your ideas that go against the grain.

- **Rehearse your shooting:** Or more appropriately, attend the rehearsal. Then you'll know exactly what to expect. The practice run gives you a chance to communicate with the bride and groom before the stress of the actual day overtakes them. All it takes is a run-through for you to know what's important at the ceremony.

- **Scope out the location.** Do this before you're actually shooting to get some idea what you're up against. Check church access, outlets in the reception hall, sunlight patterns, and anything else of importance. Figure 23-1 shows the church where the ceremony will take place.

- **Follow a script.** After assessing all this information, create a rough script to follow on the day of the shoot. You'd be surprised how many small details you miss when shooting an event, and because those little elements often combine for great things, a script helps you remember.

Figure 23-1: Something as simple as checking the church exterior before the wedding helps you figure out the best position to shoot.

Capture the Necessary Moments

Unless someone else commissions you, your emphasis stays on the bride and groom. Of course, the party, family, and setting are still important, but only because they support the imagery of the day's events. Remain open to shooting anything interesting that happens around you, but also consider the following as must-haves:

- **The happy couple:** Walking separately to the ceremony, walking down the aisle after married, first dance, cutting the cake, and well, you get the idea.

- **The couple's parents:** Walking down the aisle, entering the reception, dancing with the bride.

- **The family formals:** Though this is a photo op, it makes for interesting video to capture the waiting and anticipation, as seen in Figure 23-2. It's also a great time to get some random quotes.

- **Cultural moments:** The breaking of a glass at a Jewish ceremony, jumping the broom at an African-American wedding, or hand-washing at a Korean wedding. These and other culturally unique moments are important to capture.

- **The guests:** Weddings are about more than the day; it's also a people event where families celebrate. Capture as much of that as you can and don't forget about the little ones. Kids are often the wedding money shot. Whether it's the ring bearer or the littlest guests, you can't go wrong by including them, as seen in Figure 23-3.

Figure 23-2: All too often, a wedding is the only time families get a group portrait.

Figure 23-3: Kids having fun with the DJ.

Create a Narrative Through Interviews

Although there's no shortage of visuals when it comes to capturing a wedding, some of the best are those moments on camera when family and friends share their feelings for the happy couple. By talking to everyone from the bride and groom to the maid of honor to childhood friends, you can tell a story that goes beyond the rituals.

Try the following:

- **Come up with valid questions.** Although you want folks to congratulate the newly married couple, you also want to delve deeper, asking subjects about their fondest memories of the one they know.

- **Listen to the speeches.** After hearing those words of honor, ask the best man or maid of honor more details about a story she shared for the toast.

- **Have an irreverent question in mind.** It's important to seek out those comedic elements, especially as they get "more comfortable" (in other words, as they drink more). Ask something like "How long did it take to get dressed today?" and see where it goes from there.

Monitor Your Audio

Control the audio like the head bean-counter at an accounting firm's department of inner operations. Be sure to use a separate microphone for interviews, and let either the on-camera microphone or a separate shotgun microphone

deal with ambient sound. Always make sure that audio signals are never over-modulated. Also, use headphones to monitor the audio and make adjustments when necessary.

Shoot a Healthy Dose of B-Roll

The b-roll is made up of the basic shots of all the elements of the day, including the church exterior, interior, wedding reception space, food, flowers, the DJ, dancing, eating, and anything else you may come across. Figure 23-4 shows a unique toast at a theme wedding. All of these elements help with the pacing of the video, not to mention help cover the event.

Figure 23-4: Revelers make a toast at this period wedding.

Pay Attention to Focal Length

Weddings are an interesting blend of expansive views and detail shots. For example, you may have a wide expanse of the guests celebrating on the dance floor and a detailed shot of the couple placing the rings on each other's hands, but there are also a lot of medium shots. Aunt Mary and Uncle Sal dancing, or Uncle Mo doing the worm at his age are essentially medium shots. As a result, it's important to have at least a wide to moderate telephoto zoom lenses, perhaps a 24-105mm, as well as something ultra-wide and another lens in the telephoto range. Close-ups let you capture emotion, and that blends nicely with some of the more irreverent content from the party.

Try Some Tricks

There's no reason why you cannot exercise your creative muscle, providing it works with the theme of the video.

Consider the following:

- ✔ **Change the pace.** Set up the camera on a tripod to capture a time-lapse of people being seated. (For more information, see Chapter 6.)

- ✔ **Make a black-and-white version.** You can do this in postproduction after the actual video is edited by making a second copy. If the married couple doesn't like it, you can supply the original, as seen Figure 23-5.

- ✔ **Produce a consumer DVD.** Make a cover and include extras, outtakes, alternative versions, and other videos. For example, if you also capture the engagement party, the rehearsal dinner, or the video presentation of old photos that usually plays at the reception, you can use that footage for the DVD.

Figure 23-5: Black-and-white footage lends a timeless look to a wedding video.

Make It Happen in Editing

After you've captured everything the bride and groom have asked you to do, it's time to put it together. There are two schools of thought when it comes to editing. Some believe that you should give the couple most of what you've

shot, so they can finally enjoy the moment. The other idea is to show a shorter version with quick highlights. The former certainly makes the couple happy, whereas the latter tends to please the general audience. A fair compromise has you giving both: a raw-ish version of the day (which is essentially a raw version with setups, out-of-focus shots, and alternate takes taken out) as well as an edited version. This buys some time, so you don't have to rush.

For the edited package:

- **Keep the shots short.** A rolling stone gathers no moss, and neither do constantly changing visuals. People get bored when the action doesn't change after five or ten seconds. Use your editing skill to keep it interesting by using b-roll, cutaways, and different angles.

- **Use b-roll for speeches.** Now is the time to cutaway to b-roll while the best man, maid of honor and other dignitaries make their toasts.

- **Make a dance montage.** This keeps the action moving.

- **Create a shot list.** After you understand what you've got, you can begin to put it together on paper.

- **Avoid tacky transitions.** You may think that they're cool today, but trust me, they're not.

Be Responsible and Finish the Job on Time

After the stress of the wedding and adjustment to married life, the happy couple wants to finally enjoy their special day via video. Don't deny them that pleasure. Deliver the video as soon as it's finished. Taking a couple of weeks to deliver it is reasonable, but a month isn't.

Ten Tips for Creating a Documentary

*O*scar-winning films like *Taxi to the Dark Side* (2007) and *March of the Penguins* (2005), are clearly documentaries, but so is the video you made commemorating your mother's 60th birthday or your son's first haircut. (Put them together and you get *Taxi to Your Mom's 60th Birthday*, or *March of the Barbers*, but I digress.)

By definition, a documentary is a non-fiction account of a topic. They include the long-form feature-length movies, multi-part television series like Ken Burns' *Jazz, Baseball,* and *The Civil War,* as well as news segments that range from one minute to one hour. The duration doesn't matter as long as you grab the attention of your audience.

To make your documentary of any length and subject matter into something that people will find interesting, consider these ten tips.

Know the Topic You're Going to Cover

Whether you're making a two-hour feature length film or a two-minute online video, as seen in Figure 24-1, you need to understand the subject; otherwise, you're not going to fully understand what to include, ask the right questions, or draw the appropriate conclusion. There's a variety of ways to accomplish this task:

- ✓ **Research the topic.** Understand the issue for both sides.

- ✓ **Understand the subject.** There's nothing worse than asking questions that don't pertain to the subject due to poor research.

- ✓ **Seek out experts.** Try to get a handle on the topic from someone familiar with it.

Figure 24-1: A screen grab of a Colorado scene.

Plan Your Shoot Well

Making a documentary is about more than shooting a series of scenes, putting them together with a narration track, and expecting to have a compelling movie. Quite the contrary: A documentary encapsulates classic storytelling with a beginning, middle, and an end, along with detailing the conflict and coming to some sort of resolution.

In order to do all that, you need to meticulously plan for each shoot and the actual message. Here are a few tips:

- ✔ **Make calls ahead of time.** Before you even take out the camera, see who will talk to you and what access you can have with them.

- ✔ **Know your questions ahead of time.** This helps you shape the story and provides the opportunity for the relative impromptu follow-up questions.

- ✔ **Create a shot-by-shot outline.** Even if it's rough, a working script works well as a guide for your movie.

Have the Right Equipment

Even professionals find themselves without the right gear sometimes because some situations require specific equipment for coverage. For example, if you're doing a sports documentary, you'll need telephoto lenses, or if it's a music piece, you'll need more audio gear. These decisions are vital before you get started.

Have a Plan for Shooting

Planning the shooting is not to be confused for planning the documentary. Remember to shoot your movies with the proper variations for each scene. Use focal length, camera angle, and camera-to-subject distance to capture the necessary shots. For example, if you wish to depict the subject entering, or leaving, a key location, concentrate on the variety of ways that happens with an eye to pre-visualizing how it works in editing.

- ✔ **Be sure to capture visuals referenced by the subject.** It's not random when you include relevant scenes surrounding an interview, like a barn at the bottom of the hill or a prized family heirloom.

- ✔ **Don't forget the cutaways.** Whether you capture these before, during, or after the interview with a second camera doesn't matter as long as you get them. These include a tight shot of fidgeting hands, fingers going through hair, tapping feet, or some other gesture, as seen in Figure 24-2.

- ✔ **Shoot adequate b-roll.** Not the same as a cutaway, b-roll supports the subject. Shoot a popular location, relevant object, or point of interest, as seen in Figure 24-3.

- ✔ **Draw the viewer into the scene.** Starting with wide shots, bring the viewer closer and closer to create drama.

Figure 24-2: During a performance video, details of this artist's unique wardrobe were captured.

Figure 24-3: Powell Street in San Francisco serves as b-roll for a music video shot on location.

Make Contact with Sources Before Shooting

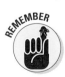

Unless you're capturing a family event, chances are you won't know the subject, nor will you shoot in your backyard or even your town. So the idea of talking to people you don't know in a place you're not familiar with demands that you communicate before doing anything else.

Here are a few suggestions:

- ✔ **Map the location.** Don't stop short of using a map or be afraid to mark it with notations. Sometimes that's the only way to get a clear idea of your sense of pride.

- ✔ **Call or e-mail.** You can even use Pony Express, if that's your thing. After you make contact, make sure you're cordial and express your basic intentions.

- ✔ **Set up meeting times.** Whether it's in person or on the phone, arrange a time and don't be late.

Don't Under/Overestimate Your Social Skills

Use your charm to approach each interview with politeness and wide-eyed optimism. Don't assume you know the answers before you ask the questions. Yes, some people do that! Instead, try to think of the explanation required by your 8-year old self to get the necessary clarification.

Consider the following:

- ✔ **Be respectful.** Even if you don't agree with her position or attitude, don't let it show. Many times, you'll need to ask tough questions. When you do, be sure to preserve dignity.

- ✔ **Listen to the subject.** I've seen interviewers tune out the response to their previous question as they attempt to ask the next question, almost like a kid in a car asking: "Are we there yet?" Don't ask if you're there yet. Just listen while you capture the interview.

- ✔ **Make eye contact.** All the sincerity in the world means nothing if you don't look someone in the eye. Trust me, a little goes a long way.

- ✔ **Don't read your notes.** The objective is to get a conversation started, and looking at questions breaks the rhythm of the interviews. Instead, have a discussion, but one structured with questions that allow you to segue into the areas you need to cover. That part is up to you to do effectively.

- ✔ **Be ready for impromptu interviews.** Always have the camera ready to roll and audio levels set to stun-ning! You never know when someone will reveal something, so be ready for it.

Have a Strong Narrative

In a perfect world, James Earl Jones would narrate your story, but chances are, that's not going to happen. That doesn't mean you can't find a strong solitary voice to carry the storyline and set up people, places, issues, and other elements.

Here a few suggestions:

- ✔ **Find the right voice.** Every topic has the right voice, be it serious, irreverent, seductive, or sarcastic.
- ✔ **Trolling for talent.** Acting and broadcasting schools are not bad places to find someone. You're looking for voices, and they're looking for an opportunity. It can be a win-win.
- ✔ **Write a script.** The voiceover script should include a tightly written, witty account of your story with references to footage in the movie.

Shoot Much More Than You'll Ever Use

I remember a discussion while in film class that said the average documentary shot at a 20:1 ratio between overall footage and what ended up in the movie. Because the movie is not scripted, you never know how long each interview takes to provide the content that you need. Because the story comes together in editing, it's hard to tell how much you'll need to shoot.

Using Still Photos

Although using still photos in a documentary movie may sound more boring than watching your cousin's homemade wedding video, that all changed with the work of Ken Burns. He took the static nature of a photo and made it move, added compelling narration, and took the audience through a place they never thought they'd go, or for that matter, like.

While Burns used Adobe After Effects, some followed up with Final Cut. Now you can do it using Adobe Premiere Elements.

Consider the following:

✓ **Fill the frame:** Most photographs have a different aspect ratio than HD video, so they're often presented either pillar-boxed or letterboxed, as seen in Figure 24-4. Crop them a little to fill the frame, as seen in Figure 24-5.

✓ **Zoom:** Pull in or out of a photo to show detail or setting, respectively.

✓ **Pan:** Move from right to left; left to right; or up and down.

✓ **Twist:** Shift the horizon a little, or go crazy with a psychedelic spin.

✓ **One more thing:** Use time to properly pace these moves. Some are more effective to move gradually, whereas others are ultra-quick.

Figure 24-4: A pillar-boxed image.

Figure 24-5: A corrected image.

Watch Documentaries to Understand Narrative

Although a filmmaker learns how to make films by making films, the same can be said when it comes to watching them too. That applies to documentaries, too, yet some people confuse them with those boring public service films from junior high school like *Your Hormones and You.*

Get past the misconception of documentaries as tedious, boring movies on topics you don't care about. When they're made correctly, they are as entertaining as a feature film, and you may learn something too.

Besides the previously mentioned choices, here are a few more to consider:

- ✔ *Bowling for Columbine* (2002)

 Director: Michael Moore

 The director of *Roger and Me* (1989), and *Fahrenheit 9/11* (2004) won an Academy Award for this humorous take on the serious subject of gun control after the tragic school shooting in Columbine, Colorado. By putting himself in the film, he changed the context of the narrative.

- ✔ *Waiting for Superman* (2010)

 Director: Davis Guggenheim

 As his previous film *An Inconvenient Truth* (2006) took on the controversial subject of global warming, this one takes on the public education system and how it inhibits academic growth rather than encouraging it.

- ✔ *Woodstock* (1970)

 Director: Michael Wadleigh

 This Oscar-winning documentary chronicles the historical three-day event that became the symbol of a generation. When Wadleigh took on the project, he had no idea it would turn into a cultural icon. It's a great example of being ready for anything and going out there and capturing it. Of course, legendary performances by Santana, The Who, and Jimi Hendrix don't hurt either.

Index

• E •

• *N* •

• U •

• V •

• W •

Notes

Notes

Apple & Mac

iPad 2 For Dummies,
3rd Edition
978-1-118-17679-5

iPhone 4S For Dummies,
5th Edition
978-1-118-03671-6

iPod touch For Dummies,
3rd Edition
978-1-118-12960-9

Mac OS X Lion
For Dummies
978-1-118-02205-4

Blogging & Social Media

CityVille For Dummies
978-1-118-08337-6

Facebook For Dummies,
4th Edition
978-1-118-09562-1

Mom Blogging
For Dummies
978-1-118-03843-7

Twitter For Dummies,
2nd Edition
978-0-470-76879-2

WordPress For Dummies,
4th Edition
978-1-118-07342-1

Business

Cash Flow For Dummies
978-1-118-01850-7

Investing For Dummies,
6th Edition
978-0-470-90545-6

Job Searching with Social
Media For Dummies
978-0-470-93072-4

QuickBooks 2012
For Dummies
978-1-118-09120-3

Resumes For Dummies,
6th Edition
978-0-470-87361-8

Starting an Etsy Business
For Dummies
978-0-470-93067-0

Cooking & Entertaining

Cooking Basics
For Dummies, 4th Edition
978-0-470-91388-8

Wine For Dummies,
4th Edition
978-0-470-04579-4

Diet & Nutrition

Kettlebells For Dummies
978-0-470-59929-7

Nutrition For Dummies,
5th Edition
978-0-470-93231-5

Restaurant Calorie Counter
For Dummies,
2nd Edition
978-0-470-64405-8

Digital Photography

Digital SLR Cameras &
Photography For Dummies,
4th Edition
978-1-118-14489-3

Digital SLR Settings
& Shortcuts
For Dummies
978-0-470-91763-3

Photoshop Elements 10
For Dummies
978-1-118-10742-3

Gardening

Gardening Basics
For Dummies
978-0-470-03749-2

Vegetable Gardening
For Dummies,
2nd Edition
978-0-470-49870-5

Green/Sustainable

Raising Chickens
For Dummies
978-0-470-46544-8

Green Cleaning
For Dummies
978-0-470-39106-8

Health

Diabetes For Dummies,
3rd Edition
978-0-470-27086-8

Food Allergies
For Dummies
978-0-470-09584-3

Living Gluten-Free
For Dummies,
2nd Edition
978-0-470-58589-4

Hobbies

Beekeeping
For Dummies,
2nd Edition
978-0-470-43065-1

Chess For Dummies,
3rd Edition
978-1-118-01695-4

Drawing For Dummies,
2nd Edition
978-0-470-61842-4

eBay For Dummies,
7th Edition
978-1-118-09806-6

Knitting For Dummies,
2nd Edition
978-0-470-28747-7

Language & Foreign Language

English Grammar
For Dummies,
2nd Edition
978-0-470-54664-2

French For Dummies,
2nd Edition
978-1-118-00464-7

German For Dummies,
2nd Edition
978-0-470-90101-4

Spanish Essentials
For Dummies
978-0-470-63751-7

Spanish For Dummies,
2nd Edition
978-0-470-87855-2

Math & Science

Algebra I For Dummies,
2nd Edition
978-0-470-55964-2

Biology For Dummies,
2nd Edition
978-0-470-59875-7

Chemistry For Dummies,
2nd Edition
978-1-1180-0730-3

Geometry For Dummies,
2nd Edition
978-0-470-08946-0

Pre-Algebra Essentials
For Dummies
978-0-470-61838-7

Microsoft Office

Excel 2010 For Dummies
978-0-470-48953-6

Office 2010 All-in-One
For Dummies
978-0-470-49748-7

Office 2011 for Mac
For Dummies
978-0-470-87869-9

Word 2010
For Dummies
978-0-470-48772-3

Music

Guitar For Dummies,
2nd Edition
978-0-7645-9904-0

Clarinet For Dummies
978-0-470-58477-4

iPod & iTunes
For Dummies,
9th Edition
978-1-118-13060-5

Pets

Cats For Dummies,
2nd Edition
978-0-7645-5275-5

Dogs All-in One
For Dummies
978-0470-52978-2

Saltwater Aquariums
For Dummies
978-0-470-06805-2

Religion & Inspiration

The Bible For Dummies
978-0-7645-5296-0

Catholicism For Dummies,
2nd Edition
978-1-118-07778-8

Spirituality For Dummies,
2nd Edition
978-0-470-19142-2

Self-Help & Relationships

Happiness For Dummies
978-0-470-28171-0

Overcoming Anxiety
For Dummies,
2nd Edition
978-0-470-57441-6

Seniors

Crosswords For Seniors
For Dummies
978-0-470-49157-7

iPad 2 For Seniors
For Dummies, 3rd Edition
978-1-118-17678-8

Laptops & Tablets
For Seniors For Dummies,
2nd Edition
978-1-118-09596-6

Smartphones & Tablets

BlackBerry For Dummies,
5th Edition
978-1-118-10035-6

Droid X2 For Dummies
978-1-118-14864-8

HTC ThunderBolt
For Dummies
978-1-118-07601-9

MOTOROLA XOOM
For Dummies
978-1-118-08835-7

Sports

Basketball For Dummies,
3rd Edition
978-1-118-07374-2

Football For Dummies,
2nd Edition
978-1-118-01261-1

Golf For Dummies,
4th Edition
978-0-470-88279-5

Test Prep

ACT For Dummies,
5th Edition
978-1-118-01259-8

ASVAB For Dummies,
3rd Edition
978-0-470-63760-9

The GRE Test For
Dummies, 7th Edition
978-0-470-00919-2

Police Officer Exam
For Dummies
978-0-470-88724-0

Series 7 Exam
For Dummies
978-0-470-09932-2

Web Development

HTML, CSS, & XHTML
For Dummies, 7th Edition
978-0-470-91659-9

Drupal For Dummies,
2nd Edition
978-1-118-08348-2

Windows 7

Windows 7
For Dummies
978-0-470-49743-2

Windows 7
For Dummies,
Book + DVD Bundle
978-0-470-52398-8

Windows 7 All-in-One
For Dummies
978-0-470-48763-1